EDWARD SHERIFF CURTIS

VISIONS OF THE FIRST AMERICANS

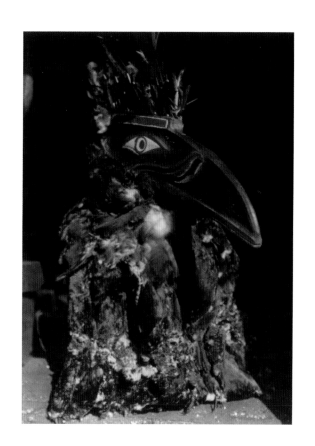

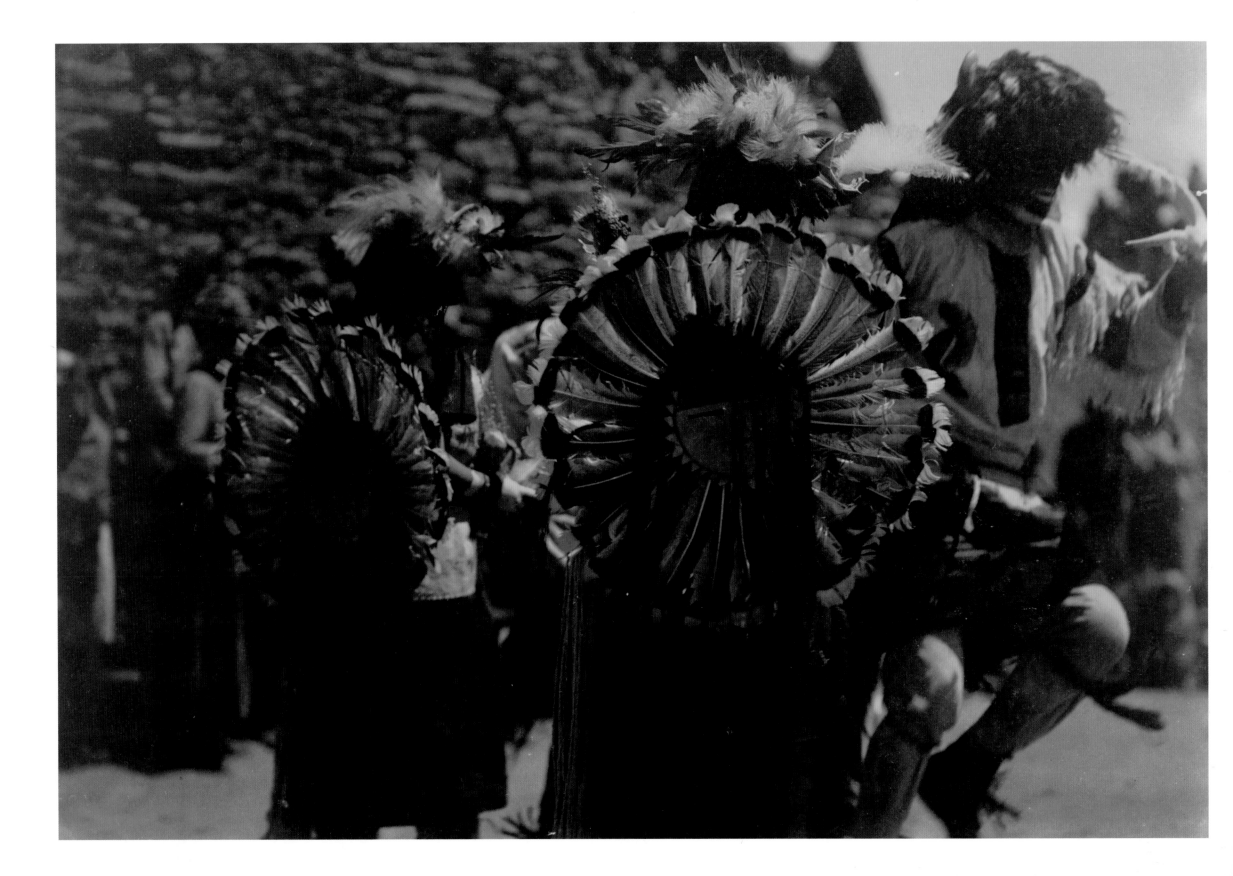

EDWARD SHERIFF CURTIS

VISIONS OF THE FIRST AMERICANS

Don Gulbrandsen

CHARTWELL
BOOKS, INC.

This edition published in 2010 by

CHARTWELL BOOKS, INC.
A Division of
BOOK SALES, INC.
276 Fifth Avenue Suite 206
New York, New York 10001

ISBN-13: 978-0-7858-2650-7
ISBN-10: 0-7858-2650-5

Cataloging-in-Publication data is available from the Library of Congress

Printed and bound in China

Design: Ian Hughes

Draftsman: Mark Franklin

Acknowledgments
All images are credited with their captions. Photos came from Corbis (thanks to Katie Johnston) and Library of Congress online facilities.
Acknowledgement must be made to: the excellent Library of Congress on-line facilities; the brilliant website of the Northwestern University Library that has an electronic version of all twenty volumes of *The American Indian* and was an essential aid to research; and Michael Johnson's *Concise Encyclopedia of the Native Tribes of North America* that was the basis for much of the tribal information in the captions.

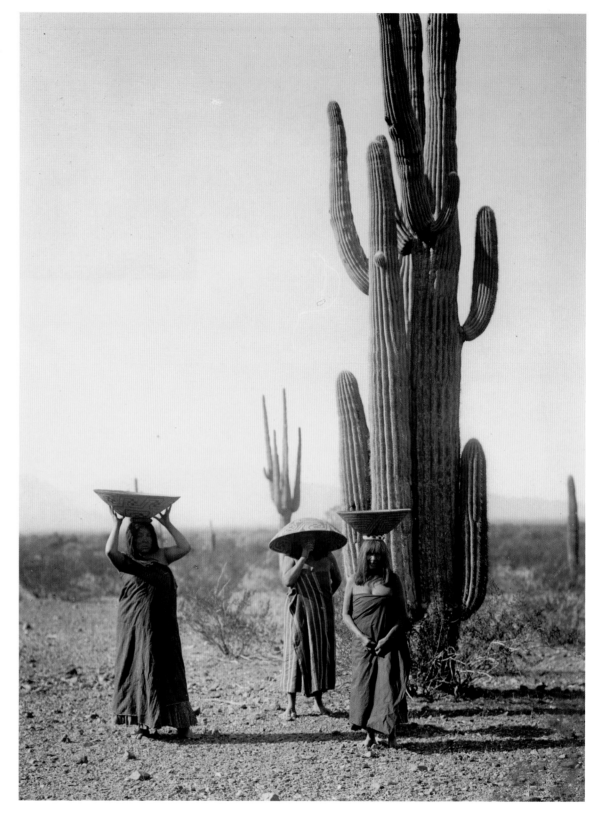

PAGE 1: Kwahwumhl—a Koskimo dancer—wearing a raven mask with coat of cormorant skins during the *nunhlim* ceremony, November 13, 1914. The image was published in Volume X on the Kwakiutl where the ceremony was discussed.
Library of Congress, Prints & Photographs Division, Edward S. Curtis Collection, LC-USZ62-52215

PAGE 2: Costumed dancers wearing dance bustles made of turkey feathers.
Library of Congress, Prints & Photographs Division, Edward S. Curtis Collection, LC-USZ62-123302

RIGHT: Three Maricopa women with baskets on their heads, standing by Saguaro cacti; c. 1907. This tribe was covered in Volume II.
Library of Congress, Prints & Photographs Division, Edward S. Curtis Collection, LC-USZ62-101181

FAR RIGHT: Umatilla woman wearing a beaded buckskin dress, shell bead necklaces, shell disk earrings, and woven grass hat. Published in Volume VIII.
Library of Congress, Prints & Photographs Division, Edward S. Curtis Collection, LC-USZ62-111291

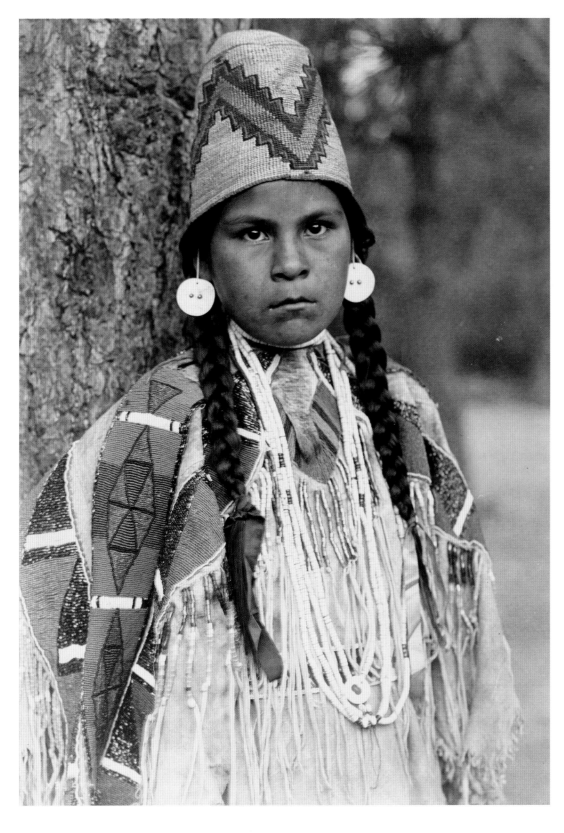

CONTENTS

INTRODUCTION

Edward Sheriff Curtis: Visions of the First Americans

The faces stare out at you, images seemingly from an ancient time and from a place far, far away. Their names are just as arresting—Shot in the Hand, Two Moon, Bear's Belly, Raven Blanket—monikers that don't immediately register as human. Yet as you gaze at the faces the humanity becomes apparent, lives filled with dignity but also sadness and loss, representatives of a world that has all but disappeared from our planet.

It's startling to learn that these stunning photographs were recorded in the United States and Canada not more than a century ago, images of Indians from tribes being overwhelmed by twentieth century progress. Even more surprising is that these images—part of a body of work encompassing 40,000 photographs of American Indian life—were all recorded by a single man, Edward Sheriff Curtis. Curtis was a true visionary and a man driven by the desire—no the *need*—to record Native American cultures before they disappeared. Along the way he became, for a time, the most famous photographer in America, fame that during his lifetime proved fleeting and came with a steep price.

Today, Edward Curtis is again acknowledged as one of the country's greatest photographic artists, but this renewed recognition did not come easily. He wrapped up work on his thirty-year Indian project in relative obscurity and when he died in the 1950s few people knew much about him or his work. Curtis was rediscovered in the 1970s as part of America's growing awareness of its long-ignored native people. His photographs and ethnographic data played an essential role in educating the country about its Indian tribes and their cultures. Most importantly, Curtis's emotionally charged images were a wake-up call reminding people of all that had been *lost* in the rush of America's westward expansion.

Despite Curtis's incredible achievements, he was also one of the most complex characters of his time. Even today he has both fans and detractors. Anybody who studies Curtis can't help but wonder ponder the many contradictions that made up his life:

- He was a friend of presidents and powerbrokers and spent considerable time hobnobbing with America's rich and powerful, yet he was born into poverty and spent much of his life in debt and struggling to make ends meet.

- He conducted one of the most significant ethnographic studies in American history, and was praised by many of America's top academics, yet he had no formal training in anthropology and in fact attended school only through the sixth grade.

- He loved his family dearly and his four children were devoted to him right to the end of his long life, yet he was rarely at home during their youth and his blind devotion to work led to the acrimonious break-up of his marriage.

- He clearly respected the Indians he photographed and took great pains to learn about them as people, but he often put his photographic efforts first, making payoffs or playing politics to get images he really wanted, or favoring compositional elements over cultural ones.

Yet all these realities only make Curtis's story that much more compelling. When you start to look at the images and consider all that he set out to do and all he achieved, you begin to forgive his faults and you find yourself wanting to know more: Why did he do this? How did he manage this? As you spend time even more time with the Curtis photographs you can't help but feel a connection with the people in them—and at that point you understand the value of the gift that this amazing photographer left us.

A Budding Photographer

Edward Sheriff Curtis was born near Whitewater, Wisconsin, in 1868, the second of four children born to Johnson and Ellen Curtis. Johnson was a Civil War veteran and former army chaplain. Like many other surviving soldiers, Johnson left the war with his life but not his health and he often struggled with illness. Johnson also struggled to support his family. He was a farmer when Edward was born, but not a prosperous one. Edward was five when the family moved to a farm in Le Sueur County, Minnesota, just southwest of Minneapolis. After seven years of toiling on the property, Johnson gave up farming

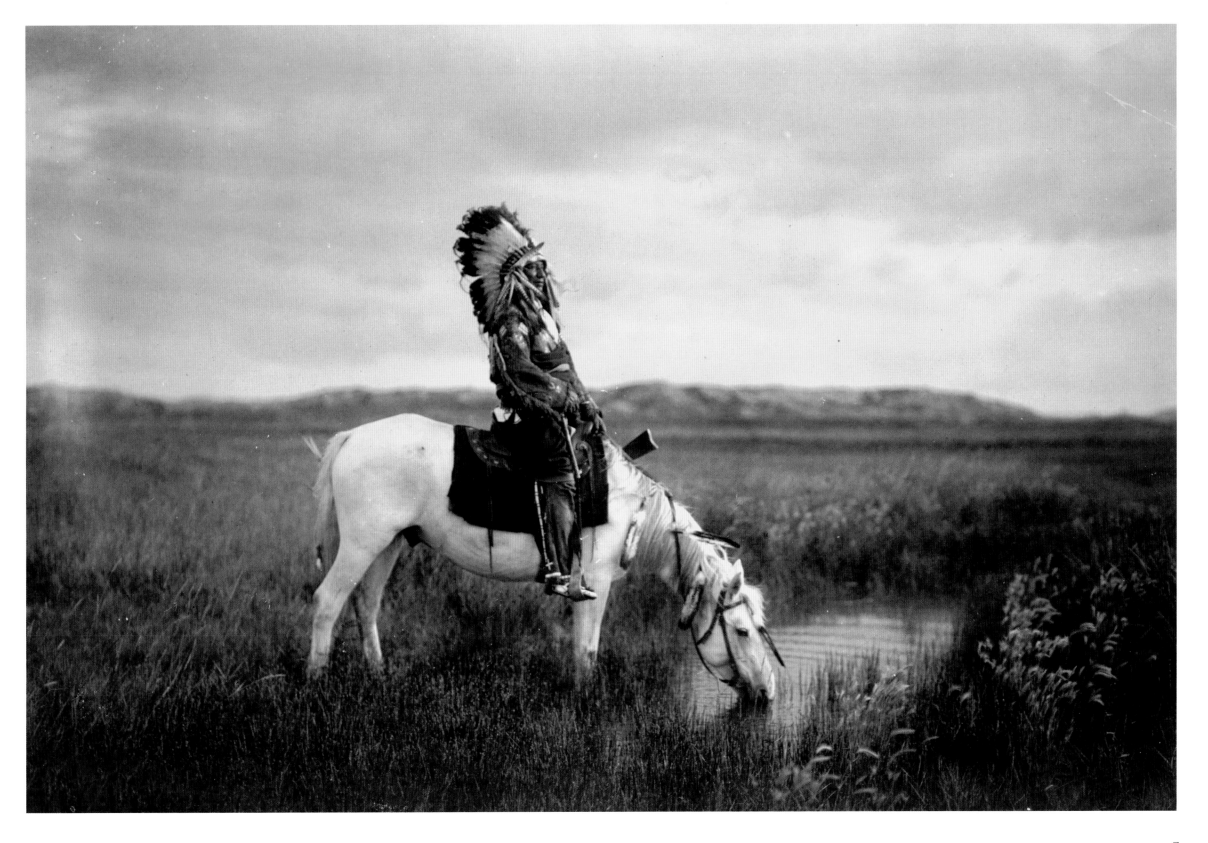

and moved to the nearby town of Cordova, Minnesota, and opened a grocery.

The new business did little to help the Curtis family fortunes. Johnson's retail acumen was on par with his poor farming skills and the store, competing with two others in the little hamlet, barely limped along. To make extra money, Johnson took a part-time job as an itinerant preacher. His parishioners in southeastern Minnesota were poor settlers in a relatively wild country and they rewarded him for his services mostly with wild fish and game.

Johnson often took Edward with him on his ministerial trips and the travels proved an excellent training opportunity for the photographer-to-be. The Curtis's often traveled on foot or via canoe, camping and living off the land on the way. Edward gained a love of the outdoors and learned woodsmanship skills that would serve him well for the rest of his life.

Photography was a new and exciting "science" in post-Civil War America and young Edward was fascinated by the idea of taking pictures. He built his first camera when he was only twelve years old, following plans provided in a borrowed book. On the front of the crude wooden-box device, Curtis mounted a stereopticon lens that his father had brought home from the war. The contraption delivered poor-quality images, but it offered a tool with which Curtis

taught himself the basic principles of photography and printing. It also opened doors that allowed the poverty-stricken boy to imagine a different life for himself.

At the age of 17, Curtis took a job in a St. Paul photographic studio, an experience that taught him valuable lessons about darkroom techniques. Boldly, the young man opened his own studio, but it quickly failed; photographic portraits were not a top priority in a growing frontier town. Instead, he hired on with the Soo Line Railroad and successfully supervised a gang of 250 French-Canadian tracklayers. The fact that he was practically a boy and didn't speak French didn't matter. He was a tall and imposing and had a strong belief in himself, qualities that would come to the forefront in later years as he rubbed shoulders with some of the country's most powerful people.

The Road West

The following year, Edward's life took a dramatic turn. Johnson Curtis, his business and health failing, desperately looked to the west to turn around his fortunes. In the fall of 1887 he and Edward traveled to what is modern-day Port Orchard, Washington, across Puget Sound from Seattle. The father and son homesteaded in the invigorating new land, and the elder Curtis laid the groundwork for opening a brickyard.

Johnson convinced his wife, along with their two younger children, to join them. Three days after they arrived, Johnson died. Edward became the sole supporter of his mother and siblings.

Edward was a tireless worker and he immediately took steps to care for his family—fishing, felling trees, digging clams, tending an orchard, working as a hired hand at local farms or lumberyards. In 1890 Edward suffered a debilitating back injury at a lumberyard and found himself bedridden. Over the following months, Edward's mother, helped by a sixteen-year-old neighbor girl, Clara Phillips, nursed him back to health. Two years later, Curtis married the beautiful, bright, and well-read Clara.

The back injury prevented Curtis from returning to manual labor so he turned to the opening the brickyard. But like other businesses conceived by Johnson, this one was destined to fail—demand for building bricks was low in the timber-rich Pacific Northwest. This impending failure was a fortuitous one for Edward Curtis because at this time he was also rediscovering his love of photography. After his back injury, he had made a chance purchase of a 14 x 17 camera from a gold seeker traveling through Seattle on the way to the Klondike. Soon he was spending his time recording life around Puget Sound on the glass-plate negatives that eventually became the primary tool of his trade.

In 1891, much to his mother's chagrin—she thought photography terribly impractical—Edward sold the brickyard, mortgaged the family homestead, and bought half interest in a Seattle photo studio, partnering with Rasmus Rothi. The next spring, Edward married Clara Phillips and formed a new partnership with Thomas Guptil. The new studio was soon thriving; it became *the* place for the wealthy residents of booming Seattle to go for fine portraits. By 1896, he and Clara had moved their growing family—which included son, Harold, and first daughter, Beth—to a large house they had purchased. Curtis's mother and siblings, as well as other relatives from Clara's family also lived with them. Every member of the family, even the children, worked in the Curtis studio (which eventually bought out Thomas Guptil). Their efforts were essential because the photographer whose name graced the business soon started to become an infrequent visitor to his own studio.

Indians, Mountains, and Gold

The outdoor-loving Curtis had few interests

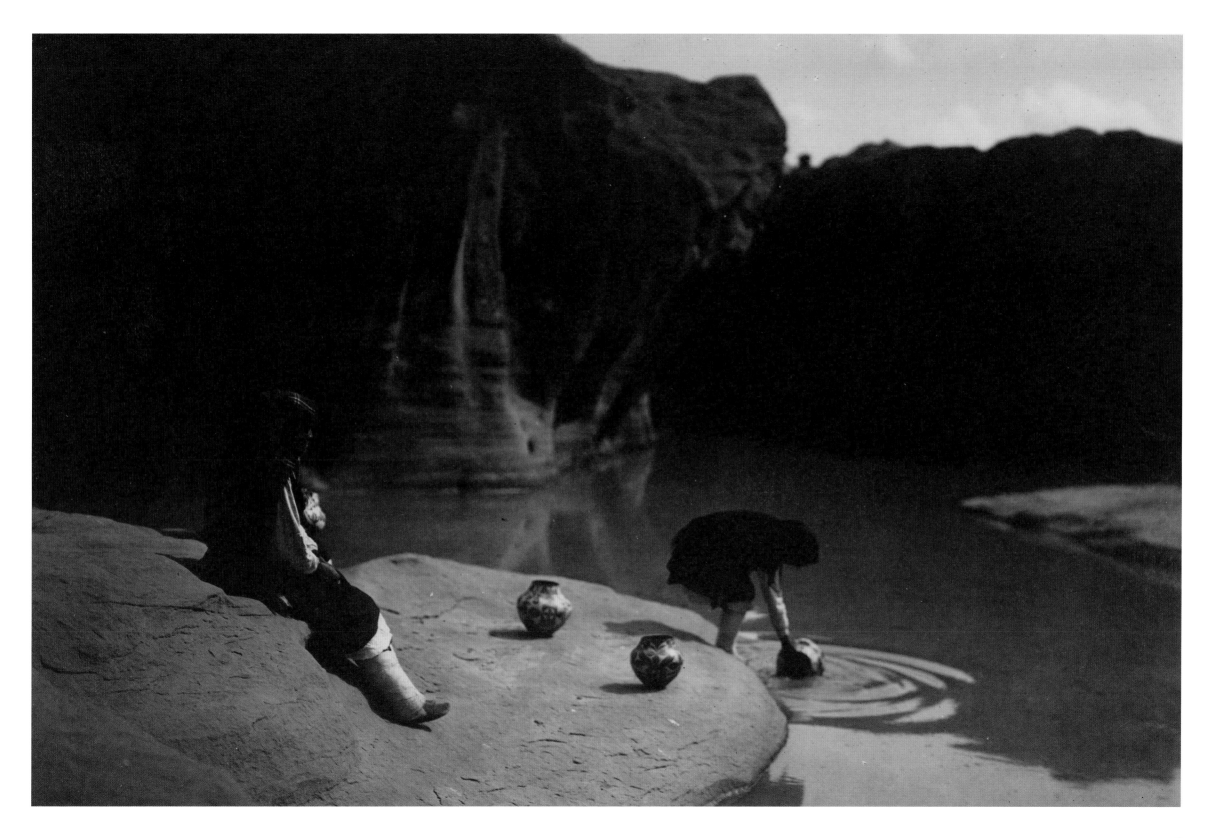

beyond photography and he found the beautiful world outside his studio too hard to resist. Even with the portrait business booming he spent more time exploring around Seattle and photographing the region's people and landscapes. In 1895 Curtis took his first photos of an Indian. The subject was the elderly daughter of Chief Siahl—Seattle—namesake of the city. The old women, known as Princess Angeline, lived in poverty and wandered the mud flats of the sound digging clams. Curtis convinced her to pose—probably paying her in silver dollars, which became his standard fee for Indian models. In 1898 pictures of Princess Angeline were included in a traveling exhibition sponsored by the National Photographic Society that exposed Curtis's work to a wide audience. Curtis was soon traveling to photograph tribes living around Puget Sound and he started to gain recognition as a photographer of American Indians.

Despite this growing reputation, mountain landscapes initially aroused the most passion in Curtis. He enthusiastically embraced mountain climbing, scaled Mount Rainier several times, and was named an honorary member of Portland's prestigious Mazamas mountaineering club. In 1897, while leading one of the group's large expeditions on Rainier, a tragic accident provided Curtis with more national exposure. During the descent, one climber fell to his death and a

second one fell into an ice crevasse and had to be rescued in dramatic fashion. Stories in major newspapers and even *Harper's Weekly* recounted the tragedy and prominently mentioned Curtis.

That summer, gold fever gripped the West as prospectors rushed to the Klondike in search of riches. Seattle was a primary departure point for the gold-seekers and Curtis and his younger brother Asahel followed them north with cameras in hand. Curtis returned in October and pitched a story to *Century Magazine* about the gold rush. The article, complete with seven photographs, appeared in the March 1898 issue and contributed more to his growing reputation.

In December 1897 Curtis sent Asahel back north on another photographic expedition to the gold fields. The young photographer stayed two years, sending back to Seattle an impressive body of work—photographs for which Edward claimed copyright. Though having a studio owner claim copyright for photographs taken by an employee was standard practice in this era, Asahel was infuriated by his older brother's actions. He quit the studio and set out on his own, eventually becoming a famous photographer in his own right. This conflict over copyright was never resolved and sadly the two brothers were estranged for the rest of their lives.

Traveling with Scientists and Rail Barons

Edward Curtis's frequent trips to Mount Rainier continued in 1898 and it was during one of his climbs a chance encounter would lead his life in a different direction. While setting up camp on the mountain's flank, Curtis spied what appeared to be a struggling group of climbers. He later recounted, "I managed to get them to my camp where I thawed them out and bedded [them] down." The party was actually a group of prominent scientists, including Dr. C. Hart Merriam, chief of the U.S. Biological Survey; Gifford Pinchot, at that time chief of the Division of Forestry and later one of America's great conservationists; and George Bird Grinnell, editor of *Forest and Stream* and an authority on American Indians.

This accidental meeting and the friendships resulting from it resulted in Curtis being named official photographer for an 1899 scientific expedition to Alaska organized and funded by

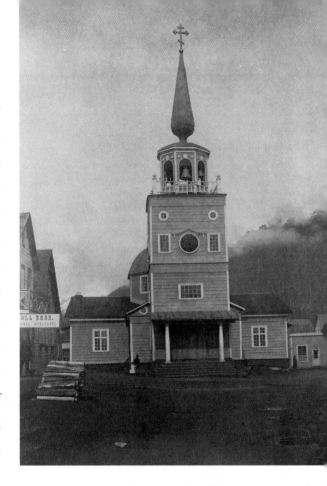

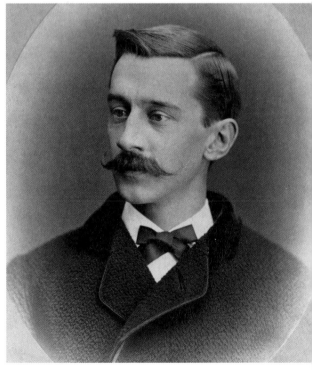

ABOVE RIGHT: A photograph of St. Michael's Cathedral in Sitka, taken by Curtis during the Harriman Alaska Expedition of 1899. *Corbis*

RIGHT: American naturalist George Bird Grinnell. *Corbis*

FAR RIGHT: Graves in a Russian cemetery, again photographed by Curtis during the Harriman Alaska Expedition of 1899. *Corbis*

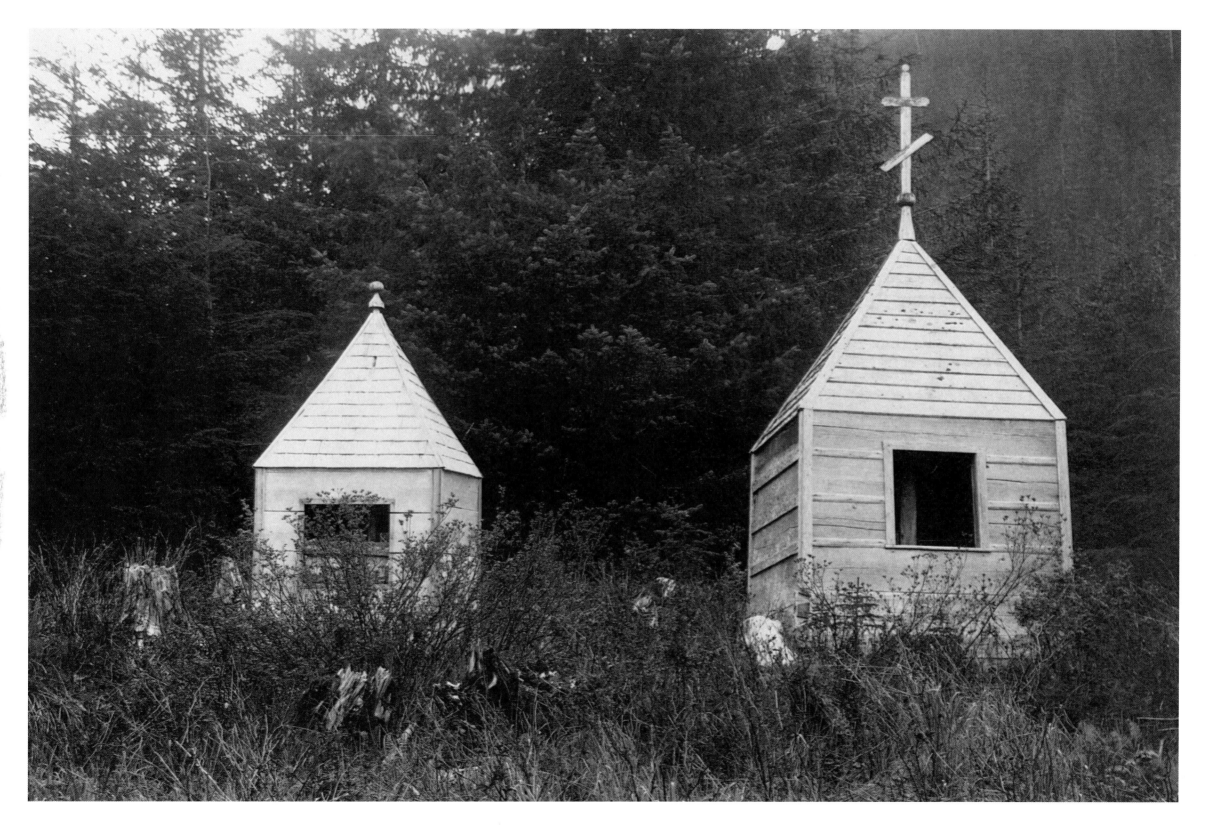

railroad tycoon E.H. Harriman. In addition to the three famous scientists he rescued on Rainier, the expedition including such noteworthy names as naturalists John Muir and John Burroughs, who spent much of the trip arguing with each other.

Curtis had no contract for the trip but thought he could turn a profit by selling photographs to other participants. He spared no expense in his preparations, purchasing new equipment and hiring an assistant to help him. Curtis eventually recorded more than 5,000 images of the Alaskan landscape and spent months afterward in the darkroom. Unfortunately his optimistic sales projections never panned out. Many of the participants seemed satisfied with photos taken by their cheap Kodak cameras and weren't willing to invest in Curtis's expensive prints.

Despite its limited financial rewards, the expedition provided Curtis many other benefits. Curtis photographed and became captivated by native Alaskans—who were suffering under the onslaught of white prospectors and settlers—planting seeds for future work. The expedition also provided him with unimagined opportunities for networking with some of the most powerful people in the country. In particular, Curtis bonded tightly with George Bird Grinnell, a man who would soon fuel his growing interest in Native Americans.

Driven by an Unforgettable Experience

One year later, in 1900, Edward Curtis found himself sitting on the back of a horse looking over a vast Montana plain from a tall bluff. Next to Curtis was Grinnell, who had been visiting the area for two decades and had invited the photographer to join him. Below, hundreds of Blackfoot, Blood, and Piegan people gathered for their annual Sun Dance. Tipis covered a broad swath of the landscape. Curtis later admitted, "The sight of that great encampment of Prairie Indians was unforgettable." Spending time with the tribesmen and photographing them had an even greater impact. Curtis quickly realized that he was witnessing a unique way of life—one that was destined to disappear in the very near future—and that he needed to capture it in photographs before it vanished completely.

Curtis soon made his was to the desert Southwest to photograph the Hopi Snake Dance. The event, held every other year, had become a major tourist attraction for whites from all over the country. But to the Hopi, the dance was a sacred event, and Curtis—even as he was driven to photograph everything he saw while among the Hopi—felt just as drawn to the religious aspects of the dance. He wanted to know more and quizzed the Hopi priests about their beliefs. He wanted to understand these people from the *inside*.

Soon it all became clear to Curtis: Before the western Indians and their cultures disappeared completely, somebody needed to reach out to these people, gain their confidence, and record their existence—in words and pictures—before they were gone forever. Curtis believed he was the man to take action in the face of what he called a "national tragedy." In correspondence to his friend Grinnell, he declared, "I can do something about it. I have some ability."

A Grand Plan Develops

For two years following his experiences in Montana and Arizona, Curtis traveled in the Pacific Northwest and the Southwest taking photographs of many different tribes. As he worked, he developed an ambitious plan to conduct a comprehensive ethnographic study of the tribes of the western U.S. and Canada. Photographs were an important part of the plan, but he was also determined to record religious beliefs, tribal customs, and even language and songs. The fact that he had no training in anthropology (or formal education beyond the sixth grade) did not deter Curtis. He knew that this was his calling in life.

In 1903 Curtis had an opportunity to photograph Chief Joseph of the Nez Perce in his Seattle studio. The aging chief, who died only a year later, made a considerable impression on Curtis. The photographer later described him one as of the greatest men that ever lived. His portraits of the defeated-but-dignified leader remain as some of the most memorable ever made of any Native American. That same summer, Curtis presented in his studio his first exhibition of Indian photographs. His reputation was fast becoming established as the country's leading photographer of Native Americans.

At this same time, Curtis began to experience a problem that would curse him for the rest of his life—a lack of money. Traveling to Indian country and recording images on glass-plate negatives was terribly expensive, and traveling took him away from his lucrative studio business. More and more he was becoming an absentee owner, with his wife and other family members keeping the studio going. In 1904 he fortuitously hired a photographer named Adolph Muhr, who impressed Curtis with his portfolio of Indian portraits taken at an 1898 international exposition. Muhr soon shouldered the load for both Curtis Studio portraits and darkroom work on the Indian photographs.

RIGHT: Edward S. Curtis helps the sons and cousin of Theodore Roosevelt bury a dog at Sagamore Hill c. 1904. Left to right: Quentin Roosevelt, Archie Roosevelt, Edward S. Curtis, and Nicholas Roosevelt.
Corbis

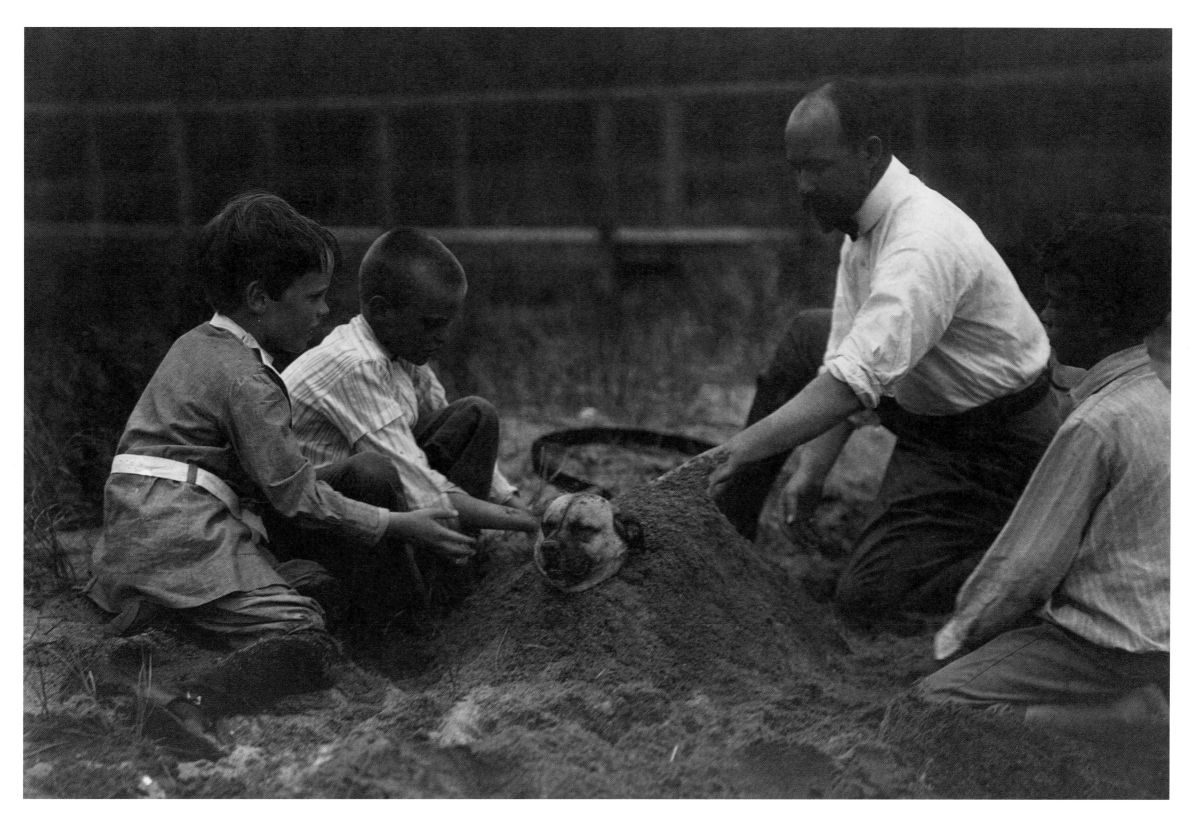

Curtis already had decided that hopes for financing his grand plan lay not in his studio, but in the East. In the summer of 1903 he traveled to Washington, D.C., to present his plan to the Smithsonian Institution. No money was forthcoming for such an ambitious project, particularly one run by someone without ethnographic credentials. The trip did provide Curtis with one priceless contact: Frederick Webb Hodge, a noted ethnographer and secretary of the Institution's Bureau of Ethnography, saw merit in Curtis's plan and encouraged him.

The President's Photographer

Rebuffed by government scientists, and also by New York publishing houses unwilling to invest in the book series that Curtis planned to produce as a result of his project, the photographer returned to Seattle and made plans for his 1904 fieldwork. He added a motion picture camera to his repertoire and departed for Navajo country in the spring to record the tribe's famous Yeibechei Dance. With the help of local trader Charley Day, who had grown up with the tribe, Curtis convinced the Navajo to re-create the dance for him to film and photograph. In the process he caused a great stir with government officials who were trying to crack down on native religious practices. But Curtis got his pictures, along with more notoriety from newspaper articles that hailed his efforts.

That summer brought Curtis a surprising and fortuitous opportunity: President Theodore Roosevelt wanted him to photograph his family at their New York home. The foundations for this invitation were laid in 1903. Curtis had placed third in a national child photography contest sponsored by the *Ladies Home Journal*. Roosevelt's personal portrait painter, Walter F. Russell, was on a trip to Seattle when he decided to visit the Curtis studio. Russell was impressed with the Indian portraits on display. He recommended that the president hire the photographer to capture Roosevelt's rambunctious sons on film so that Russell could paint portraits of the resulting pictures.

Curtis fit in well with the energetic Roosevelt clan and immediately bonded with the adventure-loving president, who was moved by the Indian photographs that Curtis shared with him. The president's views on Native Americans were more forgiving than those of the average politician of the time. Though he led a government that appeared single-mindedly driven to erase Indian culture, personally he had becoming sympathetic to their plight and their important place in the West that he loved so much. Curtis left New York with the president's encouragement to pursue his plan, along with a pledge to assist him in any way he could.

Promoting Indian Photographs and a Dream

Curtis returned home for only a short time before trekking again to the Southwest to photograph and film the Hopi Snake Dance. With each trip to the area he gained greater trust from the Hopi priests, who started to reveal more about their religion to the curious photographer. Curtis felt more at home with the Indians, but at the same time could not escape the demands of civilization. He realized that he was going to have to work harder than ever to promote his planned study and to drum up the financing he needed to move forward.

In late 1904 Curtis rented a hall in Seattle and gave the first public lecture devoted to his Indian photographs. The response was enthusiastic and as 1905 started he found himself presenting similar programs to the nation's scientific elite in Washington, D.C. In March of that year, E.H. Harriman helped him arrange a special program for some of New York's richest denizens at the Waldorf-Astoria Hotel. Curtis was shocked at the bill for renting the room, but eventually turned a profit on the event by selling prints to the well-heeled attendees. He also drew high praise from New York newspapers and hobnobbed with Mrs. Herbert Satterlee, daughter of J. Pierpont Morgan, the world's wealthiest man—and somebody who would soon figure prominently in Curtis's endeavors.

Curtis also had the opportunity to build a friendship—and photograph—one of the greatest surviving conquered Indian chiefs, the Apache Geronimo. Curtis first took the old chief's picture in February 1905 at the Carlisle Indian School in Pennsylvania, and then a month later at Theodore Roosevelt's inauguration in the nation's capital. Geronimo was part of a contingent of chiefs who had been invited by the president to participate in the event.

Despite the president's sympathy for Native Americans, the quality of life for most tribes was deteriorating rapidly, a reality that Edward Curtis experienced firsthand during his 1905 fieldwork. In South Dakota he found the proud and once-feared Sioux chiefs Red Hawk and Red Cloud living with their people in complete poverty. The final crushing blow to American Indians had taken place at nearby Wounded Knee only 15 years earlier, when 150 unarmed Sioux were gunned down by jittery U.S. troops. Curtis found himself documenting the desperate lives of conquered and impoverished people largely ignored by the rapidly modernizing and affluent culture surrounding them.

Assistance from an Unlikely Source

As 1906 dawned, Curtis continued to struggle with his own economic problems. Despite the fact that he had befriended and become the darling of some of the country's wealthiest

people, he had yet to secure the funding he needed to continue his work. Not surprisingly, Curtis turned to his friend Theodore Roosevelt for support. At this time, though, the reform-minded president was engaged in trust-busting and found himself at odds with many of the powerful people that Curtis might approach for assistance. He informed Curtis that "there is no man of great wealth with whom I am on sufficiently close terms to warrant my giving a special letter to him." Nonetheless the president obliged with a glowing general letter of introduction that the photographer could use as he searched for a wealthy benefactor.

On January 24, 1906, Curtis received the big break he desperately needed: He was given a personal appointment with mighty financier J. Pierpont Morgan. Who helped arrange the meeting is unclear. Many think that Roosevelt's influence was important, but it appears that Robert Clark Morris, a prominent New York lawyer and Republican who had befriended Curtis, played the key role in gaining the photographer access to the banker.

Morgan was an intimidating individual and notoriously short on patience. Before the meeting, Curtis sent Morgan a carefully

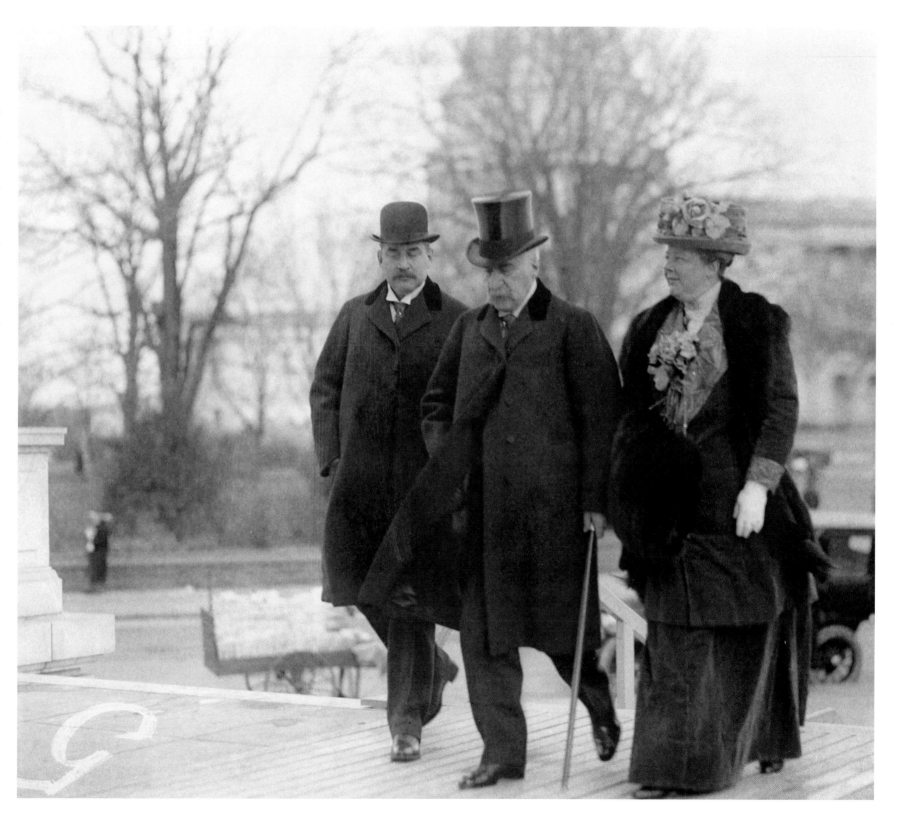

RIGHT: Mrs. Herbert Satterlee with J.P. Morgan and J.P. Morgan Jr. in 1911. *Bettmann/ Corbis*

A Master of Darkroom Techniques

While Curtis was a masterful photographic artist, showing special gifts for capturing both landscapes and portraits, much of his success can also be attributed to the photographic equipment he chose and the creative darkroom techniques he developed. In an era when photography was booming as a hobby and small, inexpensive cameras capturing images on rolls of film were becoming the rage, Curtis stuck with his tried-and-true large-format cameras and glass-plate negatives. The glass plates were expensive, cumbersome, and prone to breaking, but they captured images with outstanding clarity.

In the darkroom, Curtis was a tireless and creative worker, capable of extracting stunning prints from even the most underexposed negatives. His 1904 masterpiece "The Vanishing Race" is just such an image—Curtis and his talented associate Adolph Muhr reportedly spent hours coaxing the haunting print from the stubborn glass plate. He was also a capable retouching artist, a skill that served him well in later years of the project when "modern" objects were becoming commonplace on the reservations and Curtis insisted on removing them to maintain a sense of cultural authenticity.

Curtis was also a master in the art of printmaking. He gained fame early in his career through his pioneering development of goldtone prints that he called Curt-Tones. This process involved printing a reversed image on the back of a glass plate, which was then enhanced with a lustrous coating of banana oil and gold pigment. For *The North American Indian* volumes, Curtis was not satisfied with publishing mere "photographs." The memorable images from the series were instead photogravures, products of a time-consuming offset printing process. Curtis first created a film positive from each glass-plate negative, which was then used to acid-etch an image onto a copper plate. The finished plate was then coated with ink (Curtis preferred a sepia-toned variety) and print was rendered onto high-quality paper. The resulting photogravures preserved the fine detail captured on the original glass plates far better than any traditional photographic printing process.

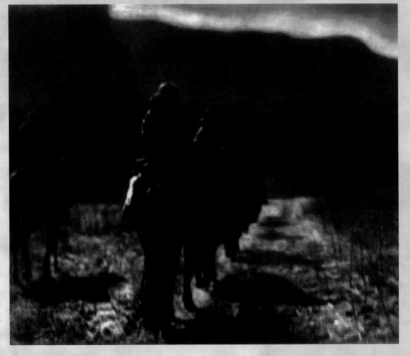

RIGHT: "The Vanishing Race."
Library of Congress, Prints & Photographs Division, Edward S. Curtis Collection, LC-DIG-ppmsca-05926

prepared written outline of his plan. When the appointment arrived, Curtis launched into a sales pitch for the project, only to be cut short by Morgan. "There are many demands on me for financial assistance. I will be unable to help you at this time." Quickly changing gears, Curtis slid samples of his Indian photographs across the desk to Morgan. The portfolio mesmerized the financier. Morgan quickly agreed to fund publication of a series of books that would feature the memorable images, along with text that would tell the story of the people they pictured. Curtis now had the money—and official validation—that he needed to move full speed ahead with his ambitious plan.

A Book Project for the Ages

After the New York meeting Curtis found himself dealing less with Morgan personally, and more with functionaries in the financier's empire. Despite his distance from the project, Morgan remained interested, because he wanted to see Curtis's ambitious plan succeed—and ambitious it was. Curtis proposed publishing twenty volumes of books, each to be printed in limited edition quantities of only 500 copies. Each volume would include pictures and detailed text that would fully flesh out the lives of a select group of tribes. The books were to be printed by University Press in Cambridge, Massachusetts, on a choice of two fine imported printing papers. In addition, each volume was to be accompanied by a portfolio of first-rate Curtis photogravures. These were going to be some of the most glorious books ever published and they carried a hefty price tag: $3,000 or $3,850 for the full set, depending on which paper was chosen.

Though Curtis was ecstatic to have Morgan's financial support—$15,000 per year for the five years Curtis thought he needed to complete the fieldwork—at the time he probably did not fully comprehend to what he had just committed himself. In addition to the travel, photography (with its time-consuming processing and printing work), and gathering of ethnographic data, Curtis had been charged with writing the text and overseeing the production and publication of the twenty books. Plus, Morgan convinced Curtis that he should personally sell subscriptions to the series to provide additional funding. Thus Curtis found himself in the unenviable role of being the writer, photographer, publisher, and sole salesman for what came to be known as *The North American Indian*.

Curtis stayed in the East until the spring, making arrangements for the project. He hired Frederick Webb Hodge to serve as the books' editor and established an office for *The North American Indian* in New York City. Morgan's intervention had not gone unnoticed: Newspaper headlines trumpeted his support of the project

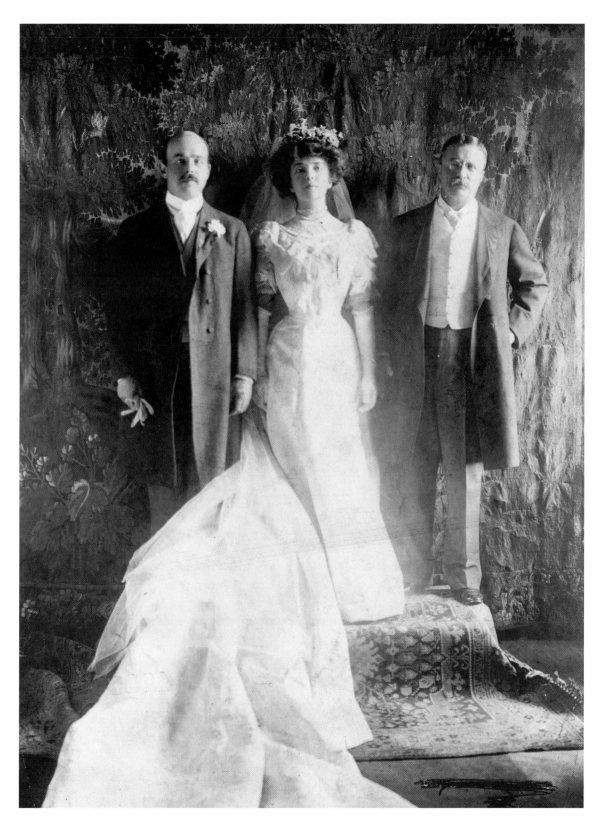

and Teddy Roosevelt sent Curtis a personal note. "I congratulate you with all my heart. This is a mighty fine deed of Mr. Morgan's." Roosevelt also extended an invitation to Curtis to serve as the only photographer at his daughter's upcoming wedding, a tremendous honor of which he took full advantage—newspapers from all over the U.S. were obliged to pay Curtis to use his exclusive photos of the event.

A Most Capable Assistant

In the midst of this hoopla, Curtis returned home to Seattle in the spring to prepare for his 1906 fieldwork. One of the first orders of business was an expensive one: He was forced to replace cameras and other equipment that had been stored in San Francisco and were destroyed in that city's devastating earthquake. Curtis also hired a man whose eventual contributions to *The North American Indian* were nearly as great as the photographer himself: William Edward Myers.

Like Curtis, Myers was a Midwesterner who had fallen in love with the West. Born in Ohio and a

LEFT: Curtis's wedding photographs included this one of Alice Roosevelt, her father, and her new husband, Congressman Nicholas Longworth; February 21, 1906. *Corbis*

graduate of Northwestern University, Myers was working as a reporter at a Seattle newspaper when Curtis hired him. Myers joined the project in late summer 1906 and eventually became its chief ethnographer, collecting and organizing an enormous quantity of data Myers was a gifted linguist and had a knack for picking up native vocabulary—and correct pronunciation—with just a single listen. And while Curtis fulfilled his role as primary talent and visionary behind the project, Myers soon became the guiding force that kept things on track. He was the logistics coordinator, undertaking complicated arrangements—often requiring the approval of various bureaucratic operatives—prior to every season's fieldwork. He was the books' primary writer, cleaning up rough text from his less-educated employer. And he was an organizer of the highest quality, capable of keeping straight a mountain of data that had to be turned into a saleable product.

A Curtis family story illustrates Myers's organizational skills and importance to the project. Reportedly, in 1907 the eminent Columbia University anthropologist Franz Boaz formally complained to Theodore Roosevelt about Curtis's lack of credentials. The president is said to have appointed a panel of three eminent scholars to study and rule on Curtis's ability. Curtis was able to quickly rebut the challenge by providing a description of his methods

supported by an exhaustive set of notes and wax cylinder recordings—information largely compiled and organized by Myers. The impressed scholars praised the project and Roosevelt was pleased to be able to dismiss Boaz's claims.

Back to Indian Country

Heading back to the Southwest in late spring 1906, Curtis gathered the final information and photographs for the first volumes of *The North American Indian*, which he hoped to publish over the next winter. In the process he was involved in a couple of odd incidents that only helped to confirm the contradictory nature of this talented man.

On the White Mountain Apache Reservation in Arizona, Curtis—hungry for information about the mysterious Apache religion—paid a handsome price to the widow of a medicine man to purchase a sacred buckskin prayer chart. Then he manipulated the rivalry between two other medicine men to secure the tightly guarded interpretation to the chart. Finally, he paid yet another unknown tribesman to pose for a picture with the sacred relic, pretending to be a medicine man praying over it. Curtis's actions helped to fuel the rift between rival factions on the reservation. In later years, Curtis—often credited with a reverential respect for his subjects and their beliefs—bragged about how he was

able to manipulate the Apache into giving him the ethnographic prize.

Curtis proceeded next to Canyon de Chelly, New Mexico, to spend time among the Navajo. His entire family, including Clara, joined him. The family spent many wonderful weeks with the Navajo and the fieldwork—arranged with the help of trader Charley Day—yielded exceptional results. Then a curious thing happened. Day rushed into camp one evening and convinced Curtis to pack up his family and leave immediately—a pregnant Navajo woman was suffering through a difficult childbirth and the tribe blamed the white visitors. Day said that if the woman died, the tribe was planning deadly retribution. Curtis didn't stay long enough to find out if Day overstated or misunderstood the risk. He was so frightened by the incident that he decided to never again take his whole family on trips to Indian country. This decision probably sealed the future of a marriage that had started to disintegrate from the pressures of the photographer's single-minded devotion to his work.

Publishing the First Volumes—in Red Ink

Curtis sent his family to Seattle and stayed in the Southwest after the scare with the Navajos. It was during a visit with the Hopis that Curtis was adopted into the tribe and allowed to experience

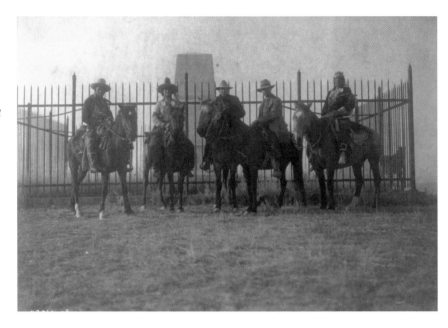

RIGHT: Edward S. Curtis (second from right) and four Crow men on horseback at the Custer Monument, July 6, 1908. *Library of Congress, Prints & Photographs Division, Edward S. Curtis Collection, LC-USZ62-60394*

FAR RIGHT: In 1908 Curtis was joined in Montana's Little Bighorn valley by three Crow men (on left) who had served as Custer's scouts on the day of his ill-fated battle with the Sioux. On the right is Curtis's trusted Crow assistant, Alexander Upshaw. *Corbis*

the sacred Snake Dance firsthand. Curtis and Myers then worked with the Havasupai, who lived on the floor of the Grand Canyon, until the weather turned cold on them. They realized it was time to compile the first two volumes of *The North American Indian*.

Curtis, Myers, and two other assistants hid themselves away for three months in a secluded cabin on Puget Sound and prepared the two manuscripts. Volume I covered the Navajo, Apache, and Jicarilla; Volume II was devoted to nine smaller tribes primarily in Arizona, including the Havasupai, Papago, and Mohave. Curtis's devotion to writing was just as fervent as his workaholic habits in the field—the team worked seventeen hours a day, seven days a week to complete their task. In early 1907, an assistant was sent east to Boston with the completed

manuscripts to get publication started. Curtis went to New York to present the first set of master prints to Morgan's librarian and he started correspondence with Frederick Webb Hodge regarding the editing process. Curtis even secured President Roosevelt's pledge to write a foreword for the first volume.

Events that should have warranted a celebration were soon forgotten, overshadowed by the project's growing financial problems. Morgan's $15,000 per year stipend fell far short of Curtis's fieldwork expenses, bills from engravers and printers were now arriving, and in 1907 subscription sales were hard to come by thanks to an economic downturn. Curtis was in debt and needed help. Friends in Seattle helped him arrange a $20,000 loan from a group of businessmen, but this did little to stem the flow

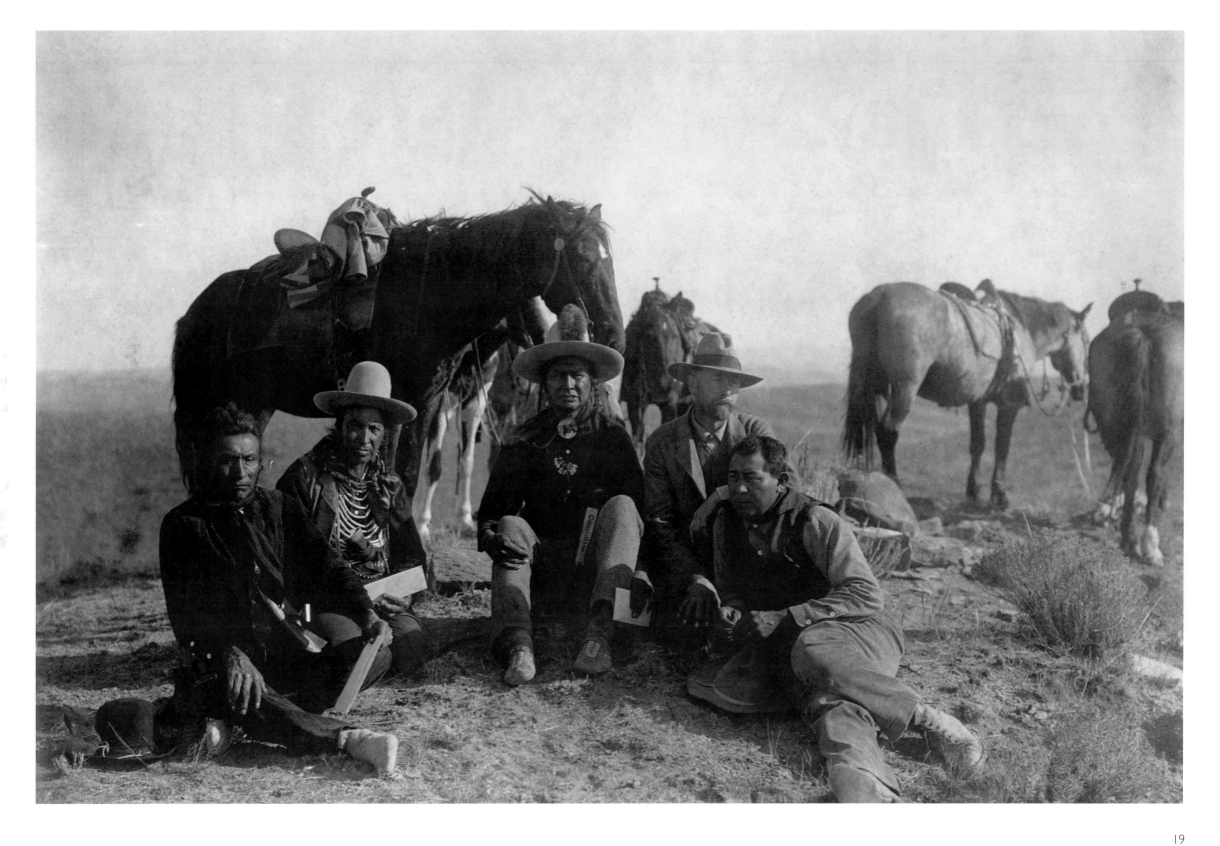

of red ink—and the work in Indian country had to go on.

In July Curtis rendezvoused with Myers, along with his wife Clara and son, Harold, at the Pine Ridge Reservation in South Dakota. The crew planned an extended visit gathering photos and information for Volume III; Clara and Harold planned to stay until the end of the boy's summer break from school.

Curtis's time among the Sioux was a mix of highs and lows. At one point he found himself in an angry dispute with tribal chiefs at Wounded Knee over how much beef he would provide at a promised feast. Eventually the Sioux relented, reenacting tribal rituals and even battles that were captured spectacularly by the photographer. Curtis then traveled to Montana for a moving visit to Little Bighorn Battlefield. Curtis explored the battlefield with Red Hawk and other Sioux who had actually participated in the event. Then he hired three Crow who had been paid scouts during the battle to get a feel for Custer's side of the event. After his exhaustive research—an interesting history-oriented departure from his ethnographic study—Curtis publicly declared that the evidence revealed several George Armstrong Custer errors that led to defeat. This position alienated many of Curtis's supporters from the wealthy establishment.

Upon the group's return to Pine Ridge,

Harold came down with a terrible case of typhoid fever. Isolated from modern medical help, the boy suffered for weeks and Curtis feared his son would die. When the fever finally broke, Clara and Harold were taken by wagon to the nearest railroad tracks, where they started a circuitous rail journey back to Seattle via Chicago. Harold eventually recovered, but Clara had seen enough of Indian country. She never returned to the field. Because Edward rarely came home, their marriage, for all intents and purposes, was over.

More Writing and the Odd Story of Two Turtles

Despite his son's illness, Edward Curtis had more work to complete before the weather turned cold in 1907. Curtis and his assistants worked feverishly among the Mandan and other tribes until snow started to fall in October. They then hunkered down in a cabin on the Crow Reservation in Montana to assemble the next two volumes of *The North American Indian*. Curtis felt pulled to New York to deal with the business side of the project and left the others to keep writing in his absence.

Because of the sour economy, New York was not an easy place to sell a $3,000 set of books. Instead he focused on the ongoing publication of the first two volumes. Satisfied that progress was being made, he ventured back to the plains, where he entered into one of the strangest

arrangements of his long career.

Curtis and one of his assistants had been negotiating with the Mandan to photograph the tribe's sacred turtles—actually two turtle-effigy drums made out of buffalo skins. No white man had ever seen, let alone photographed, the turtles and Curtis was obsessed with being the first. A large, well-placed bribe gained Curtis the chance to photograph the relics. He even convinced the conspiring Mandan to remove the turtles' ever-present feather coverings, move them into better light, and pose in a picture with the drums. When discovered by other tribesmen in the midst of this act, Curtis pretended to be simply interviewing the man. As with other curious episodes during his work, he seemed more consumed by the prize than by respect for the subjects of his studies.

The Triumph of the First Two Volumes

As 1907 turned into 1908, Curtis and his team continued working on the manuscripts for volumes III and IV, which were largely completed in the spring. In the meantime, the first two volumes had been printed and bound. In April Curtis personally delivered the first copies to Morgan and subscribers in New York. As the books circulated, praise emerged from all corners. The eminent anthropologist Frederick Ward Putnam was among those who endorsed

both the artistic and ethnographic success of the project. "It is indeed fortunate that this work is to be done by one who has the skill of an expert photographer and the mind and eye of an artist united with a sympathetic understanding of this much-misunderstood people," Putnam gushed in a personal letter to Curtis.

With books in hand, Curtis finally had some modest success selling subscriptions, but the project's financial footing was no more secure. Around this time, he estimated that his expenses were averaging $4,500 per month. Curtis was falling further into debt. Nonetheless he pushed on, working successfully towards his goal of completing three volumes in 1908 after yet another ambitious season of fieldwork.

Curtis returned to New York and remained on the East Coast through the following winter, splitting his time between attending to the publication of volumes III through V and selling subscriptions, promoted in part by public

RIGHT: A portrait of the Oglala chief Red Cloud published in Volume III in 1908. *Corbis*

FAR RIGHT: A portrait of an Oglala warrior, His Fights, who took part in the Battle of Little Bighorn; published in Volume III in 1908. *Library of Congress, Prints & Photographs Division, Edward S. Curtis Collection, LC-USZ62-83595*

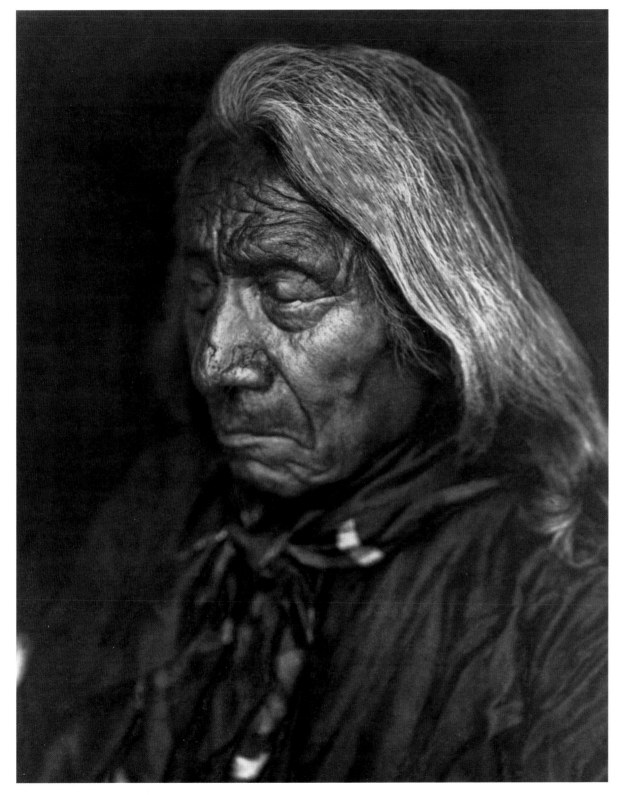

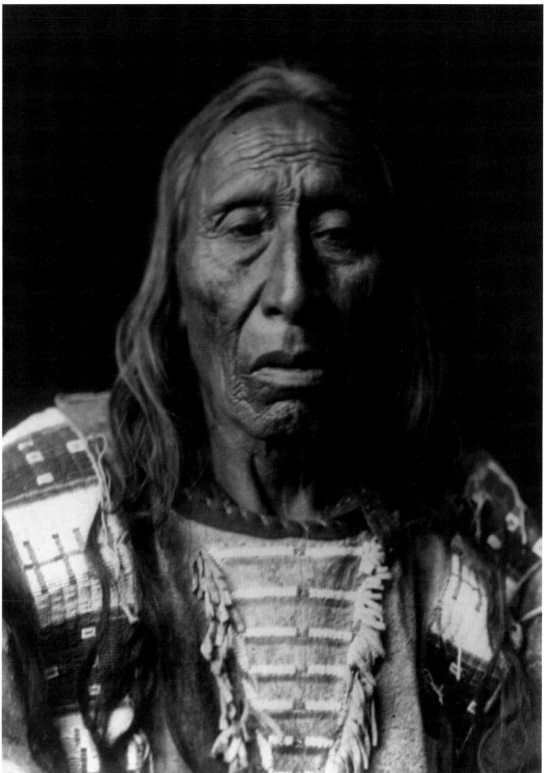

speaking engagements. A familiar pattern emerged in 1909: selling out East until the weather warmed, photography and data gathering out West in summer and early fall, exile in the winter in an isolated location to write. The system appeared successful as volumes VI, VII, and VIII were soon completed. Yet two problems continued to haunt Curtis.

The first, as always, was money. Curtis was in debt to a number of important contributors to the project and without at least some money to assuage their concerns he faced the risk of assistants abandoning him or printers refusing to produce his books. Curtis succeeded in easing his financial woes somewhat in late 1909 by convincing Morgan to give him an additional $60,000 for the project. The cash buoyed Curtis's spirits and allowed him to compensate firms and individuals whose support he desperately needed.

Curtis's other problem was his collapsing marriage. The photographer's workaholic habits and their precarious finances convinced Clara that she no longer had a future with Edward. The Curtis's youngest child, Katherine, was born in the summer of 1909, but he hardly saw her during her childhood. In fact, around the time of her birth, Curtis changed his permanent address to that of Seattle's Rainier Club. He confided to a few people close to him that he no longer had a home to call his own.

Adventure in the Pacific Northwest

Edward Curtis's family may have escaped him, but he still had his work, and in the spring of 1910 he threw himself into it as never before. First, he traveled by boat down the Columbia River in an effort to retrace the final leg of Lewis and Clark's epic journey to the Pacific. Curtis had not lost his sense of adventure. He insisted on riding the whitewater—through rapids swollen to dangerous fury by spring runoff—in his small, flat-bottom boat loaded down with photographic equipment. He survived several chancy passages, but eventually scared off his retired riverboat captain guide, who abandoned him when they neared Portland.

Upon reaching the ocean, Curtis traded up to a forty-foot boat and started a northward journey up the coast. His destination was Fort Rupert, British Columbia, where he would meet with a man named George Hunt, a half-Indian who was part of the Kwakiutl tribe. The Kwakiutl had a notorious reputation as headhunters and cannibals, and the literate, English-speaking Hunt was just the man to introduce Curtis to these fascinating people. Something of an amateur anthropologist, Hunt had been writing a book to record the complex religious beliefs of his people. He was intrigued by the ethnographic aspect of Curtis's work and used his powerful position in the tribe to gain Curtis unprecedented access to Kwakiutl culture.

Curtis was captivated with the Kwakiutl. He

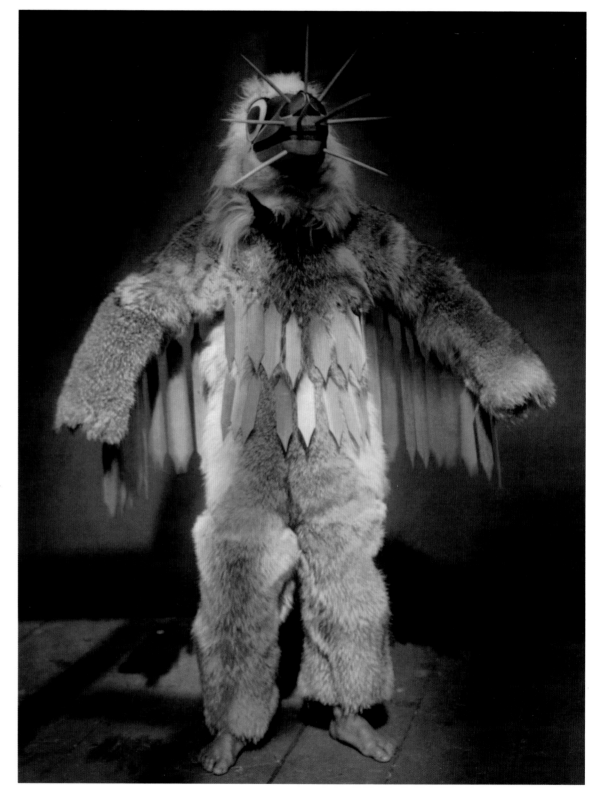

spent the entire summer of 1910 with them and returned several times in subsequent years. That summer also produced some of the most colorful tales of the Curtis legacy. In later years he recalled the time he tried his hand at the Kwakiutl tradition of wading the tidal shallows to capture giant octopus by hand. Curtis soon found himself engaged in a losing battle with a particularly large "devilfish," as the tribe called them. Hunt had to come to Curtis's rescue to free him from the animal's tentacles.

Later that summer, Curtis was determined to photograph stellar sea lions in their natural habitat in the Queen Charlotte Islands. Curtis, Myers, and Hunt's son, Stanley, were dropped on a small, rocky island for an overnight stay. Much to their horror, they soon discovered that the island became almost entirely submerged at high tide. They lashed themselves to the rocks with ropes and suffered through a long night, buffeted by waves and menaced by angry sea lions.

And finally, the 1910 trip produced another perplexing chapter in the Curtis story. Determined to participate in traditional Kwakiutl

religious ceremonies, he set out to fulfill the ritualistic requirements of outfitting his boat with a human mummy and skulls. In the process he raided tribal burial islands, with the help of George Hunt and his wife, Loon. It is also possible that he participated in a secret cannibalism ceremony, though even in his old age he would never admit to exactly what happened, adding another layer to the Curtis mystique.

The Picture Musicale

Curtis was understandably spent after 1910's fieldwork, but with books to sell, he made his way to New York, where he spent most of the next several months. During this time he hatched an entirely new idea to raise funds: a transcontinental lecture tour called "The Vanishing Race."

Being a Curtis invention, the tour presented far more than run-of-the-mill lectures. Publicity for "The Vanishing Race" called it a "picture-opera." Curtis described it as a "picture musicale." Curtis narrated from a script while slides of his stunning images were displayed in front of the audience and an orchestra played musical pieces inspired by native songs and chants. The first performance, in November 1911 at New York's Carnegie Hall, was praised by all who attended. Curtis's fame soon grew to the point that he was probably the country's best-

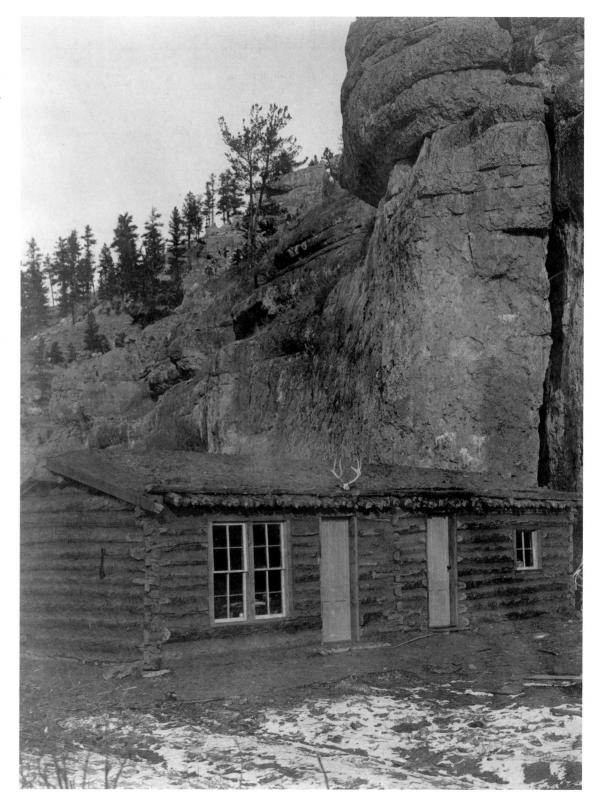

LEFT: A photograph of a Kwakiutl man, Hamasilahl, wearing a wasp costume representing an inherited crest, published in Volume X in 1915. *Corbis*

RIGHT: "Camp Curtis"—a log cabin in clearing in front of a large rock formation; c. 1908. *Library of Congress, Prints & Photographs Division, Edward S. Curtis Collection, LC-USZ62-130191*

An Artist with a Complex View of His Subjects

Looked at through the filters of time, Edward Curtis's views on his Indian subjects are anything but simple. Today, people consider the sympathetic images he recorded and his desire to experience native religious ceremonies as an insider and assume that he must have been something of a champion of native rights and culture. Yes and no. Indians fascinated Curtis, but his views about them fell squarely in the mainstream of white attitudes. Studying his written and spoken record reveals that he was more or less in agreement with the aims of the government to assimilate natives into white culture. Accordingly, Curtis saw the disappearance of Indian culture as inevitable. While he may have grieved over this loss, he didn't see it as his job to try to save native culture, but rather *record* it—thus the urgency with which he approached *The North American Indian* project.

Modern day critics also point to the down-and-dirty dollars-and-cents attitude that seems pervasive in the Curtis record. From the beginning, Curtis paid for the modeling services of his subjects, doling out his ubiquitous silver dollars that usually yielded highly compliant figures on whom he could focus his lens. Rarely did they resist when he asked them to don clothing or strike a pose that wouldn't have ever been part of their typical routine. Curtis was also notorious for handing over sizeable bribes for access to items or rituals to which whites were normally excluded. Were these actions motivated by scientific curiosity or his drive to be the first to capture certain ethnographic prizes? Probably a little of both, but many still question whether the ends justified the means.

Another issue that taints the Curtis legacy was his active trade in Indian artifacts. From his earliest days of photographing the various tribes he purchased or traded for blankets, baskets, and a variety of other items, knowing they would appeal to a wide and willing audience of well-heeled collectors. Some of these items were offered for sale in his Seattle studio, while other were sold directly to museums or individuals. Curtis even found himself working as an artifact broker on behalf of some of the wealthy buyers of his book series, keeping his eye open for items they desired even as he conducted fieldwork for future volumes.

Probably the most damning modern criticism of Curtis is that many of his photographs fail as ethnographic record because of the artistic liberties he was known to take. Some of his perceived transgressions were relatively minor, including retouching negatives to remove items from white culture or dressing his subjects in clothing he provided. (The same buckskin shirt famously turns up in photographs taken with several different tribes.) More critically, Curtis has been accused of creating a mythology of Native American life that often departed from reality. His romantic images played well to the white American tastes of his time, but today look somewhat contrived. Ultimately, though, if you focus on Edward Curtis as a photographic *artist*, it's much more difficult to find fault with a body of work that rarely fails to impress in both an aesthetic and emotional context.

known photographer, and a tour of northeastern cities was scheduled for 1912.

In many ways the tour was a great success, playing to sold-out theaters and receiving enthusiastic reviews in the wake of each performance. Yet, the picture musicale was a financial failure. The challenging logistics and high costs—including composition of an original score, and hiring and transporting an orchestra of top musicians to play it—made the tour a money-losing proposition, pushing Curtis even deeper into debt. Despondent, he cancelled the remaining dates and turned his attention back to the books. By the summer of 1912, the manuscript of Volume IX was ready—but he also had other dreams in mind.

Making a Movie

Even as the "musicale" was heading towards obvious financial failure, Curtis began making plans for another representation of his Indian work—a motion picture. Curtis likely viewed America's growing fascination with moving pictures as a primary reason why he didn't make more money on the glorified lecture series. So in the best spirit of "if you can't beat 'em join 'em" Curtis dreamed up *In the Land of the Headhunters*, a filmed dramatization of Kwakiutl life.

Curtis had filmed Indian tribal rituals over the previous several years, but what he now envisioned was quite different. Curtis developed a script that he later admitted was influenced by both Shakespeare's *Romeo and Juliet* and Longfellow's *The Song of Hiawatha*, but he was also determined to present a fairly realistic interpretation of tribal life and culture. He lobbied to get both the endorsement and financial support (which never arrived) from several of the country's leading academics for his ethnographic movie.

During 1913 Curtis was not immediately able to focus on the movie as other events competed for his attention. In particular, the deaths of two key players threatened to halt the project. In April, J. Pierpont Morgan died and Curtis feared his only regular source of money would dry up. Fortunately the banker's son, Jack, quickly pledged his continuing support of the epic project. In November Adolph Muhr, Curtis's gifted studio photographer and darkroom technician, died suddenly. Curtis scrambled to plug this critical gap in his team, handing over management of the studio to another capable employee, Ella McBride, supported by his talented teenage daughter, Beth.

Filming *In the Land of the Headhunters* began in 1914. The Kwakiutl, spurred on by George Hunt, were eager participants, in part because Curtis was paying them, but also because they were able to re-create sacred rituals that had been banned by the Canadian government. Not surprisingly, Curtis took liberties in his interpretation of tribal life,

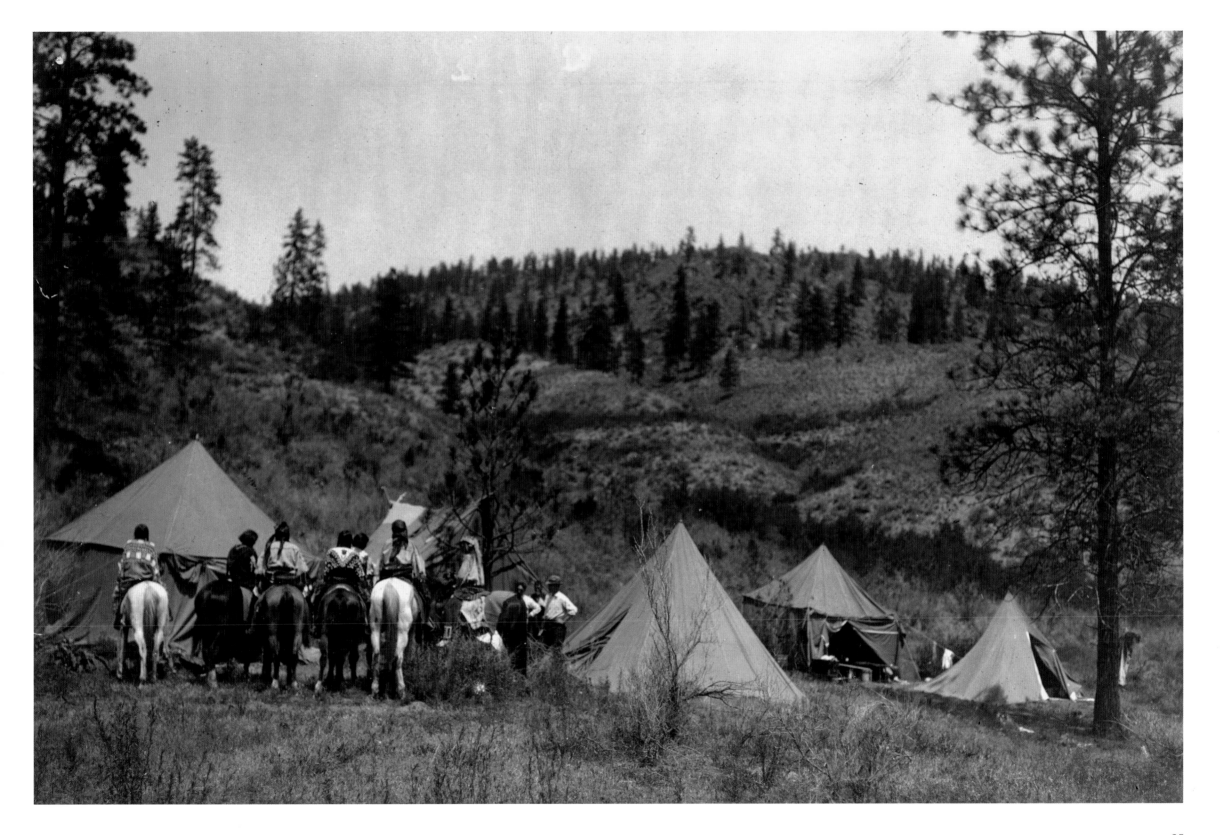

asking men to shave their facial hair and don wigs and clip-on nose rings. He also filmed a Kwakiutl whale hunt—even though the tribe did not actively hunt the sea mammals and he had actually had to "rent" a dead whale to use in the scenes.

With film in hand, Curtis returned to Seattle and quickly edited his movie, which premiered in New York in December. Like other Curtis ventures, *In the Land of the Headhunters* generated enthusiastic reviews. For its time, it represented a ground-breaking, dramatic production. But it couldn't live up to the drama unfolding in Europe as World War I captured America's attention. Curtis's Indian movie was quickly forgotten and his $75,000 investment in the project was never recouped. A decade later a cash-strapped Curtis sold the master print and all rights to the movie to the American Museum of Natural History for just $1,500.

A Personal Crisis Goes Public

With yet another financial failure haunting him, Curtis predictably turned back to his books and in 1915 Volume X, devoted entirely to the Kwakiutl, was published. By this time the subscription price had been increased to $3,500 and $4,500, but that seemed academic because relatively few were sold. Even though he was only halfway to his twenty-volume goal, far behind schedule, and deeply in debt, Curtis was driven to finish the books.

Curtis focused on fieldwork in 1915 and 1916 and maintained little contact with other participants in the project—his inability to pay people a likely reason for the silence. Nonetheless, Volume XI made it into print in 1916. Then, in October of that same year, the outside world tugged back at him with a fury: Clara filed for divorce, a development trumpeted in newspapers because of the photographer's celebrity status. The ensuing legal battle went on for three years and it tore the Curtis family apart. Ultimately, Clara was awarded the house, the studio, his photographic equipment kept there, and his countless glass negatives.

Angry at what she perceived as an unfair judgment, Beth Curtis—always loyal to her father—made prints from the glass plates and copied some of them onto film. Then, two studio employees destroyed the plates before they could be turned over to Clara. It is not clear whether Edward Curtis or Beth—or both—made the decision to take this vindictive action, but viewed from today it was a truly a tragic loss.

RIGHT: Red Bird, a Cheyenne man in full headdress, published in Volume XIX.
Library of Congress, Prints & Photographs Division, Edward S. Curtis Collection, LC-USZ62-124179

FAR RIGHT: Sioux child— her tunic is decorated with cowrie shells and elk teeth or carved bone imitations.
Library of Congress, Prints & Photographs Division, Edward S. Curtis Collection, LC-USZ62-112237

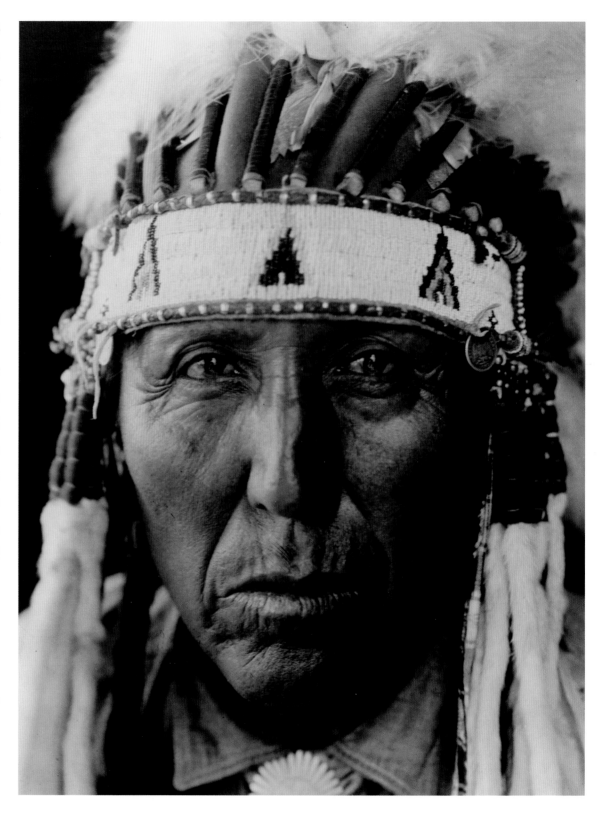

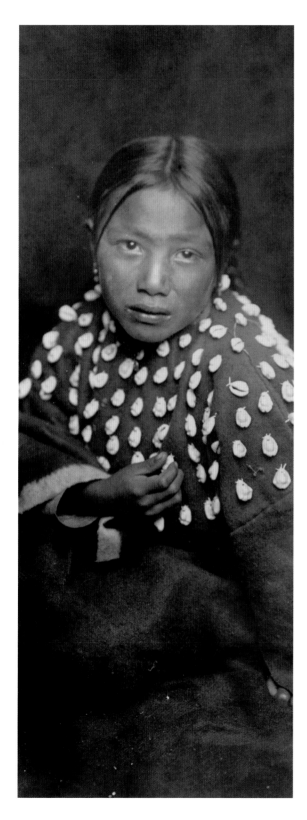

A Move to Sunnier Climes

Edward and Beth soon moved their base of operations to Los Angeles and opened a new photographic studio. Beth ran the business and Curtis turned to the growing movie industry for employment. His first job was working as a still photographer on the Tarzan movies.

Even though he rarely got paid, Edward Myers carried much of the burden for *The North American Indian*, remaining in the field and gathering data. Curtis joined him when he could afford to. He made a 1919 trip to Hopi country, his first visit in six years. He found white culture creeping into all aspects of tribal life and taking "authentic" photographs became increasingly difficult.

After a six-year gap in publishing Volume XII, devoted in its entirety to the Hopis, appeared in 1922. Because of Curtis's financial situation, Jack Morgan paid the printing bill for the remaining volumes from this point on. That same year, Myers and Curtis switched their attention and fieldwork to the tribes of northern California. The photographer invited his married daughter, Florence, to join him for the summer. They had a wonderful time, bonding after the wrenching divorce, and Curtis amassed an outstanding collection of images. The scenes of Indian life he recorded were starkly different in content and tone from his initial work two decades earlier. The lives of Native Americans had continued to deteriorate and his photographs from this time seem to reflect the emotional despair that these people were suffering even more than his earlier work.

A Fight Over Freedom

In 1923 Edward Curtis found himself fully occupied with Hollywood, working for Cecil B. DeMille as still photographer and movie cameraman on the sets of the classic movies *Adam's Rib* and *The Ten Commandments*. That same year volumes XIII and XIV of *The North American Indian* were published. Together the two volumes told the story of the northern California tribes that he had photographed the previous summer.

Curtis's schedule eased somewhat in 1924 and he traveled to Pueblo country in the desert Southwest. Myers—as always—was already there, gathering ethnographic data, but he had made a disturbing discovery. During certain religious ceremonies priests were reportedly engaging in sexual abuse of young girls. Descriptions of the rites were eventually published in Volume XVI, and the claims started a firestorm of controversy that lasted for a decade. Curtis publicly jumped into the fray with an essay titled "The Indian and His Religious Freedom," in which—ironically—he challenged the right of the priests to exploit the young girls, many of whom had been educated at white schools. He soon found himself at odds with supporters of Native Americans who thought the government should stay out of tribal culture—just the type of people who had long supported his efforts and with whom Curtis worked to further Indian rights. In fact, in 1924 Curtis was a founding member of the Indian Welfare League, which among other activities, lobbied for passage of the Indian Citizen Act that enfranchised Native Americans.

Nonetheless, as late as 1933 progressive-minding Indian Affairs Commissioner John Collier wrote to Curtis demanding a public apology for defaming the Pueblo Indians in his book. Curtis fought back, carefully refuting the accusation with documentation supporting the validity of the data he and Myers had gathered. The controversy eventually faded, but it left Curtis bitter because of the challenge to his treasured life's work.

Another Key Loss

Volume XV was printed in 1925 and Curtis and Myers spent that summer working on the plains of southern Canada with the Piegan, Blackfoot, and other tribes. Curtis had worked with the Piegan more than two decades earlier and was shocked at how much their lives had changed, primarily for the worse. At this late stage of the project it was becoming difficult to find tribes that had not been overrun by white culture.

With fieldwork remaining for just two final volumes, Curtis received a stunning blow in early 1926: William Myers resigned. Myers had married

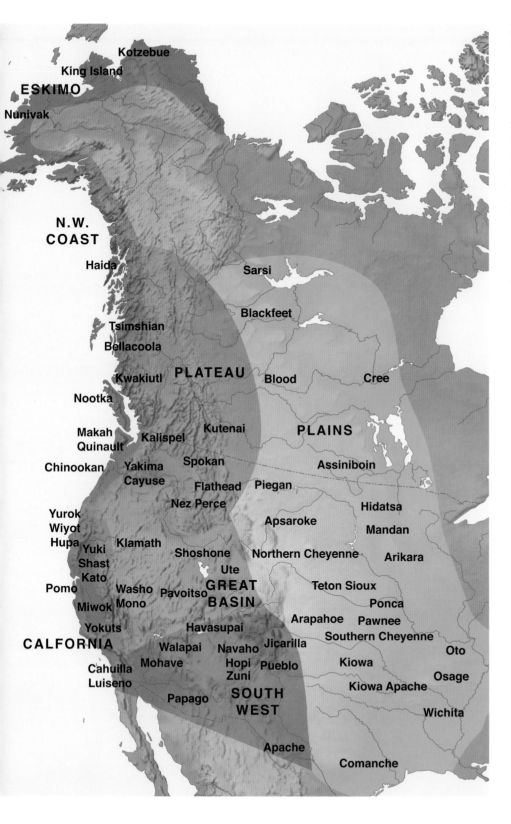

LEFT: The location of the tribes Curtis visited.

BELOW RIGHT:
Nayenezgani, a Navaho, wearing a dark leather mask, fur ruff, cloth girdle, silver concho belt, and necklaces; 1904. Printed in Volume I, published in 1905. *Library of Congress, Prints & Photographs Division, Edward S. Curtis Collection, LC-USZ62-101844*

in 1913 and his wife, Sophie, often joined him in the field. But it appeared that the pair had tired of their itinerant, impoverished lifestyle and jumped at the chance to invest in an apartment building in San Francisco and settle down to a more normal life. The man who conducted some of the country's most important ethnographic work spent the last years of his life managing various California apartments and motels. The obituary reporting Myers's death in 1949 did not even mention his work on the epic project with Curtis.

Curtis scrambled and hired young Stewart Eastwood to replace Myers. Eastwood was a recent graduate of the University of Pennsylvania. He had received some training in anthropology and came highly recommended by Frederick Webb Hodge. Though Eastwood's efforts on the last two books were important, this brash, inexperienced young man caused some problems. When Hodge received the "final" Volume XIX text from Eastwood for editing, he was furious at what perceived as a sharp dropoff

THE NORTH AMERICAN INDIAN

Volume	Title	Publication	Number of images (book + portfolio)
I	The Apache. The Jicarillas. The Navaho.	1907	81 + 39
II	The Pima. The Papago. The Qahatika. The Mohave. The Yuma. The Maricopa. The Walapai. The Havasupai. The Apache-Mohave, or Yavapai	1908	75 + 36
III	The Teton Sioux. The Yanktonai. The Assiniboin.	1908	78 + 36
IV	The Apsaroke, or Crows. The Hidatsa.	1909	74 + 36
V	The Mandan. The Arikara. The Atsina.	1909	74 + 36
VI	The Piegan. The Cheyenne. The Arapaho.	1911	74 + 36
VII	The Yakima. The Klickitat. Salishan tribes of the interior. The Kutenai.	1911	75 + 36
VIII	The Nez Perces. Wallawalla. Umatilla. Cayuse. The Chinookan tribes.	1911	77 + 37
IX	The Salishan tribes of the coast. The Chimakum and the Quilliute. The Willapa.	1913	75 + 36
X	The Kwakiutl.	1915	74 + 36
XI	The Nootka. The Haida.	1916	75 + 36
XII	The Hopi.	1922	73 + 36
XIII	The Hupa. The Yurok. The Karok. The Wiyot. Tolowa and Tututni. The Shasta. The Achomawi. The Klamath.	1924	74 + 36
XIV	The Kato. The Wailaki. The Yuki. The Pomo. The Wintun. The Maidu. The Miwok. The Yokuts.	1924	74 + 36
XV	Southern California Shoshoneans. The Diegueños. Plateau Shoshoneans. The Washo.	1926	75 + 36
XVI	The Tiwa. The Keres.	1926	75 + 36
XVII	The Tewa. The Zuñi.	1926	74 + 36
XVIII	The Chipewyan. The Western woods Cree. The Sarsi.	1928	75 + 36
XIX	The Indians of Oklahoma. The Wichita. The southern Cheyenne. The Oto. The Comanche. The Peyote cult.	1930	76 + 36
XX	The Alaskan Eskimo. The Nunivak. The Eskimo of Hooper Bay. The Eskimo of King Island. The Eskimo of Little Diomede Island. The Eskimo of Cape Prince of Wales. The Kotzebue Eskimo. The Noatak. The Kobuk. The Selawik.	1930	76 + 35

in the quality of writing from Myers's work. Hodge shipped the manuscript back, and forced Eastwood to do a complete rewrite.

One Last Journey, to the North

For the final volume of the series, Curtis turned his attention to Alaska. For his 1927 fieldwork he hoped to both relive the glory of the Harriman expedition that pushed him on his current path and to find Eskimo cultures still relatively untouched by the white world. Daughter, Beth, and Eastwood joined Curtis on the adventure and they found all that they hoped for—plus ample danger. Traveling in a boat not fit for the wild, ice-ravaged Bering Sea, they survived high winds and waves and at one point found themselves stranded on a sandbar miles from the mainland. When they reached their destination of Nunivak Island, they were rewarded with the presence of a friendly people still living in the traditional ways.

The trio stayed more than two weeks and gathered a wonderful collection of photos. In late July, Curtis bid farewell to Beth, who had to return home, and he and Eastwood pushed on. Beth later admitted that she thought she might never see her father again. But the aging photographer was not to be denied and he braved more danger for two more months before wrapping up the final fieldwork for *The North*

American Indian in late September 1927. He had been formally engaged in the project for two decades, but he had been consumed with photographing Indians for more than thirty years.

Returning to the California warmth, Curtis committed himself to finishing the final manuscripts. As he worked in the studio, he struggled with health problems brought on by years of nonstop toil in harsh conditions. Volume XVIII came into print in 1928 and the final two manuscripts were completed that same year. Minor problems delayed the last two books, but at this late date not many people noticed or cared. When volumes XIX and XX were finally published in 1930, there was no great celebration and, typically, the world seemed to conspire against Curtis. Hoping to sell his personal inventory of the now-complete set, he was greeted with little interest from a country reeling from the effects of 1929's stock market crash.

Family, Gold Fever, and a Quiet End

Edward Curtis's three-decade obsession had not come without a steep price. The project left him with almost insurmountable financial problems that during 1920s had forced signing away all his rights in the books to Jack Morgan. In 1935 the Morgan Company sold nineteen remaining sets of books, plus the original copper plates, to a Boston book dealer for a paltry $1,000. Curtis's

health had also taken a beating. In 1930 he suffered a complete mental and physical breakdown and checked himself into a Denver hospital for a long period of recuperation.

And, of course, there was the family that Curtis loved with all his heart, but for which he seemingly never had enough time. Amazingly, his children never lost their deep attachment to him, and during the 1930s he found himself surrounded by them. Repairing his relationship with them had started as early as 1927, when Edward spent Christmas with all four now-grown children—including Katherine, whom he barely knew—at Florence's house in Medford, Oregon. In 1932, the drowning death of her mother, Clara, sent Katherine Curtis to California to live near Edward. For several years, all four Curtis children lived in the Los Angeles area and were devoted to their aging photographer.

While convalescing from his breakdown, Curtis found a new obsession: gold. The last years of his life became devoted to the idea of striking it rich, and he took frequent prospecting trips—often joined by son, Harold—throughout the West in search of the elusive metal. Even as he grew older and travel became impossible, his gold-seeking dreams never wavered. He spent two years writing a stillborn book titled "The Lure of Gold" and even made arrangements to prospect in South America, but by this point in his life

these were dreams that could never be fulfilled.

Edward Curtis died of a heart attack on October 19, 1952, and sadly, few people at that time remembered exactly why he had once been famous. Obituaries mentioned that he was a photographer and somewhat of an expert on American Indians, but the country had largely forgotten him. Fortunately, two decades later, as America began to give greater recognition to its forlorn native people, Curtis's work would play an important role in this healing process. Along the way, the mastery—and mystery—of this amazing man was revealed again, and his genius finally touched the wide audience he had always dreamed of reaching.

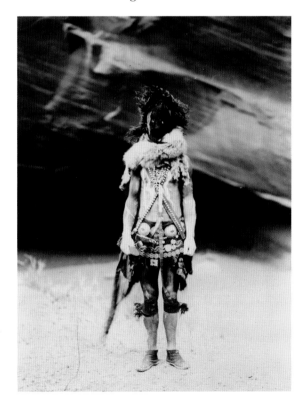

Volume I
The Apache. The Jicarillas. The Navaho.

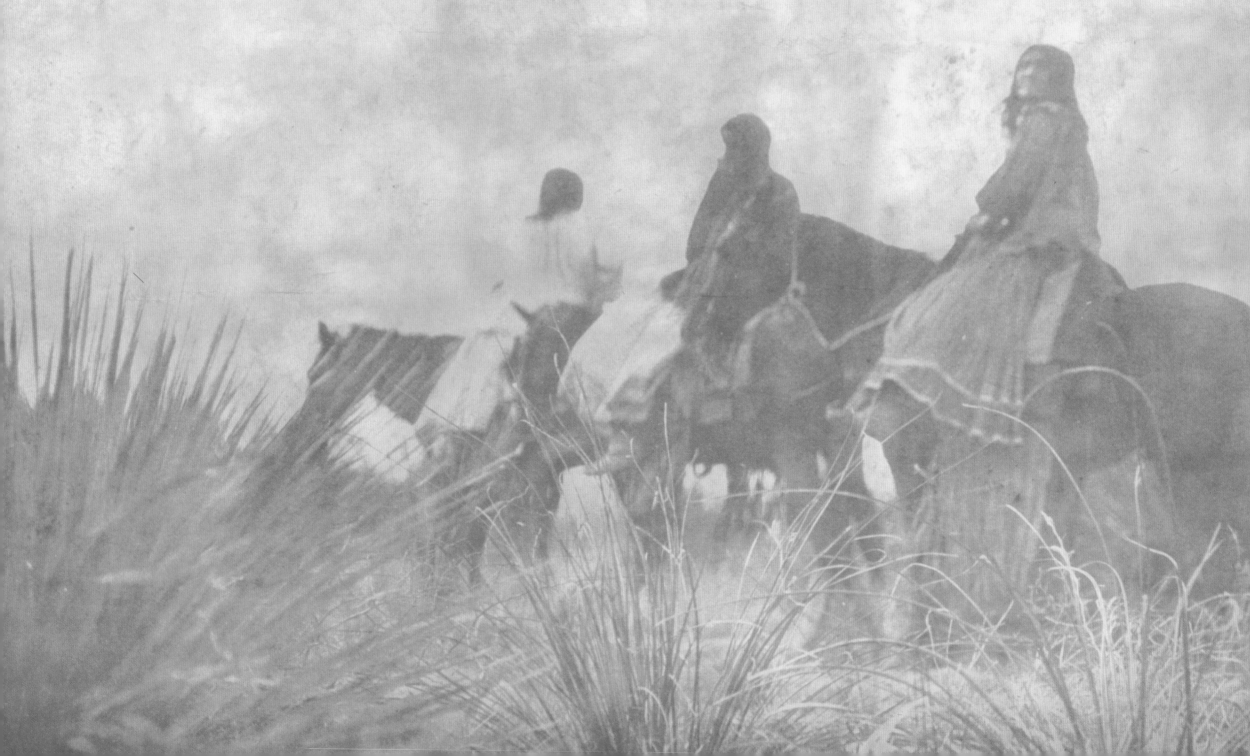

The first volume in *The North American Indian* series was significant not just because it finally brought to fruition the first tangible evidence of Edward Curtis's grand plan, but also because it featured Theodore Roosevelt's foreword—which gave credibility to the effort—and Curtis's general introduction explaining his aims and methodology. Considering his deep fascination with the religious traditions of tribes from the American Southwest, it is not surprising that Curtis dedicated the first volume of *The North American Indian* to three groups from this region.

The centerpiece of this book is its study of a sacred Apache prayer chart. Curtis used his considerable charm and political skills to secure the purchase and translation of the much-guarded relic and remained quite proud of his chicanery for the remainder of his life. Also important was Curtis's detailed explanation and photography of the Navajo Yeibechei dance ceremony, which he revealed was the culmination of a complex nine-day ritual that included Navajo traditions such as ceremonial sweats and sand painting.

Four Apache on horseback under storm clouds on December 19, 1906. Curtis described the Apaches as nomads, and the horse was the vehicle that made this habit possible. Both men and women were comfortable in the saddle, but it was the mounted warriors that struck fear into the hearts of settlers in the Southwest. Curtis declared that the Apache possessed a combination of courage, endurance, and cunning found in none of the other tribes he studied.

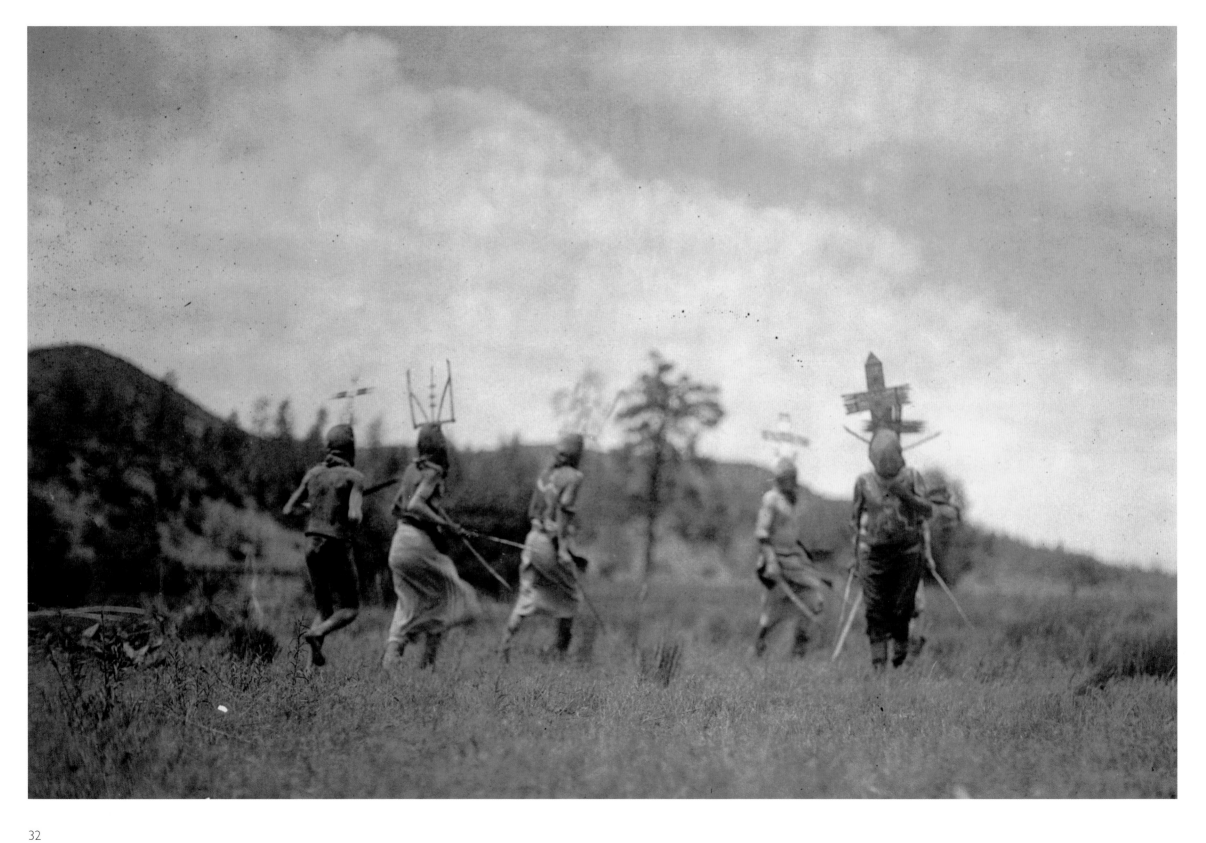

LEFT: Apache Mountain Spirit Dancer, c. 1930. Also called Gaan Dancers, they impersonate the sacred spirits who drive away sickness and evil and bring good fortune. Over black buckskin hoods with false eyes of abalone or turquoise, they wear towering wooden headdresses painted with symbols of strength, and challenge the forces of evil by charging at each other in the dark beside a fire. Several Apache groups retain the ceremony, usually combined with the girls' puberty rite.
Library of Congress, Prints & Photographs Division, Edward S. Curtis Collection, LC-USZ62-112201

RIGHT: A half-length portrait of Apache Ndee Sangochonh; c. 1906.
Library of Congress, Prints & Photographs Division, Edward S. Curtis Collection, LC-USZ62-106797

FAR RIGHT: Half-length portrait, left profile, of Apache Alchise; c. 1906.
Library of Congress, Prints & Photographs Division, Edward S. Curtis Collection, LC-USZ62-109711

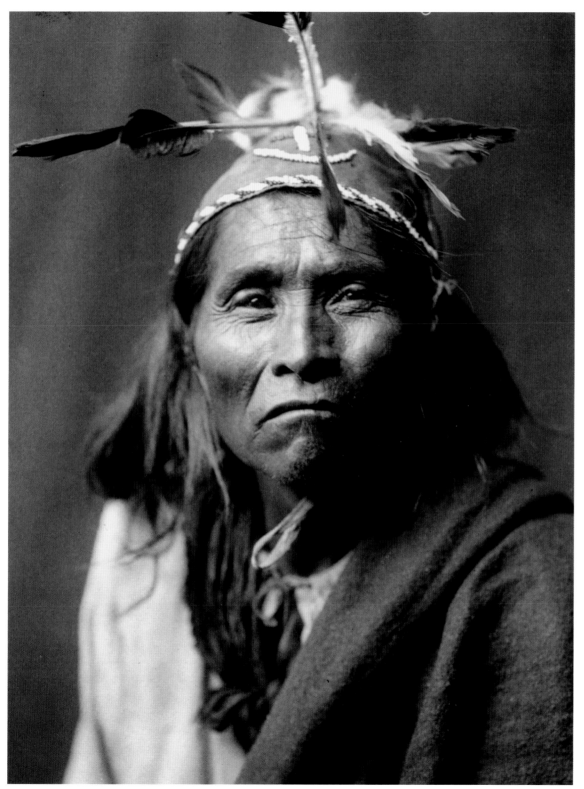

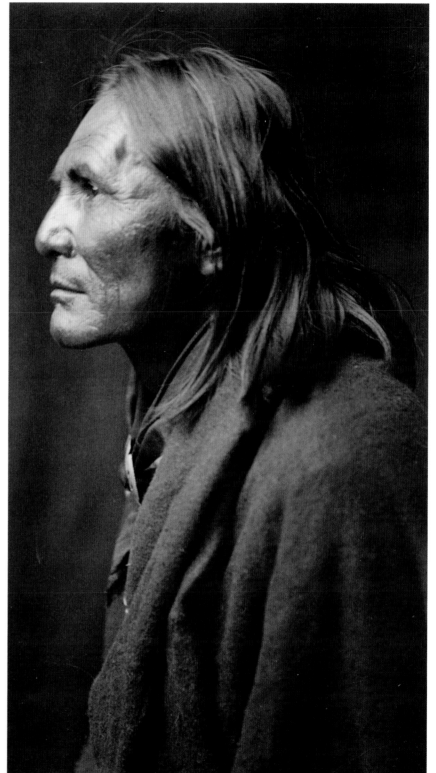

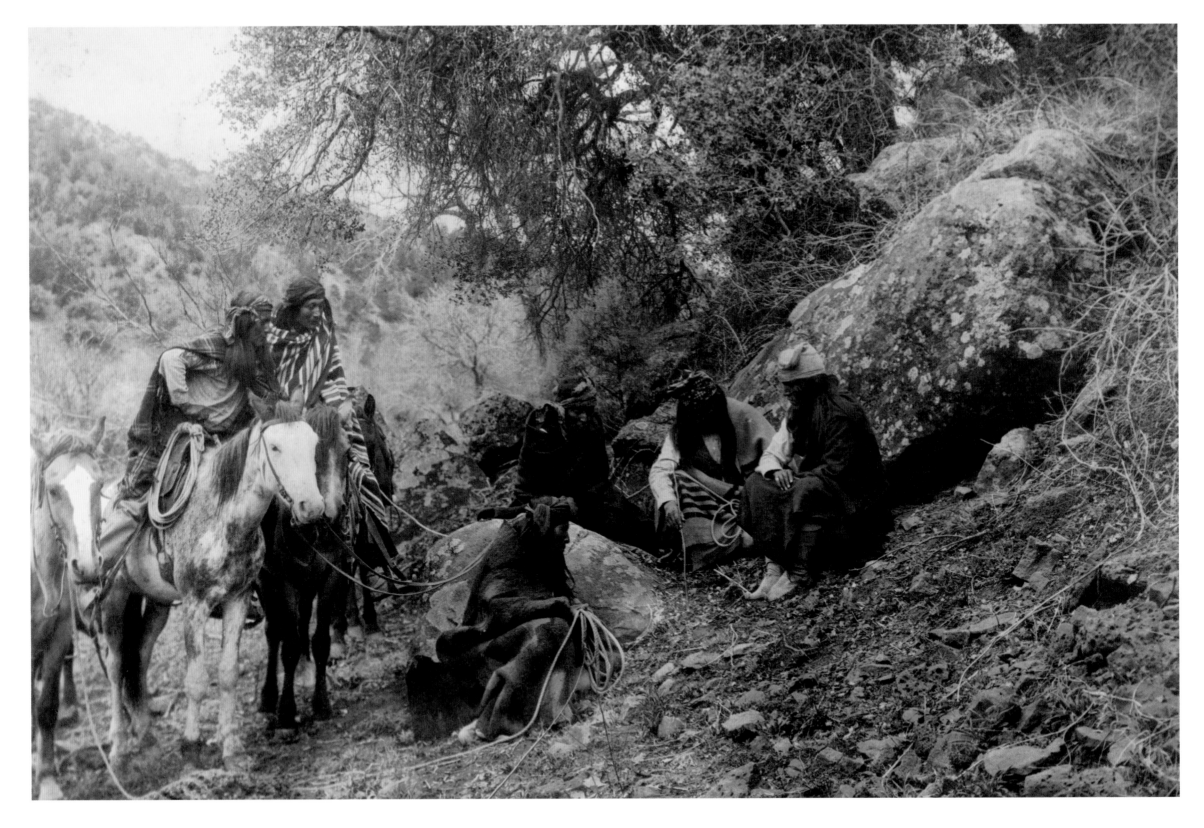

Left: Curtis visited Arizona's White Mountain Apache several times in the early years of the project. This image from 1903 records a storytelling group, an activity that Curtis noted as very popular among these people. Three years later he cause quite a stir within the tribe when he purchased one of their sacred buckskin prayer charts, then exploited the rivalry between two medicine men to learn its closely guarded secrets. *Library of Congress, Prints & Photographs Division, Edward S. Curtis Collection, LC-USZ62-49150*

Right: The Apache were expert basket makers and this grouping shows several common varieties. The coated urn (second from left) held water, while the large urn in the center was for grain storage. All Apache homes contained at least one burden basket, frequently decorated with deerskin fringe and shown lying on its side in this photo. *Library of Congress, Prints & Photographs Division, Edward S. Curtis Collection, LC-USZ62-130198*

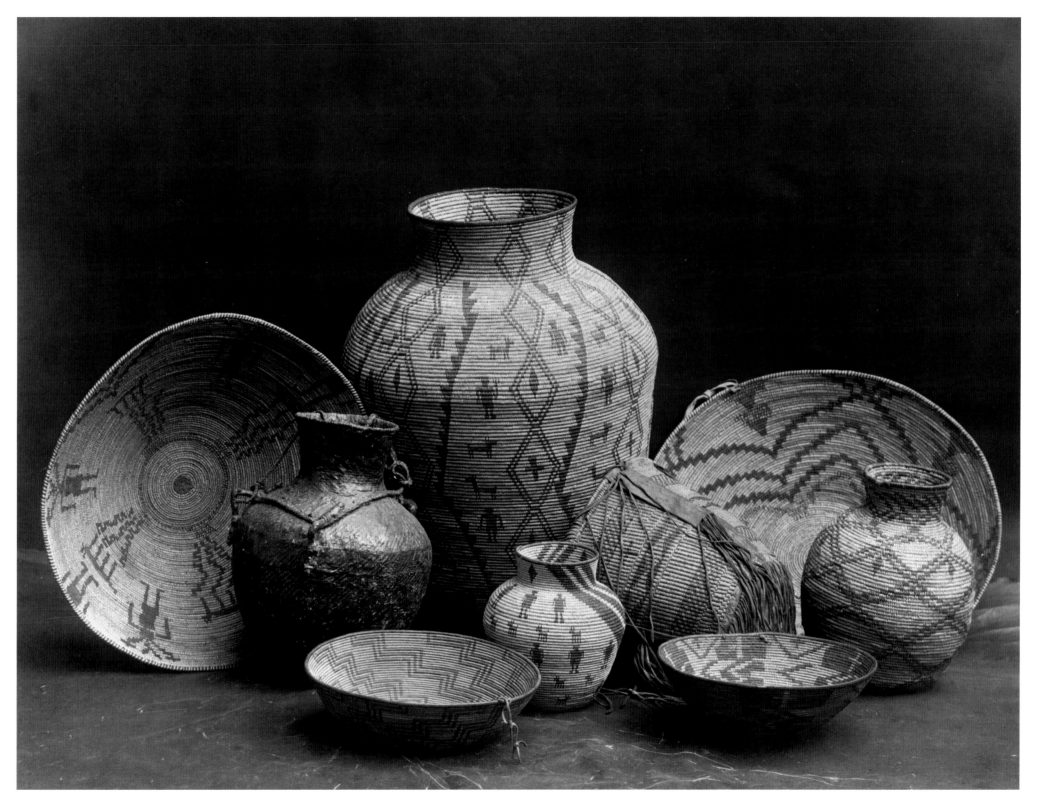

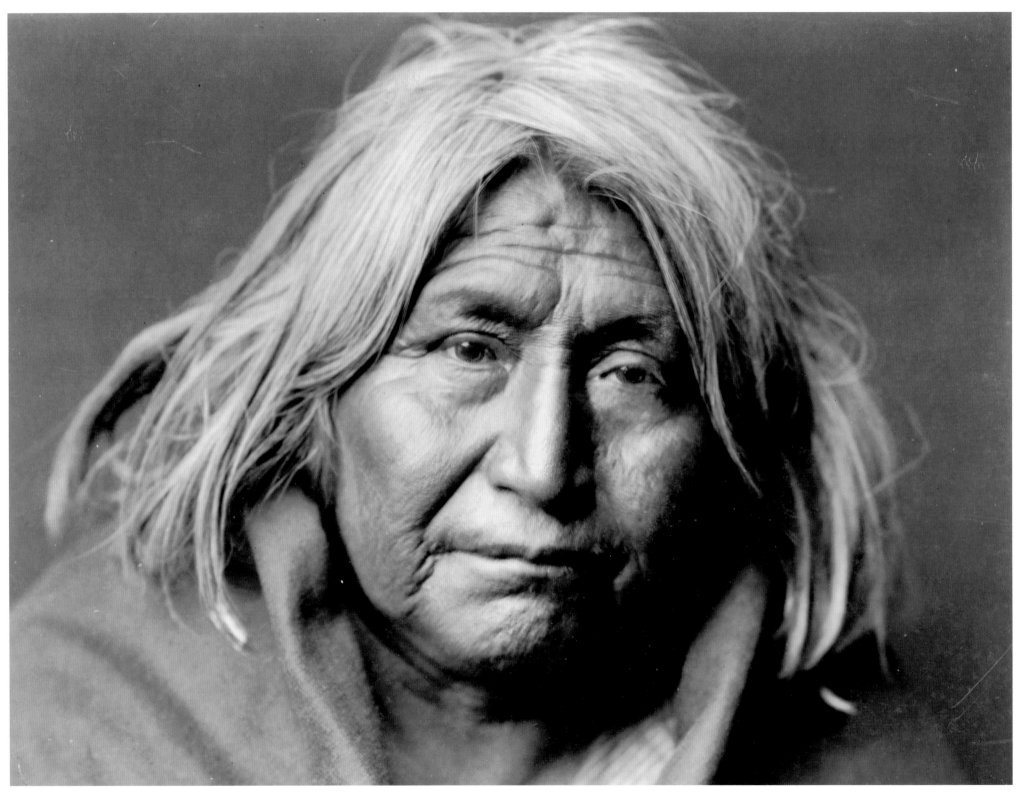

LEFT: Head-and-shoulders portrait of elderly Apache called De Gazza; c. 1903. *Library of Congress, Prints & Photographs Division, Edward S. Curtis Collection, LC-USZ62-112200*

RIGHT: An Apache wickiup—a rounded structure made out of grass, with baskets in front; c. 1903. Light poles were set in a rough circle of shallow holes, bent inward, tied together, and covered with thatched grass or brush tied on with yucca fiber in regular overlapping courses; the structure was partially covered with earth in winter. *Library of Congress, Prints & Photographs Division, Edward S. Curtis Collection, LC-USZ62-101173*

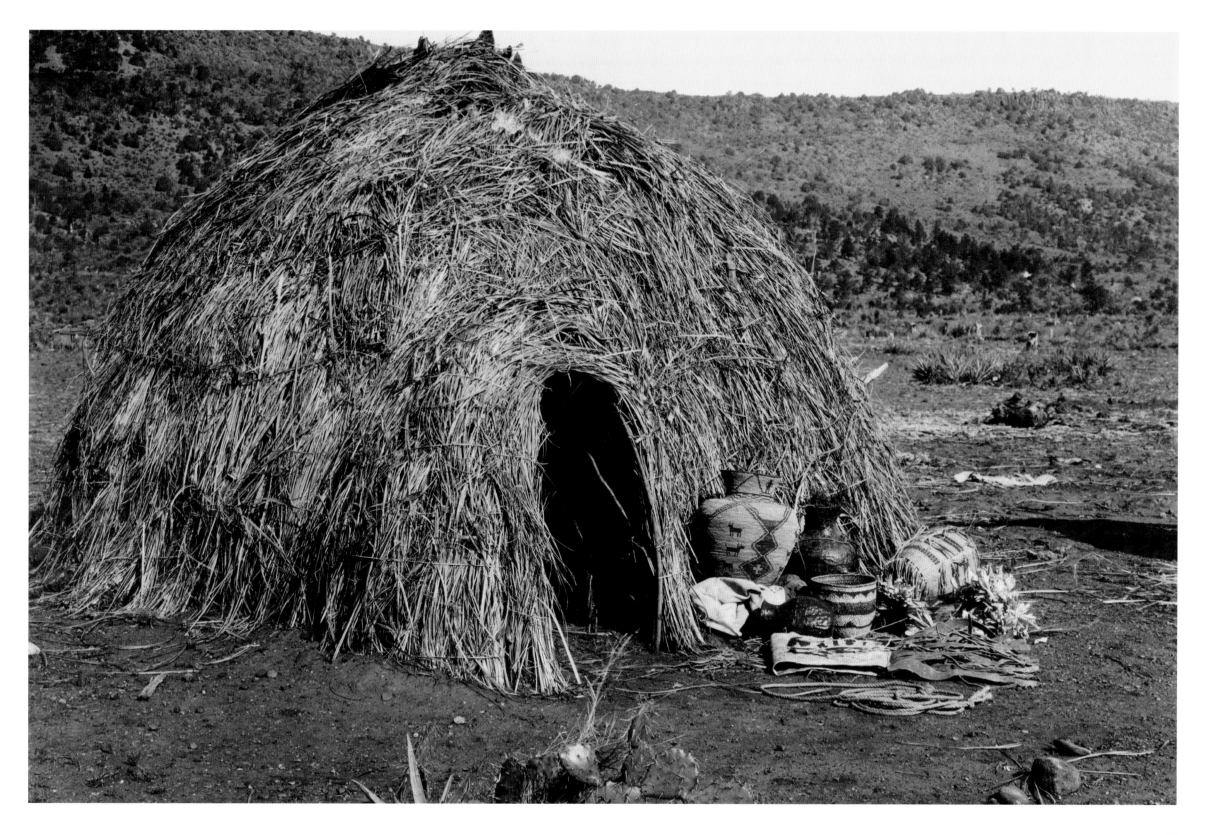

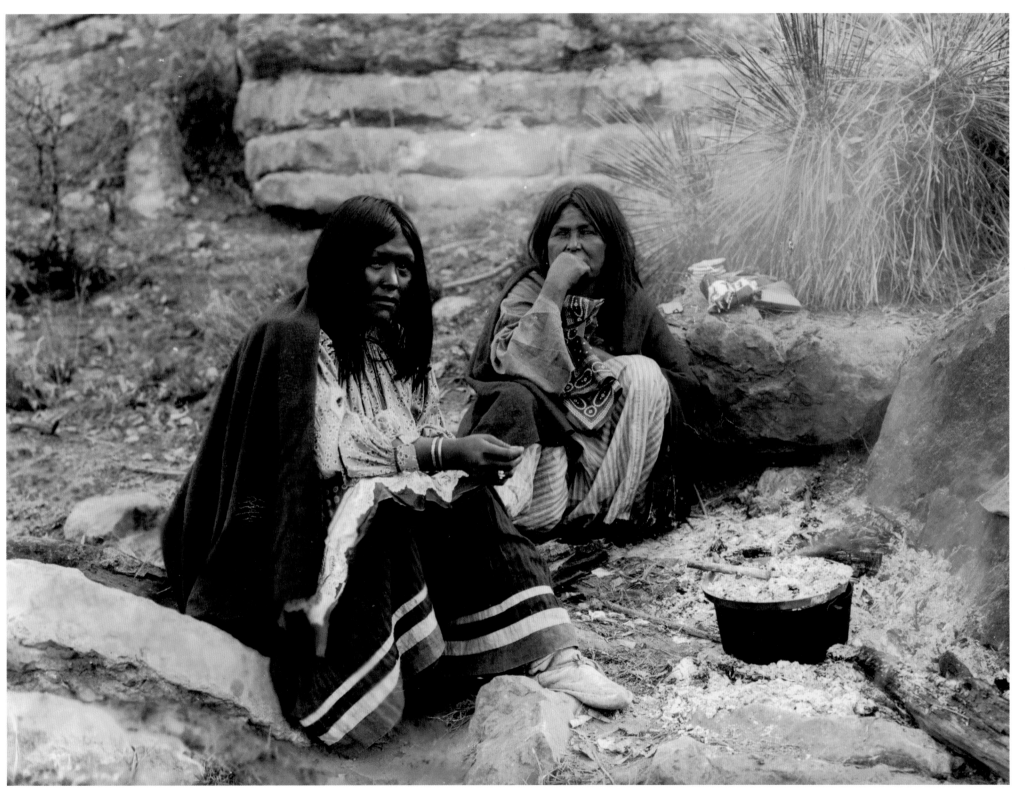

LEFT: Two Apache women prepare a meal over the campfire in 1903. Curtis noted that the tribe was very adept at living off the natural products of its desert home. *Library of Congress, Prints & Photographs Division, Edward S. Curtis Collection, LC-USZ62-101172*

RIGHT: The Jicarilla, who lived in northern New Mexico, were one of the seven main Apache tribes. Jicarilla dress and hairstyles, illustrated by this man, reflected their contact with the Plains tribes—as did their habit of living in tipis. *Library of Congress, Prints & Photographs Division, Edward S. Curtis Collection, LC-USZ62-106251*

FAR RIGHT: Jicarilla Chief Garfield. Like their kinsmen the Jicarilla raided the Pueblos extensively, and also incorporated both ritual and material culture from that source; they were the Apaches most influenced by Pueblo gardening practices. *Corbis*

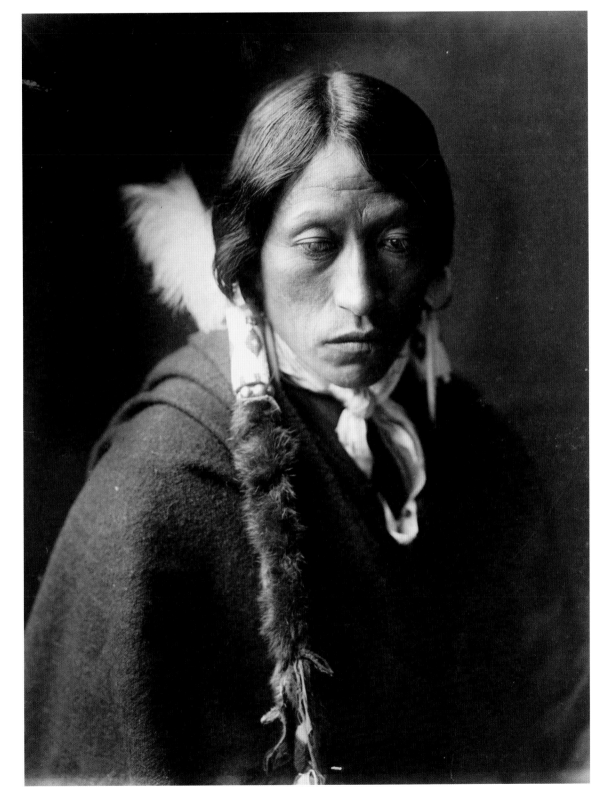

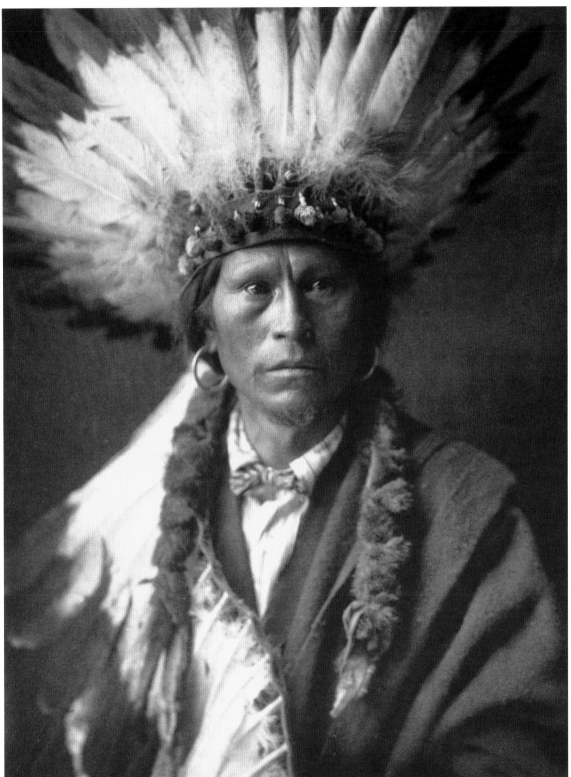

39

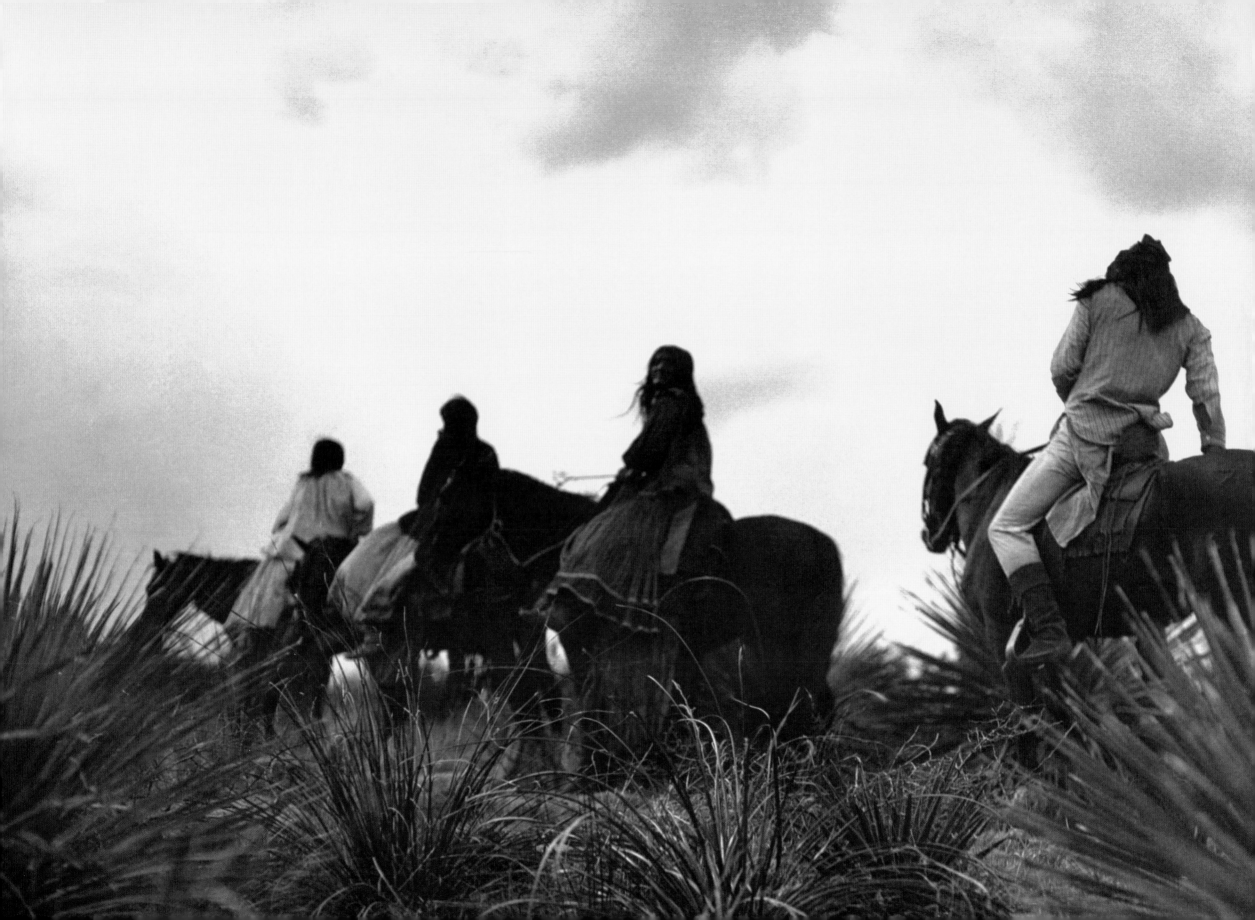

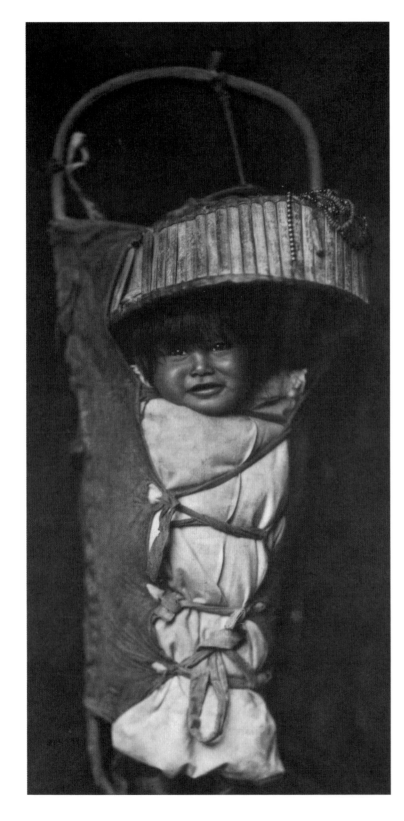

LEFT: A portrait of an Apache baby. Some groups used a cradle with a U-shaped or ovoid frame of heavy rods crossed by wooden slats, with a broad bow over the child's head made of narrower yucca slats; the cover was usually deerskin, often colored yellow. The infant was strapped in with buckskin ties, and cushioned with layers of cloth or crushed cedar bark. *Corbis*

RIGHT: "Today and Yesterday." The Navajo call themselves Diné and are close linguistically to the Western Apache. The Navajo seem to have been more heavily influenced by Pueblo culture than other Apachean groups— their pottery and weaving arts, for example, are of Pueblo origin. This is Antelope Ruin, Canyon del Muerto; c. 1906. *Library of Congress, Prints & Photographs Division, Edward S. Curtis Collection, LC-USZ62-106798*

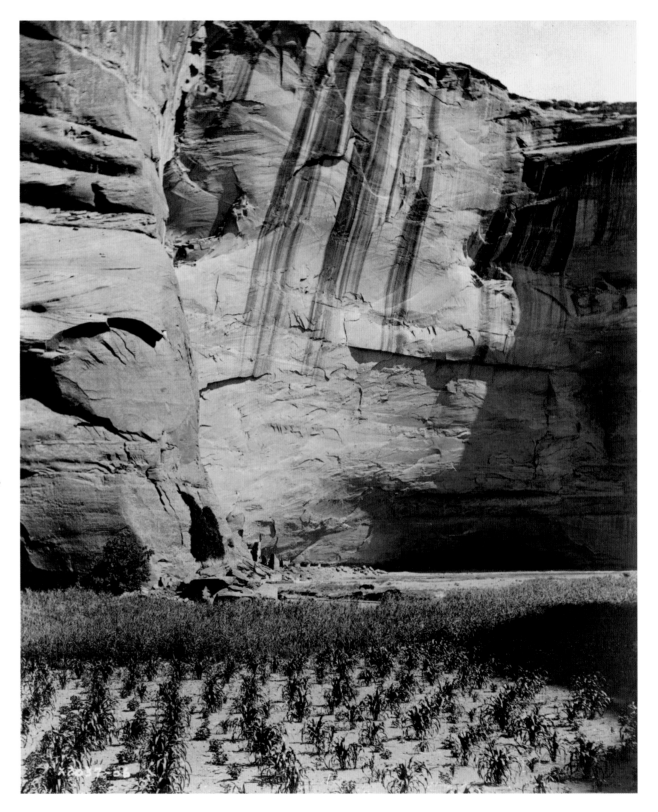

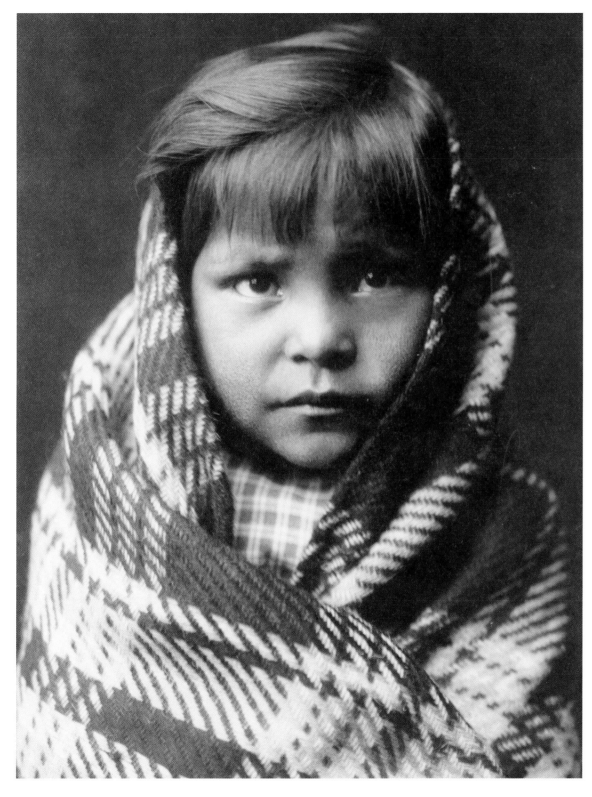

LEFT: Navajo child, swathed in a blanket; c. 1905. The classic period of Navajo weaving was the first half of the nineteenth century. Colors were usually red, white, brown, and blue and featured stripes.
Library of Congress, Prints & Photographs Division, Edward S. Curtis Collection, LC-USZ62-112208

RIGHT: "Nature's mirror." When photographed by Curtis in 1904, this Navajo woman appears to be wearing a traditional "squaw dress," a poncho-like garment made from two blankets. The photographer noted that this garb was not common by the time he studied the Navajo—suggesting this photo may be an example of Curtis having his subject don special clothing for the sake of art.
Library of Congress, Prints & Photographs Division, Edward S. Curtis Collection, LC-USZ62-100121

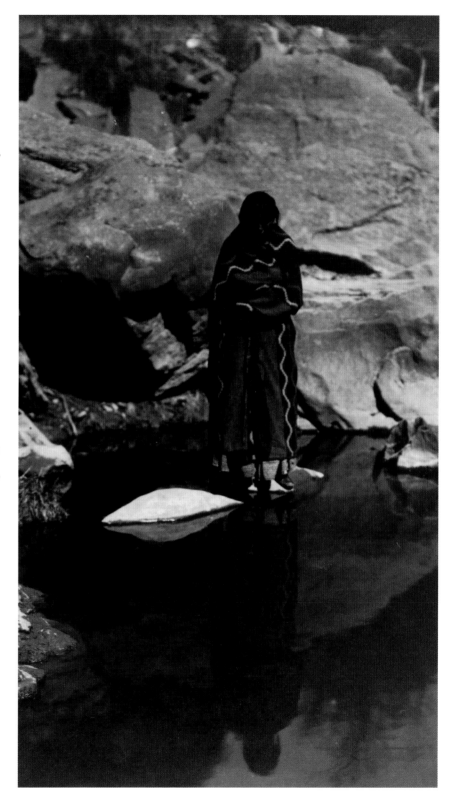

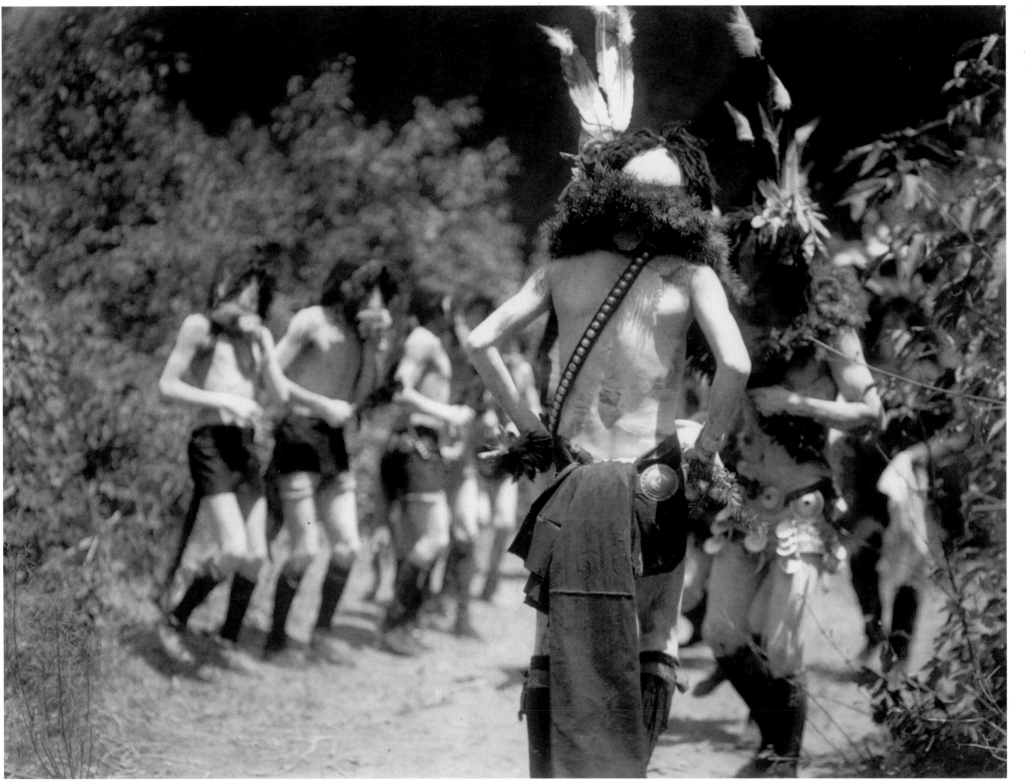

LEFT: Navajo men impersonating myth characters during Yeibichei dance; c. 1906. The majority of Navajo ceremonials are for curing disease, actual or anticipated; and for the ritualistic restoration of universal harmony once it has been disturbed, usually expressed as the "Blessing Way," through group rituals and singing which give psycho-therapeutic benefit to patients and participants. Other important rituals include the Yeibichei or "Night Chant," and the Peyote cult also became popular with many Navajos.
Library of Congress, Prints & Photographs Division, Edward S. Curtis Collection LC-USZ62-103460

RIGHT: Navajo hogan; c. 1905. Built around three forked logs locked in a tripod, poles, brush and sometimes cedar bark were piled around the framework, the whole being thickly covered with earth, leaving a smoke hole at the apex. Doorways sometimes projected like dormers, and were usually closed with a blanket.
Library of Congress, Prints & Photographs Division, Edward S. Curtis Collection, LC-USZ62-105863

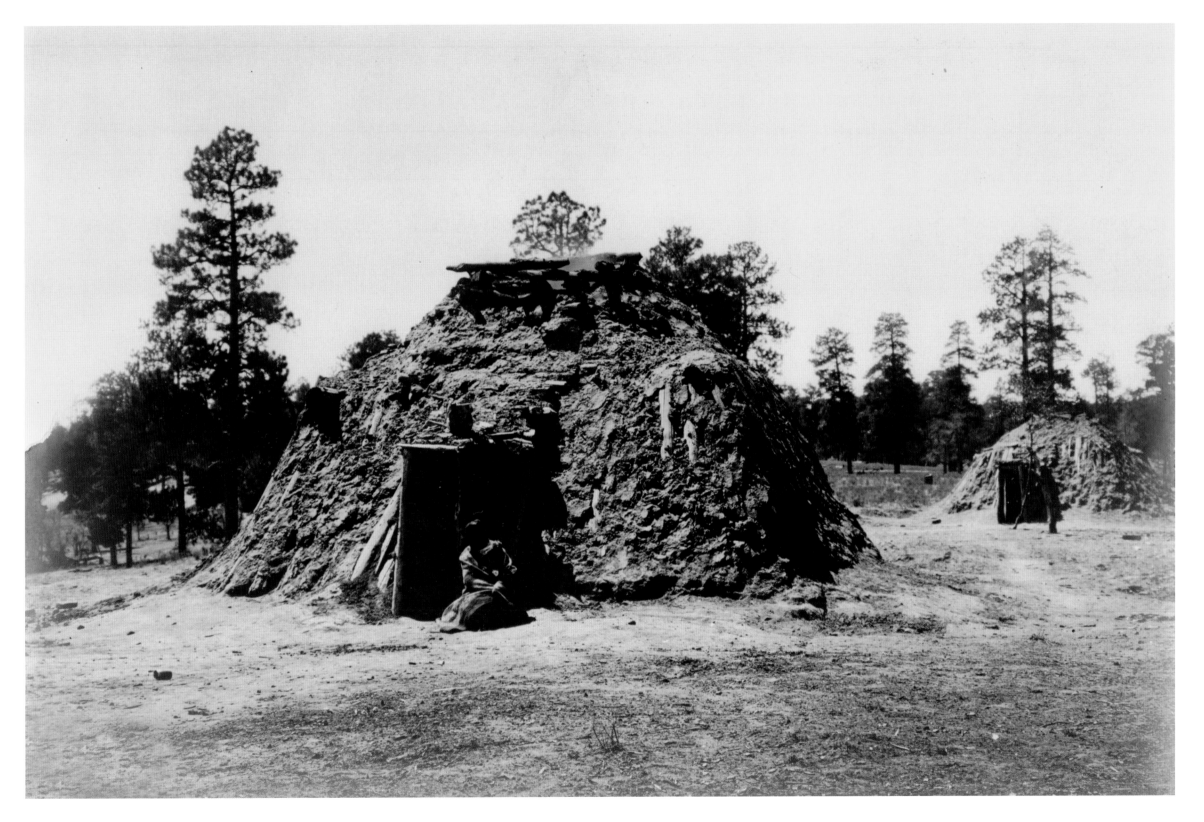

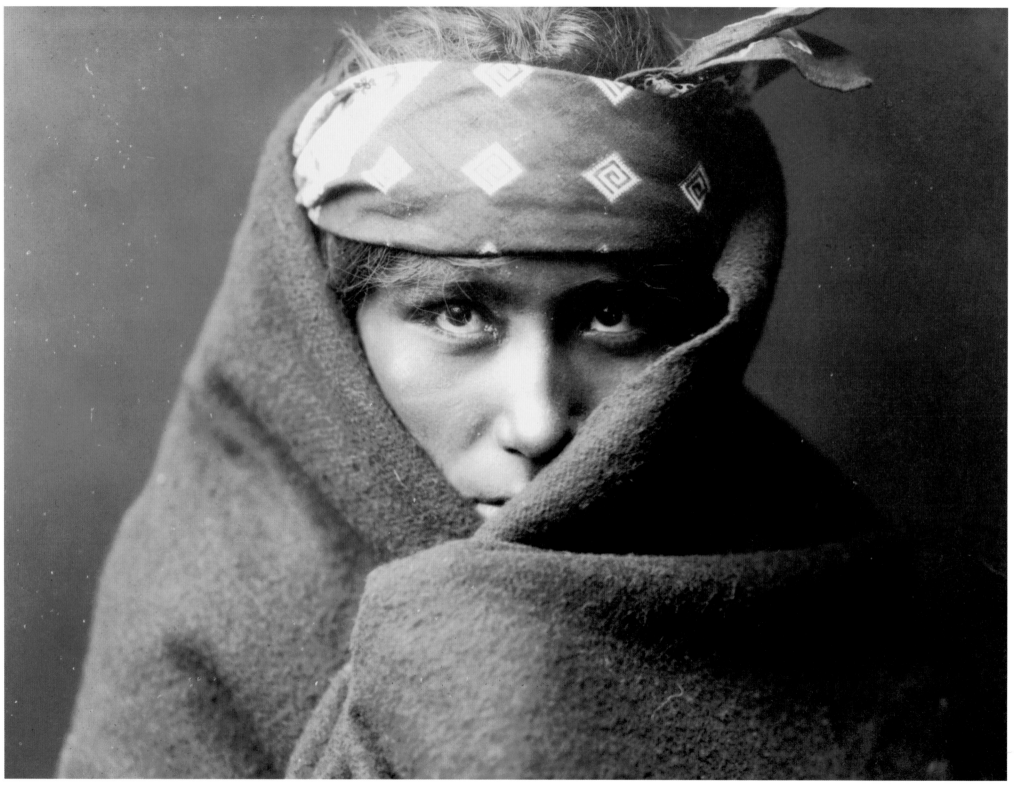

LEFT: This mysterious-looking Navajo boy photographed in 1904, identified simply as Many Goats's son, wears two very traditional pieces of clothing: a cloth headband to hold back his hair, and a blanket. The Navajo were skilled weavers and Curtis noted that their blankets were one of the most important handicrafts produced by any North American tribe. *Library of Congress, Prints & Photographs Division, Edward S. Curtis Collection, LC-USZ62-101174*

RIGHT AND FAR RIGHT: Considering his fascination with Native American religious ceremonies, it wasn't surprising that Edward Curtis focused considerable attention on the Navajo Yeibichei Dance, an elaborate ceremony that could last as long as nine days. Volume I featured several portraits of the masked Yeibichei dancers wearing the elaborate attire that represented various Navajo gods. Two examples are shown here: At right is Zahadolzha (photographed 1905), a water-dwelling spirit that appeared in the Night Chant ceremony, and at far right is Haschogan (photographed 1904), the House God. *Library of Congress, Prints & Photographs Division, Edward S. Curtis Collection, LC-USZ62-101841; Corbis*

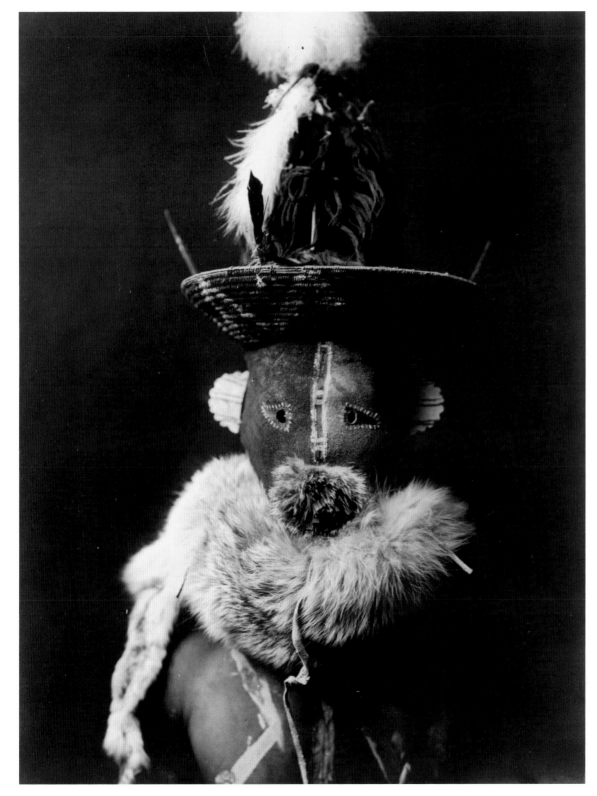

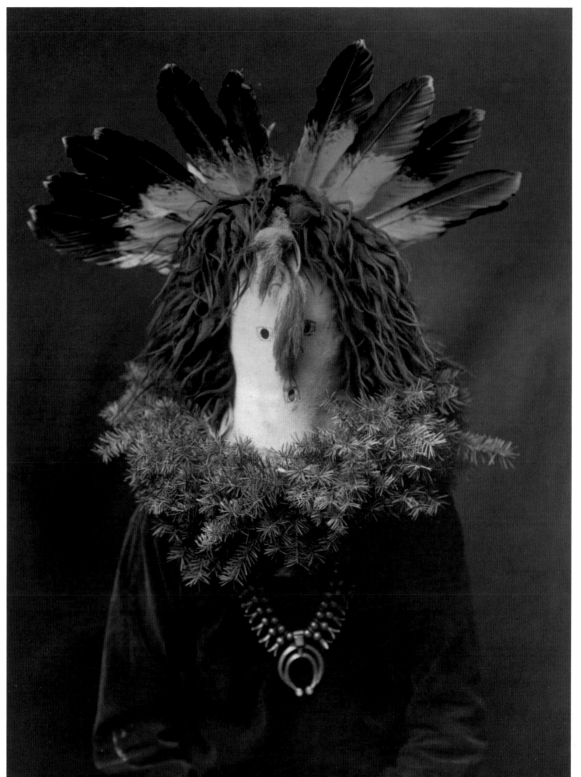

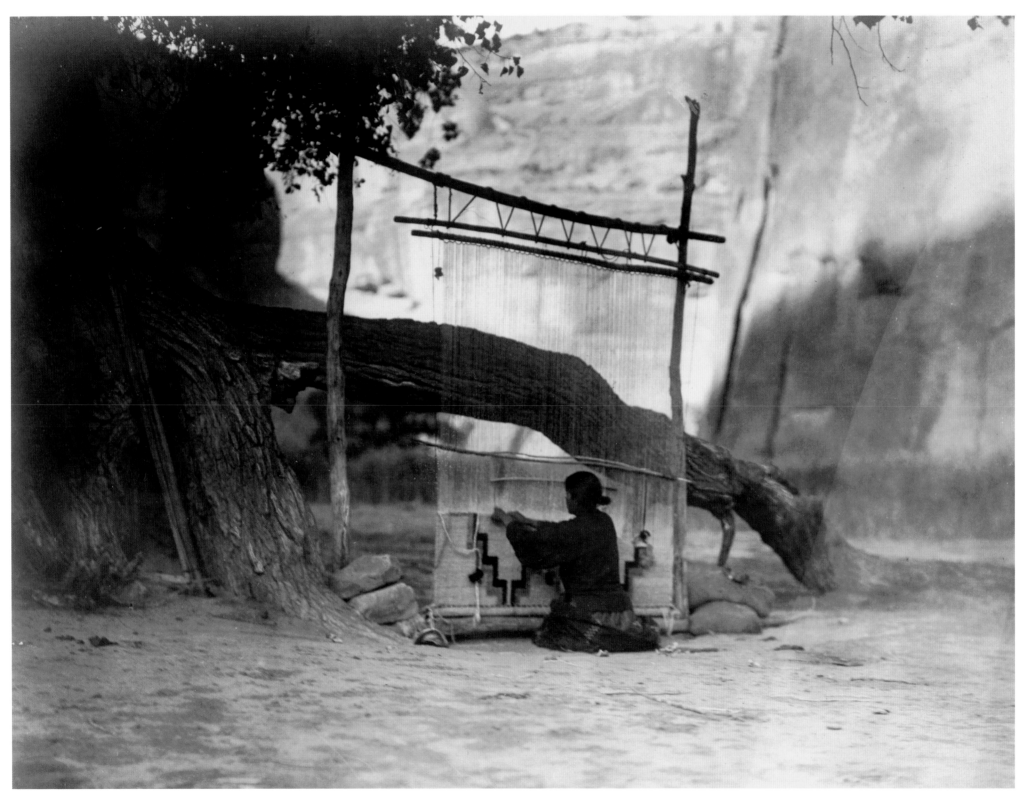

LEFT: A Navajo blanket weaver under a cottonwood tree, c. 1905. The Navajo copied the vertical loom from the Pueblos around 1700, first weaving cotton, and later wool. The earliest Navajo serapes (long, brightly colored shawls) and blankets closely resembled those of the Pueblos; but they gradually developed their own increasingly complex rug designs. They used the wool from sheep introduced to the southwest by the Spanish. *Library of Congress, Prints & Photographs Division, Edward S. Curtis Collection, LC-USZ62-116675*

RIGHT: Curtis described the Navajo, such as these photographed in 1906, as North America's best native horsewoman. This wasn't surprising considering how much time they spent astride their ponies. Navajo women were important members of the tribe: They owned most of the sheep (in addition to the dwellings and much of the other property) and were the tribe's primary shepherds. *Corbis*

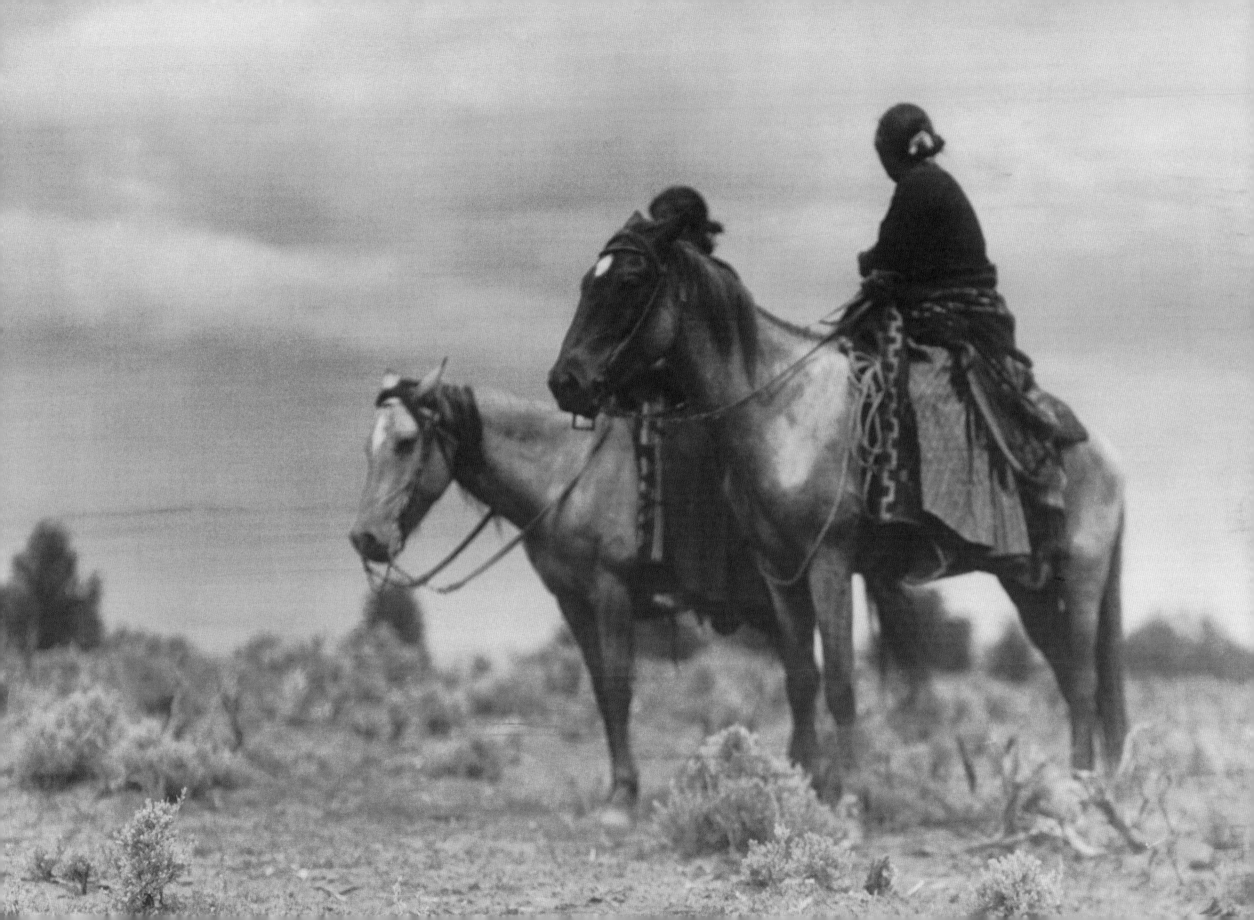

Volume II

The Pima. The Papago.

The Qahatika. The Mohave.

The Yuma. The Maricopa.

The Walapai. The Havasupai.

The Apache-Mohave or Yavapai.

For the second volume, Curtis lumped together nine tribes that lived primarily in the state of Arizona and were further joined by their shared desert lifestyles and related languages. Despite the similarities between the tribes, Curtis took great pains to treat the tribes as culturally distinct groups and elaborated on the various traditions, religious beliefs, and rituals of each.

The bulk of the photography and fieldwork for this volume was completed between 1900 and 1905, before Curtis had secured financial support from J. Pierpont Morgan or even developed a concrete plan for his project. Despite flying somewhat by the seat of his pants, he managed to amass a large amount of quality ethnographic information and photographs

Compared to other tribes in this volume, relatively little page space was dedicated to the Havasupai, but Curtis seemed to be especially taken with the small, poverty-stricken band living in the depths of the Grand Canyon. In 1905 he lobbied the Commissioner of Indian Affairs to provide some assistance to the Havasupai. Over the years it was not uncommon for him to seek government help on behalf of the tribes he studied.

Mohave woman carrying water on her head and holding a child; c. 1903. The Mohave is the northernmost Yuman tribe of the Colorado River group, living where the present states of Nevada, California and Arizona adjoin at the Mohave Valley.
Library of Congress, Prints & Photographs Division, Edward S. Curtis Collection, LC-USZC4-101179

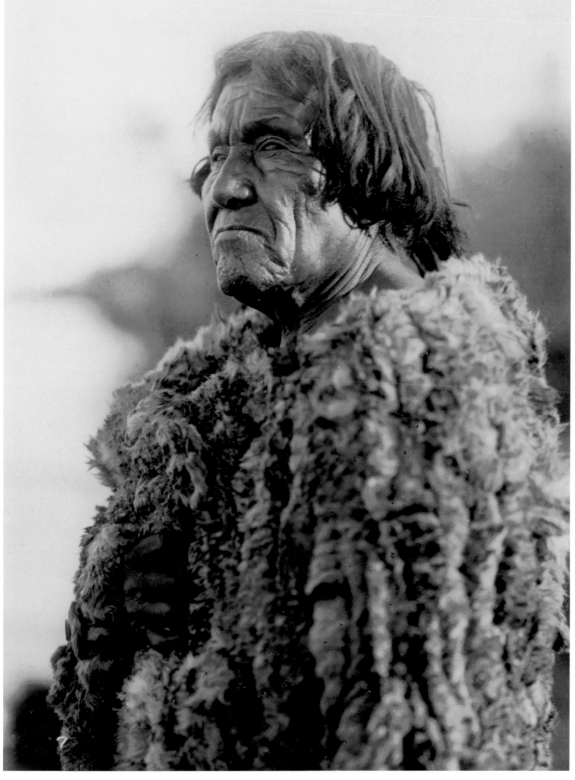
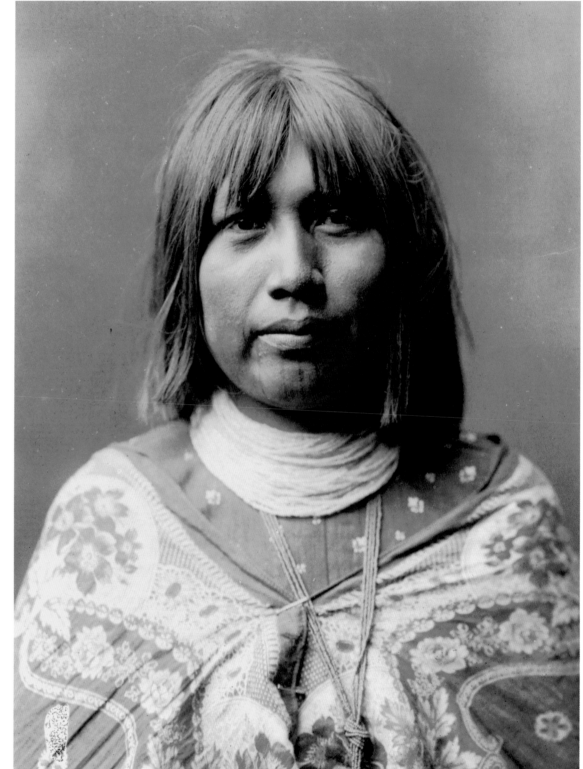

Far left: Curtis photographed this Mohave man wearing a "primitive" rabbit skin robe in 1907. The Mohave were a simple desert people whose lives focused on gathering plants, hunting, and fishing in the Colorado River. Curtis called them "dull and slow," but praised their physical condition, which he described as "probably superior to any other tribe in the United States."
Library of Congress, Prints & Photographs Division, Edward S. Curtis Collection, LC-USZC4-101178

Left: Though O Che Che, a Mohave photographed by Curtis in 1903, still wore her hair in the traditional manner, she had adopted dress from other cultures. Mohave women typically wore little more than a knee-length skirt made from willow-bark cloth.
Library of Congress, Prints & Photographs Division, Edward S. Curtis Collection, LC-USZC4-109712

Right: The Maricopa relied on cactus fruit in their diet. These women, wearing the traditional, simple wraparound dresses, are shown gathering saguaro fruit in 1907. The harvested fruit was placed in the baskets, which the women carried back to the village on their heads.
Library of Congress, Prints & Photographs Division, Edward S. Curtis Collection, LC-USZ62-111943

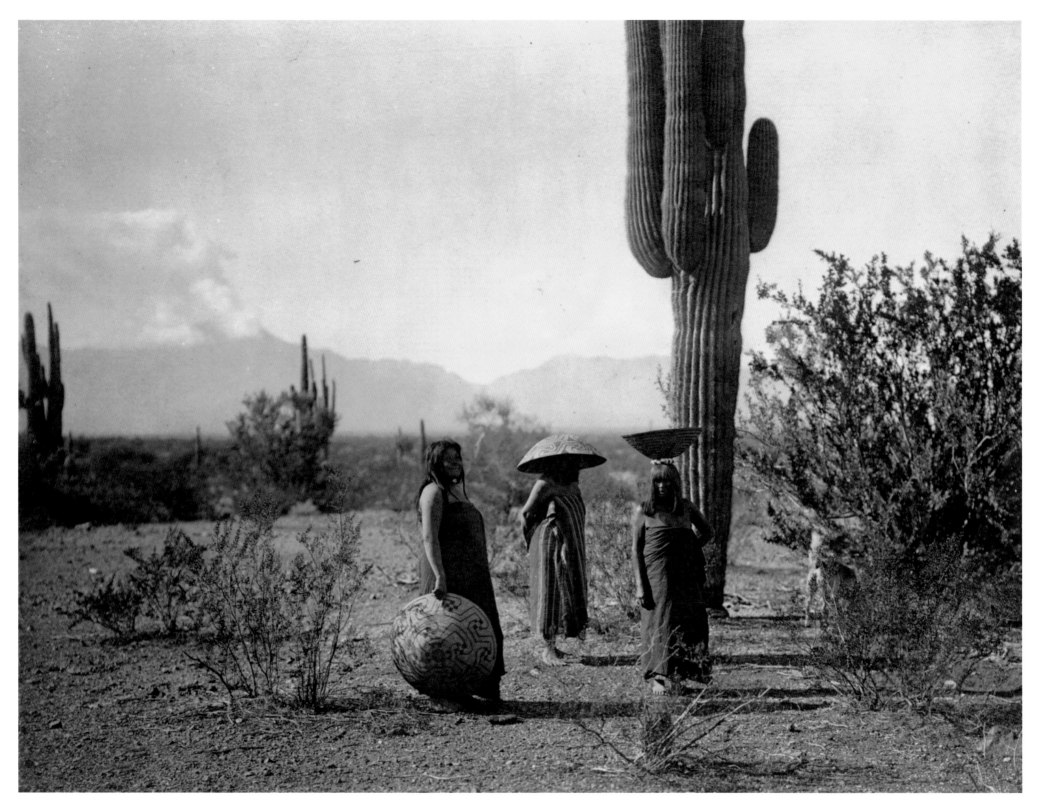

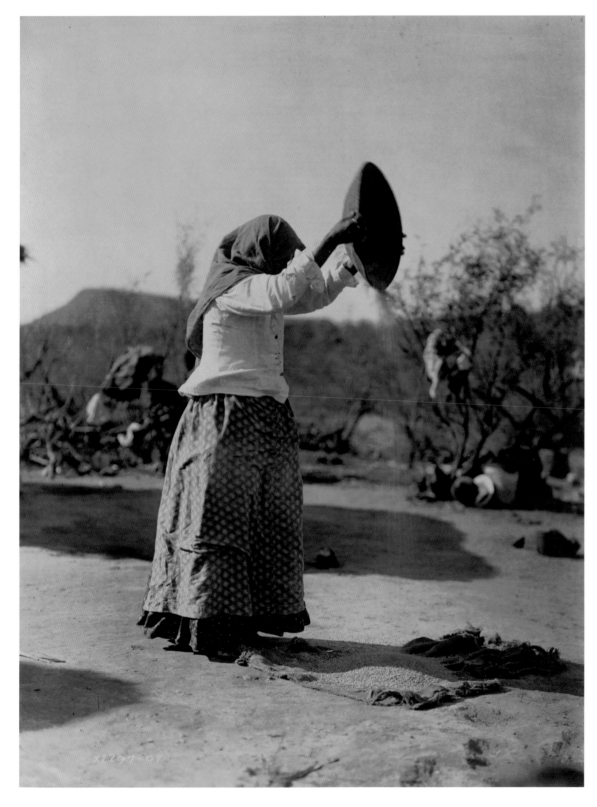

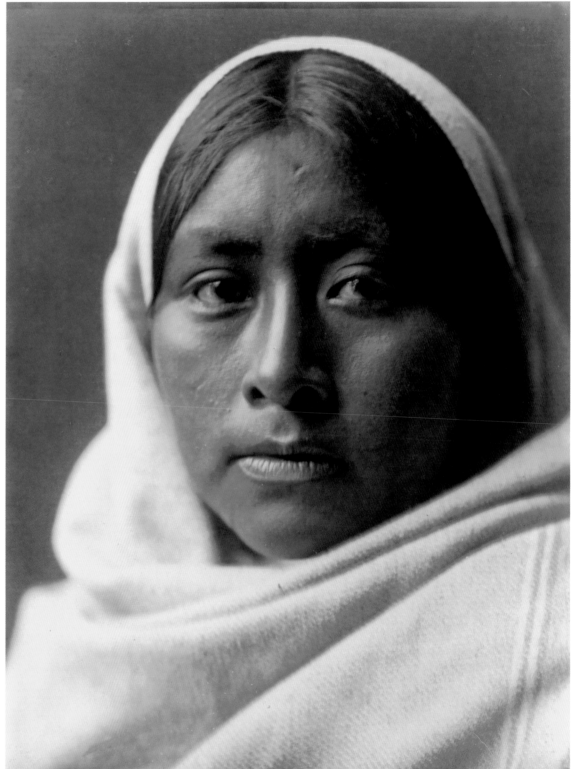

FAR LEFT: Papago winnowing (cleaning wheat); c. 1907. A division of the Upper Pima Indians of the desert region of southern Arizona and northern Sonora, Mexico, the Papago's food resources were crops of corn, beans, and squash which depended on irrigated water, often in limited supply; they also depended on wild foods and hunting.
Library of Congress, Prints & Photographs Division, Edward S. Curtis Collection, LC-USZ62-123312

LEFT: Papago woman wrapped in a shawl; c. 1907. Beginning in 1687 the Papago were Christianized following the foundation of the San Xavier Mission, which became the center of Papago religious life. In recent years the Papago have preferred to call themselves the Tohono O'odham.
Library of Congress, Prints & Photographs Division, Edward S. Curtis Collection, LC-USZ62-117000

RIGHT: Pima earth lodge, photographed in 1907. Basic construction of the Pima and Papago house was around beams set on four forked posts forming an eight-foot square. Willow poles set in the ground round the perimeter were bent inward and lashed to the beams, extending across to form a flattish dome roof; the exterior was thatched, then covered with a thick layer of earth. Smoke escaped through the single low doorway.
Library of Congress, Prints & Photographs Division, Edward S. Curtis Collection, LC-USZ62-101255

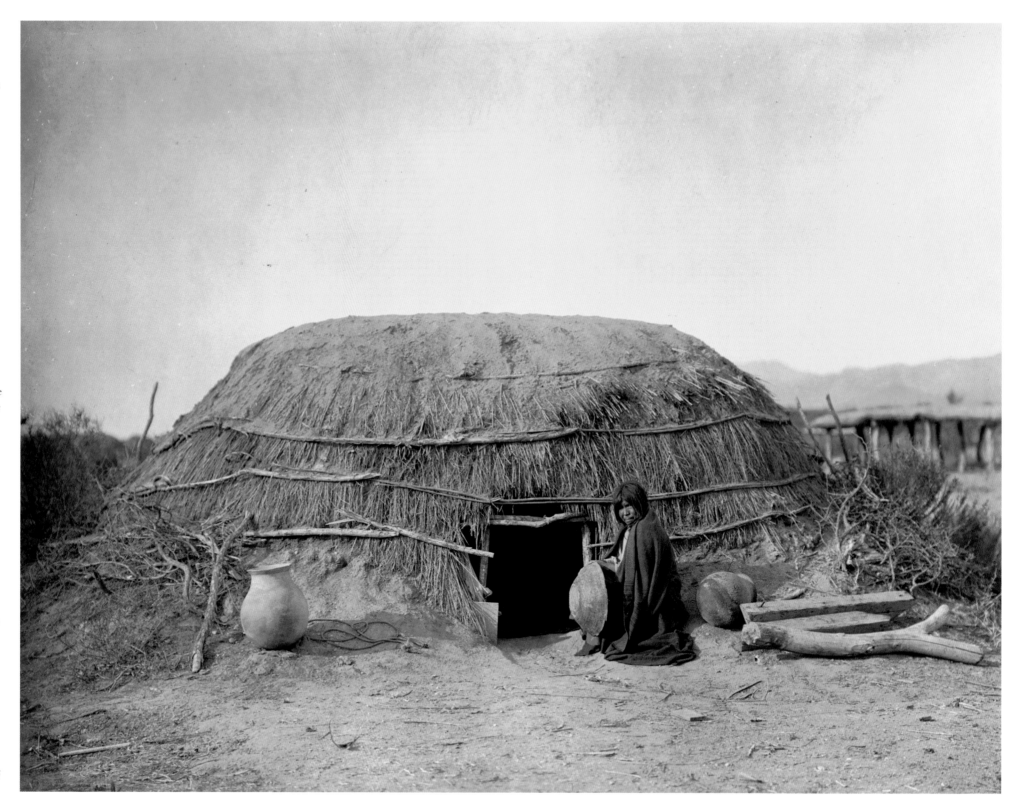

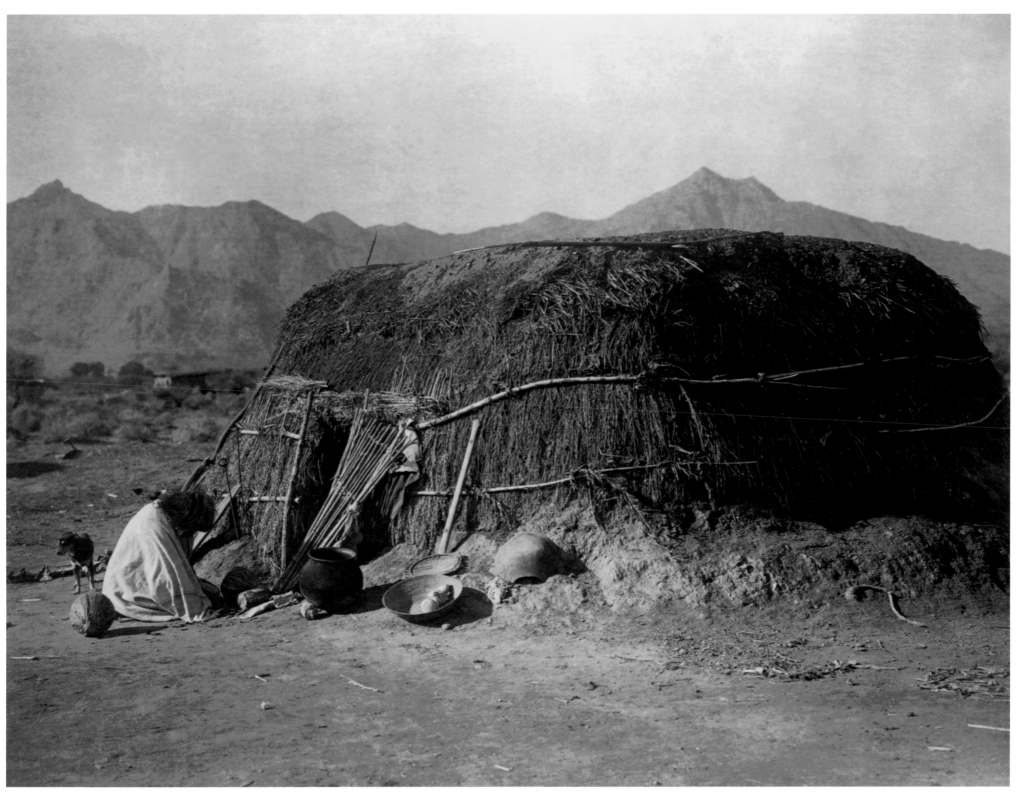

LEFT: Another view of a Pima earth lodge. Before the arrival of the Spanish in the mid-seventeenth century the Pima were part of a desert food-collecting culture grafted on to the successful farming of domesticated plants, corn, beans, and squash. *Corbis*

RIGHT: Czele Marie (schoolgirl): head-and-shoulders portrait of Pima girl; c. 1907.
Library of Congress, Prints & Photographs Division, Edward S. Curtis Collection, LC-USZ62-112212

FAR RIGHT: Qahatika girl; photographed in c. 1907. Curtis found the Qahatika some 40 miles south of the Pima Reservation in the arid desert. This landscape, Curtis notes, "has left its mark on the Qahatika and has made them as repellent as the thorny vegetation itself."
Library of Congress, Prints & Photographs Division, Edward S. Curtis Collection, LC-USZ62-112215

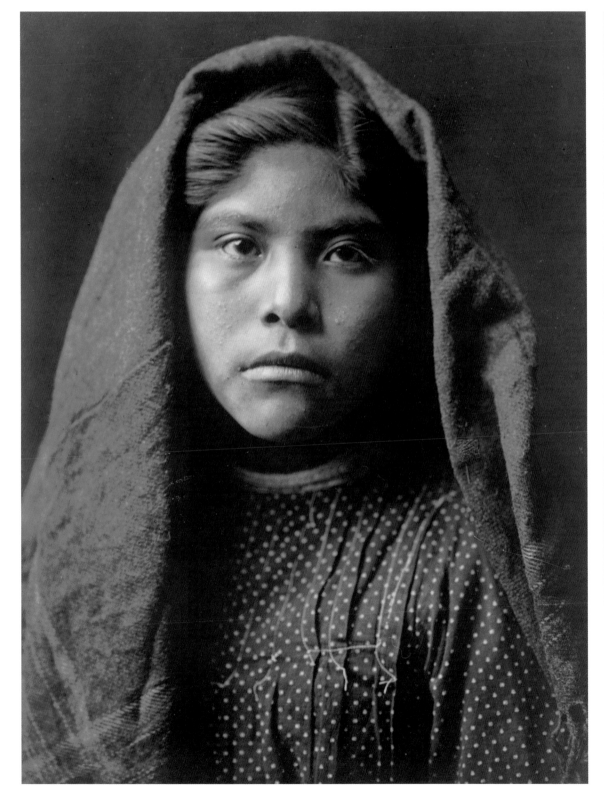

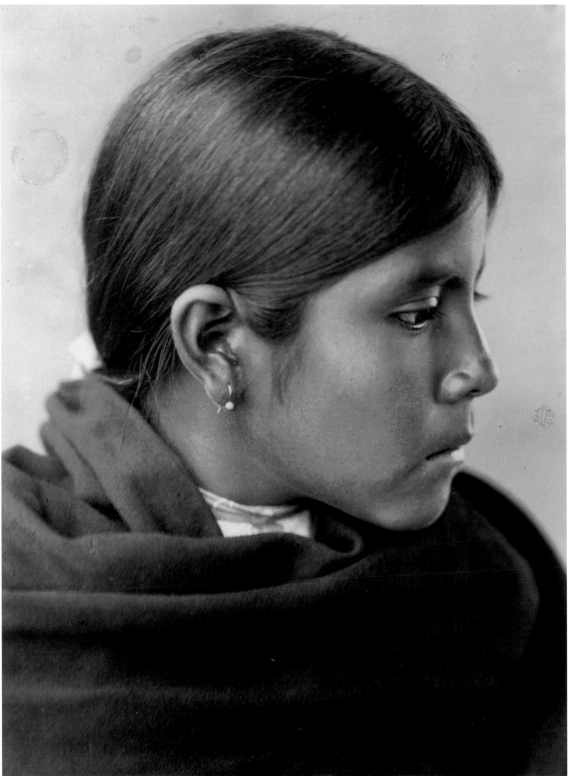

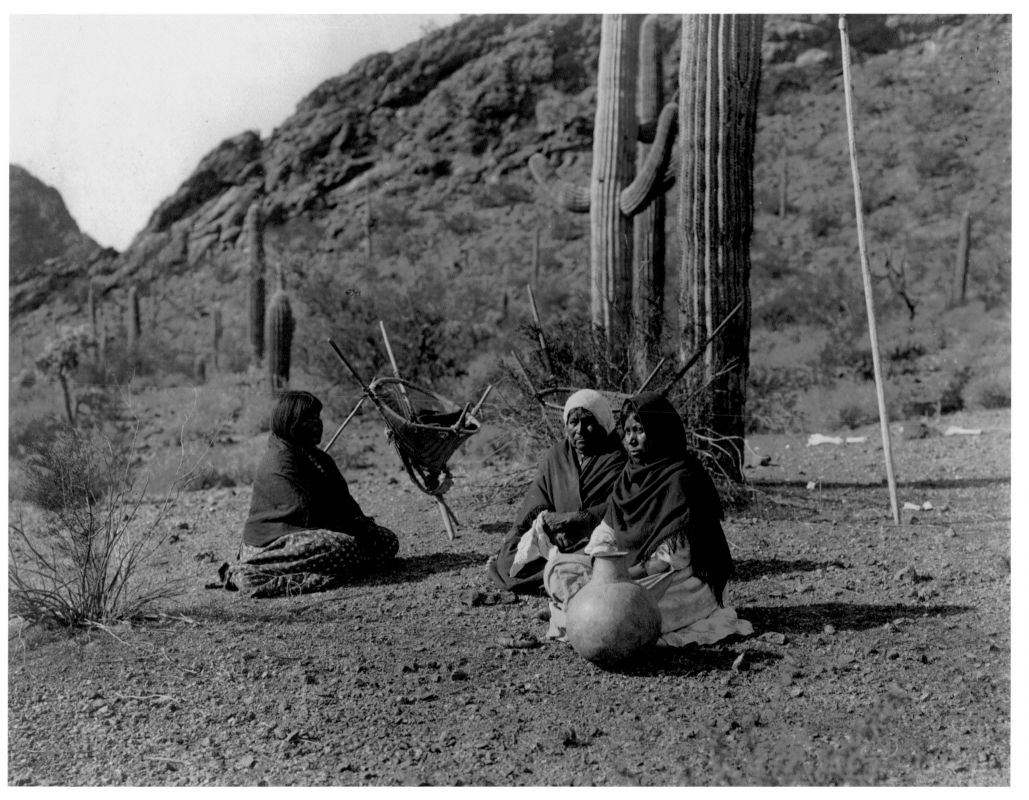

LEFT: Three Qahatika women rest while harvesting the fruit of the saguaro cacti, which they called "hasen." Curtis recorded this image while studying the tribes of the Arizona desert in 1907.
Library of Congress, Prints & Photographs Division, Edward S. Curtis Collection, LC-USZ62-115801

RIGHT: Qahatika child; c. 1907. When visited by Curtis the Qahatika lived in five small villages forty miles from the Pima reservation, but at some point in time the two tribes were one. Legends suggest that the Qahatika bands escaped into the barren desert after attacks by the Apache and stayed put.
Library of Congress, Prints & Photographs Division, Edward S. Curtis Collection, LC-USZ62-112213

FAR RIGHT: Tonovige was a Havasupai woman—a northern Arizona tribe that lived part of the year in the depths of the Grand Canyon and who were first visited by Curtis in 1903. In 1905 he personally appealed to the Commissioner of Indian Affairs to help the Havasupai, who were starving after flooding ravaged the tribe.
Library of Congress, Prints & Photographs Division, Edward S. Curtis Collection, LC-USZ62-119403

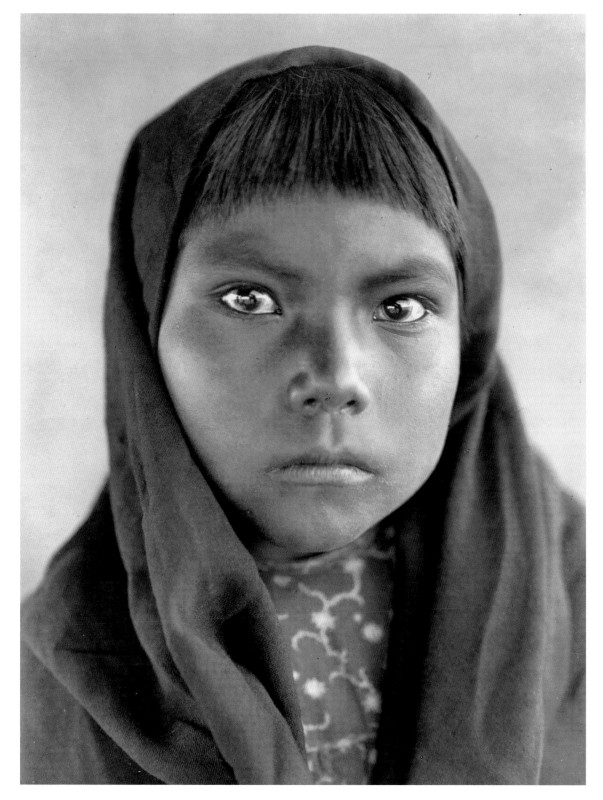

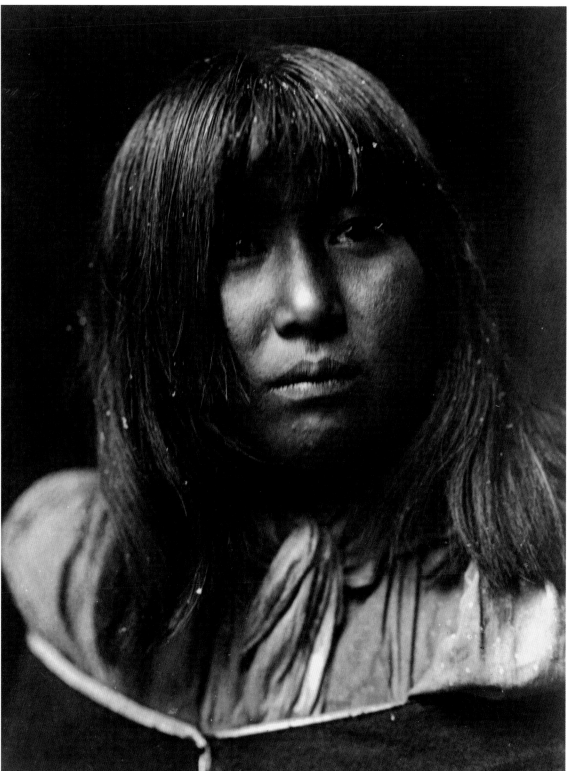

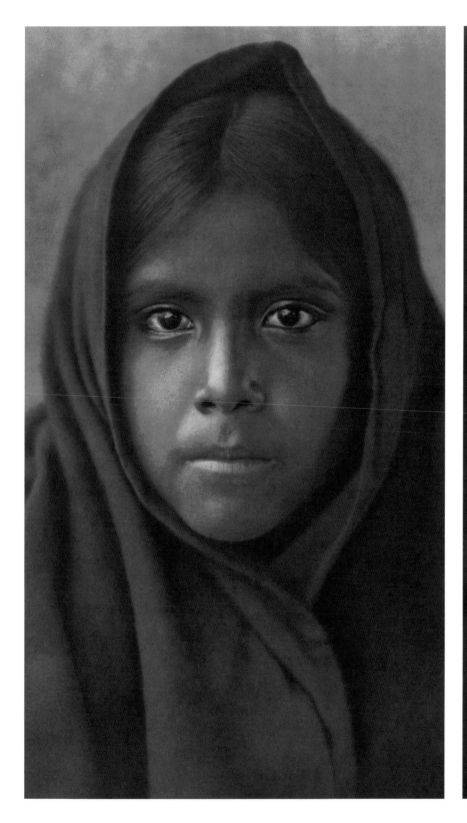

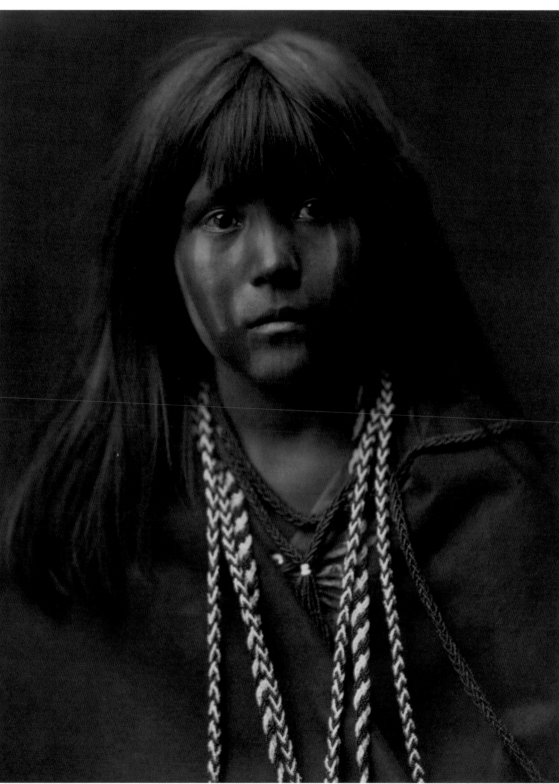

FAR LEFT: "Qahatika Girl." While he found their living conditions difficult Curtis praised the Qahatika handicraft, particularly their pottery. *Christie's Images/Corbis*

LEFT: About this portrait of Mosa Curtis wrote, "It would be difficult to conceive of a more aboriginal than this Mohave girl. Her eyes are those of the fawn of the forest, questioning the strange things of civilization upon which it gazes for the first time. She is such a type as Father Garces may have viewed on his journey through the Mohave country in 1776." *Corbis*

RIGHT: This photograph shows a Mohave potter. Curtis didn't think much of the Mohave pottery— "inferior pottery decorated in rude convention al patterns"— but he was impressed by the Mohaje's skilful beadwork. *Corbis*

FAR RIGHT: Curtis noted that this image showed, "A representative Pima matron of middle age." The photograph was taken in 1907. *Corbis*

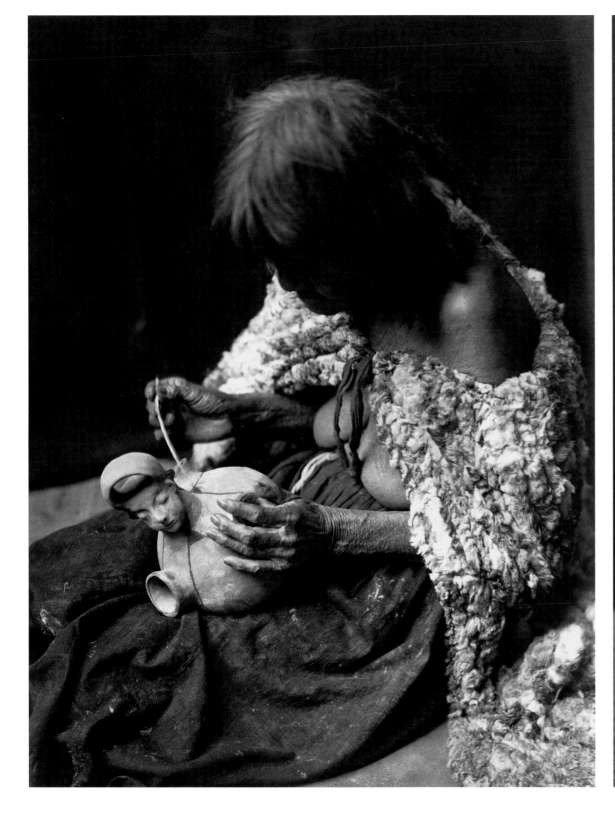

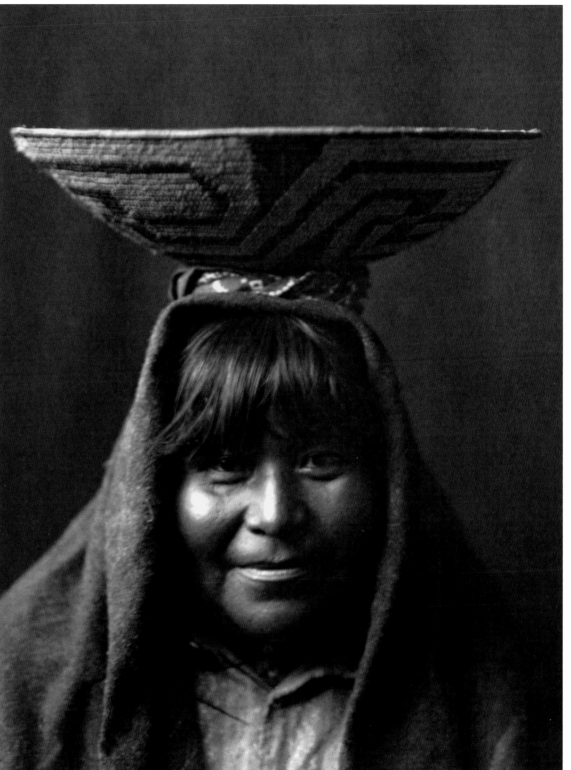

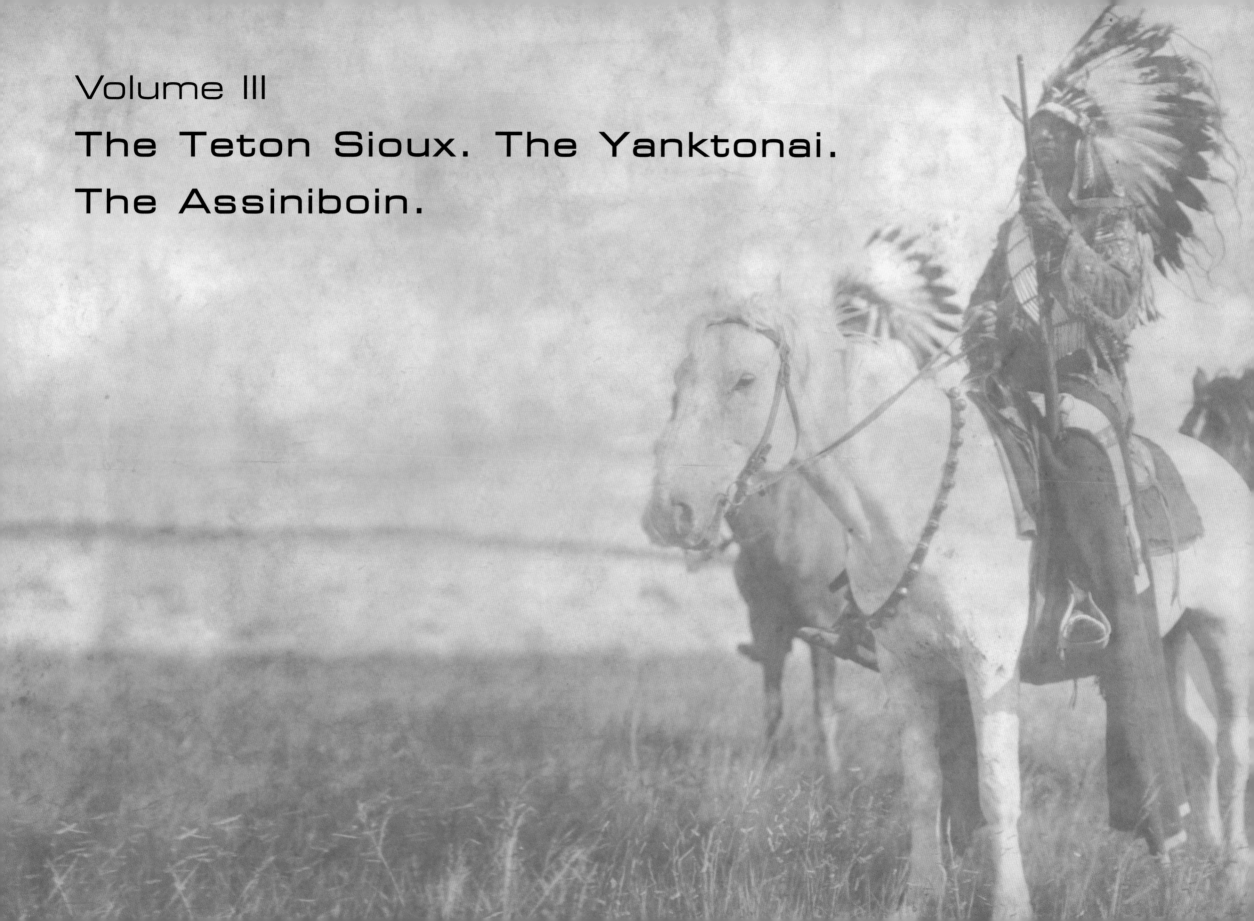

Volume III
The Teton Sioux. The Yanktonai.
The Assiniboin.

For this volume, Curtis turned his attention to the northern plains, publishing information and photographs gathered in 1905, 1907, and 1908. The vast majority of this book was devoted to the Teton, or Western, Sioux—people who were once bison-hunting, tipi-dwelling mounted warriors and on whom America's homogenized, stereotyped view of its native people was largely based.

The Teton Sioux actually consisted of seven different bands and Curtis or his assistants spent time with all of them. Sadly, the Sioux had fallen on hard times compared to their days as the country's most-feared tribe. Curtis found a desperate, impoverished people still reeling from the 1890 massacre at Wounded Knee. Despite their mean condition, the still-proud Sioux recreated battle scenes for the photographer to capture on glass plate.

The Yanktonai were a Middle Sioux tribe that lived along the border of North Dakota and South Dakota. The Assiniboin had once been a large band of Yanktonai, but had broken away sometime in the 1600s, eventually moving to what is now Saskatchewan. By the time Curtis visited them, the tribe was relatively small, its numbers decimated in the early nineteenth century by smallpox.

"Sioux Chiefs." Volume III concentrates on the Teton and Yanktonai Sioux—two of seven closely related tribes (Mdewakanton, Wahpekute, Wahpeton, Sisseton, Yankton, Yanktonai, and Teton) that made up the Sioux or Dakota. When first mentioned by the early white explorers in the mid-seventeenth century all seven tribes lived within what is now the southern half of the state of Minnesota. *Corbis*

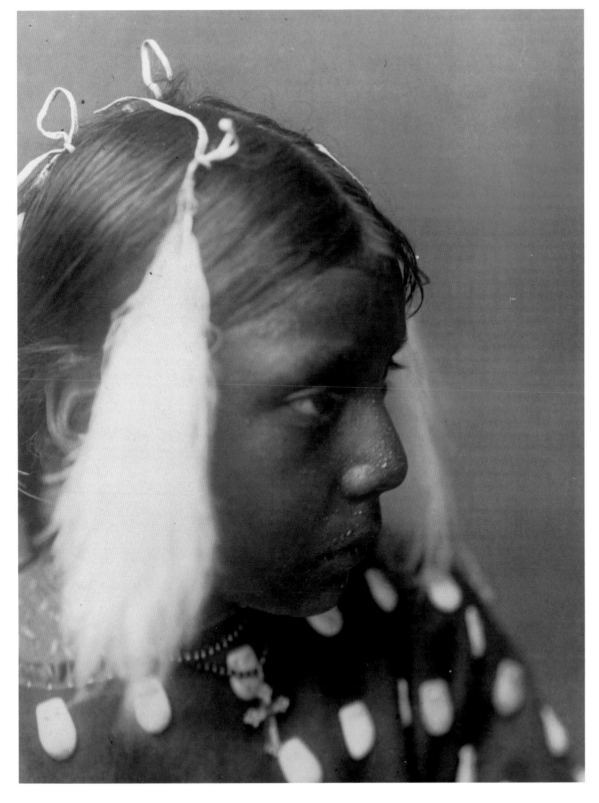

FAR LEFT: Head-and-shoulders portrait, right profile, of Red Cloud's granddaughter—Woman of Many Deeds; c. 1907. At the treaty of Fort Laramie in 1868, Chief Red Cloud demanded that white men should be kept out of their country—that the Great Sioux Reservation, the whole of present South Dakota west of the Missouri—be reserved exclusively for Sioux use. This held until 1874 when gold was discovered in the Black Hills, traditionally a sacred area, leading to a series of bitter conflicts which climaxed in the defeat of Custer's command in June 1876 on the Little Bighorn River, Montana, and the ultimate surrender of Crazy Horse in 1877 and Sitting Bull in 1881.
Library of Congress, Prints & Photographs Division, Edward S. Curtis Collection, LC-USZ62-115800

LEFT: Two daughters of a chief on horseback, riding away from camera toward tents in background; c. 1907.
Library of Congress, Prints & Photographs Division, Edward S. Curtis Collection, LC-USZ62-106269

RIGHT: "Entering the Bad Lands." Three Sioux Indians on horseback; c. 1905.
Library of Congress, Prints & Photographs Division, Edward S. Curtis Collection, LC-USZ62-107913

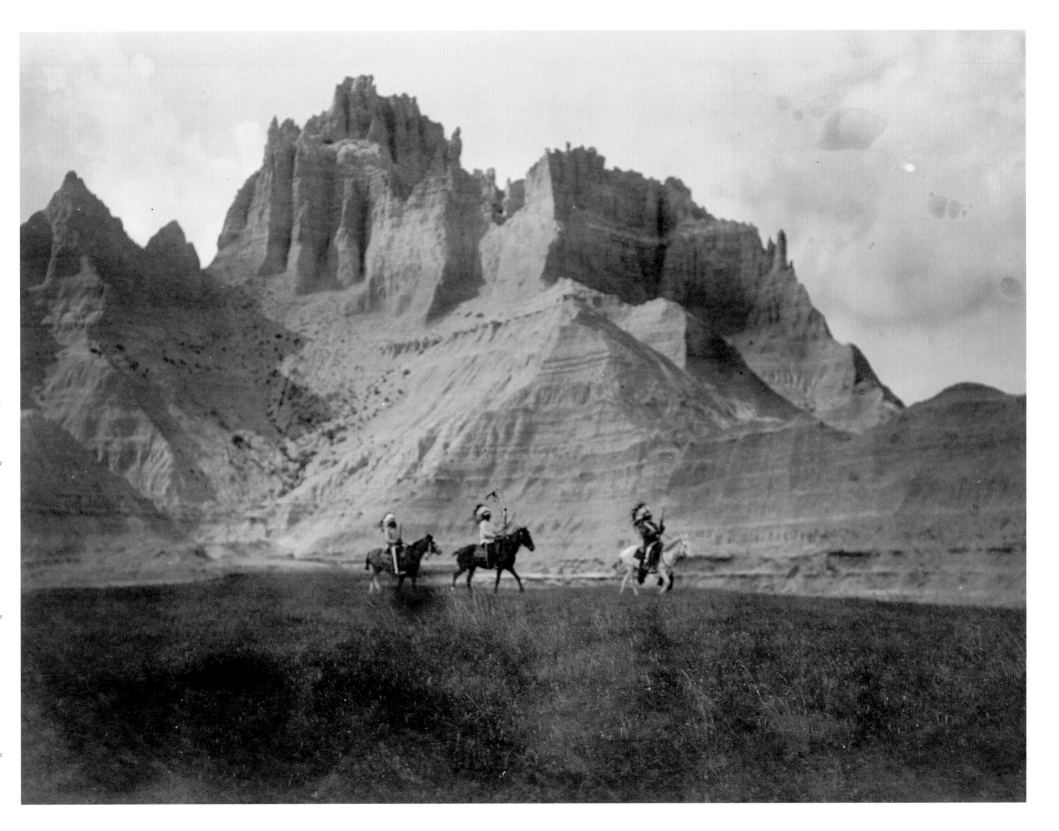

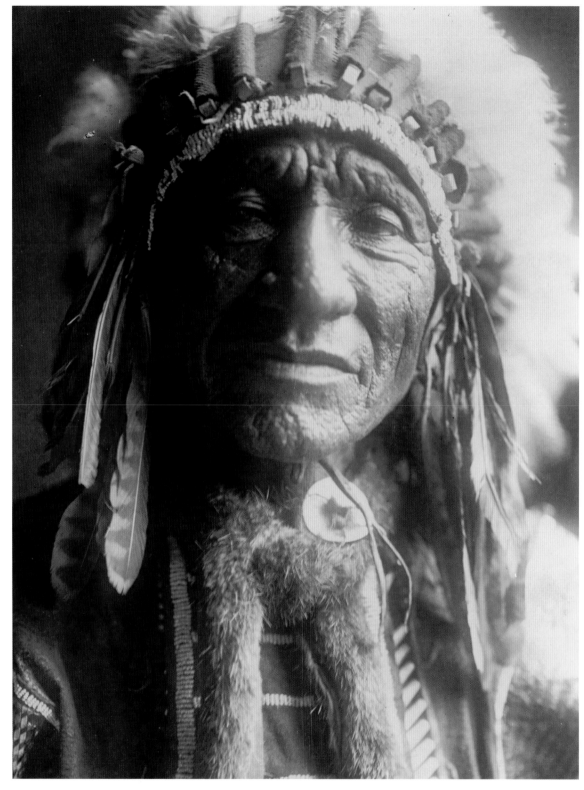

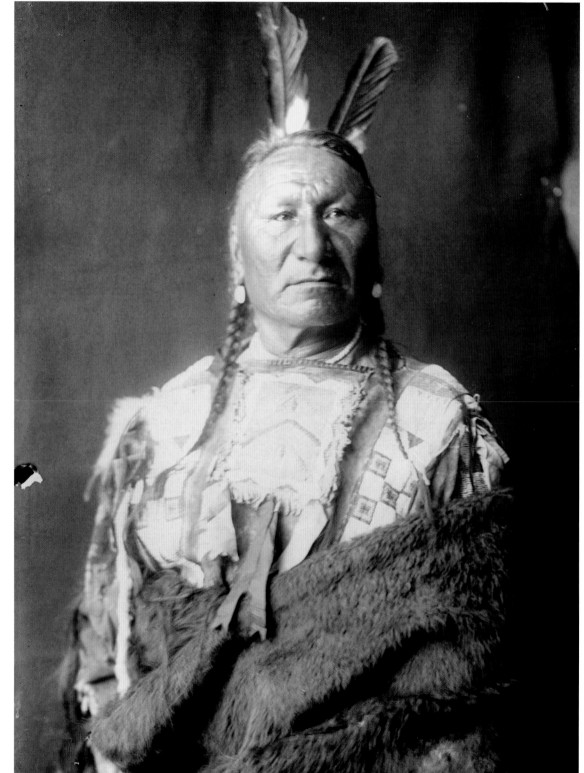

FAR LEFT: Curtis found the Sioux living in terrible poverty on their South Dakota reservation, but they were still a proud people. Men like Red Dog (*Shunka Luta*), were pleased to be able to don traditional garb and relive the tribe's better days.
Library of Congress, Prints & Photographs Division, Edward S. Curtis Collection, LC-USZ62-112246

LEFT : Yellow Horse, a Yanktonai, wears the tribe's traditional long braids, eagle feathers in his hair, and buffalo skin wrap. The more dominant of the two Nakota branches of the Sioux, speaking the same dialect as the Yankton, the Yanktonai took part in the War of 1812 on the side of Great Britain, took no part in the Minnesota War of 1862, and made peace treaties with the U.S. in 1865.
Library of Congress, Prints & Photographs Division, Edward S. Curtis Collection, LC-USZ62-114840

RIGHT: Curtis wrote at length in Volume III about the Sioux Foster Parent Chant ceremony—the Huka-lowa-pi—that he photographed in 1907. Here the "Work-do" (worker) removes the covering from the buffalo skull used in the ceremony, often performed when a child had a near-death experience.
Library of Congress, Prints & Photographs Division, Edward S. Curtis Collection, LC-USZ62-106270

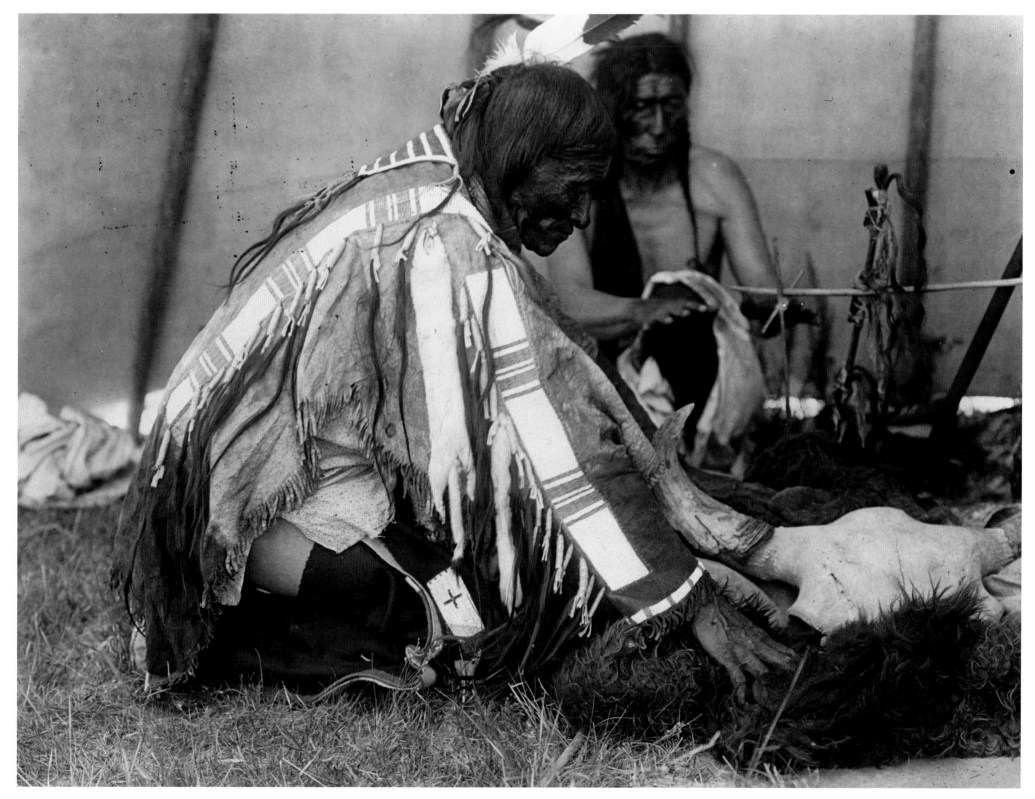

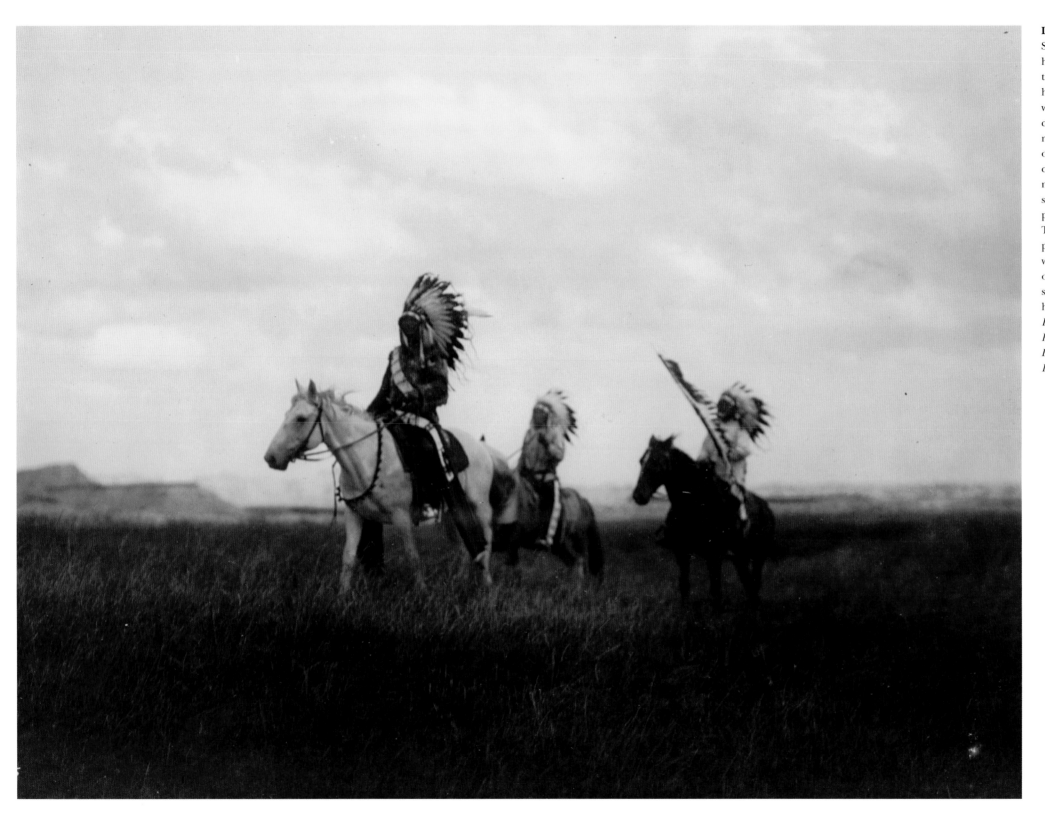

LEFT: "The march of the Sioux"—Three Sioux on horseback recall the tribe's legacy as some of history's greatest mounted warriors. Curtis was able to coax the Sioux into reenacting their glory days of the late nineteenth century; they even mustered war parties to stage mock attacks for the photographer's benefit. They were also a stubborn people, who even bickered with him over the amount of beef he planned to serve at a feast in their honor.
Library of Congress, Prints & Photographs Division, Edward S. Curtis Collection, LC-USZ62-105380

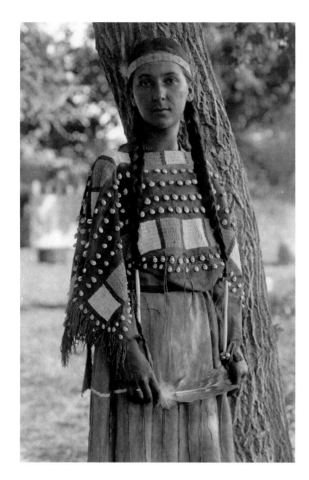

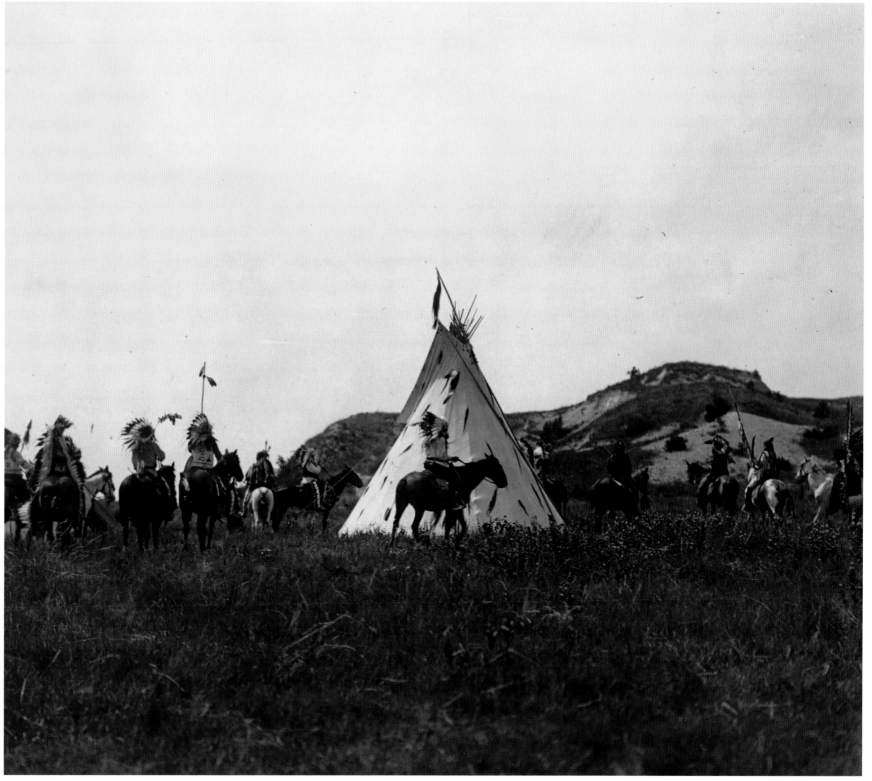

ABOVE: Sioux maiden—note beaded headband and beaded buckskin dress; c. 1908. Many of the Sioux tribes were expert at ribbonwork and beadwork. *Library of Congress, Prints & Photographs Division, Edward S. Curtis Collection, LC-USZ62-106267*

RIGHT: War preparation—Several Sioux men on horseback gather outside a tipi; c. 1907. The Western Sioux had an elaborate system of warrior societies, including the akicita or soldiers, Kit Foxes, Crow Owners (referring to a special type of dance bustle), Strong Hearts (famous for their unique ermine skin horned headdresses worn in battle). These societies often fought as a unit whenever possible. *Library of Congress, Prints & Photographs Division, Edward S. Curtis Collection, LC-USZ62-12190*

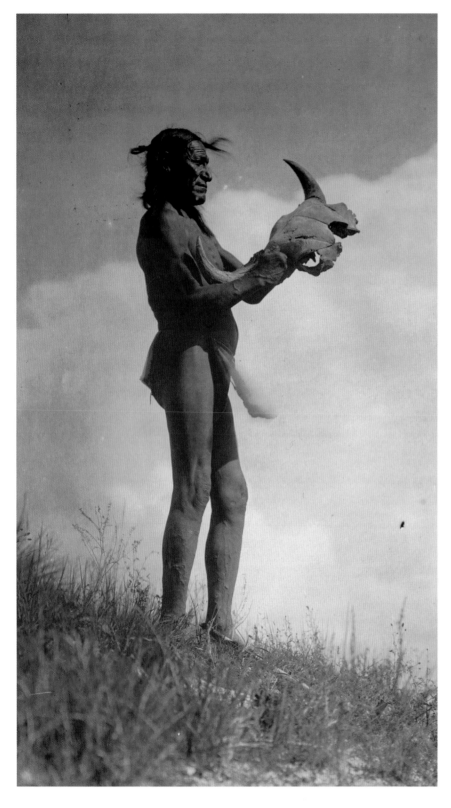

LEFT: Picket Pin, an Oglala Sioux, offers a prayer to the Great Mystery, using a buffalo skull to represent the spirit of the animal that provided food, shelter, clothing, and a point of focus to the lives of his people. Each buffalo hunt—essential to the tribe's survival—was marked by considerable ceremony, with the tribe offering numerous prayers and songs in their quest for success.
Library of Congress, Prints & Photographs Division, Edward S. Curtis Collection, LC-USZ62-112236

RIGHT: Yellow Bone Woman and her family; 1908. She is wearing horizontally strung "hairpipes"—tubular ornaments in conch shell (later in silver and brass) originally used for hair decoration (hence "hairpipes"). By the nineteenth century shell pipes were being drilled by white manufacturers in New Jersey for the Western Indian trade; after 1880 these were made from polished cattle bone. Women usually strung them vertically, men horizontally into breastplates.
Library of Congress, Prints & Photographs Division, Edward S. Curtis Collection, LC-USZ62-101183

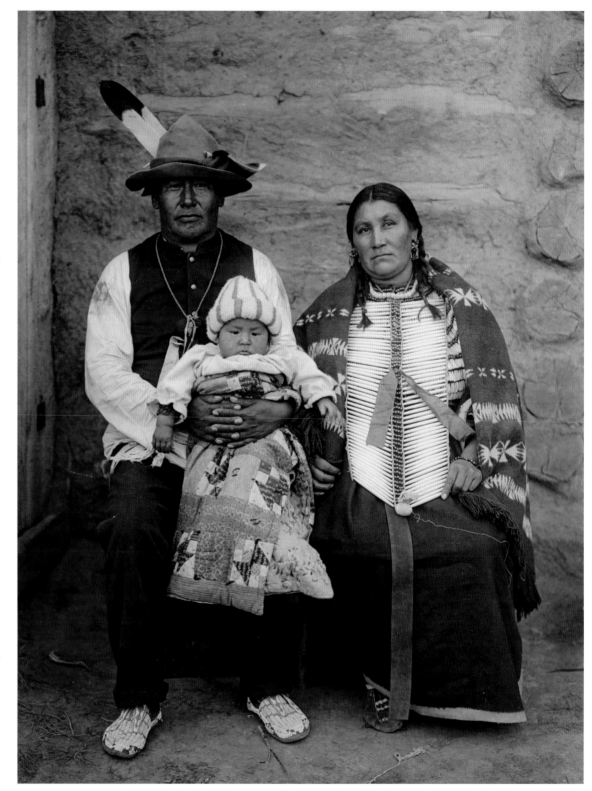

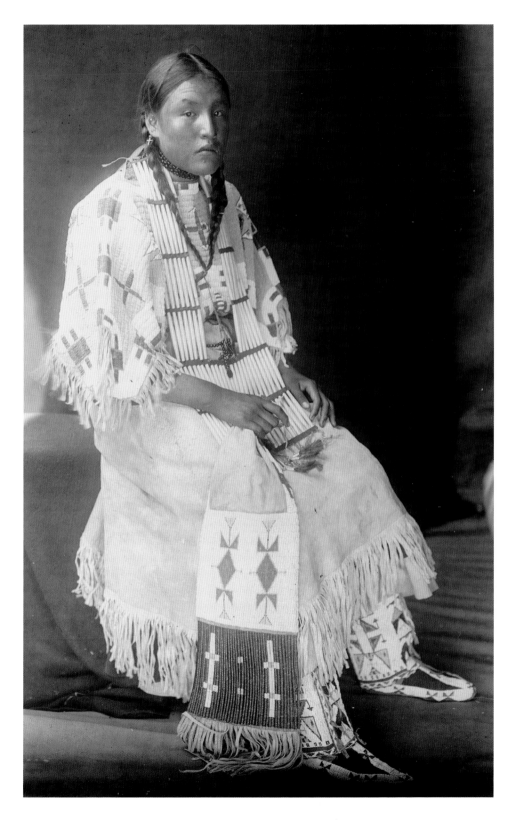

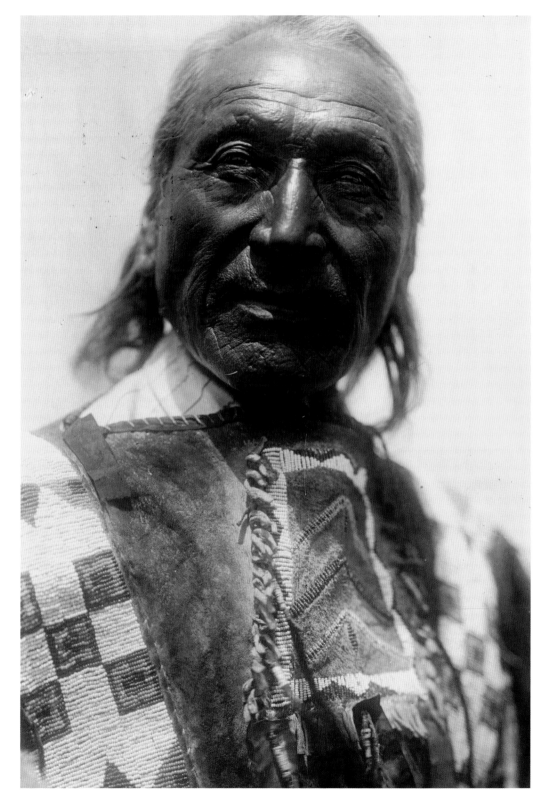

LEFT: Red Elk Woman, a Sioux girl, in a deerskin, embroidered and beaded dress, c. 1907. Curtis described Sioux women as "sunny and full of cheer" and though life in a nomadic hunting tribe was not easy, he felt that these physically and emotionally strong females were well prepared for the task.
Library of Congress, Prints & Photographs Division, Edward S. Curtis Collection, LC-USZ62-110502

RIGHT: This Oglala man named He Crow was photographed in 1907.
Library of Congress, Prints & Photographs Division, Edward S. Curtis Collection, LC-USZ62-121688

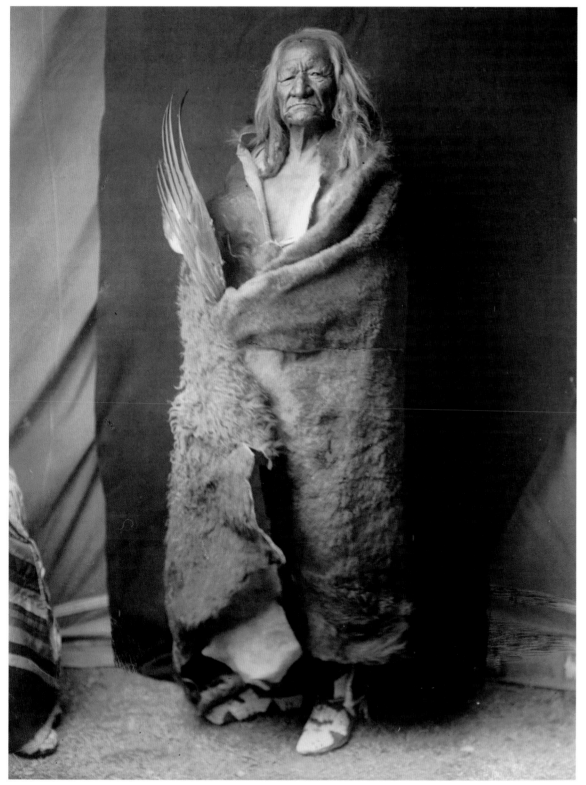

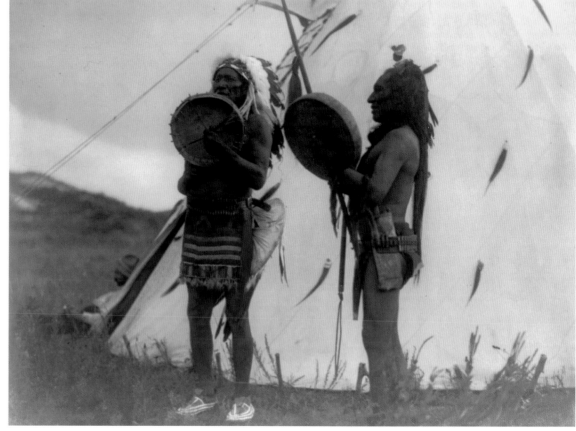

LEFT: Black Eagle—an Assiniboin, wearing buffalo hide, holding the wing of a bird; c. 1908. In the seventeenth century the Assiniboin are said to have divided from the Yanktonai and moved to Canada; they still refer to themselves as Nakoda, but are now considered as a separate people. Curtis gives details of Black Eagle's life: born 1834, he went to war at thirteen and gained honors in later battles with the Yanktonai and Atsina, capturing horses and killing enemies. He married at eighteen. *Library of Congress, Prints & Photographs Division, Edward S. Curtis Collection, LC-USZ62-105371*

ABOVE: Another image of the Huka-lowa-pi ceremony. "Singing deeds of valor"—two Dakota men playing hand drums outside a tipi; c. 1908. *Library of Congress, Prints & Photographs Division, Edward S. Curtis Collection, LC-USZ62-46980*

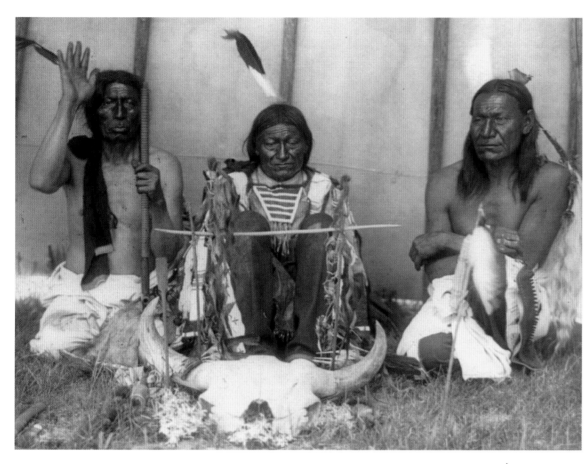

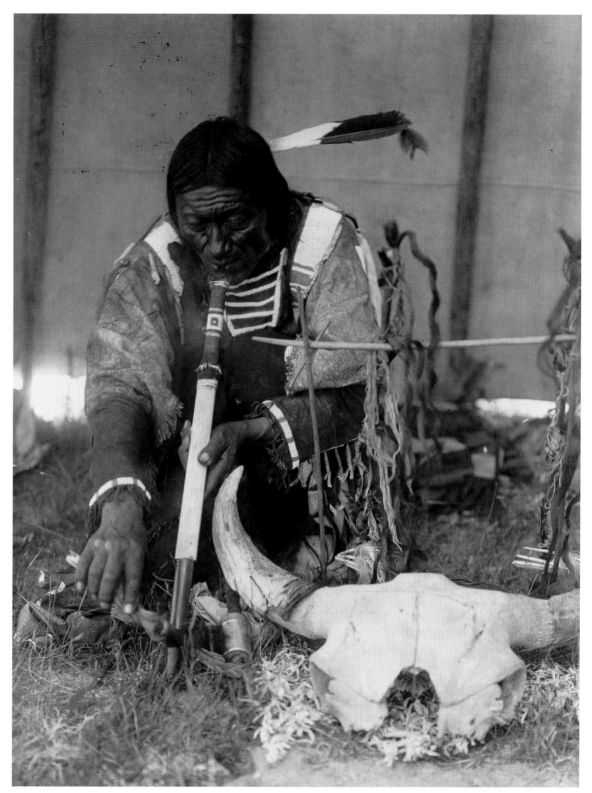

ABOVE: Another image of the Huka-lowa-pi ceremony. Here, Slow Bull, Saliva, and Picket Pin kneel with a bison skull and altar.
Library of Congress, Prints & Photographs Division, Edward S. Curtis Collection, LC-USZ62-97084

RIGHT: Saliva lights up the calumet—a smoking pipe made from pipestone— kneeling by altar inside the tipi. Pipestone quarries are preserved in the Pipestone National Monument in Minnesota.
Library of Congress, Prints & Photographs Division, Edward S. Curtis Collection, LC-USZ62-112247

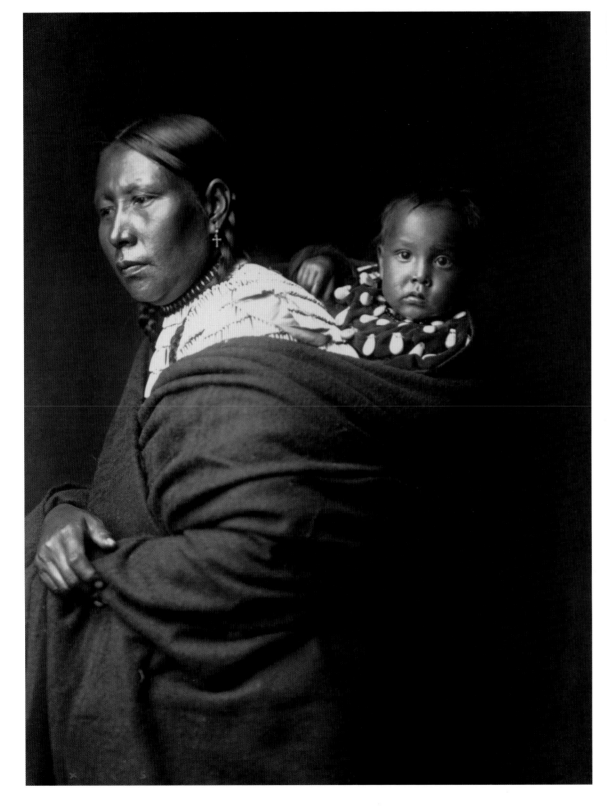

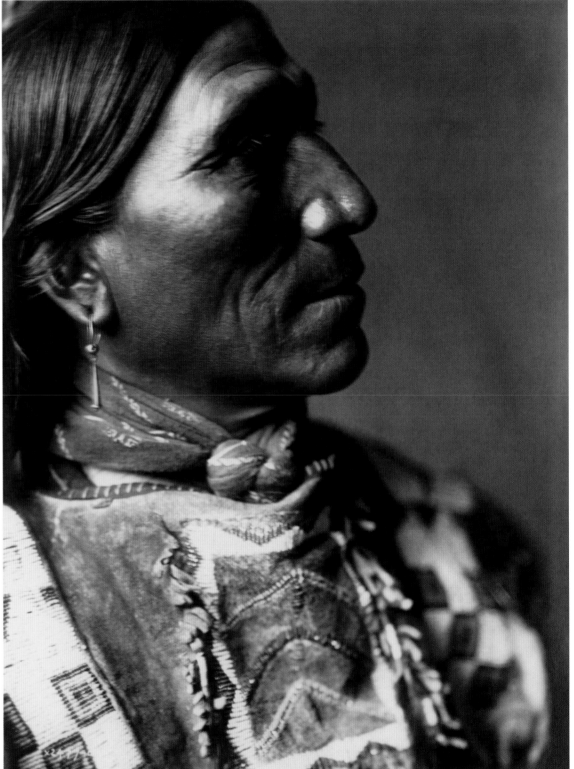

FAR LEFT: A Sioux mother and child. *Corbis*

LEFT: Little Hawk. Curtis thought this portrait showed typical Brule physiognomy. The Brule are a subtribe of the Tetons, mentioned by Lewis and Clark, and split into two reservations— Rosebud and Lower Brule. *Corbis*

RIGHT: "Planning a Raid." Curtis thought the Indians, in their striking and characteristic costumes, unconsciously formed themselves into most picturesque groups. This shows a party of Oglala Sioux on a hill overlooking the valley of Wounded Knee creek, on the Pine Ridge reservation in South Dakota. They were only too happy to reenact a war party for Curtis's camera. It was at Wounded Knee in 1890 that a massacre of Indian people took place—the last significant military engagement between whites and Indians. *Corbis*

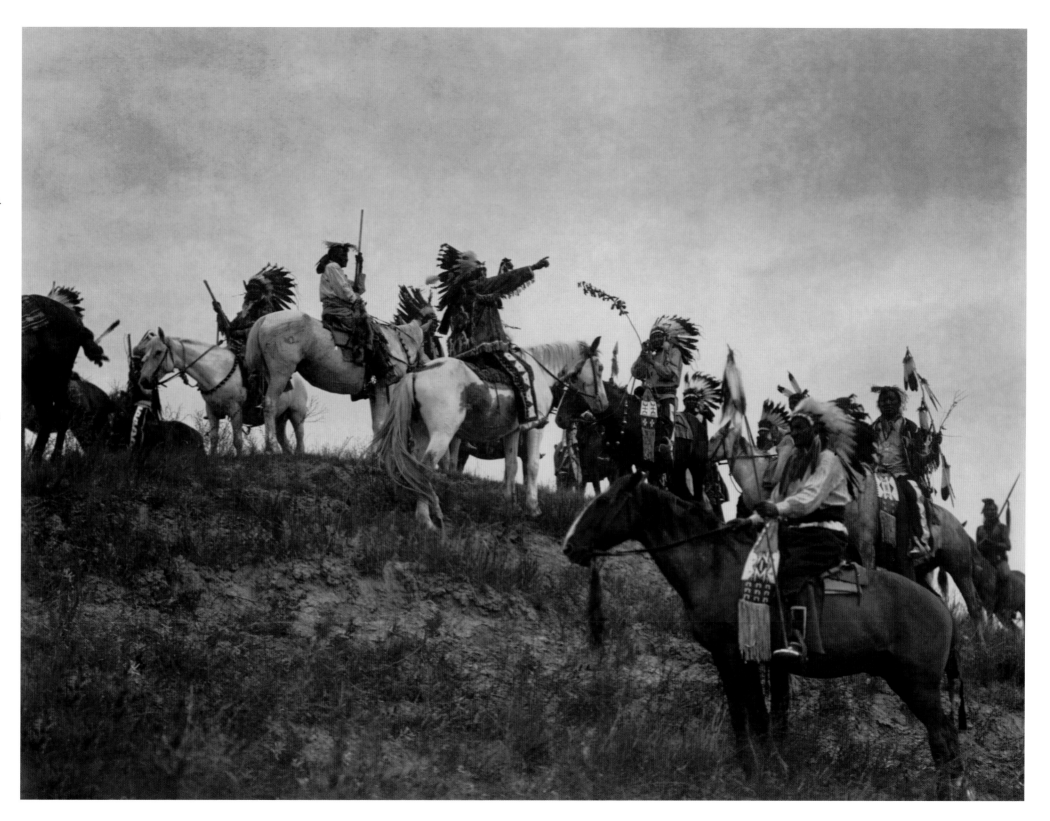

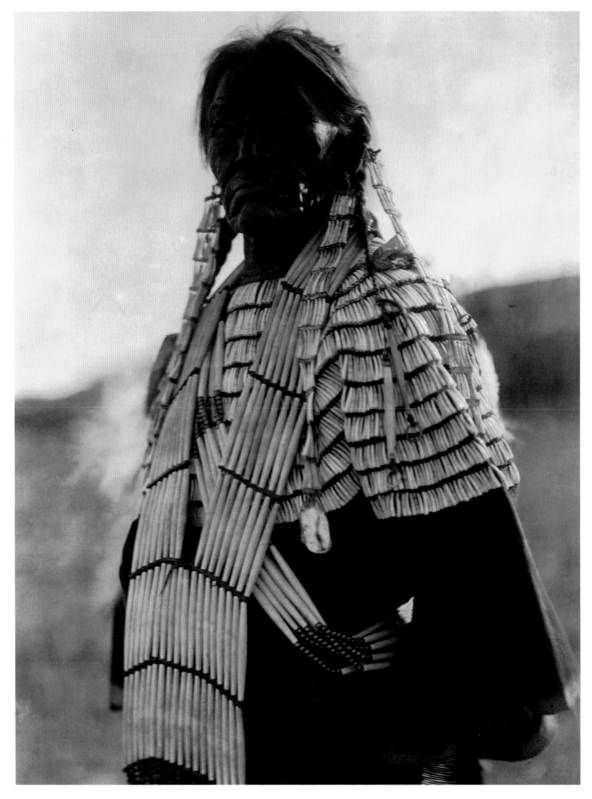

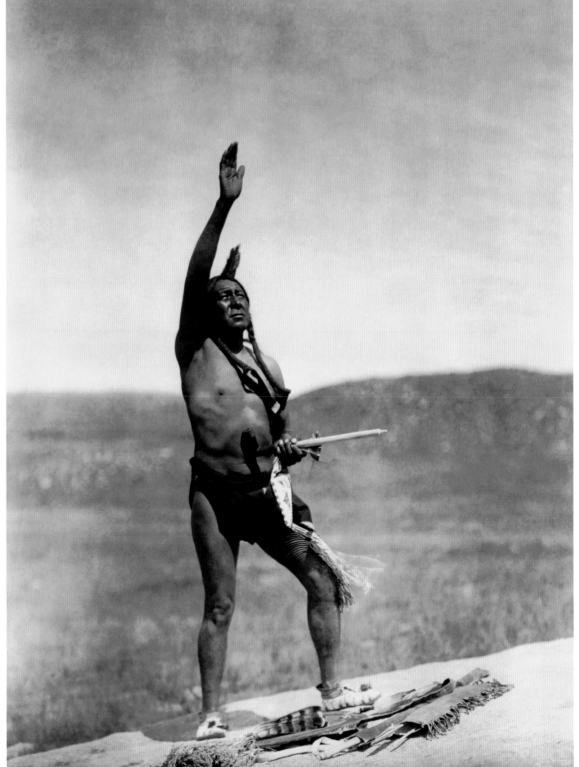

FAR LEFT: Slow Bull's wife wears a bone hairpipe necklace and a dress adorned with shells. Slow Bull was an Oglala Sioux born in 1844 who became a subchief in 1878. Curtis provided a short biography of him in Volume III. *Corbis*

LEFT: "Invocation—Sioux." Curtis said that spots that are virtually shrines were scattered throughout the Indian country. Often boulders or other rocks which through some chance have been invested with mythic significance, and to them priest and war-leaders repair to invoke the aid of the supernatural powers. The half-buried bowlder on which the suppliant stands is accredited with the power of revealing to the warrior the foreordained result of his projected raid. Its surface bears what the Indians call the imprint of human feet, and it is owing to this peculiarity that it became a shrine. About it the soil is almost completely worn away by the generations of suppliants who have journeyed hither for divine revelation. *Corbis*

RIGHT: "In the Bad Lands." A photograph of Sheep Mountain in the Bad Lands of Pine Ridge reservation, South Dakota, where the Oglala lived. *Corbis*

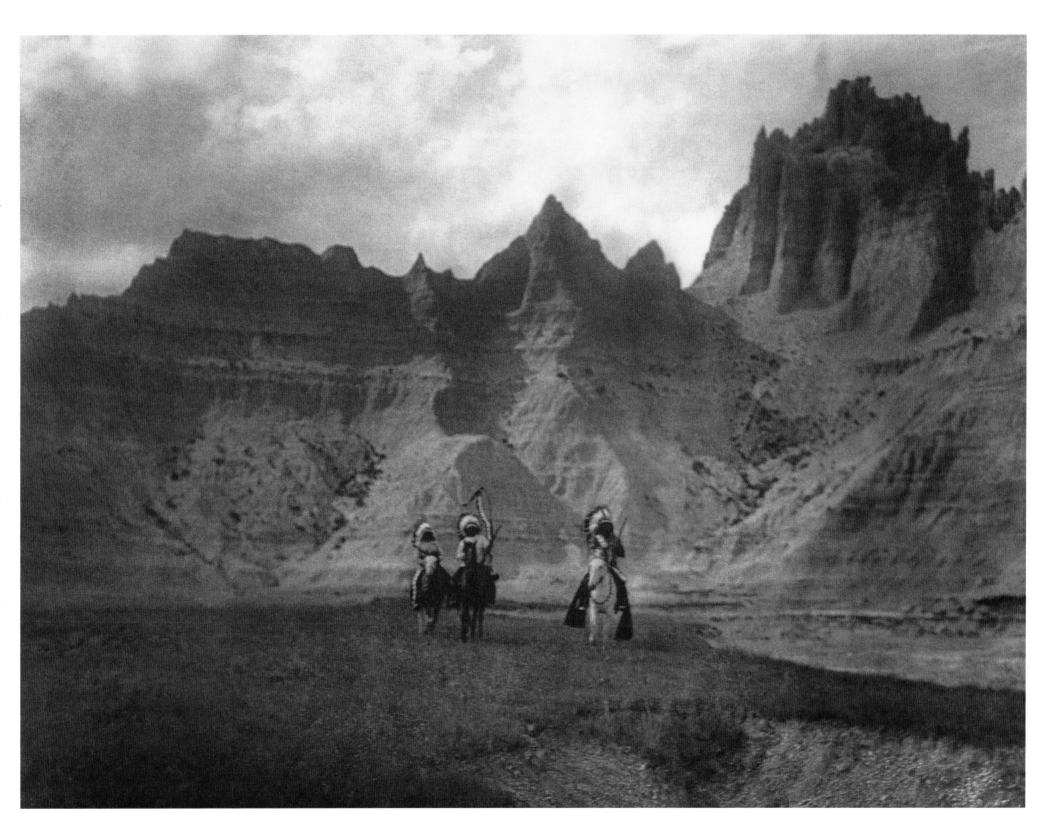

Volume IV
The Apsaroke, or Crows. The Hidatsa.

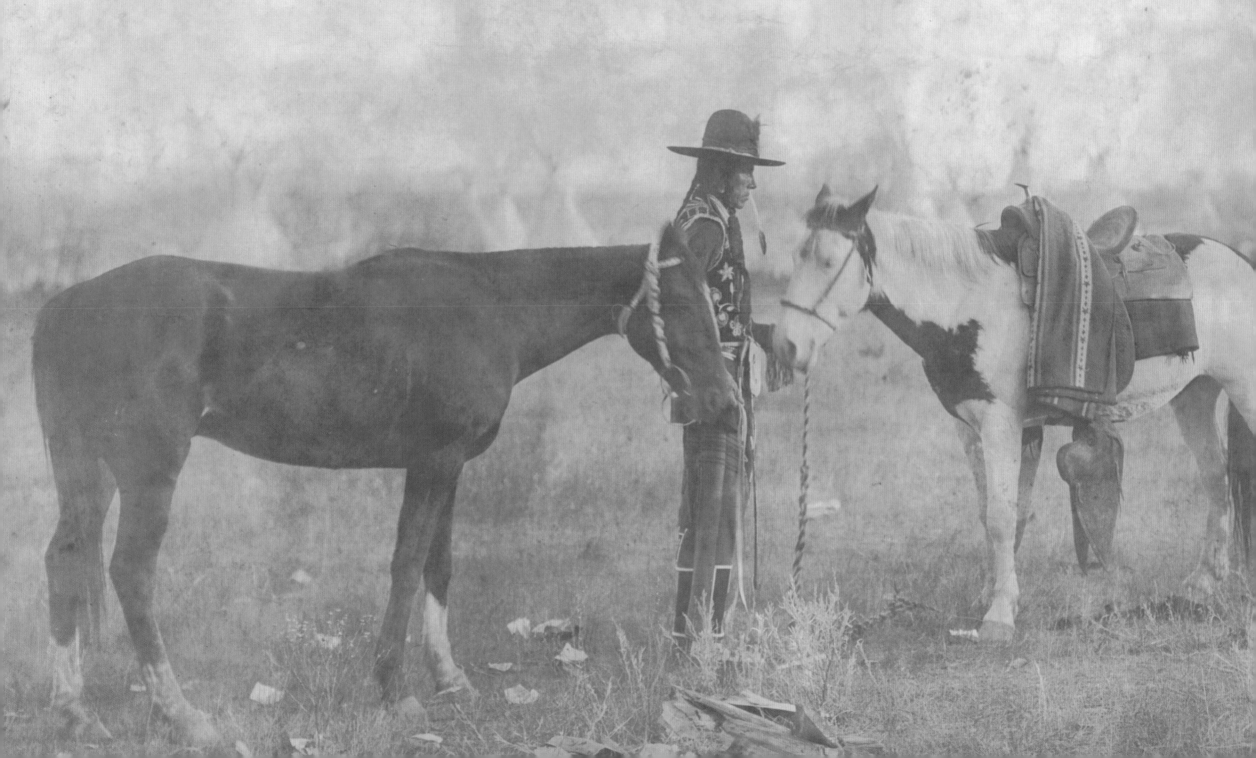

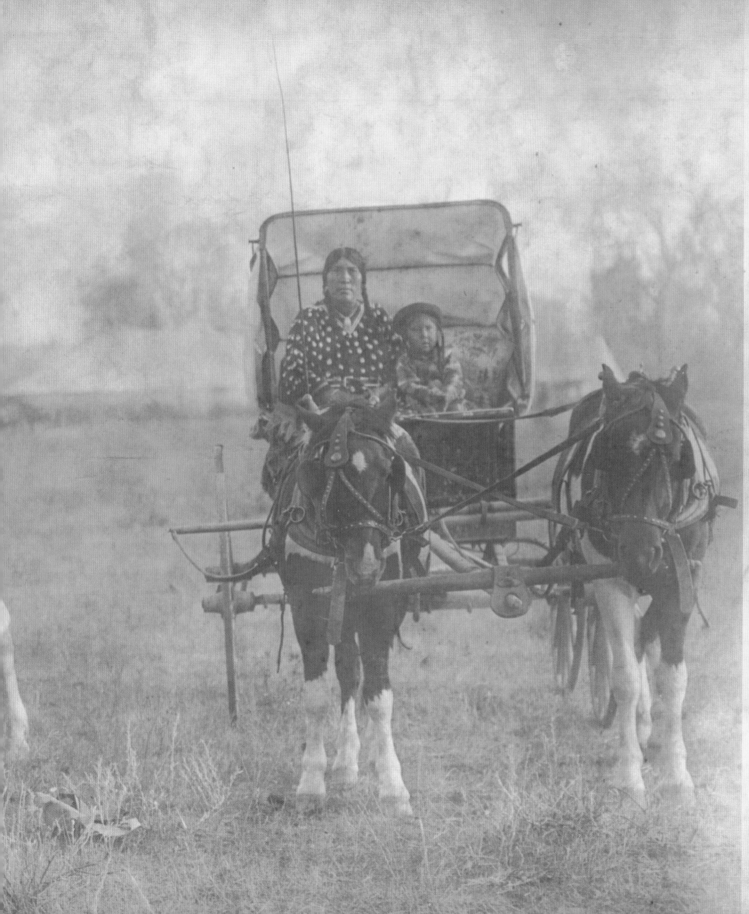

urtis stayed in the northern United States for this installment, in which he presented an interesting comparison-and-contrast study of two related but very different tribes, the Crow and the Hidatsa. The two groups had split sometime in the seventeenth century and gone on to very different existences.

In North Dakota's Hidatsa, Curtis found a tribe still living in much the way it had for many generations. The Hidatsa existed quietly along the Missouri River and, unlike other plains Indians, were not nomadic and were committed to agriculture. Like other northern plains tribes, the Hidatsa had suffered under an onslaught of smallpox that hit about seventy years before Curtis visited them.

The Crows, in contrast, had been classic bison-hunting nomads, living in the foothills and mountains of Wyoming and Montana. Unlike other tribes in the region, they had maintained relative peace with the incoming whites. Curtis owed his great success in working with the tribe largely to the efforts of one of his assistants, Alexander Upshaw, an educated Crow and former schoolteacher who had returned home and re-embraced a traditional way of living.

High Medicine Rock, a Crow, with two horses at left; Her Horse Kills with child in buggy at right; tepees and circus type tent in background, Montana; c. 1908. The Crows fared better than most Native Americans in their adaption to American culture, although they are still distinctively Indian, and hold the colorful "Crow Indian Fair" each August. They originally numbered perhaps 8,000 before smallpox reduced them.
Library of Congress, Prints & Photographs Division, Edward S. Curtis Collection,
LC-USZ62-106762

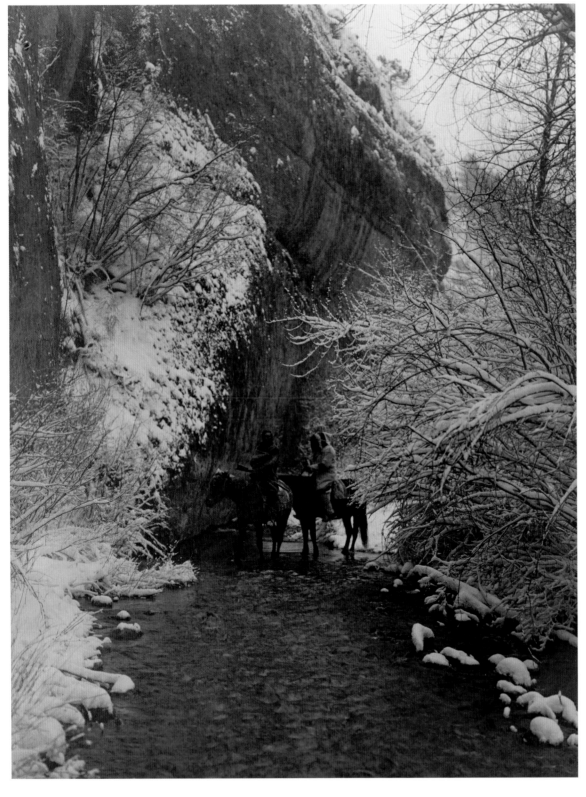

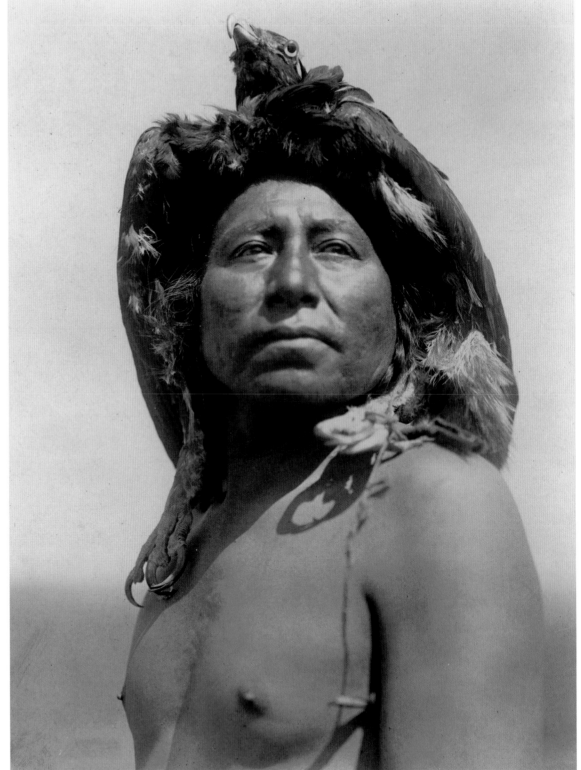

FAR LEFT: "Approaching winter." Two Crow cross a shallow stream on horseback flanked by snow-covered trees, c. 1908. The Crow split from the Hidatsa, an agricultural village people who lived in earth-covered lodges on the Missouri River, perhaps 350 years ago.
Library of Congress, Prints & Photographs Division, Edward S. Curtis Collection, LC-USZC4-120409

LEFT: This Crow medicine man wore a distinctive eagle headdress when he posed for Curtis in 1908. The artist Catlin portrayed the tribe as one of the most colorful living on the northern Plains in the 1830s.
Library of Congress, Prints & Photographs Division, Edward S. Curtis Collection, LC-USZC4-117711

RIGHT: "Apsaroke War Group," c. 1905—an ironic title for this image, which is very much a reenactment. The man on the left appears to be Alexander Upshaw, Curtis's Crow field assistant, a white-educated former schoolteacher who returned to a more traditional way of life.
Library of Congress, Prints & Photographs Division, Edward S. Curtis Collection, LC-USZ62-106887

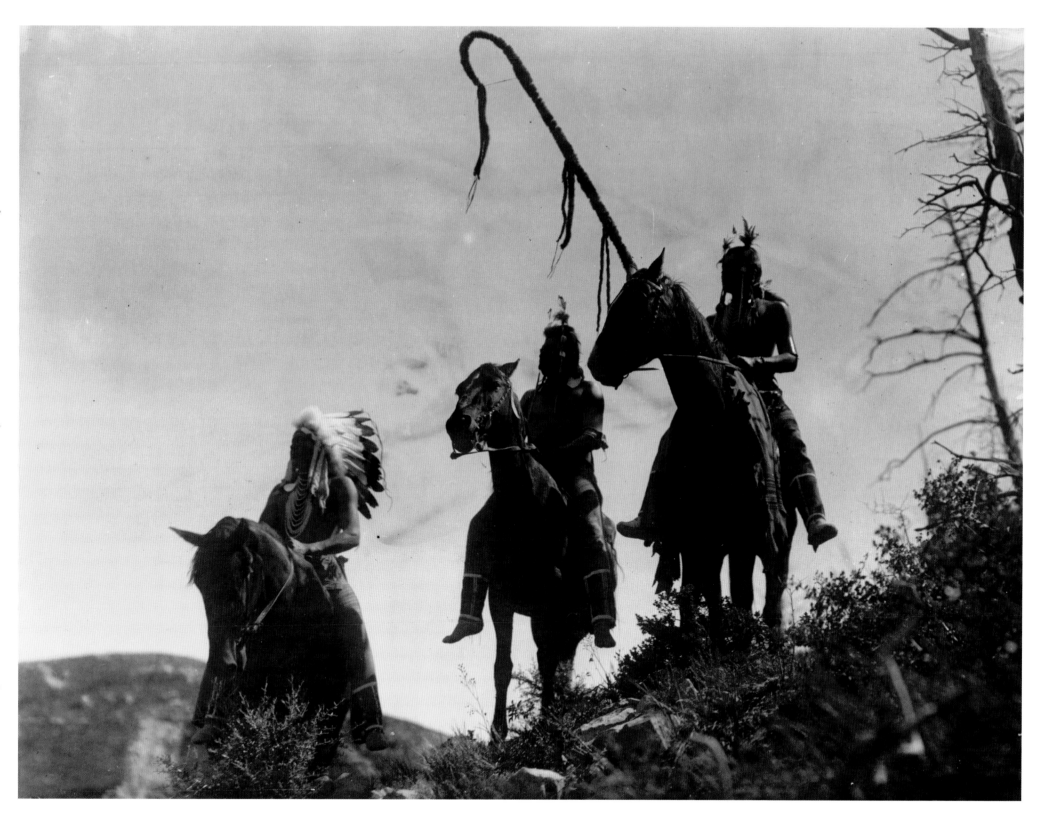

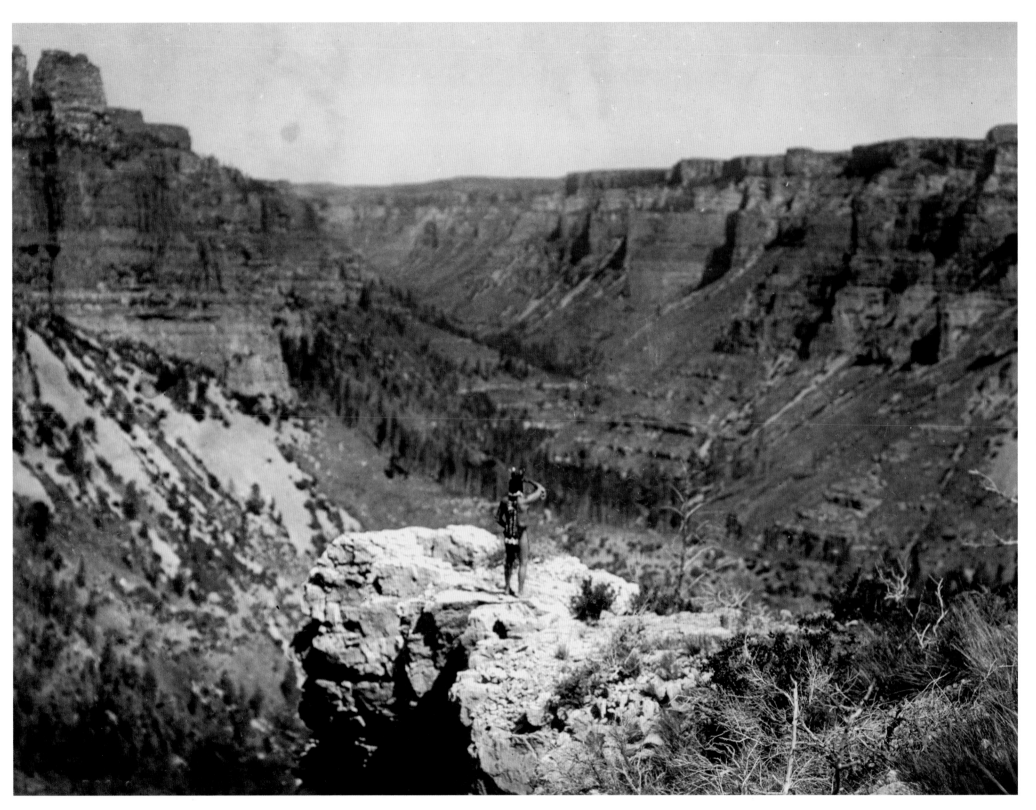

LEFT: A Crow overlooking Black Cañon; c. 1905. In time the Crow were divided into two main bands: the River Crows lived along the Missouri and Yellowstone rivers, and the Mountain Crows in the mountain valleys of southern Montana and northern Wyoming; a third, smaller band was known as "Kicked in the Bellies."
Library of Congress, Prints & Photographs Division, Edward S. Curtis Collection, LC-USZ62-110962

RIGHT: Six aging Crows in full regalia recreate a war council in 1908. In their youth, these men had been great warriors, but times had changed for the Plains tribes. As much as he respected their traditions, Curtis was convinced that the future of the Crow lay in farming and he worked with government authorities to help push the tribe toward agriculture.
Library of Congress, Prints & Photographs Division, Edward S. Curtis Collection, LC-USZ62-106884

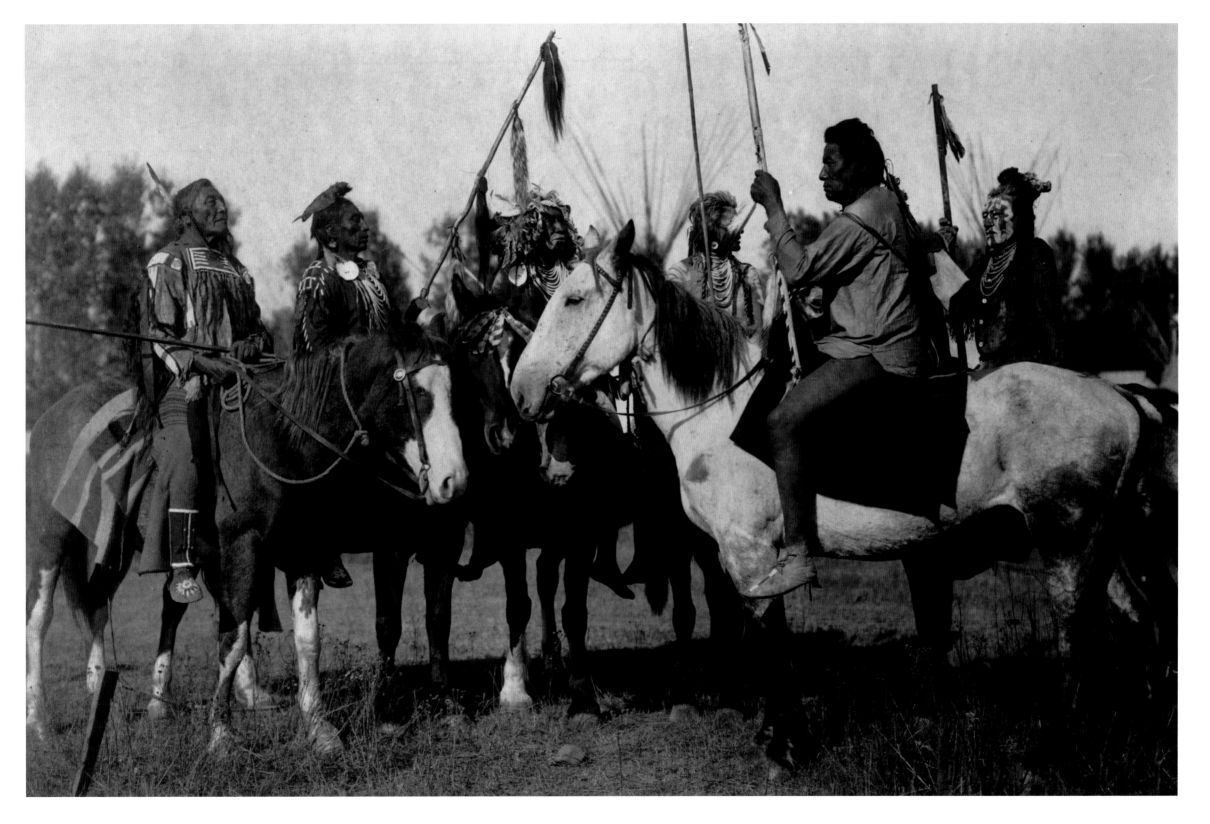

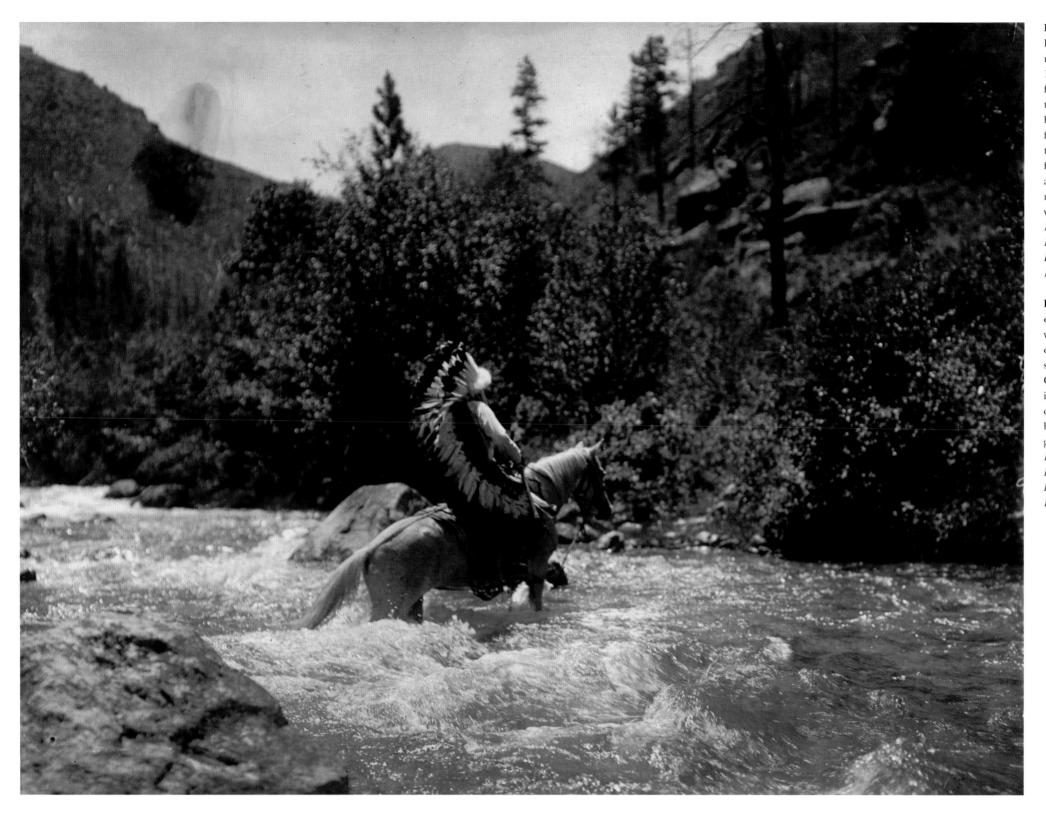

LEFT: A warbonnet-clad Bull Chief crosses shallow rapids on horseback in 1905. Curtis included a fascinating biography of this Crow leader who was born in 1825. He married fifteen times (but gave up thirteen of the wives), fathered thirteen children, and killed eight enemy men during his career as a warrior.
Library of Congress, Prints & Photographs Division, Edward S. Curtis Collection, LC-USZ62-123301

RIGHT: Mounted Crow exchange items under the watchful eye of a chief, c. 1905. Curtis spent considerable time with the Crow and the ethnographic data he compiled is considered some of the best information ever gathered on the tribe.
Library of Congress, Prints & Photographs Division, Edward S. Curtis Collection, LC-USZ62-130201

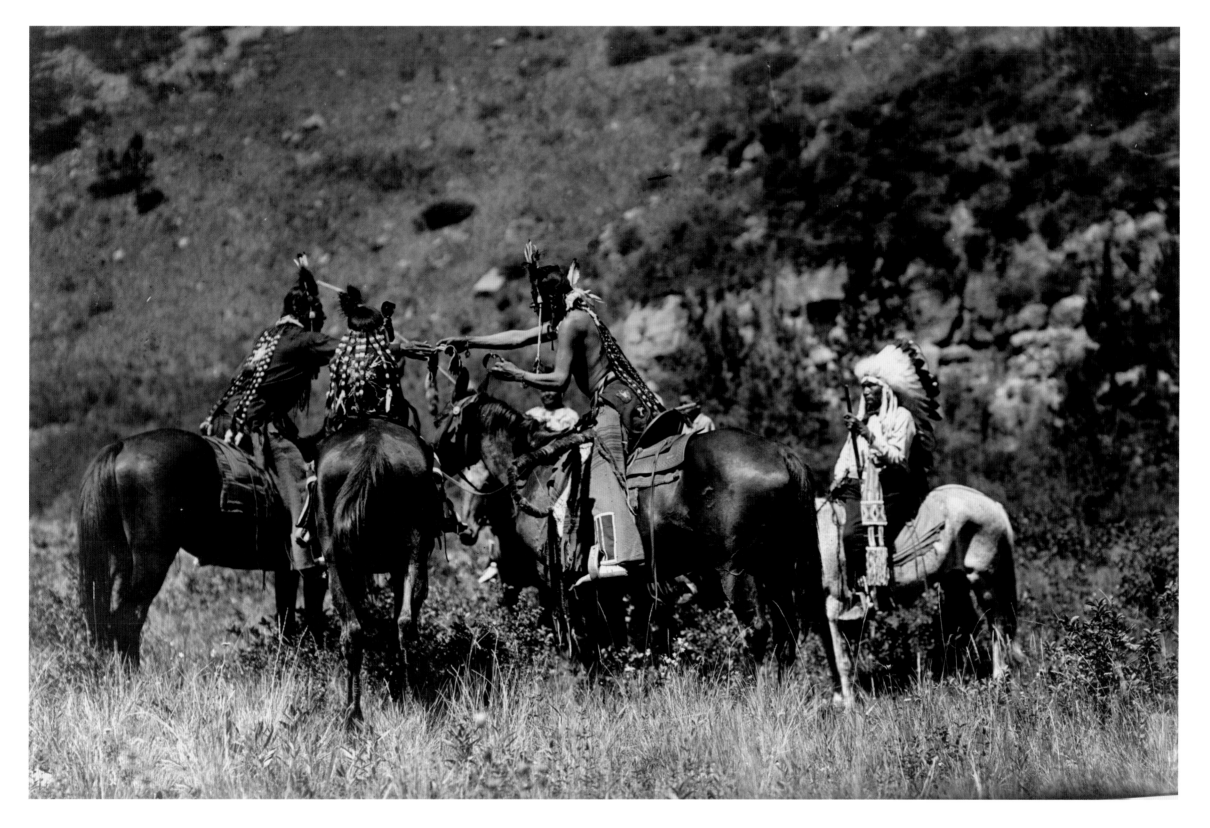

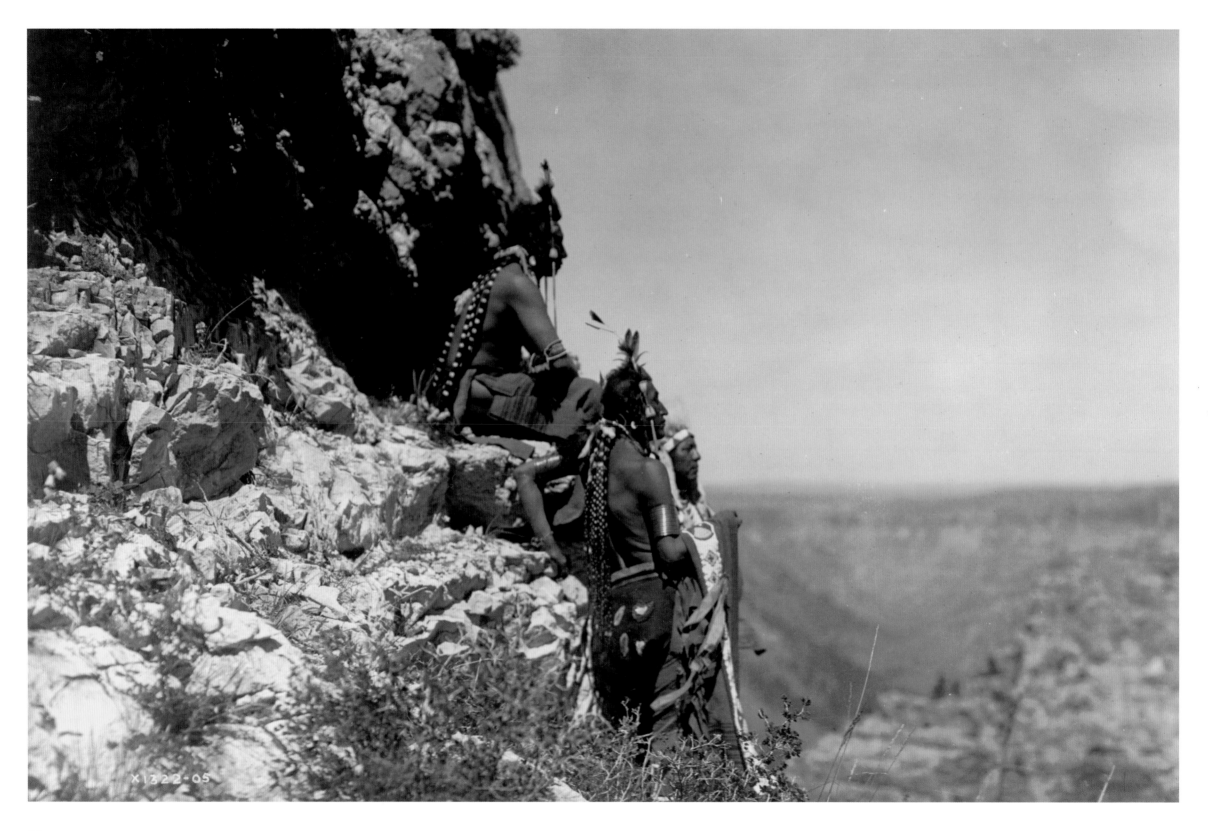

X1322-05

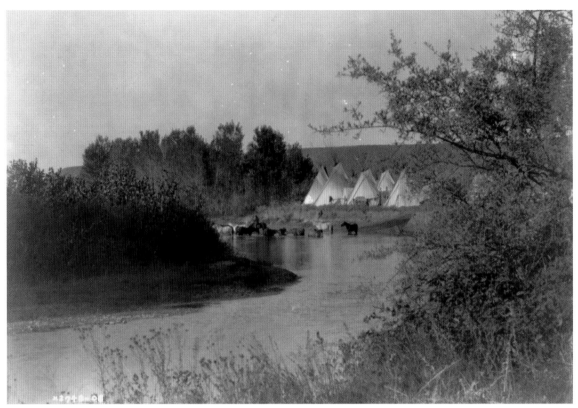

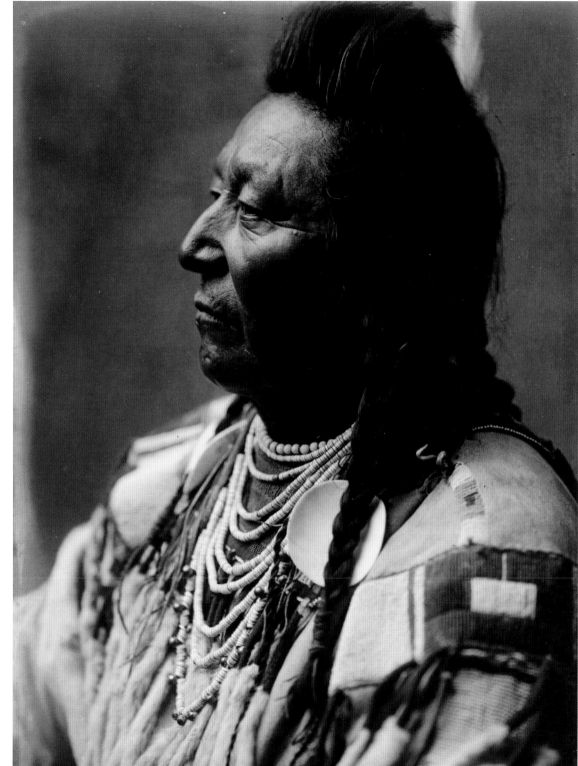

LEFT: "Rigid and statuesque"—Three Crow, including Alexander Upshaw (on right), perched on a rock ledge, c. 1905. After completing his work with the Crow, Curtis maintained contact with Upshaw, even assisting in his former employee's effort to prevent the government from leasing Crow land out for cattle grazing. *Library of Congress, Prints & Photographs Division, LC-USZ62-123304*

ABOVE: A Crow encampment along the Little Bighorn on July 6, 1908. Crow were present in 1876 at the battlefield bearing the same name, with several working as scouts for Custer. Curtis hired three of these men for a 1907 tour of the battlefield, in the process learning much about the event from Custer's viewpoint. *Library of Congress, Prints & Photographs Division, LC-USZ62-46972*

RIGHT: Head-and-shoulders portrait of Plenty Coups, a Crow, with a pompadour, temple braids, beaded buckskin shirt, shell beads around neck; c. 1908. The Crow also developed their own styles of ceremonial costumes, with dyed porcupine quillwork and later beadwork decoration of unique composition. *Library of Congress, Prints & Photographs Division, Edward S. Curtis Collection, LC-USZC4-109715*

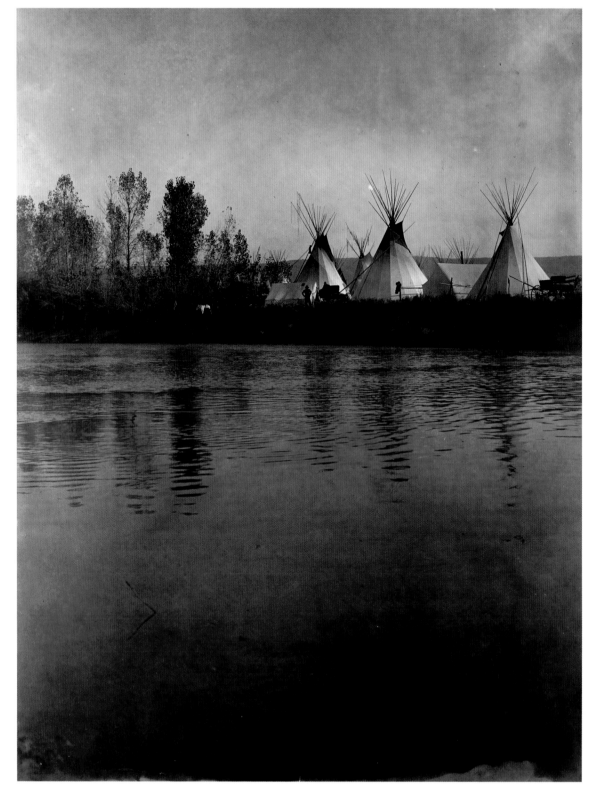
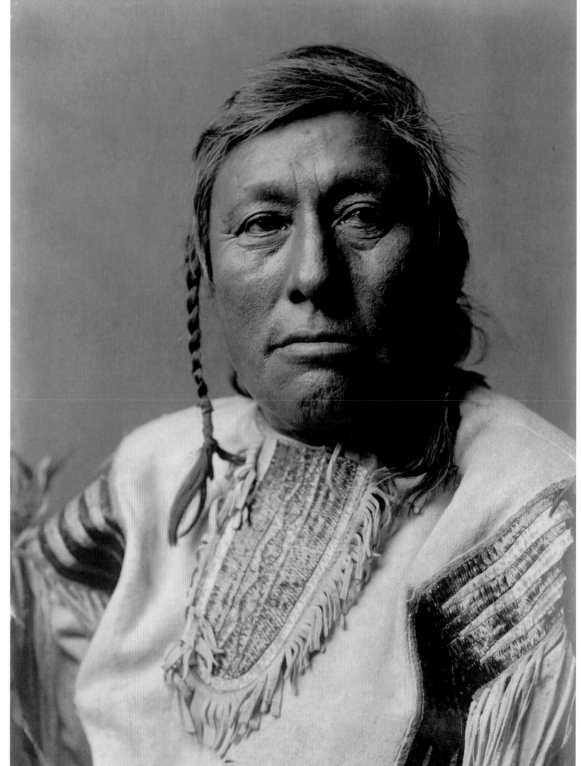

FAR LEFT: On the river's edge—a Crow encampment with tipis, tents, wagons, horses and men as seen from the distant shore of the river; c. 1908.
Library of Congress, Prints & Photographs Division, Edward S. Curtis Collection, LC-USZ62-130192

LEFT: A head-and-shoulders portrait of Long Time Dog; c. 1908.
Library of Congress, Prints & Photographs Division, Edward S. Curtis Collection, LC-USZ62-130160

RIGHT: Apsaroke woman on horseback, packhorse beside her July 6, 1908. Except for the cultivation of tobacco the Crow abandoned agriculture after their separation from the Hidatsa and became a true, nomadic Plains people, heavily dependent on the horse for bison-hunting, though they also gathered roots and berries for food.
Library of Congress, Prints & Photographs Division, Edward S. Curtis Collection, LC-USZ62-46965

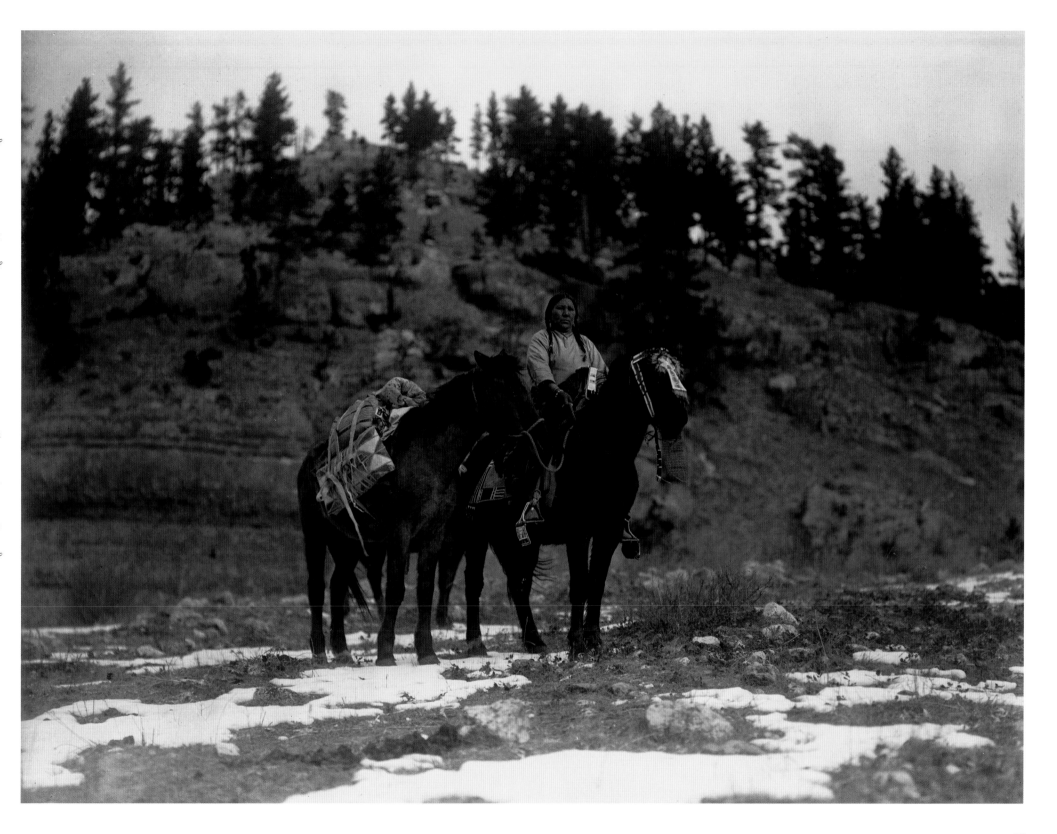

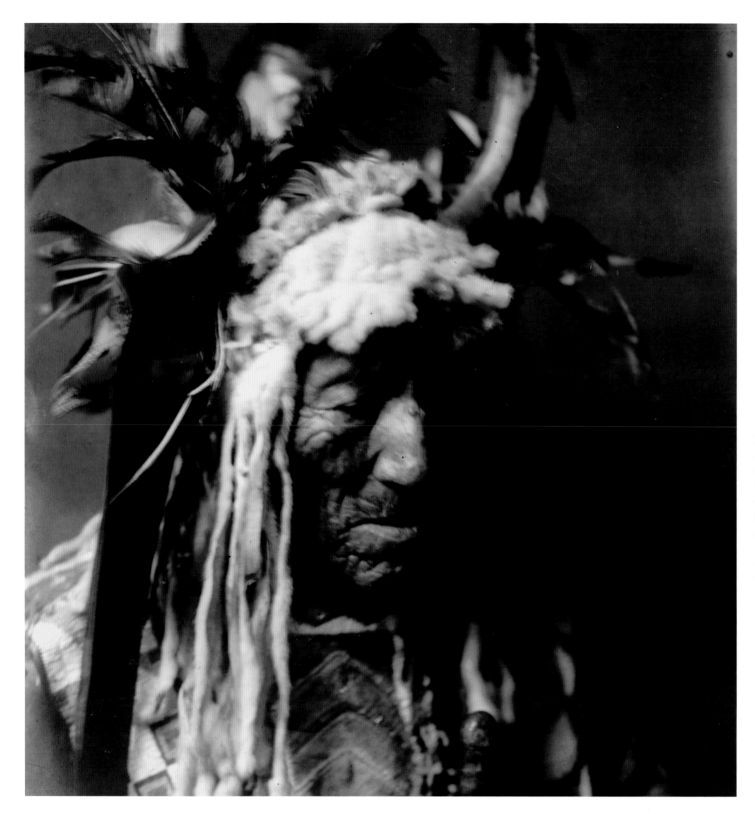

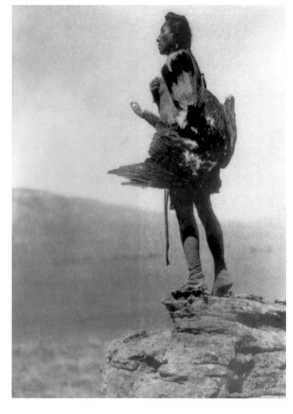

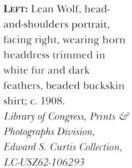

LEFT: Lean Wolf, head-and-shoulders portrait, facing right, wearing horn headdress trimmed in white fur and dark feathers, beaded buckskin shirt; c. 1908.
Library of Congress, Prints & Photographs Division, Edward S. Curtis Collection, LC-USZ62-106293

ABOVE: Hidatsa Indian standing on large rock overlooking valley, holding an eagle; c. 1908. The Hidatsa or Minitaree was a tribe on the upper Missouri River in North Dakota who, according to tradition, came from somewhere to the northeast but met and allied themselves to the Mandan and shared with them the agricultural pursuits for which they have become famous. After their arrival on the Missouri, the people later called Crow had split from the Hidatsa after a dispute.
Library of Congress, Prints & Photographs Division, Edward S. Curtis Collection, LC-USZ62-96189

RIGHT: A portrait of a Mountain Crow man, Shot in the Hand, who was born around 1841. Curtis gave him a short biography in Volume IV — outlining many tales of bravery in battle. *Corbis*

FAR RIGHT: "The Oath—Apsarok." To make the oath the man has thrust in Curtis's words "an arrow through a piece of meat, placing it upon a red-painted buffalo-skull, and then raising it toward the sun." He then touched the meat to his mouth to show his words were true.
Christie's Images/Corbis

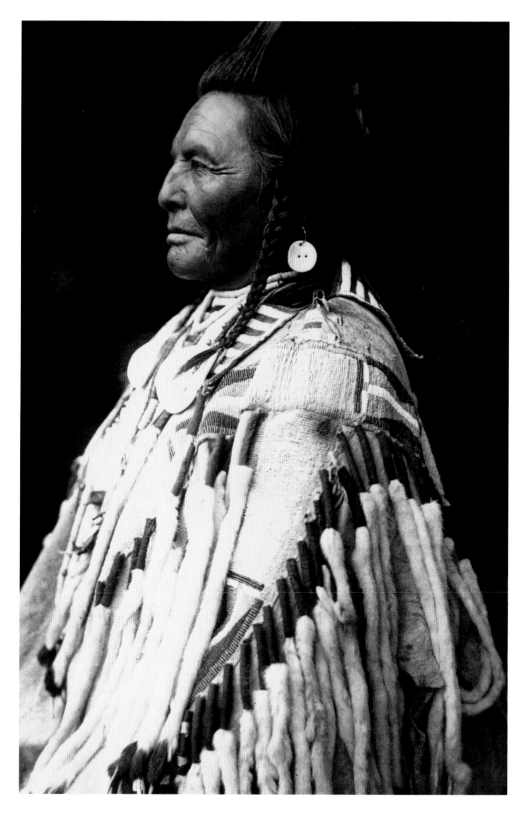

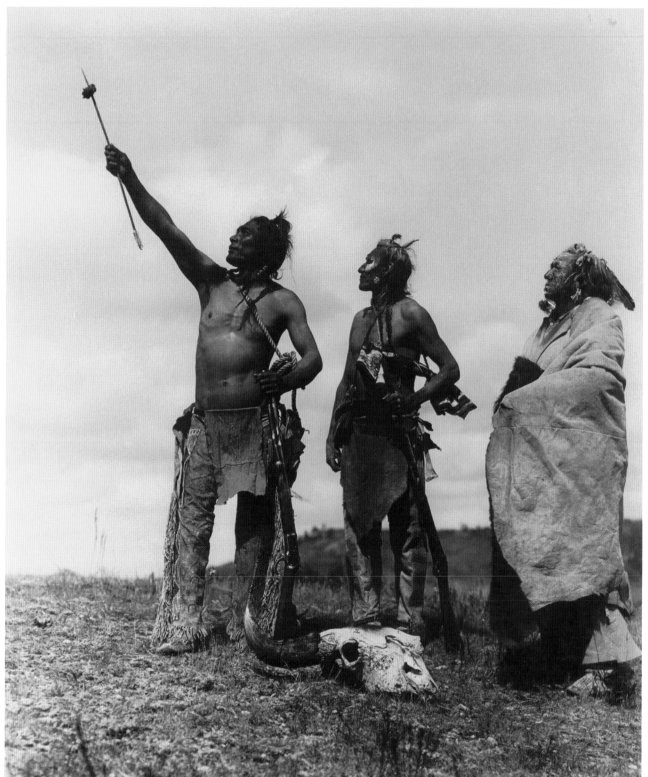

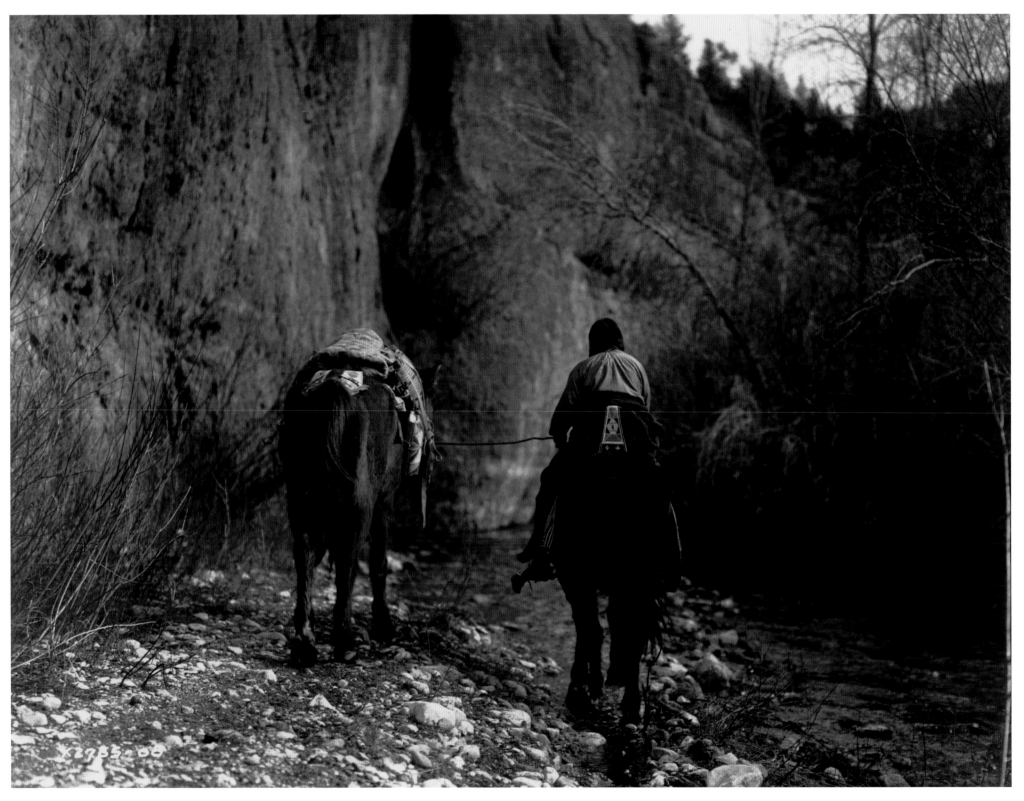

RIGHT: "Winter—Apsaroke." A Crow tepee in winter. Curtis mentions how the Crow made their winter camps in the thick forests along the banks of mountain streams. *Corbis*

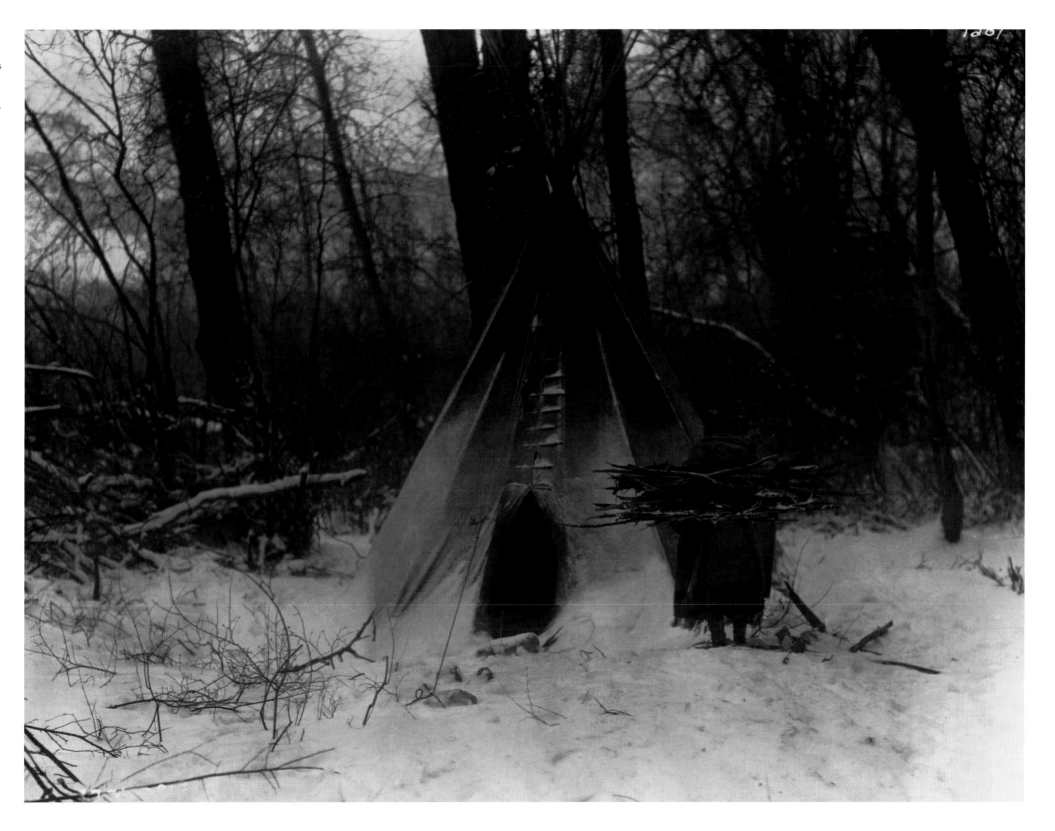

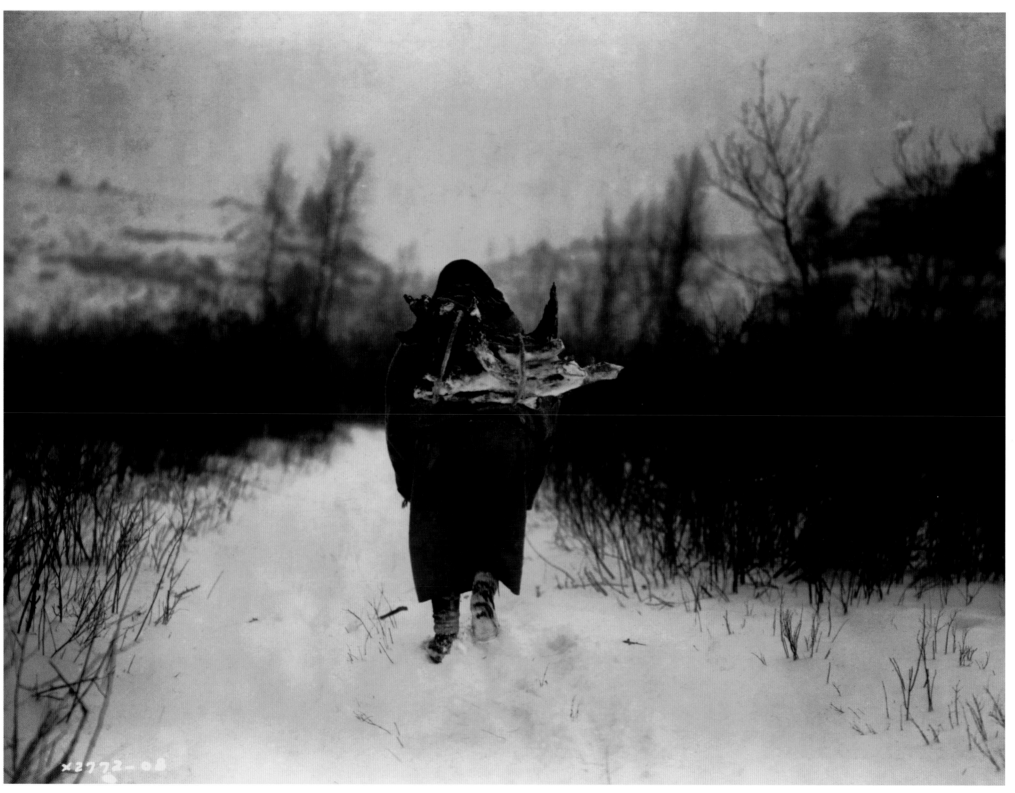

LEFT: A photograph taken at a small Crow winter camp on Pryor Creek in the Pryor Mountains of Montana. *Corbis*

RIGHT: "The Scout in Winter—Apsaroke." The accounts of scouting and hunting parties during the severest winter weather finish many thrilling stories and show a manly indifference to bodily discomfort. The hardships of winter hunting are well shown in the narration found in Volume IV. *Corbis*

FAR RIGHT: "For Strength and Visions." Curtis describes the ritual , where 40 men were tied to posts like this . They cried, "Oh Sun I do this for you," and pulled back on the ropes crying and praying for strength and visions. *Corbis*

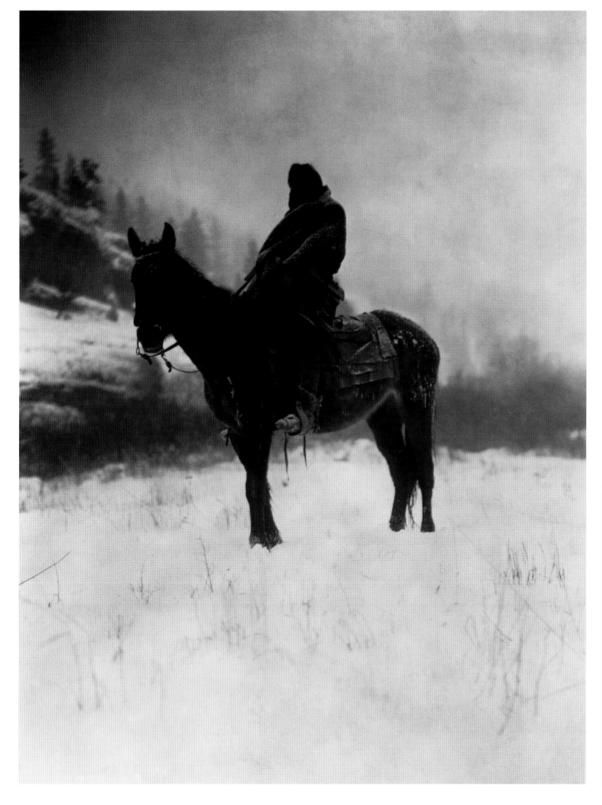

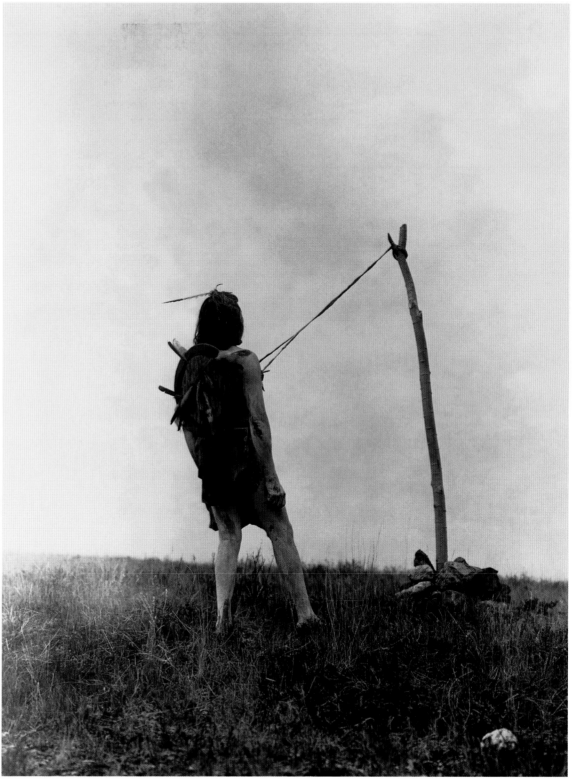

Volume V
The Mandan. The Arikara. The Atsina.

This volume was the final manuscript completed in a flurry of productivity in 1908, securing Edward Curtis's goal of finishing three books during that calendar year. This installment featured three related tribes residing in the upper Missouri River basin. Curtis took great pains to paint them as distinctly different people. The Mandan and Arikara lived almost side-by-side and were practically indistinguishable to many whites. Curtis's work delineated the sharp cultural differences between the two groups. Curtis also took great pride in his coverage of Montana's Atsina (also called the Gros Ventre); he hoped his work would overcome some misconceptions about them.

The Mandan were the stars of this volume and they also were one of the country's best-known and often-studied tribes. Mandan notoriety could be attributed to Lewis and Clark living among them over the winter of 1804-1805, and to the vivid paintings of George Catlin, who spent time with them in the 1830s. By the time Curtis photographed the Mandan, the tribe was a shadow of its former greatness, its vitality sapped by smallpox, war with the Sioux, and the influx of white settlers into North Dakota.

Mandan earthen lodge, with bull boat by doorway, North Dakota; c. 1908. The largest and most important of the three Upper Missouri River horticultural tribes, they lived in dome-shaped earth-covered lodges stockaded into villages; planted maize, beans, and pumpkins; but also hunted bison. The "bull boat" is a round hide river craft.
Library of Congress, Prints & Photographs Division, Edward S. Curtis Collection,
LC-USZ62-114582

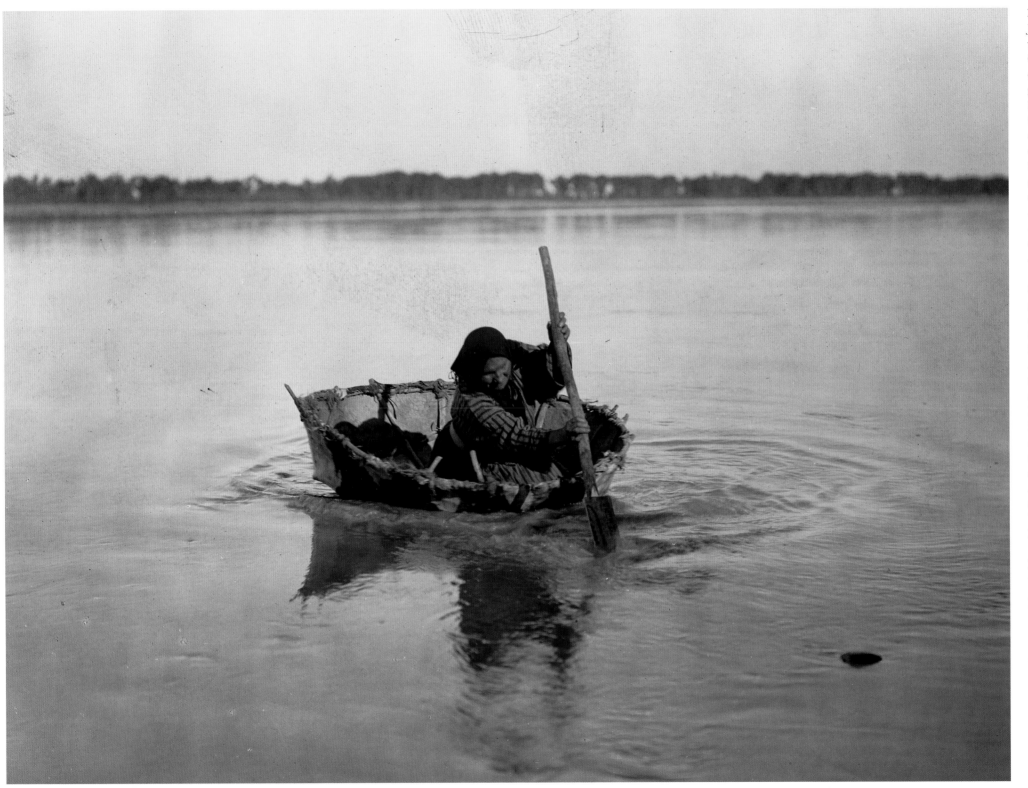

LEFT: Mandan bull boat, July 6, 1908. The Mandan were the subject of one of Curtis's questionable feats of trickery when a generous bribe gained him access to photograph the tribe's sacred turtle effigy drums. When nearly caught in the act by other Mandan, Curtis simply lied about what he was doing and quietly left the scene. *Library of Congress, Prints & Photographs Division, Edward S. Curtis Collection, LC-USZ62-46966*

RIGHT: Sitting Bear —a portrait of an Arikara man. The third of the upper Missouri River horticultural tribes, the Arikara or Ree, in 1862 they joined the Hidatsa and Mandan on the Fort Berthold Reservation, North Dakota, where their descendants have since remained. Despite their early hostility to Americans, some Arikara served as scouts for the U.S. Army during the Indian Wars. *Corbis*

FAR RIGHT: A half-length portrait of Bear's Belly, an Arikara indian, wearing bearskin; c. 1908. *Library of Congress, Prints & Photographs Division, Edward S. Curtis Collection, LC-USZ62-105497*

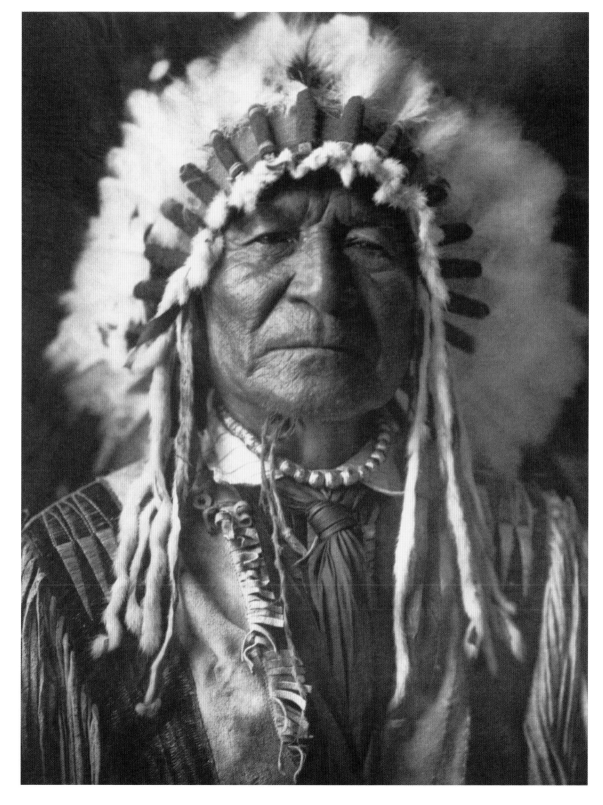

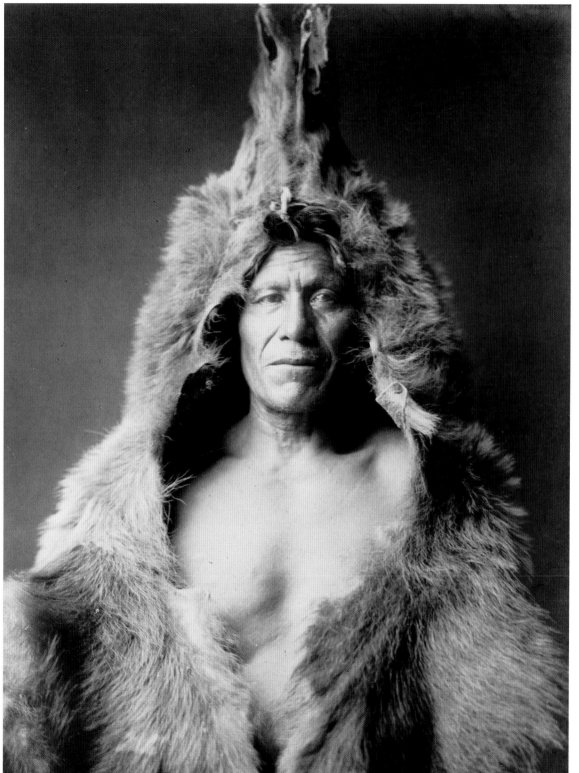

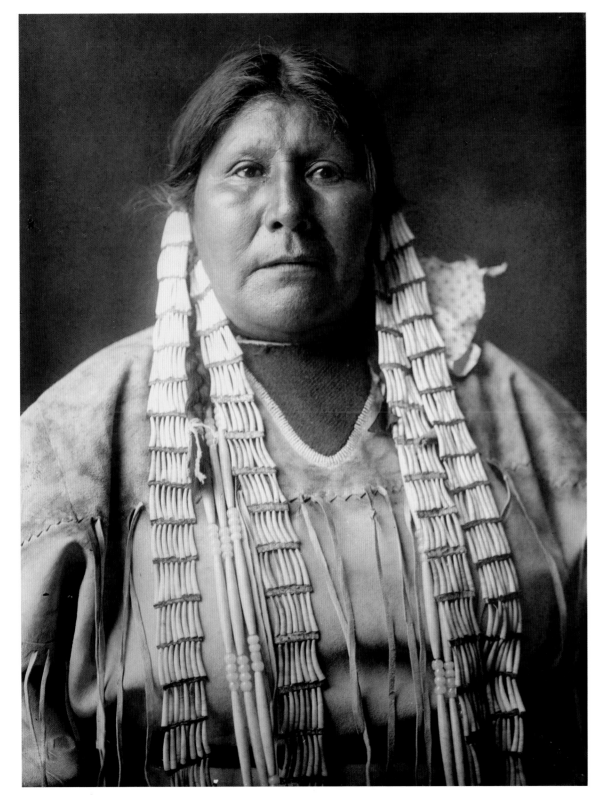

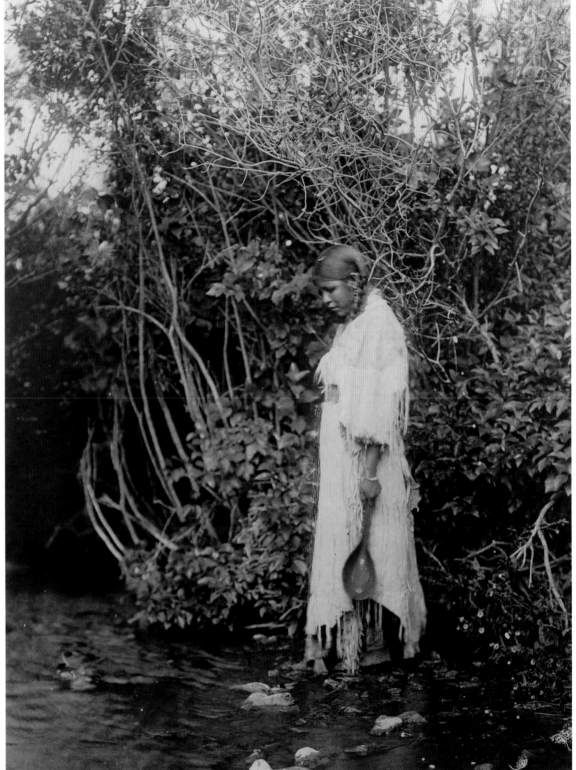

FAR LEFT: A half-length portrait of an Arikara woman; c. 1908.
Library of Congress, Prints & Photographs Division, Edward S. Curtis Collection, LC-USZ62-101187

LEFT: "At the water's edge."A young Arikara Indian stands in shallow water, wearing a buckskin dress, with trees in background, North Dakota.
Library of Congress, Prints & Photographs Division, Edward S. Curtis Collection, LC-USZ62-107915

RIGHT: Arikara medicine ceremony, c. 1908. Curtis noted that traditionally this ceremony included many tricks that were designed both to prove the supernatural powers of the medicine men and to entertain their audience. Though time had toned down the trickery by the time of this photo, Curtis still found the rite highly entertaining.
Library of Congress, Prints & Photographs Division, Edward S. Curtis Collection, LC-USZ62-106273

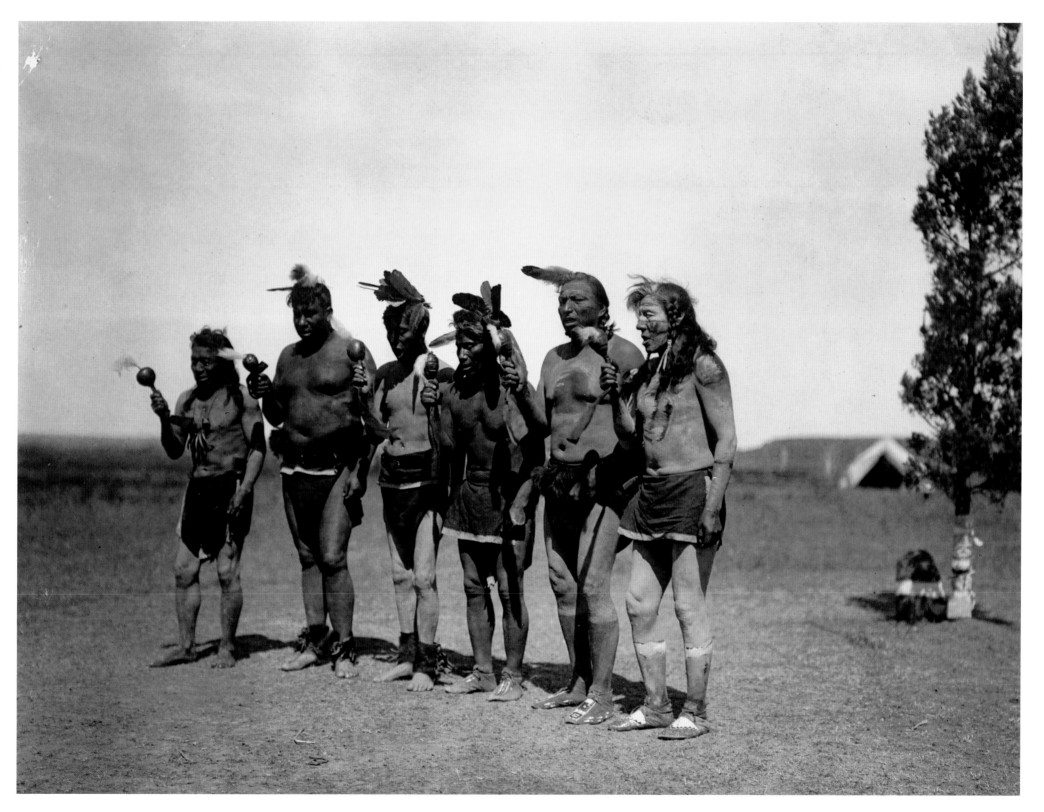

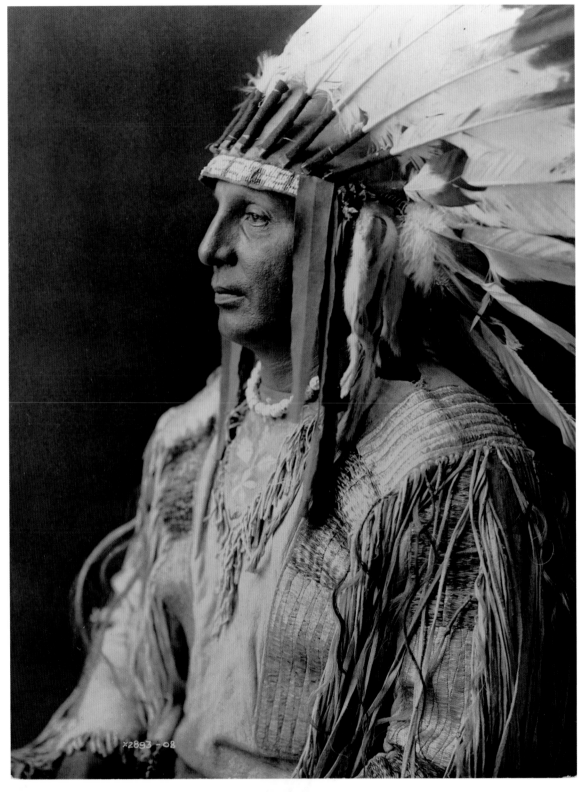

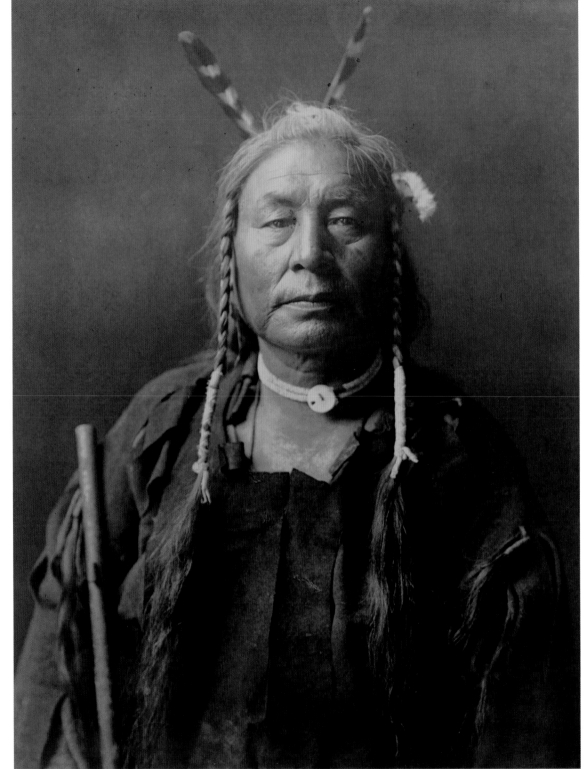

LEFT: Eagle Child, an Atsina man. Born in 1862 he was afforded a short biography at the end of Volume V. *Library of Congress, Prints & Photographs Division, Edward S. Curtis Collection, LC-USZ62-121686*

FAR LEFT: White Shield, an Arikara man, c. 1908. To many whites, the Arikara were hardly indistinguishable from the Mandan, among whom they lived, but Curtis found the Arikara to be a fascinating people with a different language and their own unique religious beliefs. He took great pains to paint these two tribes as culturally distinct people—a trend he followed throughout the project, and a much-needed dose of reality for Americans who tended to view "Indians" as a homogenous group. *Library of Congress, Prints & Photographs Division, Edward S. Curtis Collection, LC-USZ62-125926*

RIGHT: "On the Warpath—Atsina." Gros Ventre warriors reenacting a war party. *Stapleton Collection/Corbis*

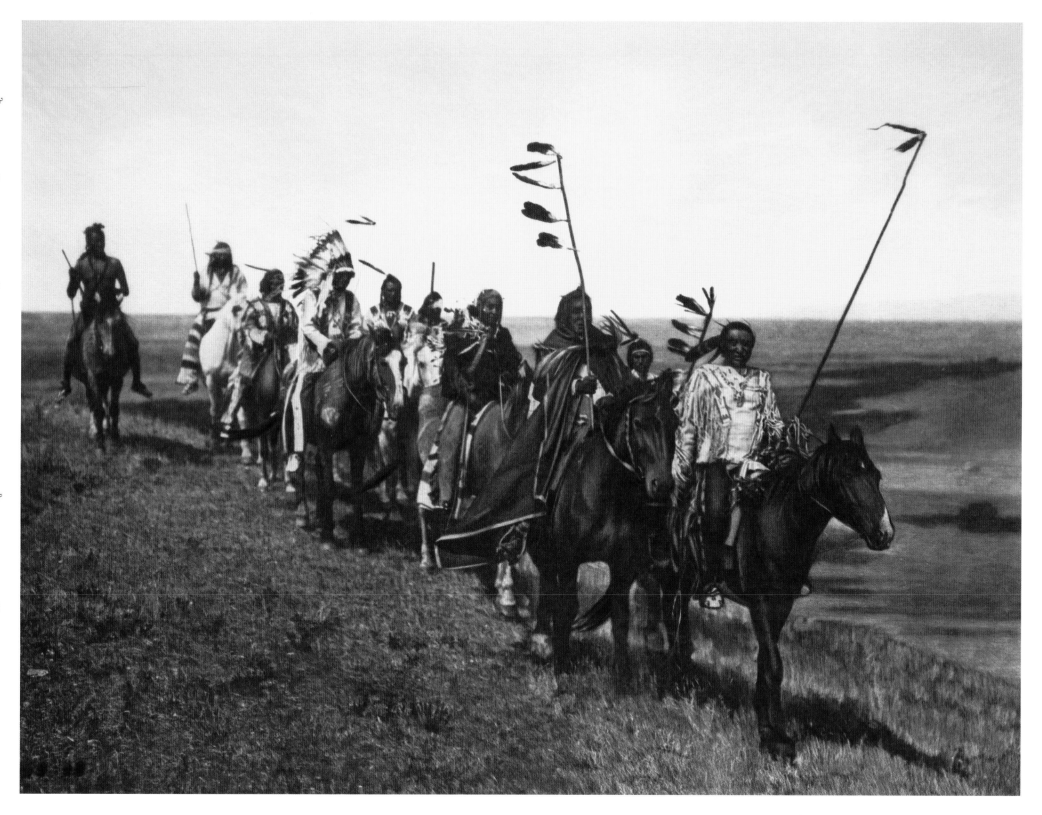

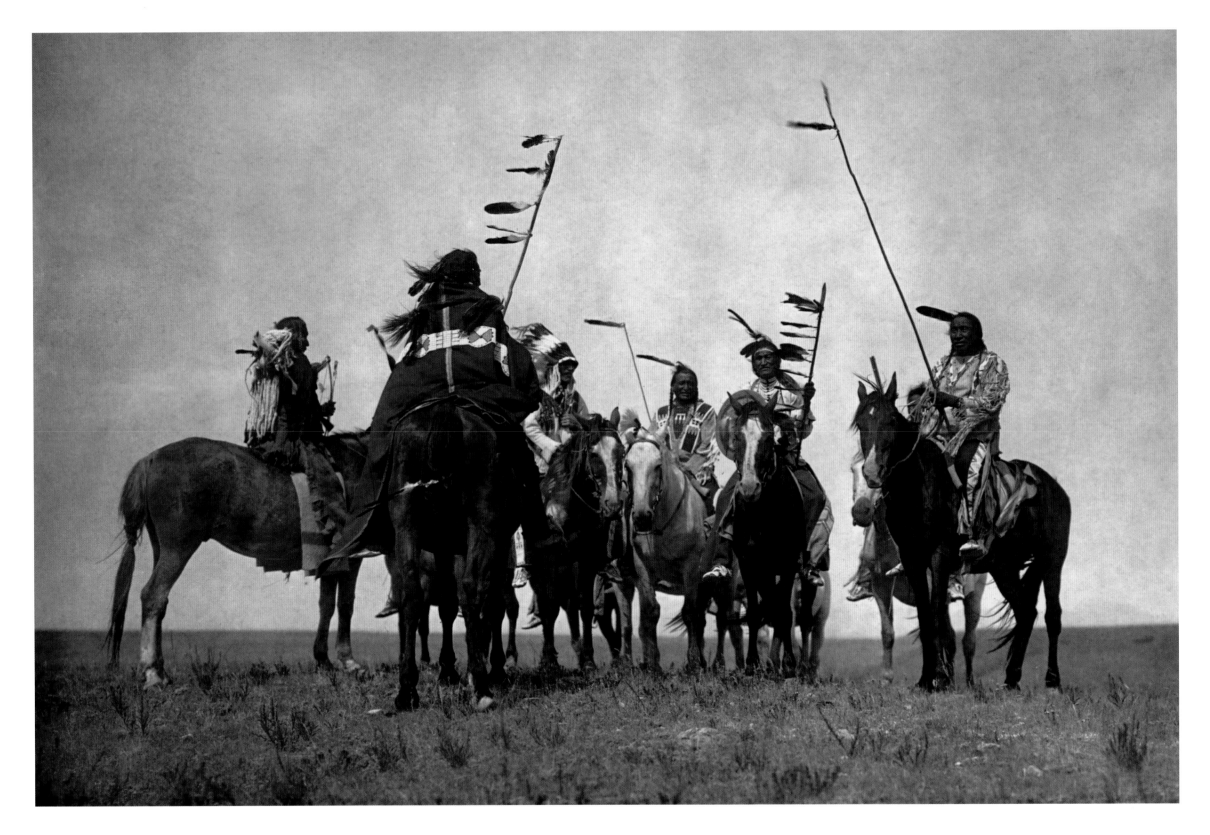

LEFT AND RIGHT: "Atsina Warriors" and "The Land of the Atsina." Two more views of Atsina or Gros Ventre warriors reenacting a war party. An Algonkian tribe of the northern Plains, considered once part of the Arapaho but for much of the nineteenth century allies of the more powerful Blackfoot, their French name apparently derives from the movement of the hands over the abdomen to indicate hunger in the Plains Indian sign language. Their culture and history parallel those of the Blackfoot, their powerful neighbors to the west. Their home for most of the nineteenth century was between the South Saskatchewan River in Canada and the Missouri River in Montana, particularly around the Milk River. *Corbis*

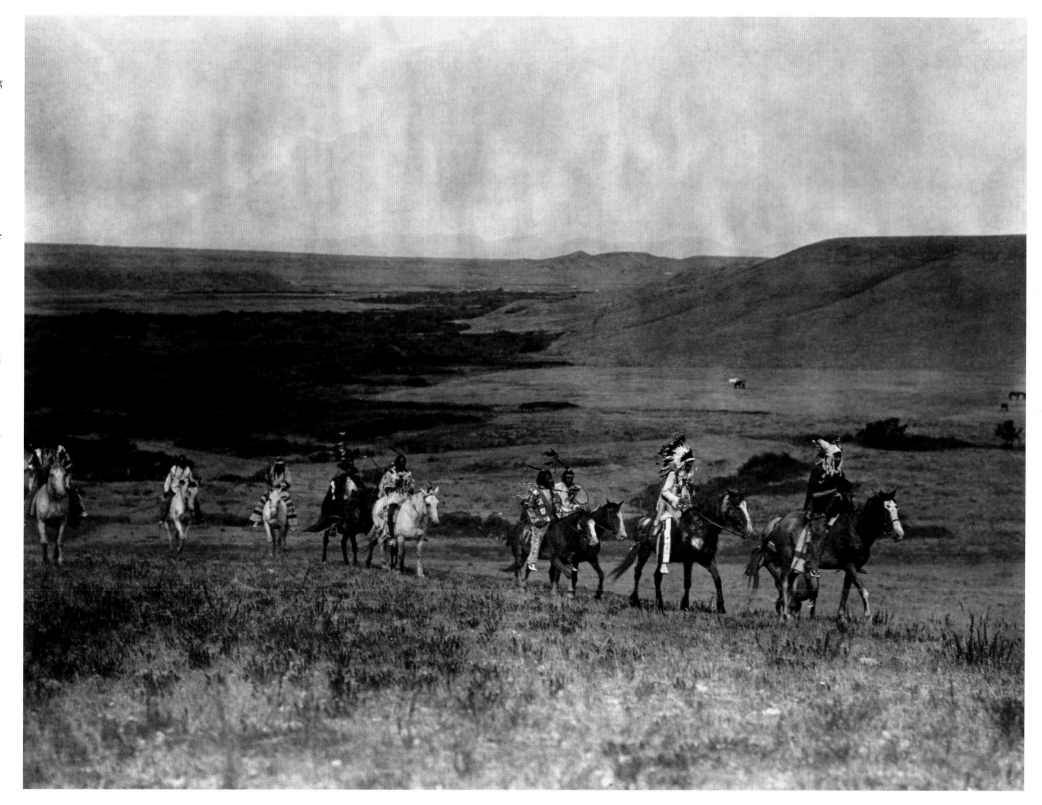

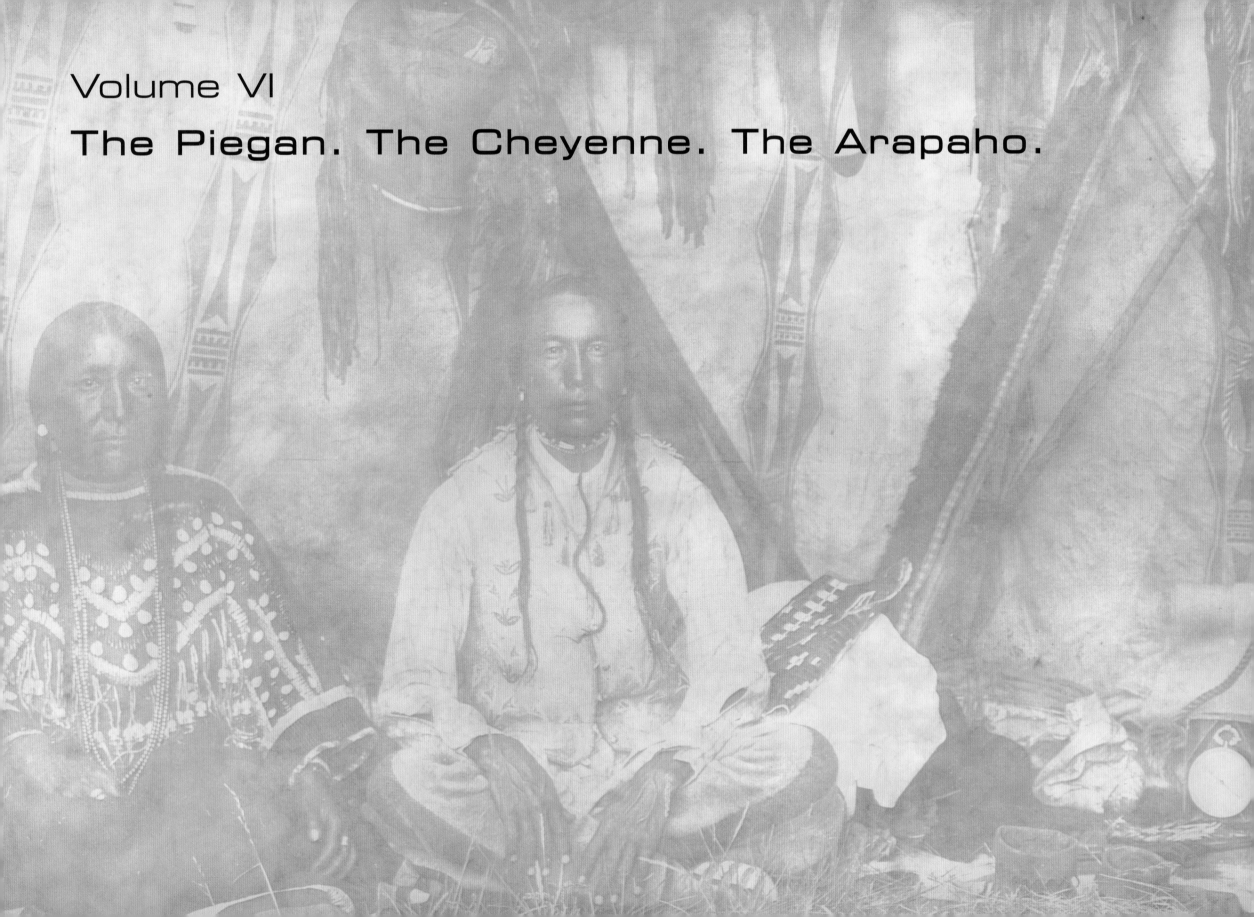

Volume VI

The Piegan. The Cheyenne. The Arapaho.

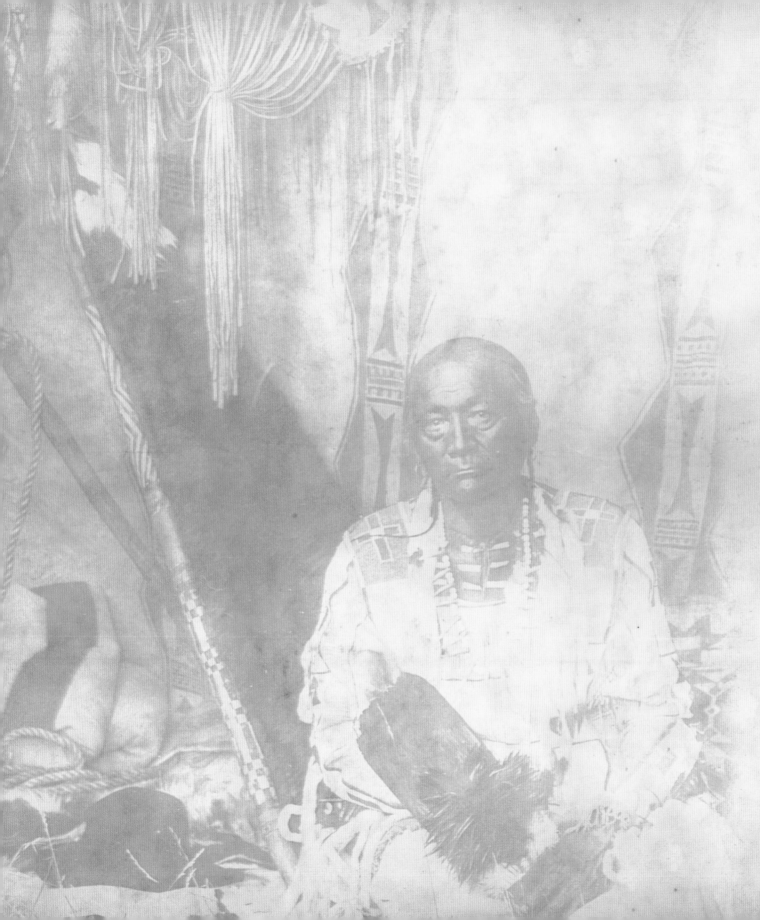

This was the first of three volumes largely written in 1909 and published throughout 1911. As this book was being compiled, Curtis was facing serious personal and professional challenges, including a crumbling marriage and a growing mountain of debt.

The Piegan were part of the Blackfoot family of tribes that Curtis first visited with George Bird Grinnell in 1900. The stunning view of the massed tipis may have been the defining moment in pushing the photographer on his quest. In this book, Curtis directed readers to consult the work of Grinnell—who had studied the Piegan for two decades—but he still painted a very complete picture of the tribe, punctuated by a number of memorable images.

The Cheyenne (northern band) and Arapaho are often lumped together because of their related languages, bison-oriented lifestyles, and residence in Wyoming and southern Montana, but they were very different people. In particular, the Cheyenne were very warlike and aggressively resisted white intrusion on their lands. When Curtis worked with them, the Cheyenne and Arapaho also shared the extreme poverty that had beset many of the conquered plains tribes.

A portrait of Piegans Little Plume (right) and his son Yellow Kidney in their lodge. The historic Blackfoot were a loose confederacy of three closely related tribes: the Blackfoot or North Blackfoot (Siksika), the Blood (Kainah), and Piegan (Pikuni). Note the clock in the photo, symbolic of encroaching white civilization. Curtis used his darkroom skill to replace the clock with a basket before the photo was published in the book. *Corbis*

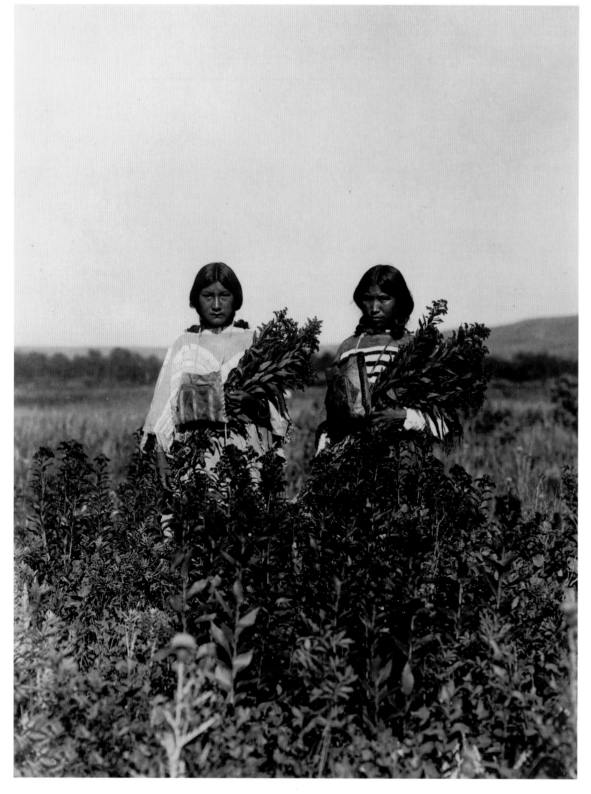

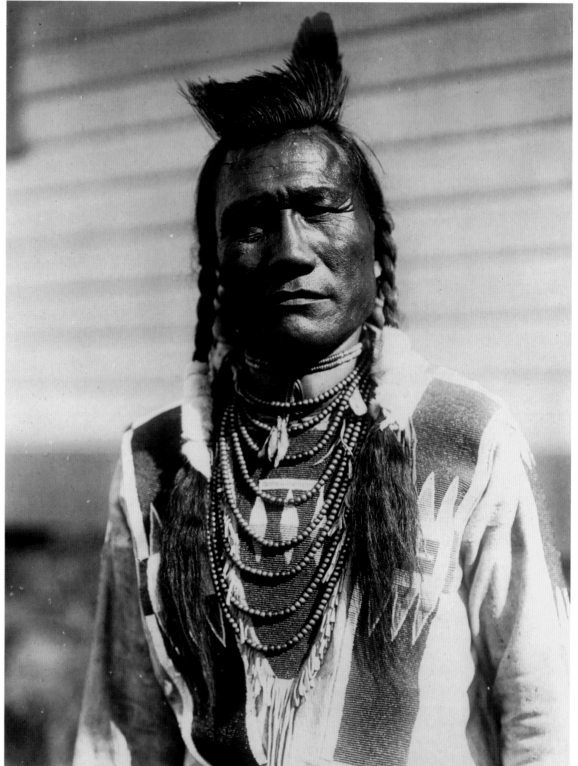

FAR LEFT: Two Piegan girls standing in a field of goldenrod; c. 1910.
Library of Congress, Prints & Photographs Division, Edward S. Curtis Collection, LC-USZ62-106992

LEFT: Half-length portrait of Bird Rattle, a Piegan man, wearing a beaded buckskin shirt, a feather, and a loop necklace; 1909. They were a typical Plains tribe, as exemplified by a dependence on the buffalo for food, for tipis, bedding, shields, clothing, and containers.
Library of Congress, Prints & Photographs Division, Edward S. Curtis Collection, LC-USZ62-101251

RIGHT: Overlooking the Piegan camp—One man and two women, seated on hill; c. 1910. Despite the ravages of smallpox, particularly among the Piegans, the pre-reservation Blackfoot became the most powerful tribe of the northern Plains. They once held an immense territory stretching from the North Saskatchewan River, Canada, to the headwater of the Missouri River in Montana, including the foothills of the Rocky Mountains.
Library of Congress, Prints & Photographs Division. Edward S. Curtis Collection, LC-USZ62-106275

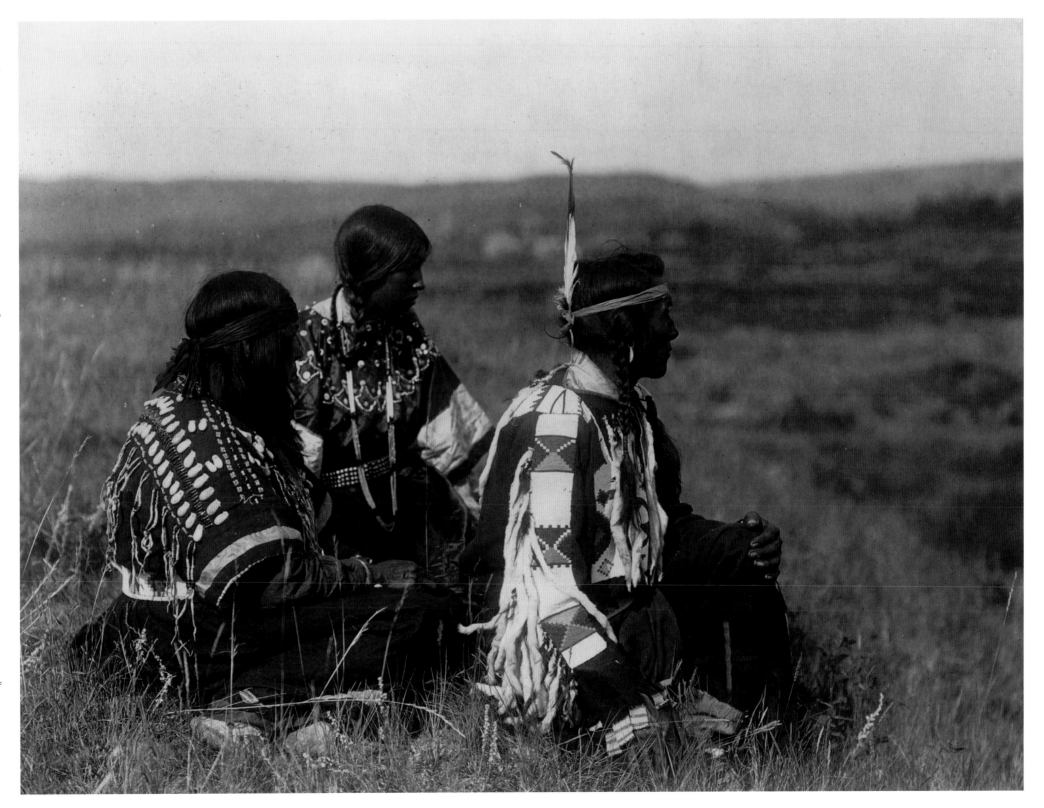

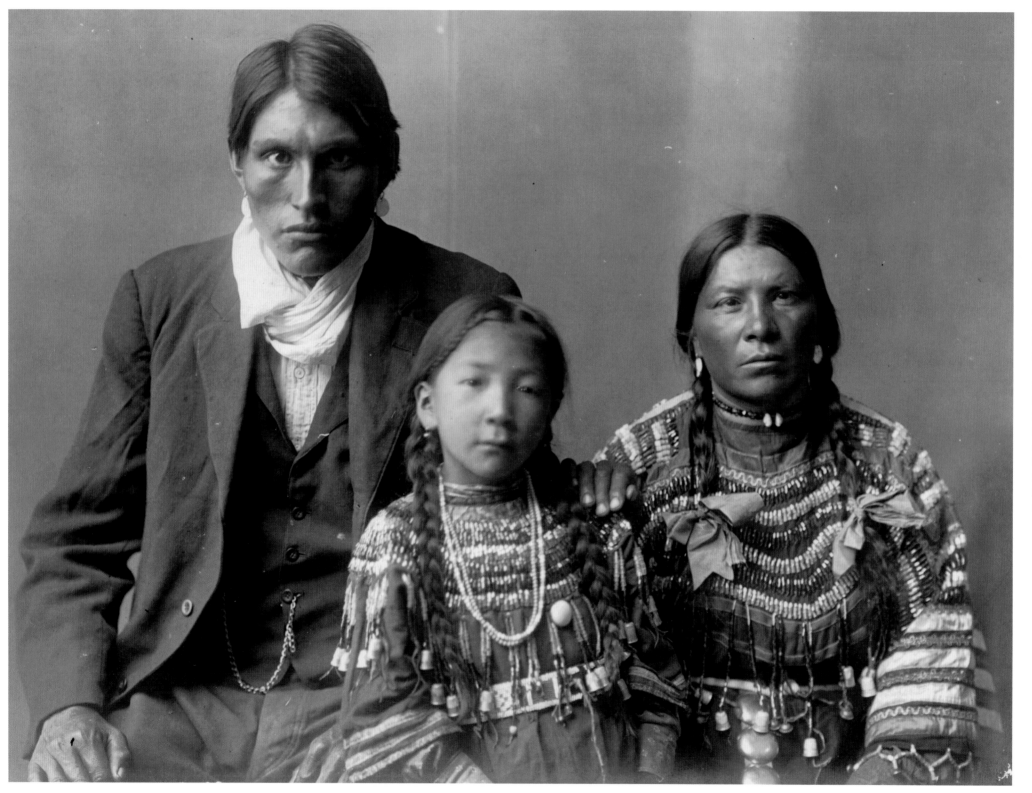

LEFT: Half-length portrait of Reuben Black Boy and family; c. 1910. The mixed styles of dress indicate what Curtis was facing at this point in the project—native cultures were quickly being overwhelmed by the white world. This fact gave him the sense of urgency that he needed to push on, but it also made the job difficult. While visiting many tribes he struggled to find photographic subjects who still wore their clothes and hair in the traditional manner. *Library of Congress, Prints & Photographs Division, Edward S. Curtis Collection, LC-USZ62-112264*

RIGHT: Two Kill—a full-length portrait of the Piegan woman seated on blankets inside tipi; c. 1910. *Library of Congress, Prints & Photographs Division, Edward S. Curtis Collection, LC-USZ62-117609*

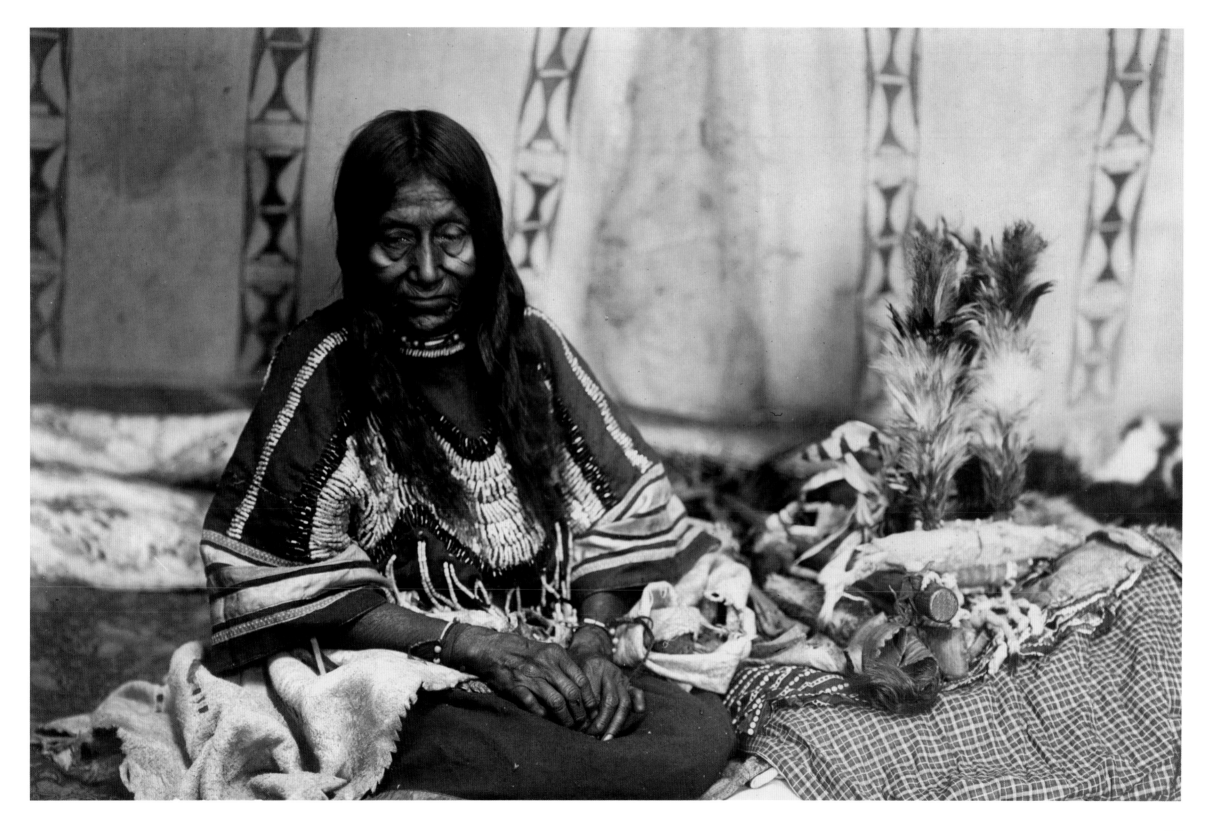

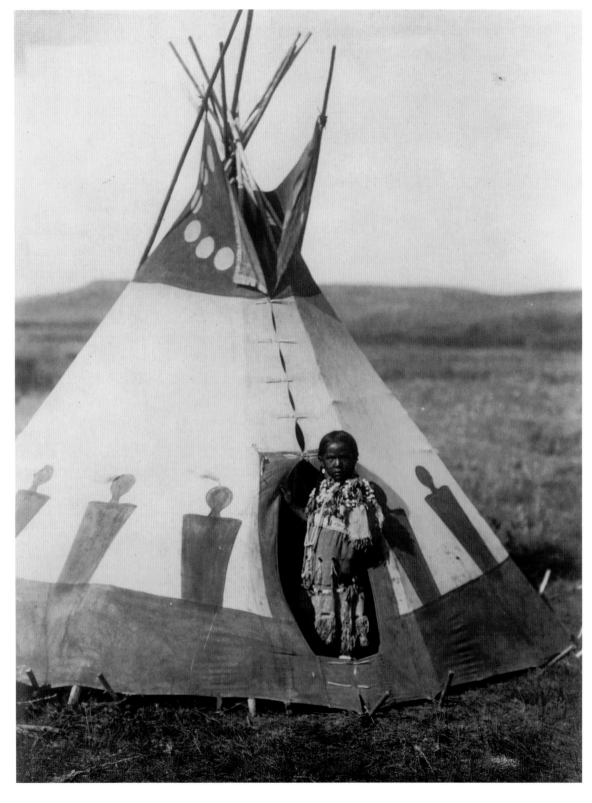

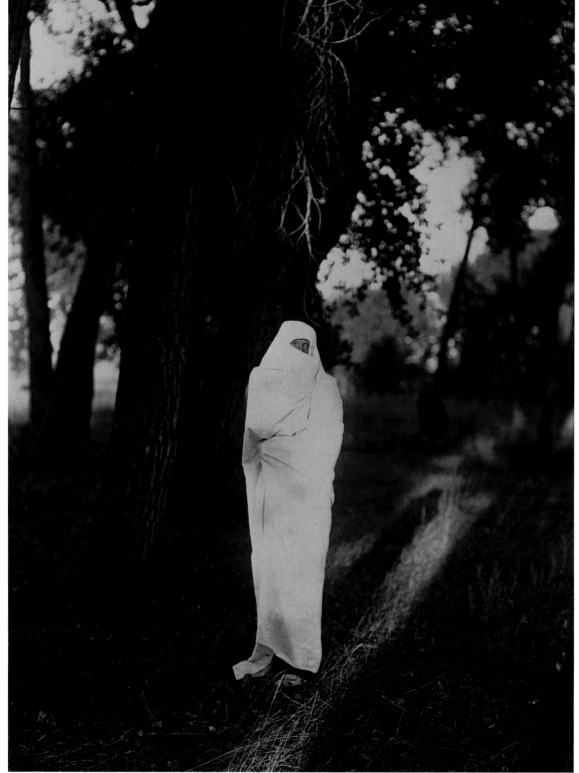

FAR LEFT: Crow Chief's daughter—a Piegan girl—standing in doorway of tepi, wearing a beaded buckskin dress, Montana; c. 1910.
Library of Congress, Prints & Photographs Division, Edward S. Curtis Collection, LC-USZ62-106768

LEFT: A young, unmarried Cheyenne man waits in the forest wearing the traditional "noncommittal" blanket, hoping for a visit from the young woman he someday hopes to marry; c. 1910. Curtis remarked that the Cheyenne, while on the outside very much like other Plains' tribes, internally possessed a unique sense of superiority, along with a strong sense of individualism. *Corbis*

RIGHT: Sun dance lodge with Cheyenne people inside; c. 1910. From 1860 to 1878 the Cheyenne actively fought the whites, acting with the Sioux in the north and with the Kiowa and Comanche in the south. They probably lost more than the other tribes in proportion to their number during these conflicts.
Library of Congress, Prints & Photographs Division, Edward S. Curtis Collection, LC-USZ62-117712

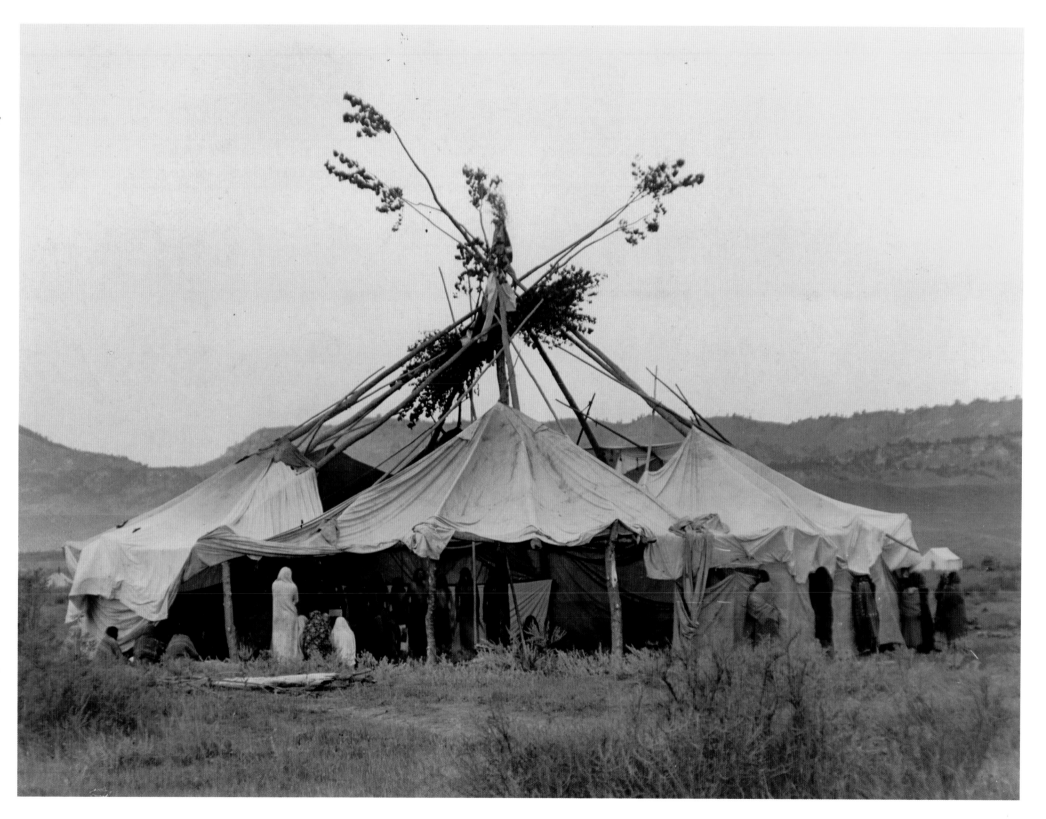

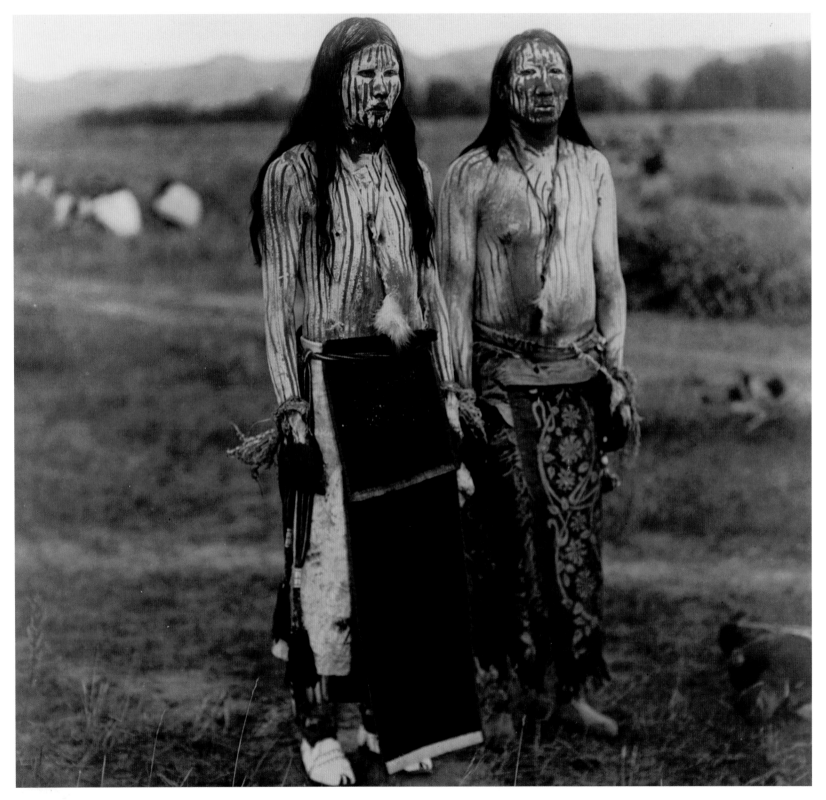

LEFT: Sun dance pledgers—two young Cheyenne men in ceremonial paint; c. 1910. The Cheyenne had the most concisely and consciously preserved meaning of the sun dance. They called the sun dance shelter New Life Lodge or Lodge of New Birth, where the ceremony recreates, reforms, and reanimates the earth, vegetation, animal life, etc., while offering thanks to a Supreme Being. *Library of Congress, Prints & Photographs Division, Edward S. Curtis Collection, LC-USZ62-106280*

RIGHT: The Valley of the Rosebud—Cheyenne wearing headdress, on horseback; c. 1905. In consequence of the building of Bent's Fort on the upper Arkansas River in Colorado in 1832, a large part of the tribe moved south to the Arkansas while the rest remained on the North Platte, Powder, and Yellowstone rivers. Thus came into being the geographical division of the tribe into the Northern and Southern Cheyenne. *Library of Congress, Prints & Photographs Division, Edward S. Curtis Collection, LC-USZ62-106769*

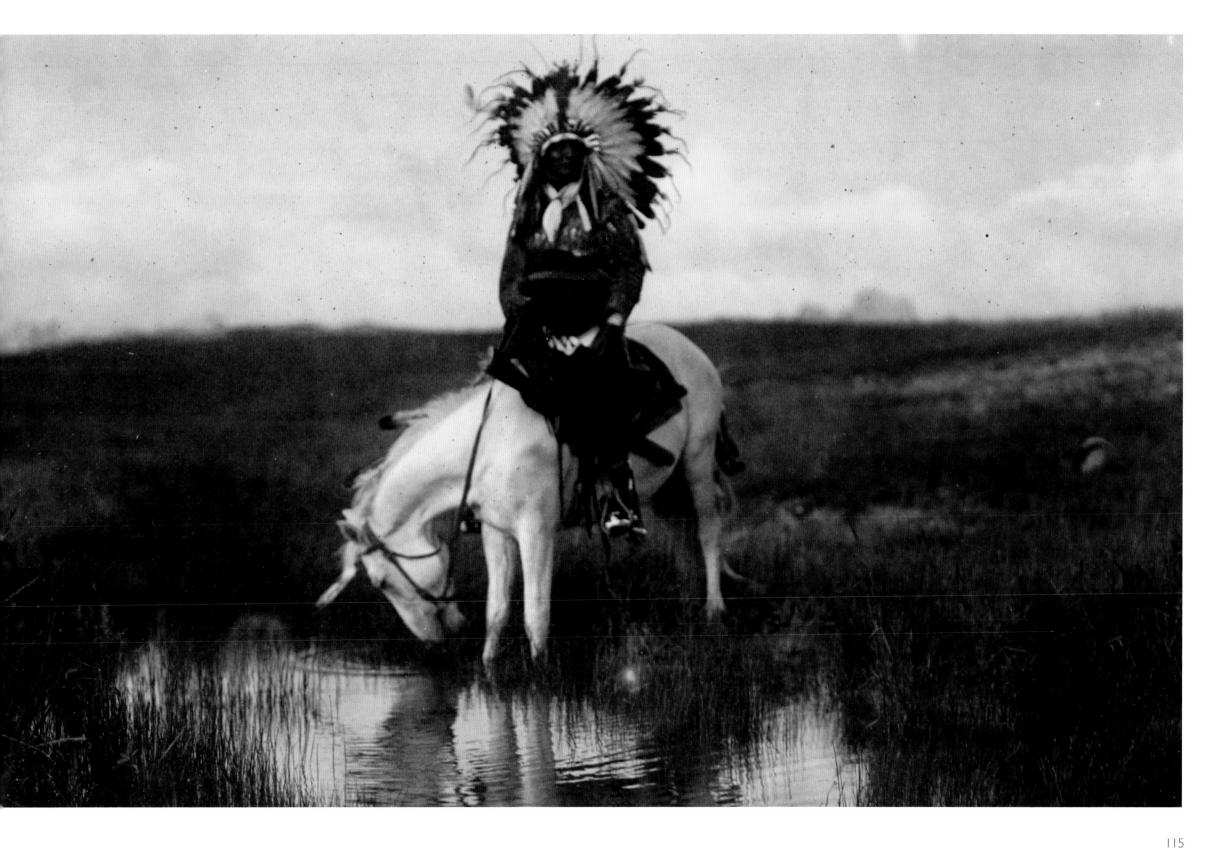

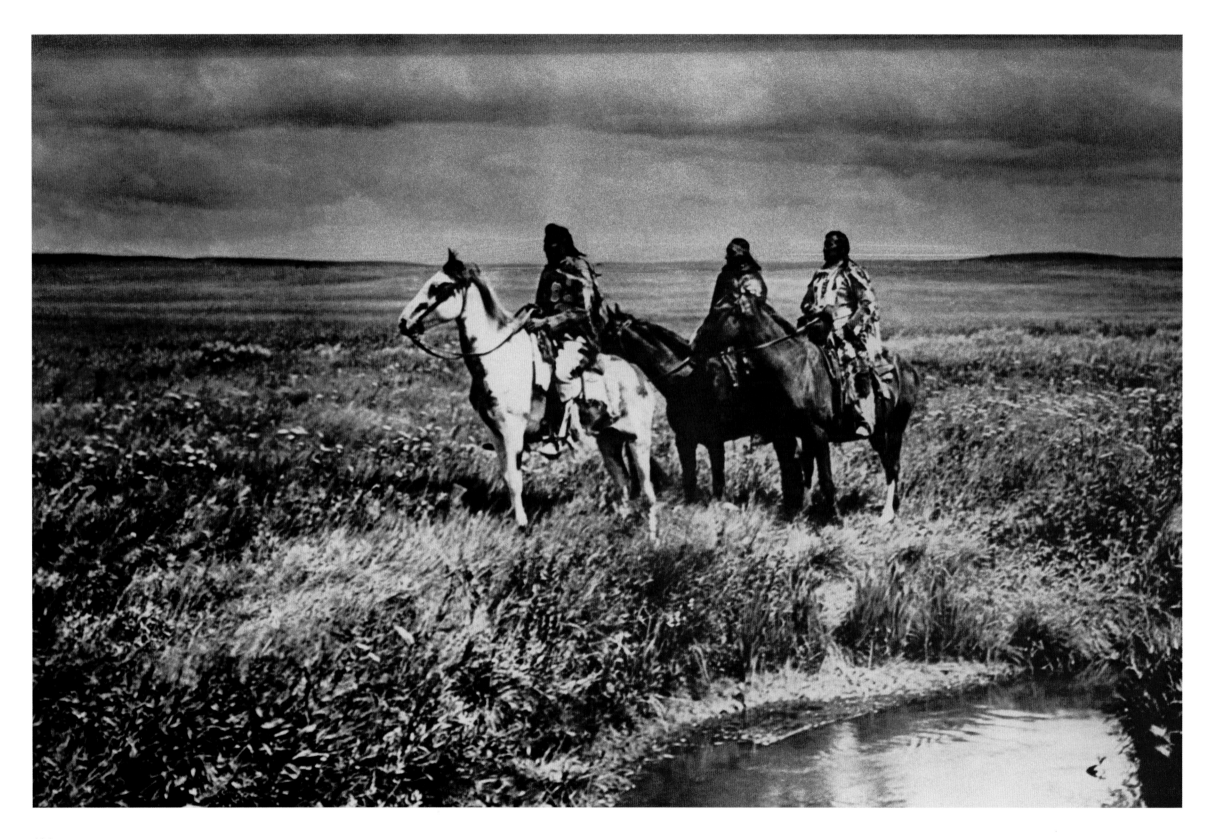

LEFT: "The Three Chiefs—Piegan." Curtis wrote, "Three proud old leaders of their people. A picture of the primal upland prairies with their waving grass and limpid streams. A glimpse of the life and conditions which are on the verge of extinction." *Christie's Images/Corbis*

RIGHT: "The Ancient Arapaho." *Corbis*

FAR RIGHT: "Little Wolf—Cheyenne." The proud silhouette of Little Wolf, one of the group who broke away from the Northern Cheyenne under Dull Knife who were taken to Indian Territory in summer 1877. When Dull Knife was captured Little Wolf and a band escaped, They were joined by the 15 survivors of Dull Knife's group who escaped from captivity in Fort Robinson, Nebraska. Little Wolf and his band were finally taken prisoner on March 25, 1879. They were allowed to remain in the north in a reservation on Tongue River in Montana that Curtis described as "small, discouragingly sterile." *Corbis*

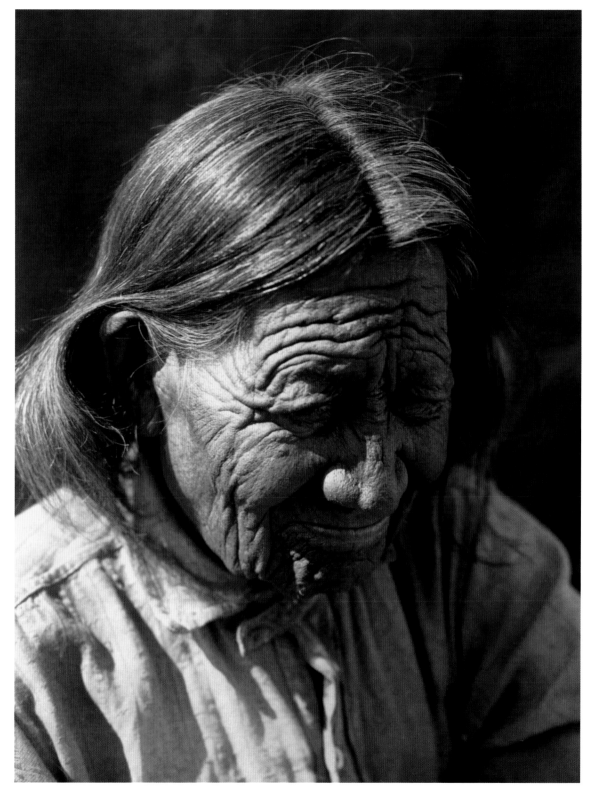

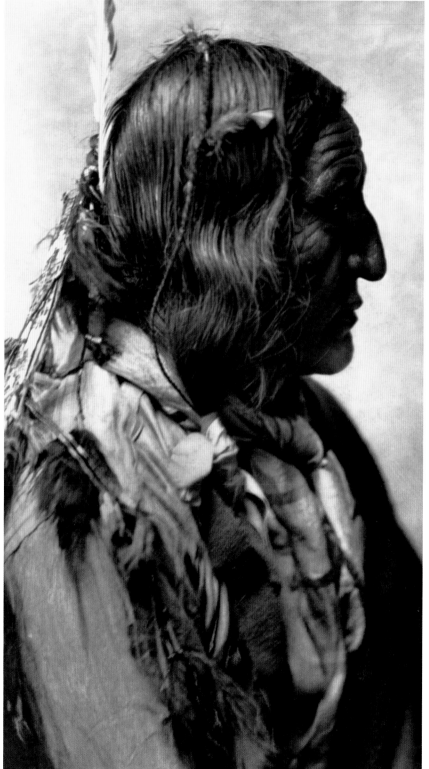

Volume VII
The Yakima. The Klickitat.
Salishan tribes of the
interior. The Kutenai.

This volume was dedicated to many small, related tribes that lived in the Columbia River basin. The mighty river and its tributaries played an essential role in the lives of these people, providing them with the fish that was their primary food source.

Like plains tribes, the Kutenai lived in tipis, but they were relatively sedentary. Curtis recorded memorable images of the tribe at work in their distinctive canoes on Flathead Lake, but he described the reservation-bound "modern" Kutenai in less-than-glowing terms.

The range of the Salishan tribes spread from the Bitterroot Mountains of western Montana west to central Washington. Curtis focused on the easternmost tribes of the group, the Flatheads and Pend d'Oreilles (Kalispel) who had adopted aspects of plains culture, including bison hunting and tipi dwellings.

The Yakima and the Klickitat lived farther down the Columbia basin in south central Washington, each residing near eponymous rivers. When Curtis and Myers visited these people they had very separate lives, but during the twentieth century the Klickitat relocated to the Yakima reservation and culturally blended into the larger tribe.

A small Spokane camp occupies a clearing in a northern Idaho forest c. 1910. The Spokane was one of several related tribes that spoke a variation of the Salish language and lived in the upper Columbia River basin. Curtis discovered that at this point in time, these cultures were closely tied to the yet-to-be-dammed river, which still yielded rich catches of salmon to native fishermen living far from the Pacific Ocean.
Library of Congress, Prints & Photographs Division, Edward S. Curtis Collection, LC-USZ62-113091

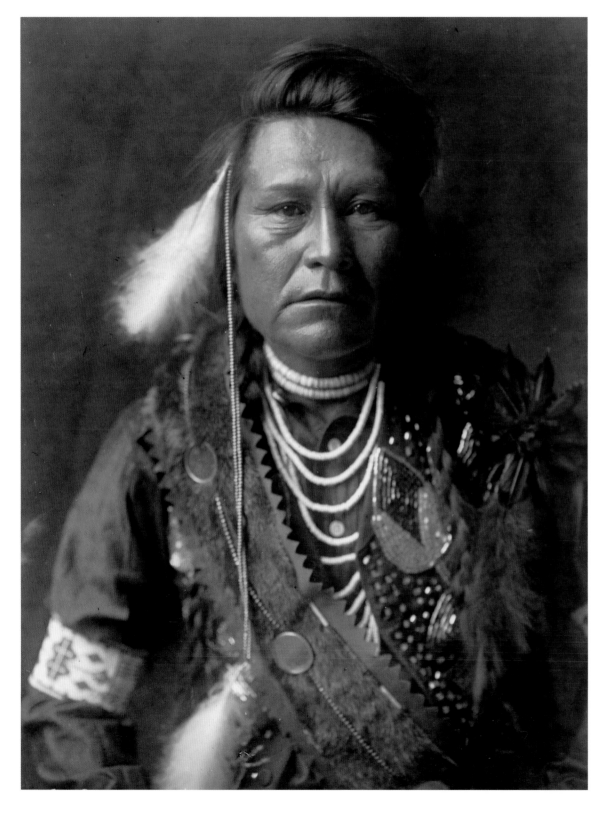

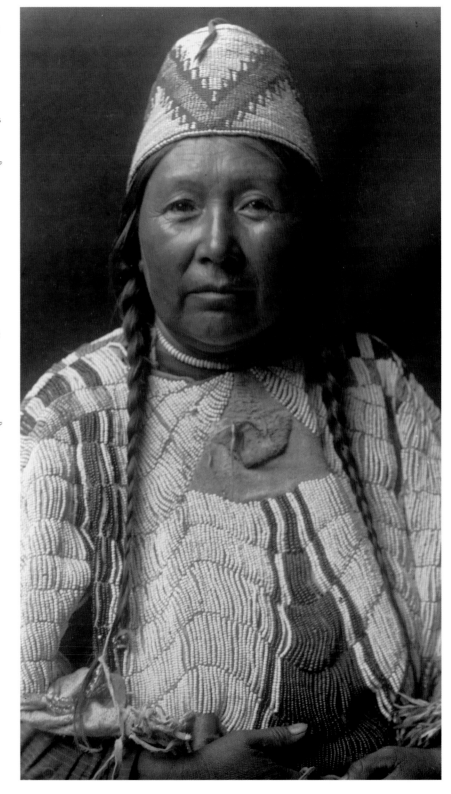

LEFT: Half-length portrait of Inashah, a Yakima man; c. 1910. This important group occupied the valley of the Yakima River, a northern tributary of the Columbia on the east side of the Cascades Mountains in present Yakima County, Washington.
Library of Congress, Prints & Photographs Division, Edward S. Curtis Collection, LC-USZ62-119409

RIGHT: Half-length portrait of the wife of Mnainak; c. 1910. The collective name "Yakima" has for many years been used to designate all the confederate groups on the agency built around the true Yakima, which also includes some Wishram (or Wishham) and Wasco of Chinookian origin.
Library of Congress, Prints & Photographs Division, Edward S. Curtis Collection, LC-USZ62-115806

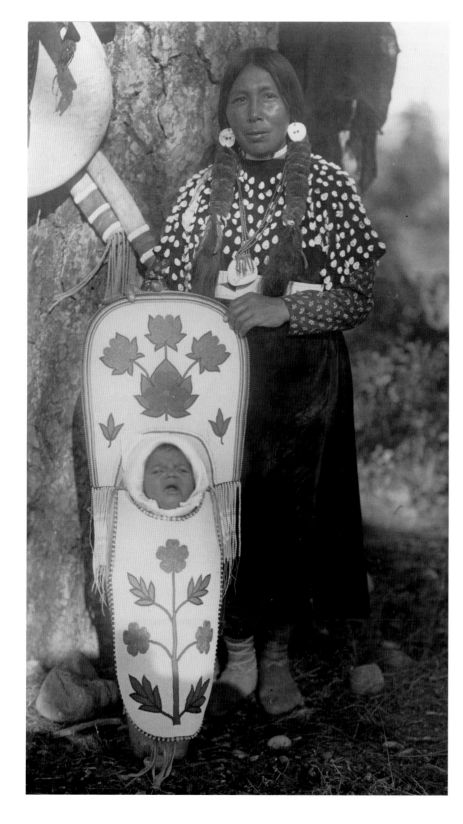

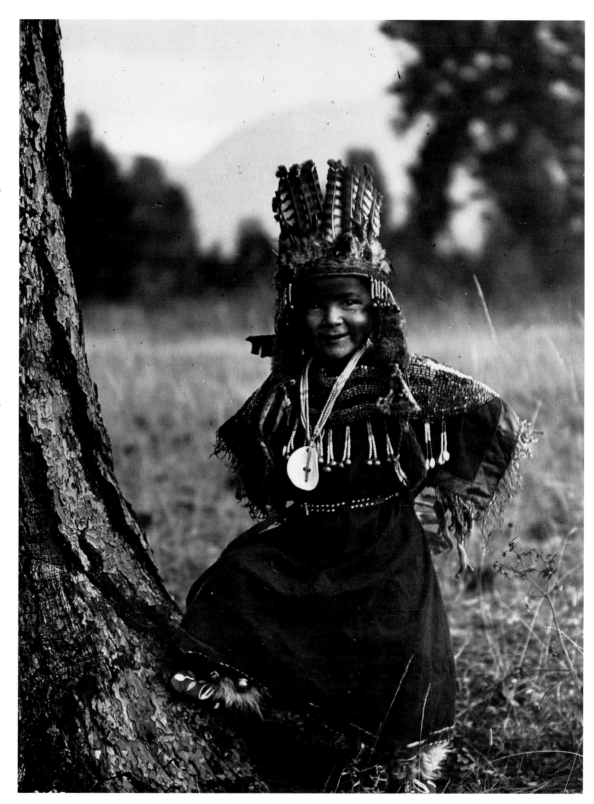

LEFT: Flathead woman standing by tree holding baby in cradleboard in front of her; c. 1910. The name "Flathead" derived from the fact that, in contrast to tribes farther west, they did not deform the heads of children by compression with a board in the cradle.
Library of Congress, Prints & Photographs Division, Edward S. Curtis Collection, LC-USZ62-115804

RIGHT: Flathead childhood—a Salish boy, posed wearing costume and headdress; c. 1910. Flathead culture was superficially much like that of the Plains tribes, although they never held the sun dance.
Library of Congress, Prints & Photographs Division, Edward S. Curtis Collection, LC-USZ62-98071

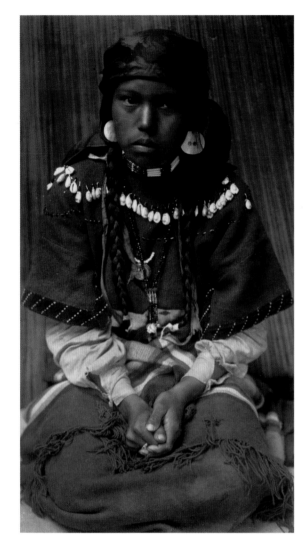

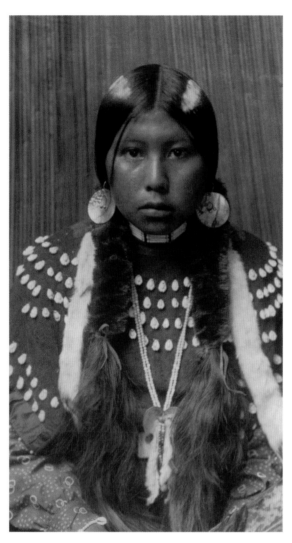

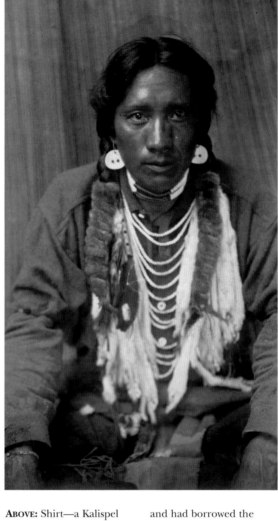

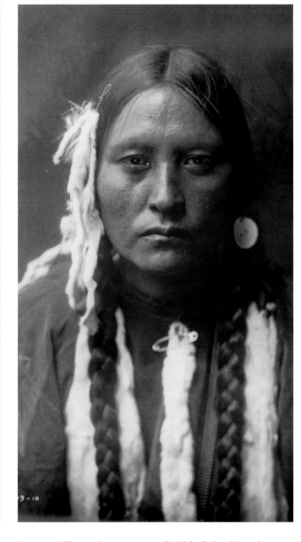

ABOVE: Touch her Dress—a Kalispel girl sitting on her knees, hands folded in lap; c. 1910. Also known as Pend d'Oreilles in reference to the large shell earrings which some of them wore, they were divided into the Upper Kalispel of western Montana, around Thompson Falls on the Clark Fork of the Pend d'Oreille River, and the Lower Kalispel extending into present northern Idaho up to Priest Lake, almost to the Canadian border. *Library of Congress, Prints & Photographs Division, Edward S. Curtis Collection, LC-USZ62-113092*

ABOVE: This Kalispel young woman, Skohlpa (Dusty Dress), is garbed in a dress ornamented with shells that imitate elk-tusks. The braids of hair are wound with strips of otter fur, and a weasel skin dangles from each. The bands of white on the hair are effected with white clay. *Corbis*

ABOVE: Shirt—a Kalispel man, March 11, 1910. In his studies, Curtis found that though the Kalispel had a reputation of being a peaceful tribe, they had a history of warfare with the Blackfeet and Kutenai and had borrowed the habit of scalping from the Flatheads. *Library of Congress, Prints & Photographs Division, Edward S. Curtis Collection, LC-USZ62-133229*

ABOVE: A Kutenai woman; c. 1910. A tribe and independent linguistic family of Indians they either migrated or were forced, probably by the Blackfoot, across the Rocky Mountains into what is now southeastern British Columbia, where they seem to have split into upper and lower divisions. *Library of Congress, Prints & Photographs Division, Edward S. Curtis Collection, LC-USZ62-115810*

Two Flathead women drying meat on a stick frame; c. 1910. Curtis discovered that unlike other Salishan tribes, the Flathead had a tradition of leaving their mountain home to hunt bison on the plains to the east, providing a welcome departure from their fish-oriented diet. He also found that by the time of his studies, very few true Flatheads survived—most of the people had inter-married with neighboring tribes.

Library of Congress, Prints & Photographs Division, Edward S. Curtis Collection, LC-USZ62-113093

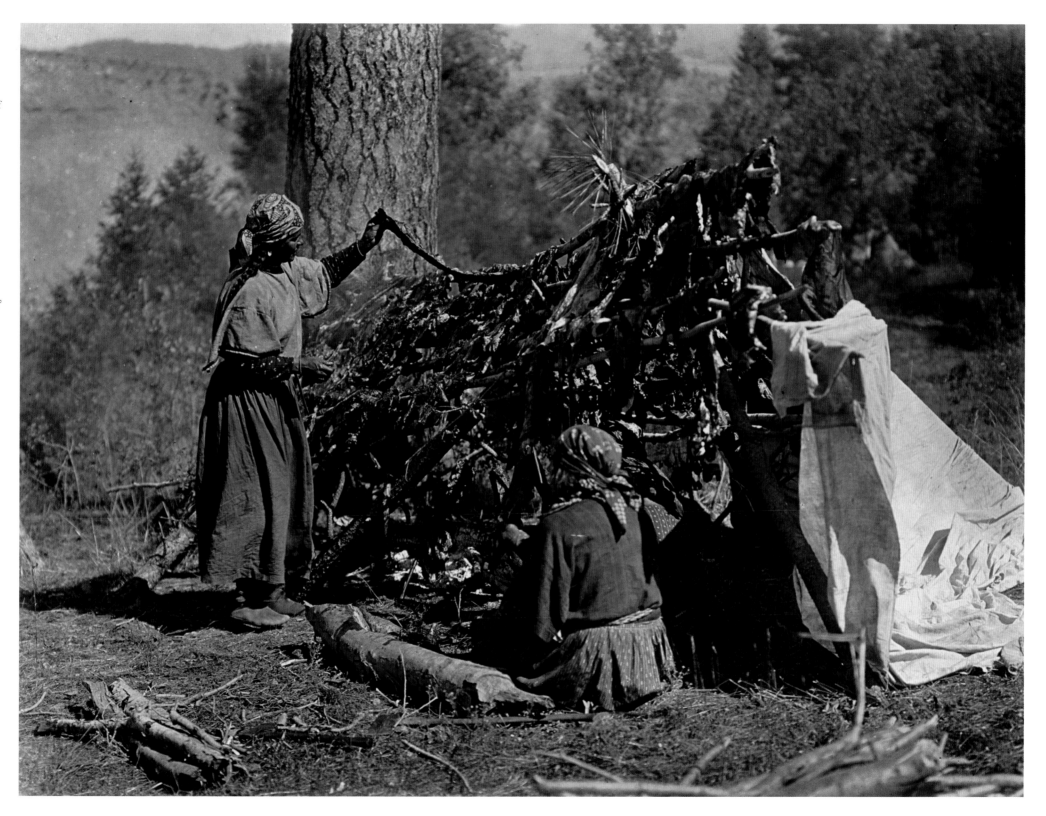

Buoyed by a new investment from J. Pierpont Morgan, Edward Curtis started 1910's fieldwork by recreating the final leg of Lewis and Clark's journey down the Columbia. As he and his team flirted with danger on the flooded river, they gathered the final pictures and data for this volume.

The Nez Perce are provided the bulk of the page space, not surprising given the legend of their 1877 war and stymied attempt to escape to Canada, and Curtis's profound respect for the tribe's Chief Joseph, whom he met and photographed in 1903. In the book, Curtis explained that he wished to focus his reader's attention not on the details of the war, but on the Nez Perce people, providing a forum for "the Indians' side of the story."

This volume is also significant for its coverage of the Wishram; Curtis declared that readers "will be refreshed by a change to a life radically different from that of any tribe hitherto treated." He was clearly smitten with the salmon-fishing Chinook people who paddled large and distinctive canoes and held mystical, magic-laced religious beliefs.

Wishram petroglyphs along the Columbia River; c. 1910. The Wishram culture was closely tied to and heavily influenced by the river. They were skilled fisherman and salmon dominated their diet. The great river also brought them into frequent contact with travelers and traders and Curtis noted that they had absorbed traditions from numerous other cultures, including Plains-style clothing.
Library of Congress, Prints & Photographs Division, Edward S. Curtis Collection, LC-USZ62-118592

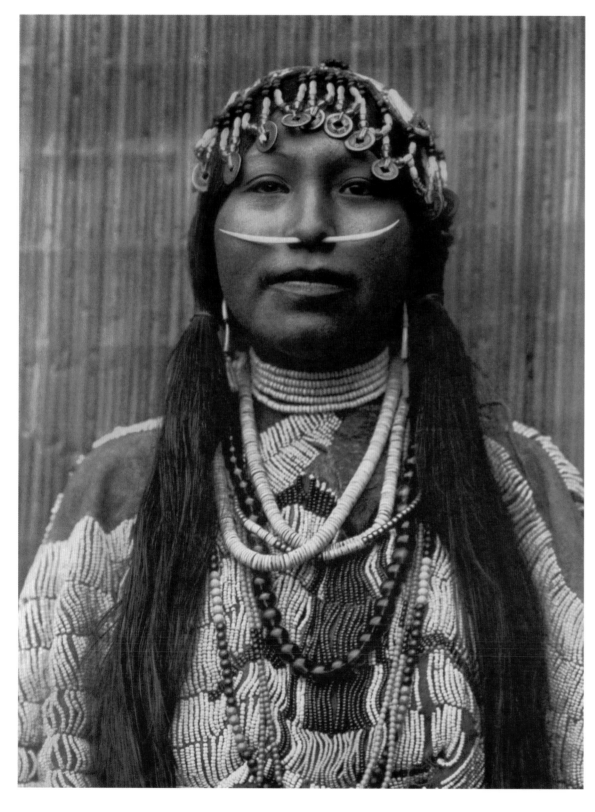

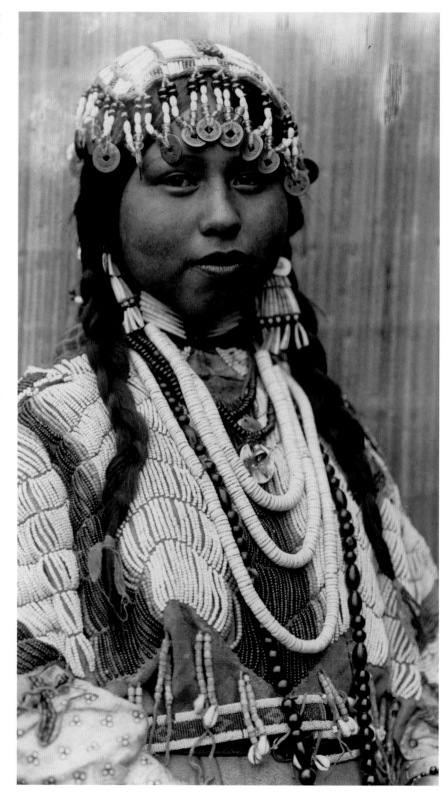

LEFT: A portrait of a young Wishram woman wearing a dentalium shell nose ornament, a headdress with Chinese coins, and a beaded dress—items all undoubtedly obtained by bartering their surplus salmon for goods delivered by visiting traders. *Corbis*

RIGHT: A Wishram bride, c. 1910. Curtis found that Wishram marriages were strictly business, with the families negotiating a suitable price for the bride, usually by messenger. When the appropriate arrangements had been made, the wedding was generally celebrated with a series of feasts.
Library of Congress, Prints & Photographs Division, Edward S. Curtis Collection, LC-USZ62-105387

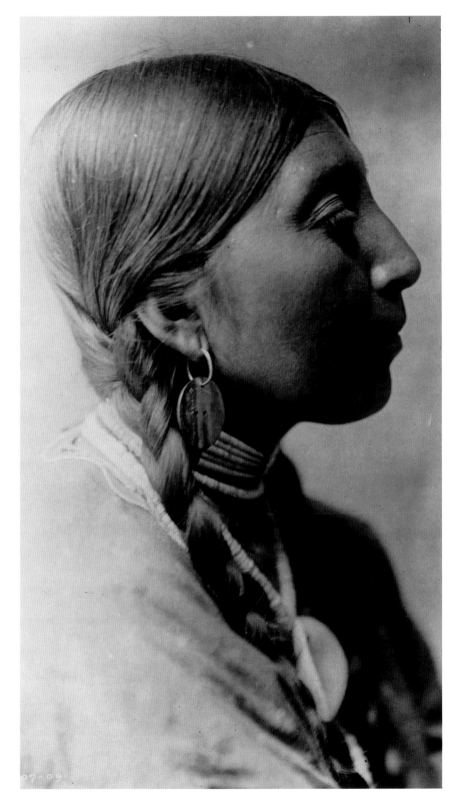

LEFT: Portrait of young Wishram woman, facing right, wearing braids, shell bead choker, and abalone shell disk earrings; c. 1910. *Library of Congress, Prints & Photographs Division, Edward S. Curtis Collection, LC-USZ62-107917*

RIGHT: Nez Perce matron; c. 1910. The most important tribe of the Shahaptian linguistic family occupied lands between the Bitteroot Mountains in the east and to the junction of the Snake and Columbia rivers in the west. They made their homes along the Clearwater and Snake rivers and in the Wallowa valley in what is now Idaho. *Library of Congress, Prints & Photographs Division, Edward S. Curtis Collection, LC-USZ62-113085*

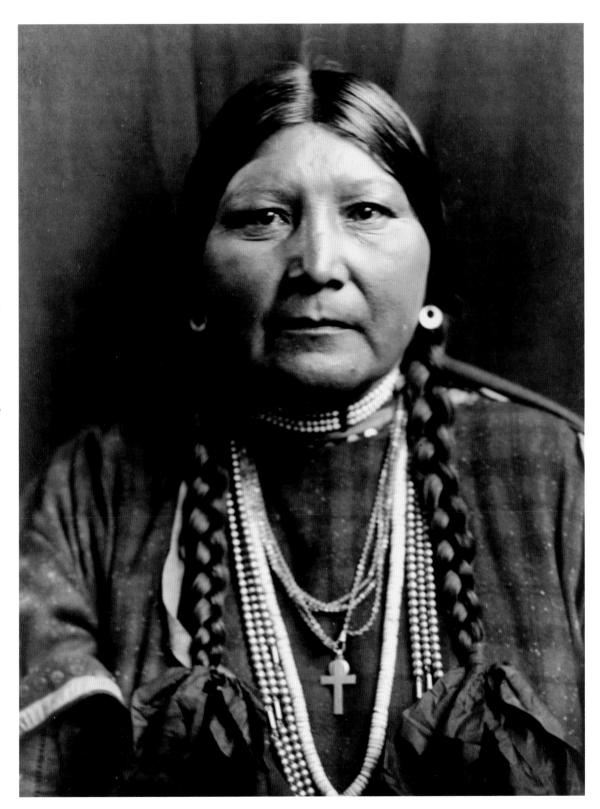

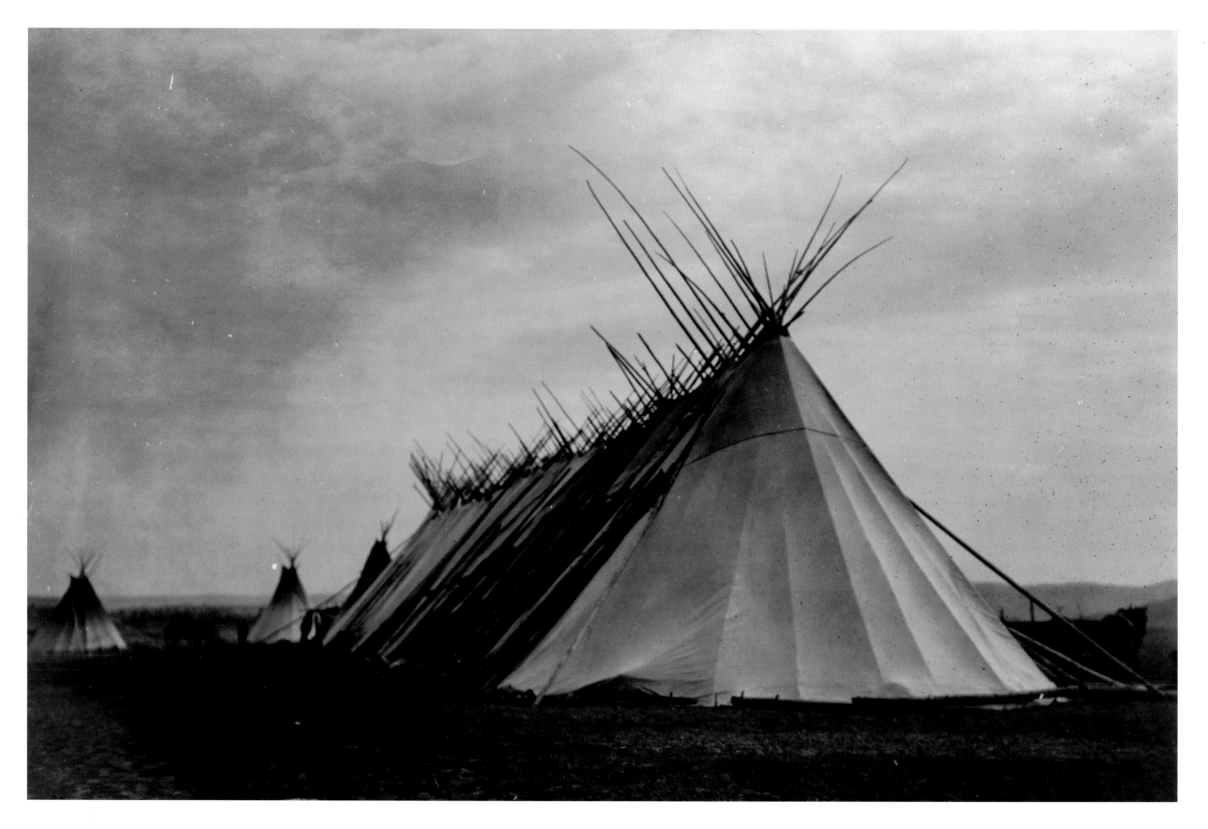

LEFT: Joseph Dead Feast Lodge—Nez Perce; c. 1905. They had strong trading links with the northern Plains Indians, particularly with the Crow, and made seasonal bison-hunting visits to the Montana plains. *Library of Congress, Prints & Photographs Division, Edward S. Curtis Collection, LC-USZ62-106478*

RIGHT: Innocence, an Umatilla girl; c. 1910. The Umatillas lived on the lower Umatilla River near its junction with the Columbia in present Umatilla County, Oregon. *Library of Congress, Prints & Photographs Division, Edward S. Curtis Collection, LC-USZ62-110503*

FAR RIGHT: A typical Nez Perce in full feather headdress, braided hair, and necklaces; c. 1910. *Library of Congress, Prints & Photographs Division, Edward S. Curtis Collection, LC-USZ62-113086*

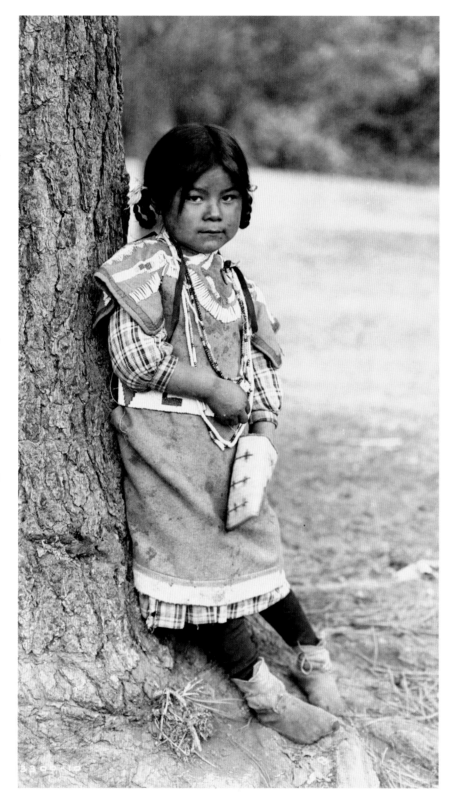

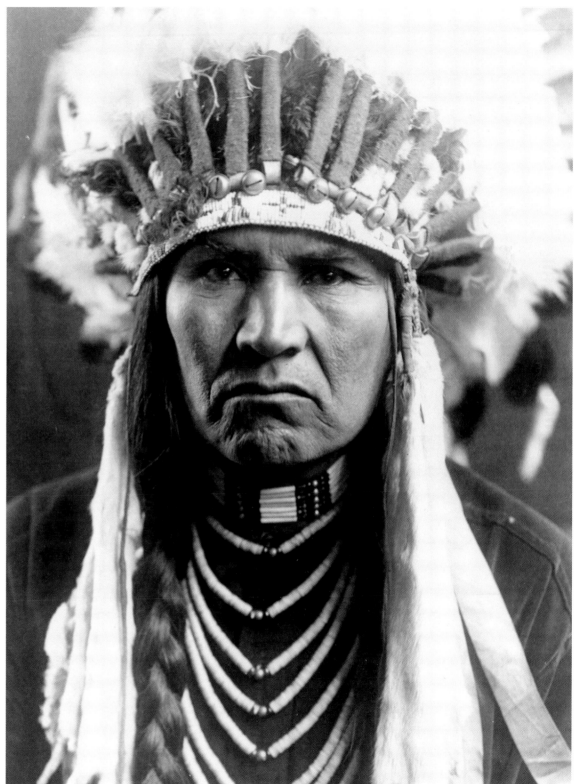

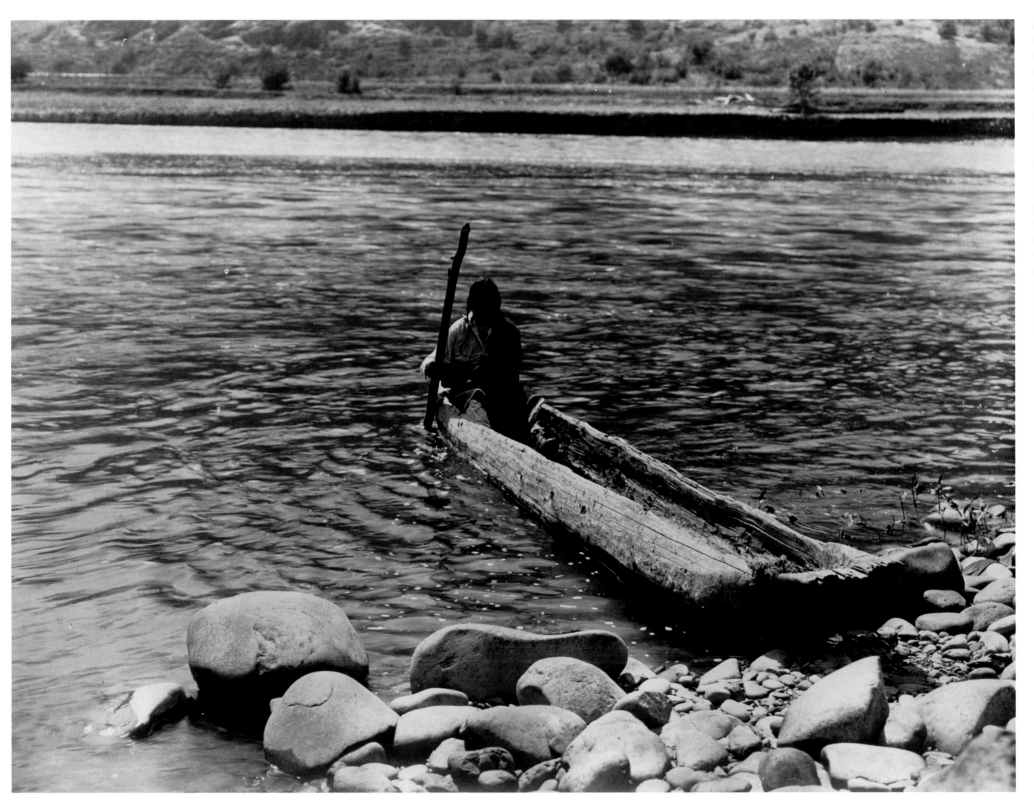

A Nez Perce man maneuvers a dugout canoe to rocky shore; December 8, 1910. Curtis had particularly warm feelings for this tribe because of his affection for their great leader, Chief Joseph. Ironically, while photographing a potlatch during a 1905 memorial service for Joseph, Curtis got into an angry shoving match with a Nez Perce chief who objected to his taking pictures of the solemn ceremony.
Library of Congress, Prints & Photographs Division, Edward S. Curtis Collection, LC-USZ62-47015

Curtis notes: Wealthy members of the tribes living on the Umatilla reservation in Oregon spare no expense in bedecking themselves and their mounts on gala occasions. The articles of adornment are usually of deerskin, or of commercial blankets on which designs are worked in beads. These are Cayuse, a tribe of the upper Wallawalla, Umatilla, and Grande Ronde rivers in northeastern Oregon, although they originally came from the Deschutes River area, who were settled on the Umatilla Reservation. They are particularly famous for their horses.
Corbis

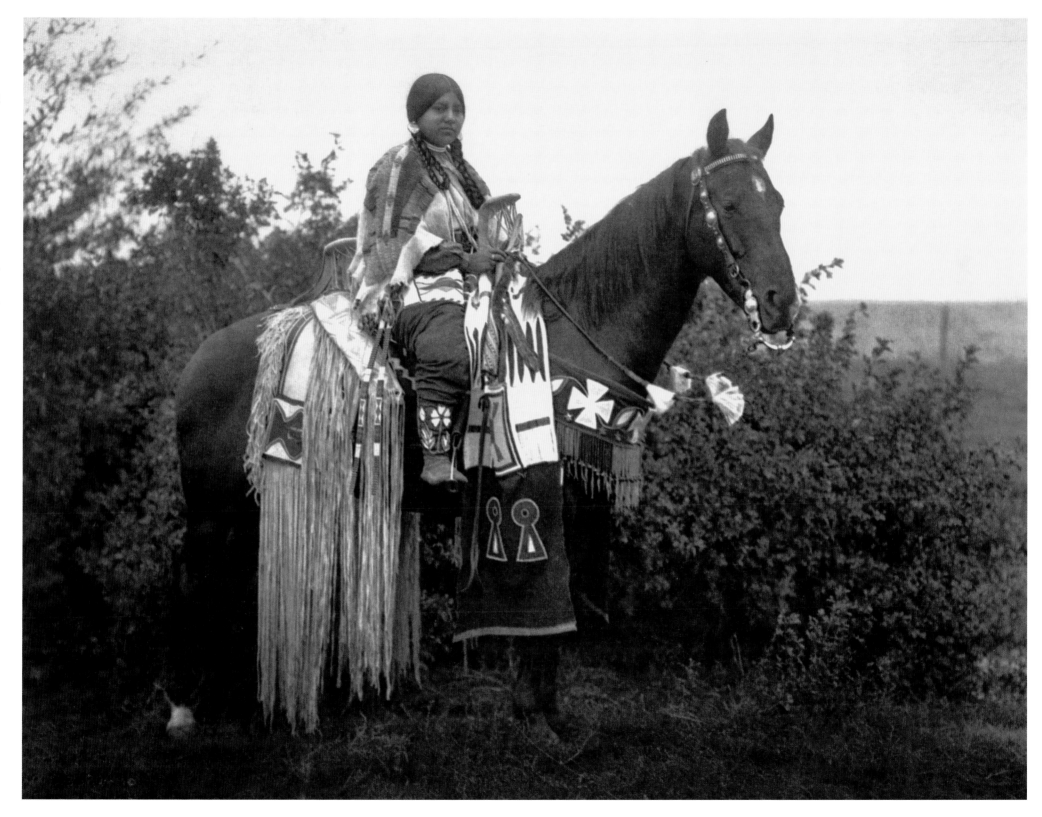

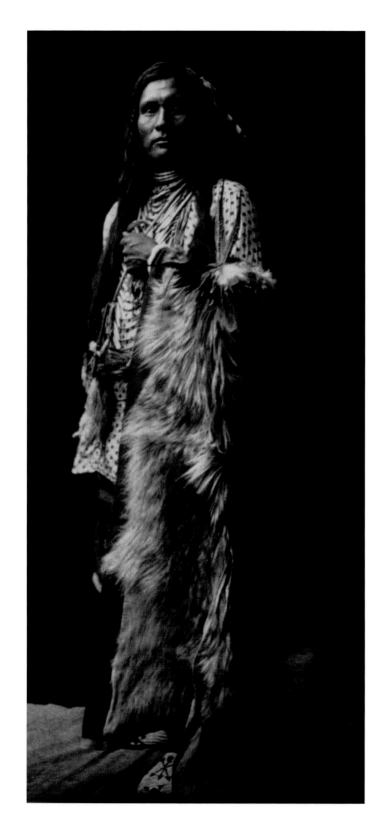

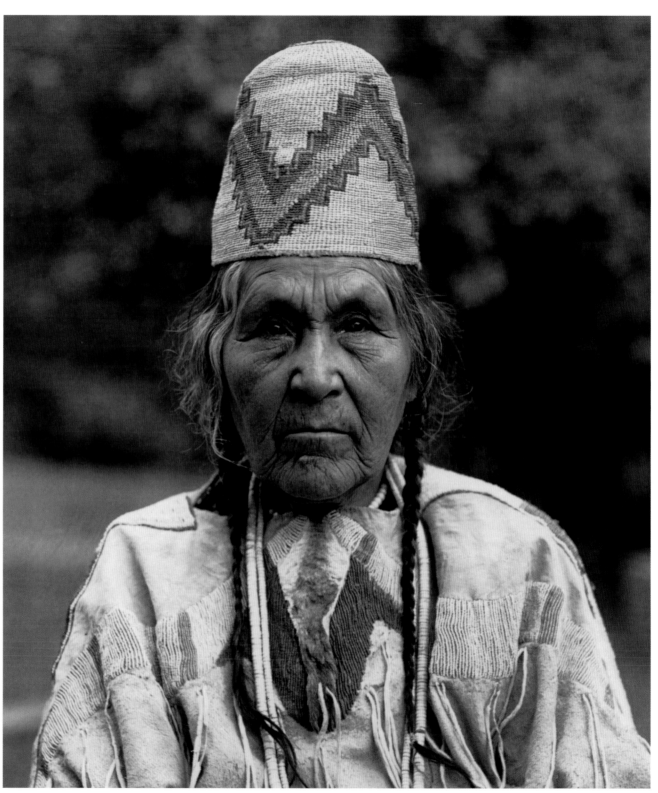

FAR LEFT: A Young Nez Perce. *Corbis*

LEFT: Cayuse matron. Note the basketry cap worn by western women from Washington State to California. *Corbis*

RIGHT: Cayuse mother and child. *Corbis*

FAR RIGHT: Chief Joseph, Nez Perce, 1903. Curtis noted, "The name of Chief Joseph is better known than that of any other Northwestern Indian. To him popular opinion has given the credit of conducting a remarkable strategic movement from Idaho to northern Montana in the flight of the Nez Perces in 1877. To what extent this is a misconception has been demonstrated in the historical effort to retain what was rightly their own makes an unparalleled story in the annals of the Indian's resistance to the greed of the whites. That they made this final effort is not surprising. Indeed, it is remarkable that so few tribes rose in a last struggle against such dishonored and relentless objection. *Christie's Images/Corbis*

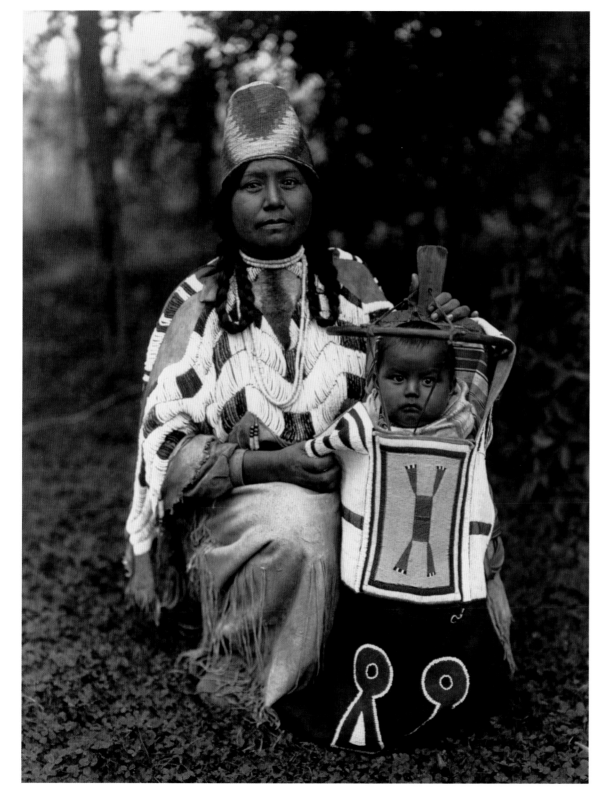

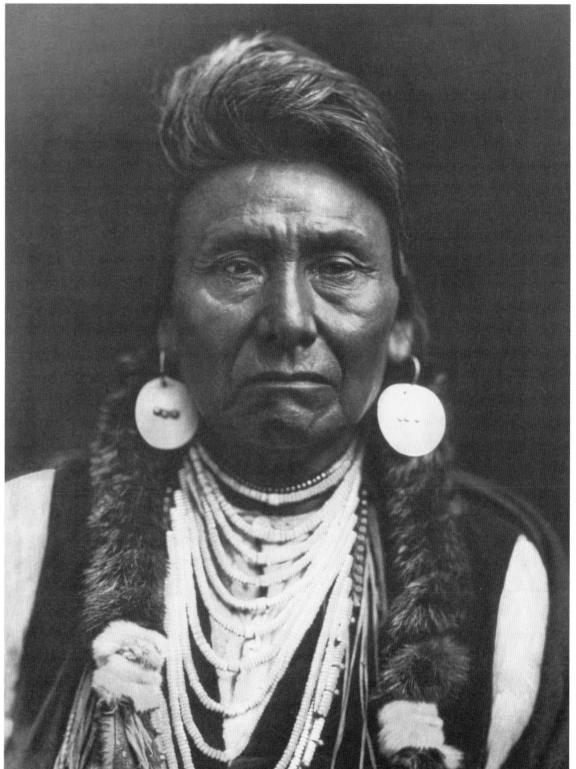

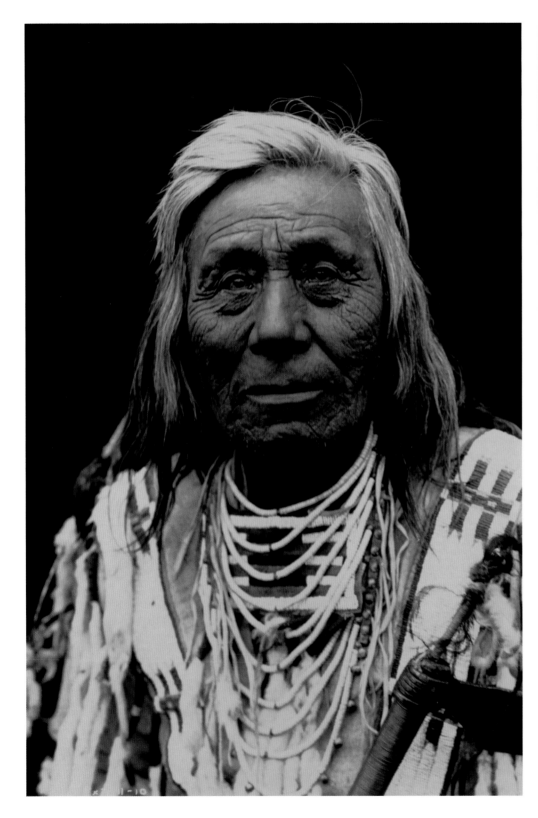

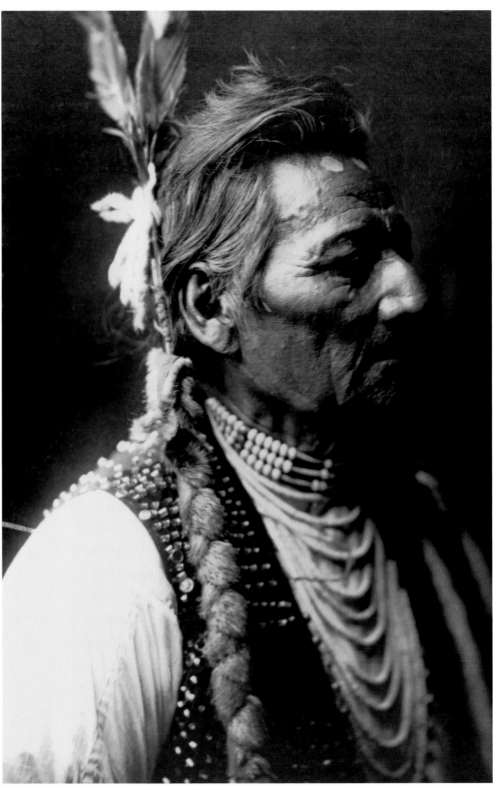

FAR LEFT: Curtis captioned this photograph "Cayuse Type." Well-known for their horses, the tribe was settled on the Umatilla Reservation and merged into the "Consolidated Umatilla." *Corbis*

LEFT: Piopio-maksmaks, a man from the Wallawalla tribe, also moved to the Umatilla Reservation where they have consolidated with the Umatilla and Cayuse. *Corbis*

RIGHT: Cayuse woman. Closely related to the Nez Perce, she wears a typical outfit for the Plateau tribes—the dress with a square-cut yoke and sleeves cut short and worn over a blouse. *Corbis*

FAR RIGHT: Wishram Fisherman. Curtis noted, "Among the middle course of the Columbia at places where the abruptness of the shore and the up-stream set of an eddy make such method possible, salmon were taken, and still are taken, by means of a long-hauled dip-net. At favorable seasons a man will, in a few hours, secure several hundred salmon— as many as the matrons and girls of his household can care for in a day." *Christie's Images/Corbis*

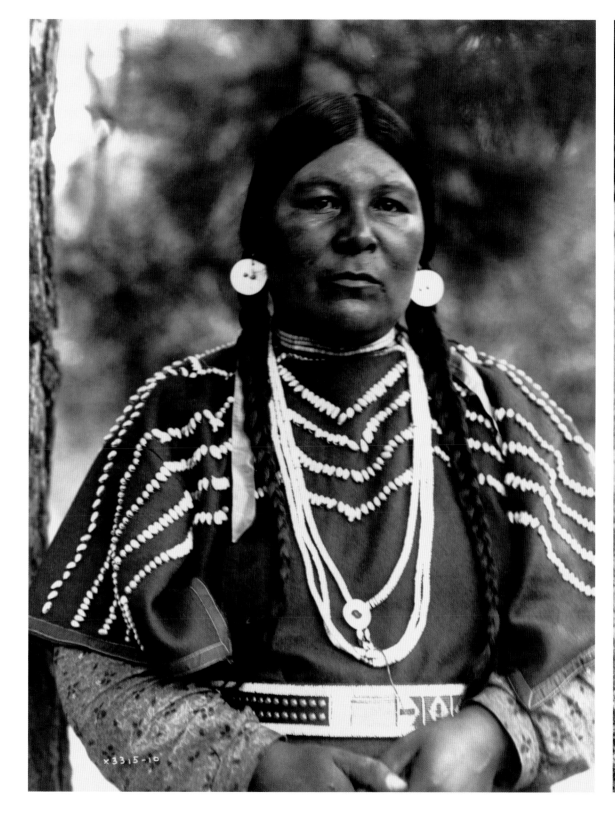

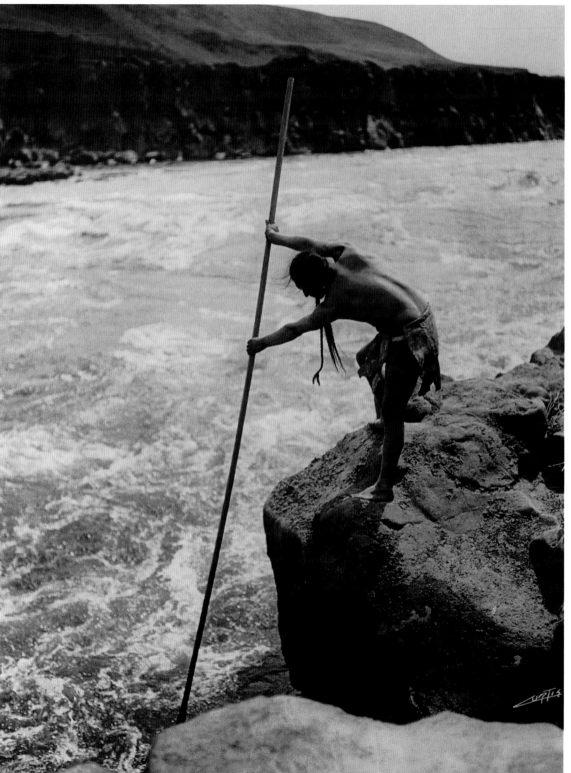

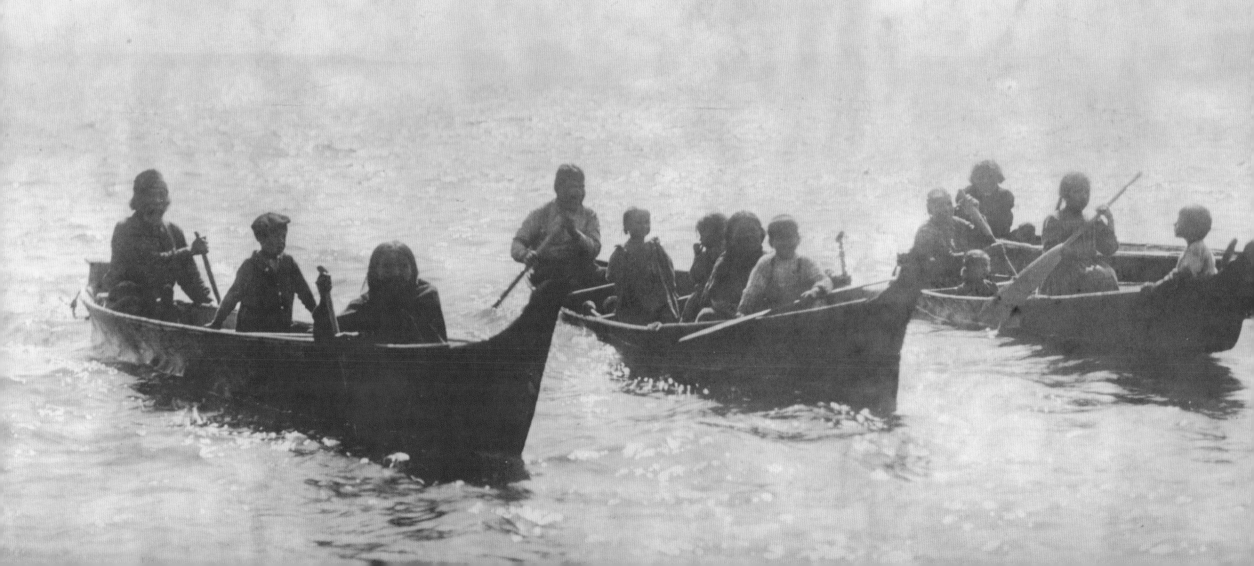

This book was published two years after the release of Volume VIII and shortly after the death of J. Pierpont Morgan. Curtis included in this volume a heartfelt tribute to the man who was the primary benefactor of *The North American Indian* project.

This volume, largely the result of fieldwork conducted in 1910, was devoted to the numerous small tribes living along the Pacific coast, primarily in Washington, but extending northward past Puget Sound into British Columbia. These tribes were all united in speaking various dialects of the Salish language and by their similar cultures. All of them relied on salmon for food, on cedar for buildings, boats and implements, and on the potlatch ceremony for maintaining social order.

That an entire volume was dedicated to these little-known tribes may seem unusual, but the coastal Salishan were among the first Native Americans that Edward Curtis photographed. Starting as early as 1896, he frequently photographed Salishan people while exploring the country near his home in Seattle.

Curtis described the natives living on the northern half of Washington's Shoalwater Bay—who called themselves "People of the Enclosed Bay"—as "salt-water Indians." As evidenced by this 1913 photo, they were most at home on the water, paddling their large canoes and fishing for salmon.
Library of Congress, Prints & Photographs Division, Edward S. Curtis Collection,
LC-USZ62-113095

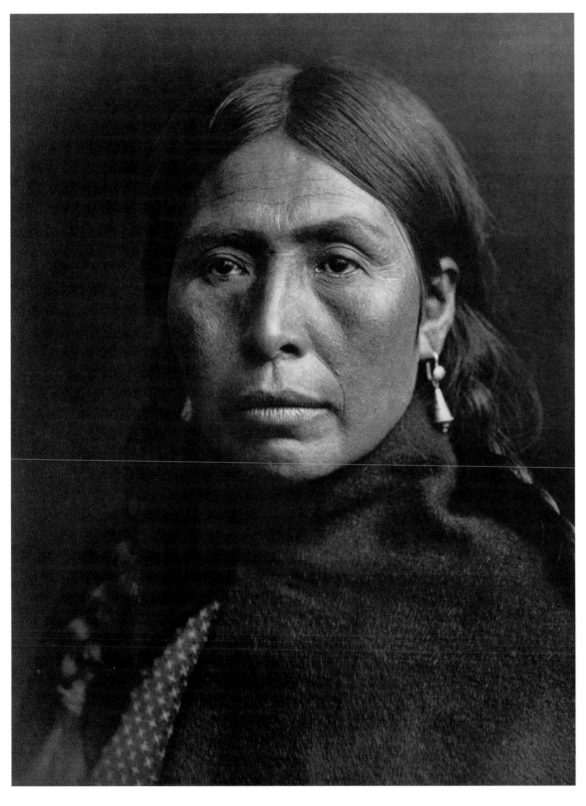

LEFT: A portrait of a Lummi woman. Related to the Songish of southern Vancouver Island, they lived around Lummi and Bellingham bays, Washington. In 1855, they relinquished a large area and moved to the Lummi Reservation. *Corbis*

RIGHT: Quilliute girl; c. 1913. Curtis observed that the tribe's standard ritual for a girl experiencing her first menstrual cycle included five days of seclusion and fasting, avoiding fire, submerging herself in a stream and, oddly, scratching her head only with a stick. *Library of Congress, Prints & Photographs Division, Edward S. Curtis Collection, LC-USZ62-118580*

LEFT: Young Quiunalt wearing shell ornaments; c. 1913. The largest and most important Salish people on the Pacific shore of Washington State, living mainly in the valley of the Quinault River and near Taholah, the site of their principal village. They remained fairly isolated until the Quinault River Treaty of 1855 and the establishment of their reservation.
Library of Congress, Prints & Photographs Division, Edward S. Curtis Collection, LC-USZ62-108467

RIGHT: Quinault woman, c. 1913. These peaceful people (Curtis uncovered evidence of only one minor battle in their recent history) lived quietly along the Washington coast between the Hoquiam and Queets rivers, catching salmon, trout, smelt, and other fish for their living.
Library of Congress, Prints & Photographs Division, Edward S. Curtis Collection, LC-USZ62-108468

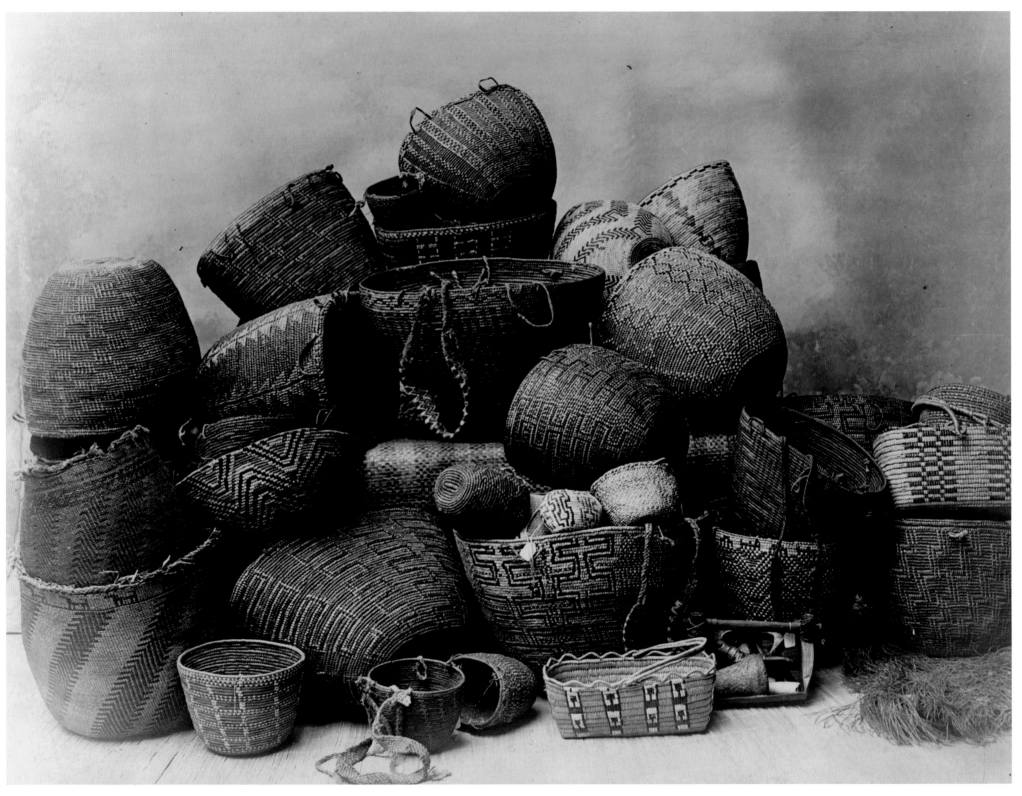

LEFT: Curtis noted the exceptional basketry of the Puget Sound tribes, singling out the Skokomish Twana band as being especially skilled and known for their soft and flexible baskets.
Library of Congress, Prints & Photographs Division, Edward S. Curtis Collection, LC-USZ62-119797

RIGHT: The Skokomish mat houses were ingenious and portable means of shelter. The rolled tule mats could be carried in a canoe and quickly assembled on a pole framework, providing travelers a dry place to sleep—always important in the rainy Pacific Northwest.
Library of Congress, Prints & Photographs Division, Edward S. Curtis Collection, LC-USZ62-105859

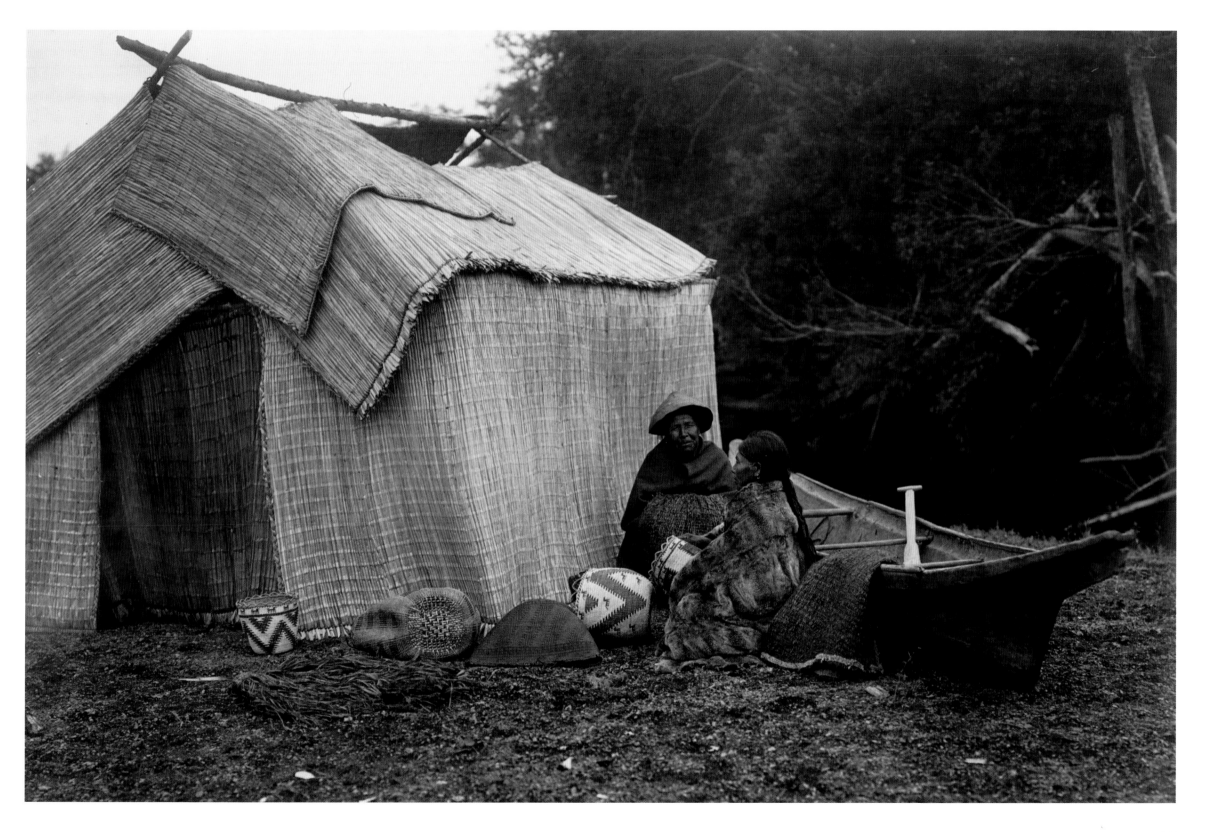

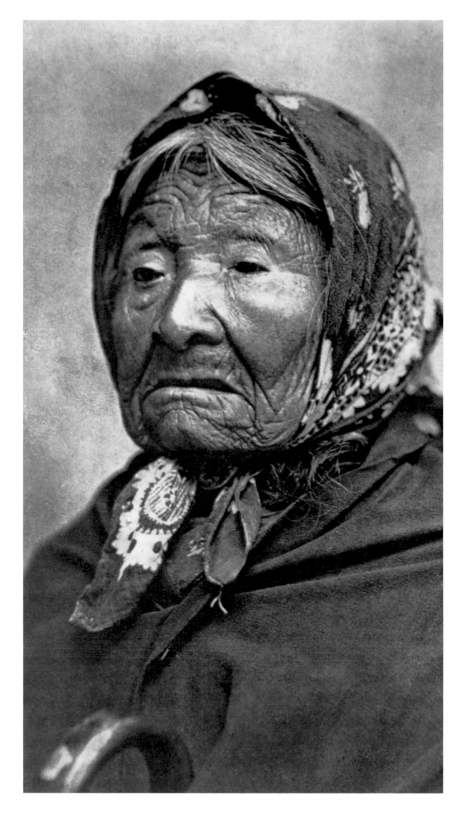

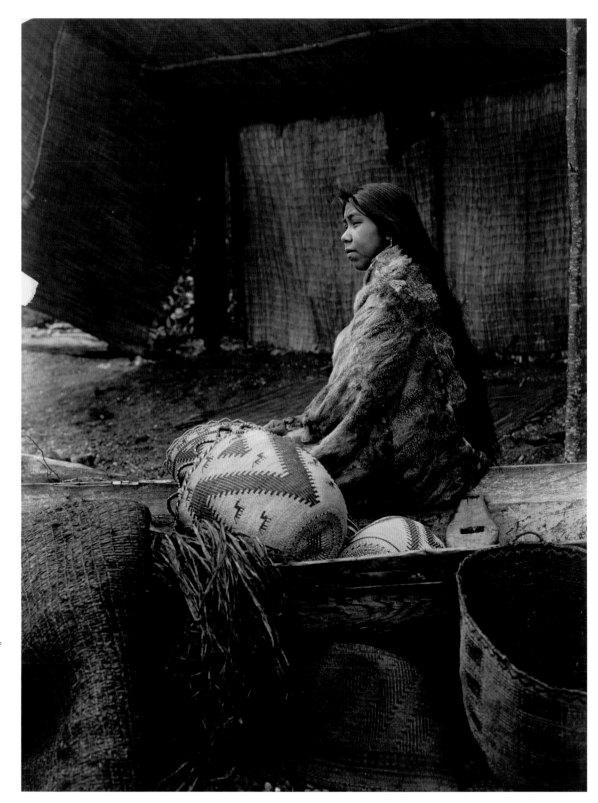

LEFT: A portrait of the daughter of Chief Siahl—Seattle—Princess Angeline. See page 10 for more information about the princess. *Corbis*

RIGHT: A Skokomish Indian chief's daughter, seated on canoe; c. 1913. A large body of Salish on the Hood Canal, Washington, the Skokomish had wide trading ties, and a complex ceremonial and social structure including the use of slaves. *Library of Congress, Prints & Photographs Division, Edward S. Curtis Collection, LC-USZ62-110504*

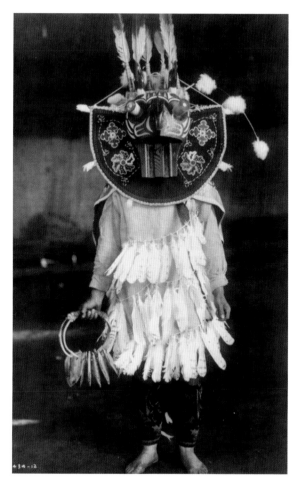

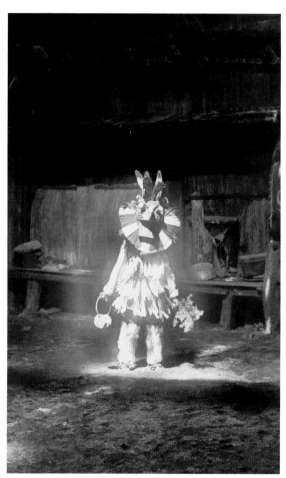

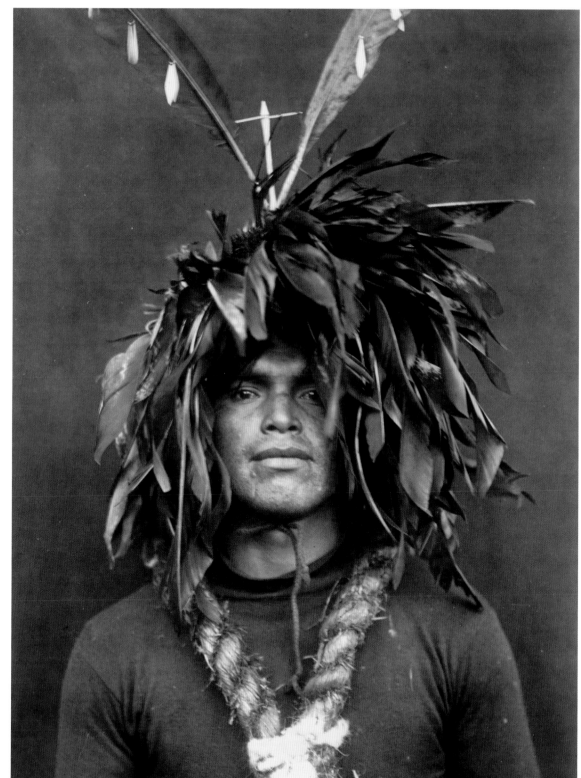

ABOVE: Curtis found the potlatch thriving with the Cowichan. They would gather during weeklong ceremonies during which the wealthy host would bestow gifts on his guests. The last day often included performances by masked dancers, such as this man photographed in June 1913. *Library of Congress, Prints & Photographs Division, Edward S. Curtis Collection, LC-USZ62-52206*

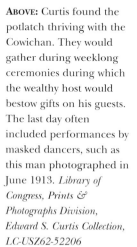

ABOVE: Cowichan, masked dancer; c. 1913. The Cowichan or Island Halkomelem occupied the southeastern coast of Vancouver Island between the Comox to the north and the Songish to the south, including a number of islands. *Library of Congress, Prints & Photographs Division, Edward S. Curtis Collection, LC-USZ62-110965*

RIGHT: Cowichan warrior's feather head-dress; c. 1913. *Library of Congress, Prints & Photographs Division, Edward S. Curtis Collection, LC-USZ62-118582*

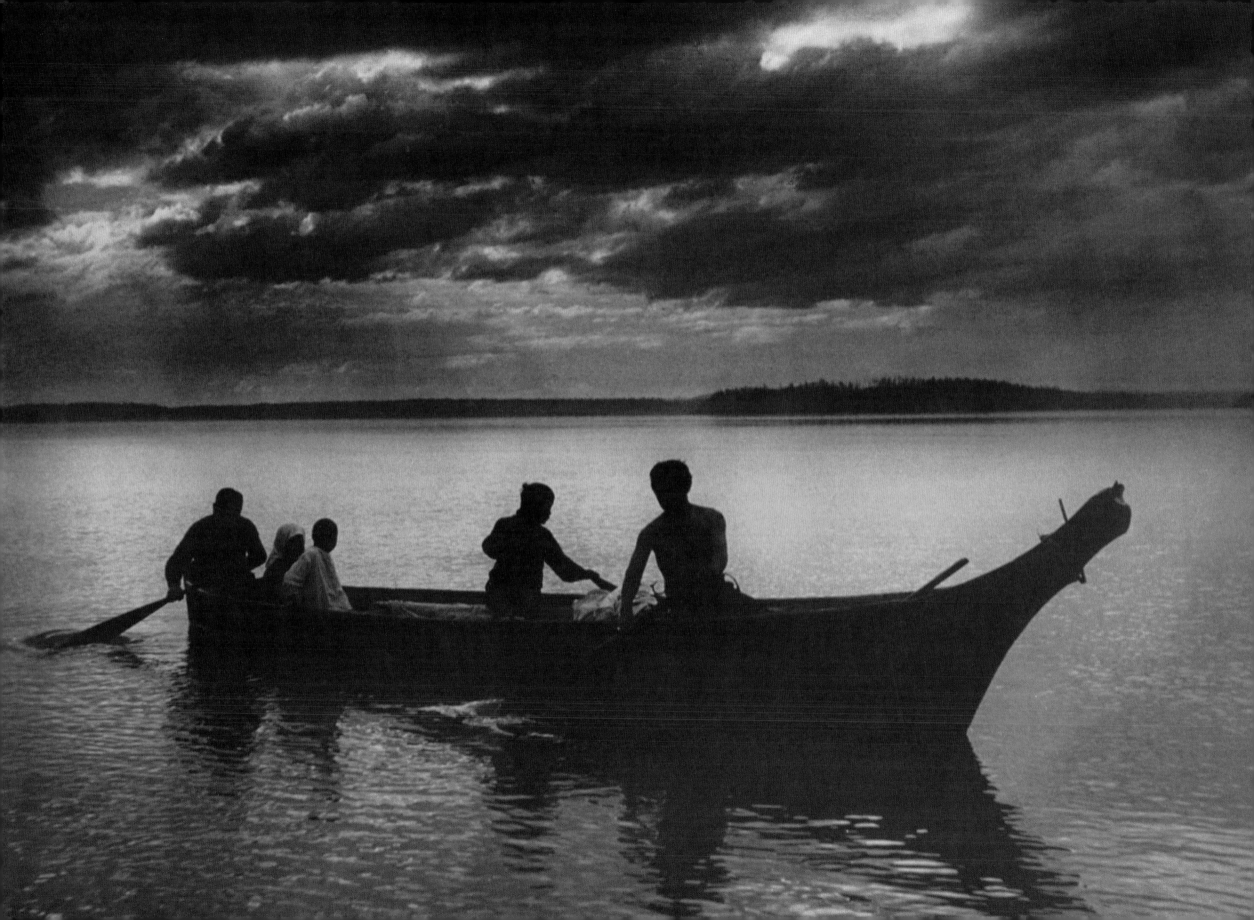

LEFT: "Homeward." A dusk view of one of the traditional west coast canoes—usually made from red cedar. *Christie's Images/Corbis*

RIGHT: "The Mussel Gatherer." The many tribes of the west and northwest coast made use of the abundant fish and shellfish stocks. *Corbis*

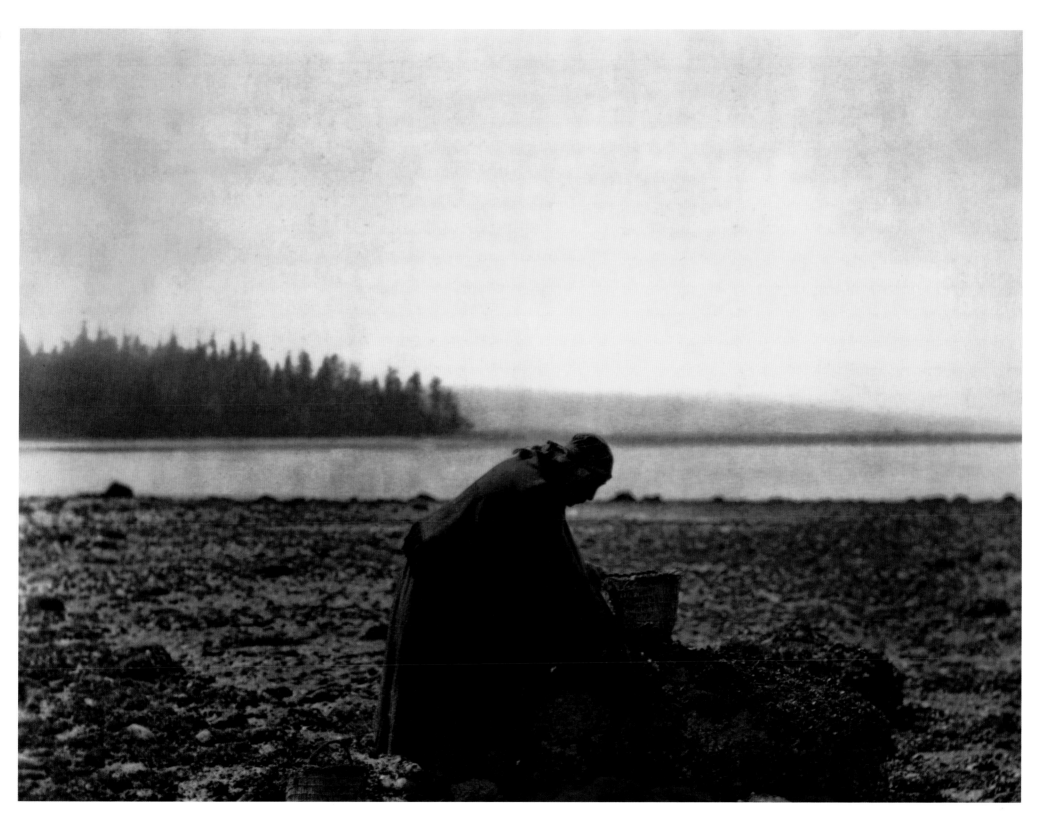

Volume X
The Kwakiutl.

In a historic book series loaded with a number of "significant" volumes, this installment on the Kwakiutl of Canada's Pacific coast may have been the most special—at least in the eyes of its author. He informed his subscribers "This volume…is worthy of special consideration…No volume of the series has required an equal amount of labor…" The last line was an understatement. From 1910 through 1914, Curtis and his team spent considerable time with the Kwakiutl, including filming a motion picture, *In the Land of the Headhunters.*

Curtis's fascination with the Kwakiutl was understandable. They had a rich and colorful culture, highlighted by elaborate potlatch ceremonies, beautiful totem poles, and mysterious religious beliefs that might have included ritual cannibalism. Acknowledging that the Kwakiutl offered a rare connection to an earlier time, Curtis explained in the book's introduction, "At the present time theirs are the only villages where primitive life can still be observed."

Curtis could have not succeeded at his task without the invaluable help of George Hunt, an educated, half-Scottish member of the tribe. Appropriately, in the published volume Curtis offered Hunt generous praise for his talent and hard work.

Kwakiutl wedding guests arrive in canoes; c. 1914. The Kwakiutl lived along the rugged coast of British Columbia, a challenging landscape of rocky outcrops and deep forest, often bathed in fog and rain. Curtis described the people as being very much a product of their landscape—mysterious and gloomy—but was mesmerized by them. He spent considerable time among them between 1910 and 1914.
Library of Congress, Prints & Photographs Division, Edward S. Curtis Collection, LC-USZ62-104025

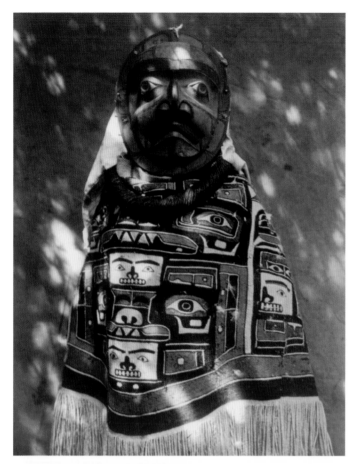

LEFT: A Tluwulahu costume—a Qagyuhl (Kwakiutl) woman wearing a fringed Chilkat blanket, a hamatsa neckring and mask representing a deceased relative who had been a shaman November 13, 1914. The Kwakiutl were particularly noted for their superb woodcarving and painting art, for totem poles, house gable fronts and columns, mortuary posts and masks.
Library of Congress, Prints & Photographs Division, Edward S. Curtis Collection, LC-USZ62-52211

RIGHT: Several Kwakiutl people dancing in a circle around a smoking fire, in an effort to cause a sky creature, which they believe swallowed the moon, to sneeze thereby disgorging it.
Library of Congress, Prints & Photographs Division, Edward S. Curtis Collection, LC-USZ62-73627

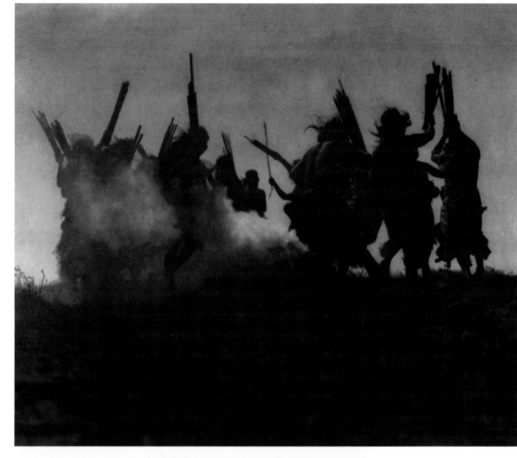

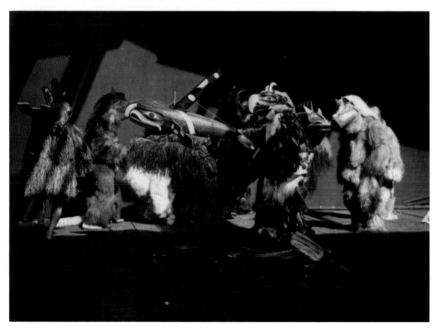

LEFT: Kwakiutl ceremonial dancers, in a circle during the Winter Dance ceremony, wearing masks and garments of fur, feathers, and other materials; November 13, 1914.
Library of Congress, Prints & Photographs Division, Edward S. Curtis Collection, LC-USZ62-52218

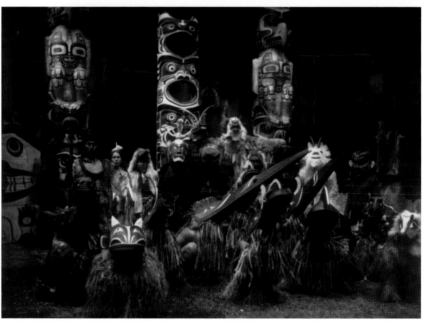

LEFT: Masked and costumed Kwakiutl dance in front of a trio of totem poles on November 13, 1914. Colorful scenes like this captivated Edward Curtis—so much that he invested $75,000 to film a motion picture about the Kwakiutl called *In the Land of the Headhunters.* Like most Curtis ventures, the resulting film was both a critical success and a financial flop.
Library of Congress, Prints & Photographs Division, Edward S. Curtis Collection, LC-USZ62-49042

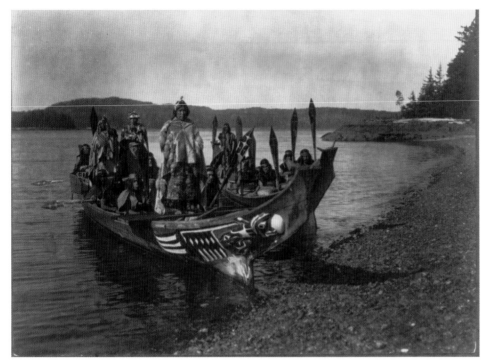

Continuing the sequence of photographs started on pages 146–147, these photographs are of a wedding party. At left, two canoes pulled ashore with the wedding party The bride and groom standing on the "bride's seat" in the stern, while a relative of the bride dances on a platform in the bow.

The guests arrive by canoe—at right two people in a canoe, one dressed in bear skin, including paws, and a mask; in the photograph at bottom right can be seen in the bow qunhulahl, whom Curtis described as "a masked man personating the thunderbird, dances with characteristic gestures as the canoe approaches the bride's village."

Finally, bottom left, is the wedding party, bride in center, hired dancers on each side, her father on far left, all standing on a platform, with a plank wall behind them, and flanked by two totem poles. The groom's father is on the right behind the man with a box-drum.

Library of Congress, Prints & Photographs Division, Edward S. Curtis Collection, LC-USZ62-51435, LC-USZ62-52191, LC-USZ62-52200, and LC-USZ62-52209

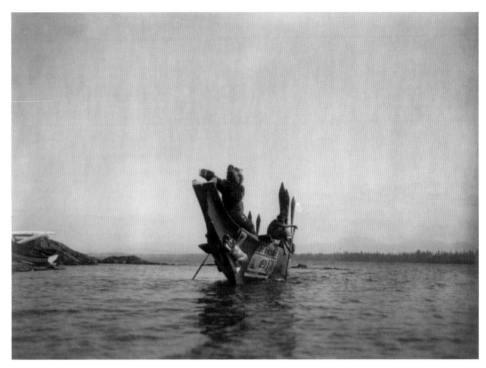

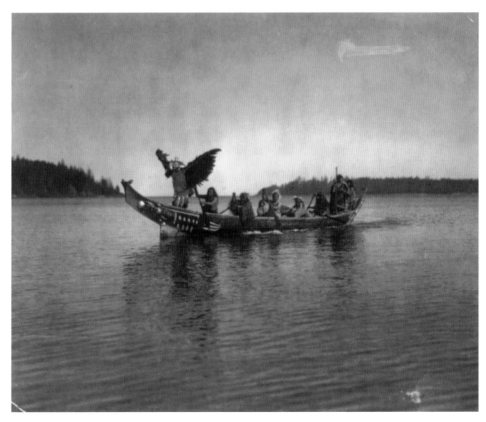

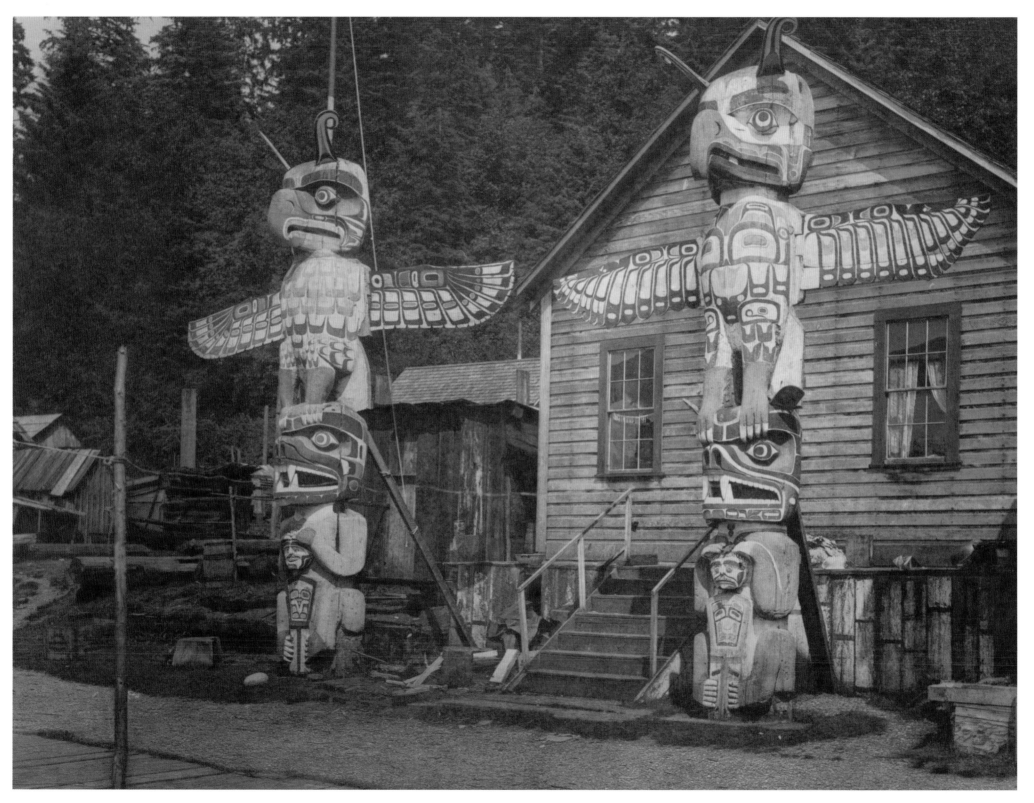

Left: Carved posts at Alert Bay. Curtis notes that these two heraldic columns at the Nimkish village Yilis, on Cormorant Island, represent the owner's paternal crest, an eagle, and his maternal crest, a grizzly-bear crushing the head of a rival chief. In recent years Alert Bay has seen a revival of Kwakiutl art and culture. *Corbis*

Right: Qa hila—a Koprino man—with bone in nose; c. 1914. The Koprino Indians are part of the Kwakiutl group. *Library of Congress, Prints & Photographs Division, Edward S. Curtis Collection, LC-USZ62-121684*

Far right: Atlumhl—a Koskimo—in costume with ceremonial mask; c. 1914. The Koskimo group lived around Klaskino Inlet *Library of Congress, Prints & Photographs Division, Edward S. Curtis Collection, LC-USZ62-102053*

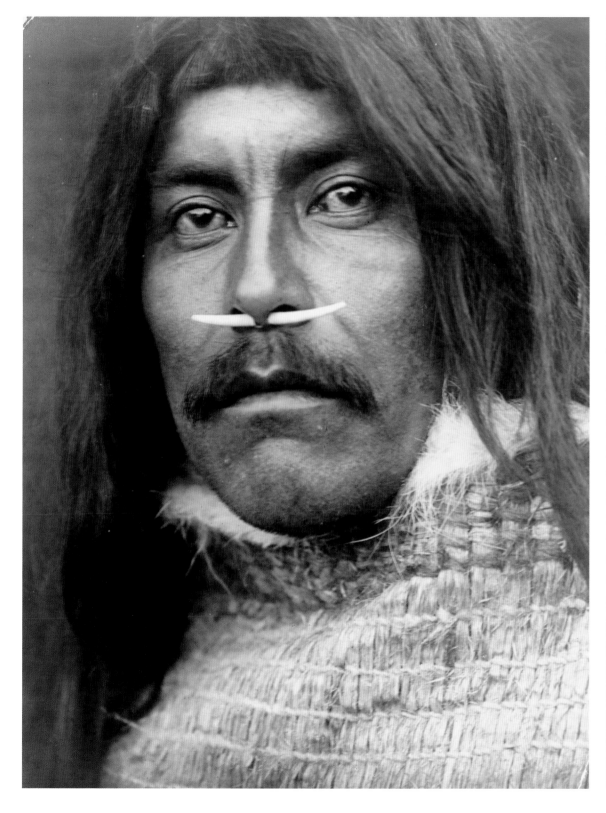

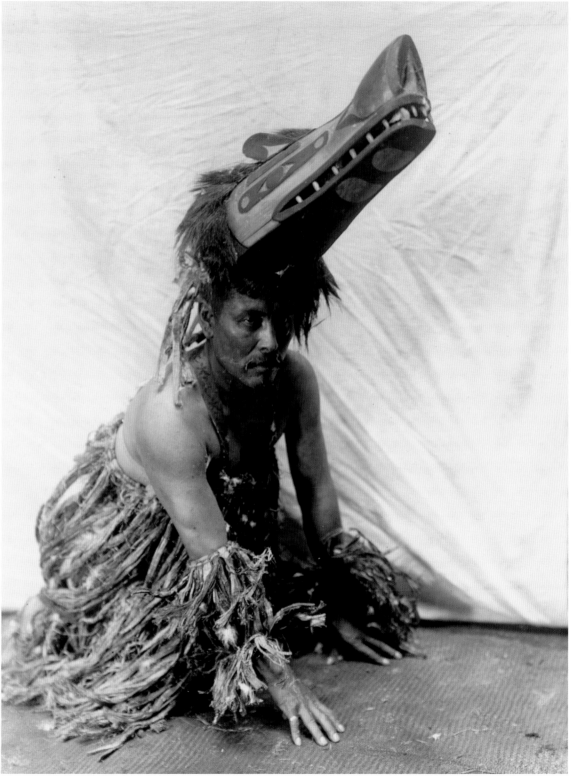

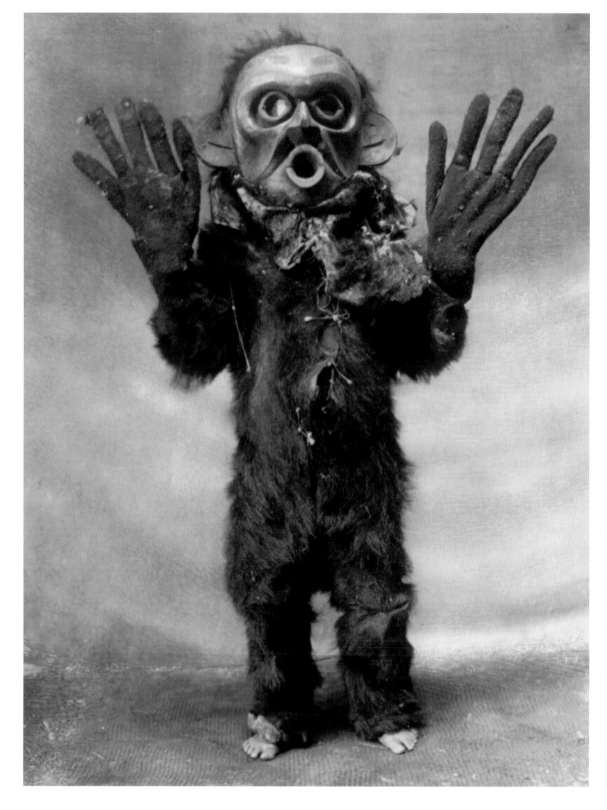

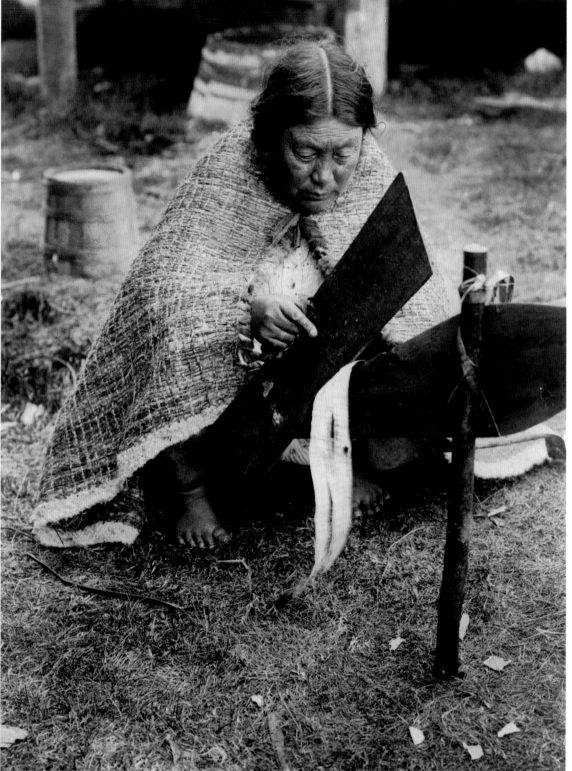

FAR LEFT: Koskimo wearing full-body fur garment, oversized gloves and mask of Hami ("dangerous thing") during the numhlim ceremony; November 13, 1914. *Library of Congress, Prints & Photographs Division, Edward S. Curtis Collection, LC-USZ62-52208*

LEFT: A Nakoaktok preparing cedar bark; c. 1914. *Library of Congress, Prints & Photographs Division, Edward S. Curtis Collection, LC-USZ62-106282*

RIGHT: A hazy morning—a Nakoaktok man standing on shore; c. 1910. *Library of Congress, Prints & Photographs Division, Edward S. Curtis Collection, LC-USZ62-106741*

FAR RIGHT: Tsawatenok girl; c. 1914. *Library of Congress, Prints & Photographs Division, Edward S. Curtis Collection, LC-USZ62-108465*

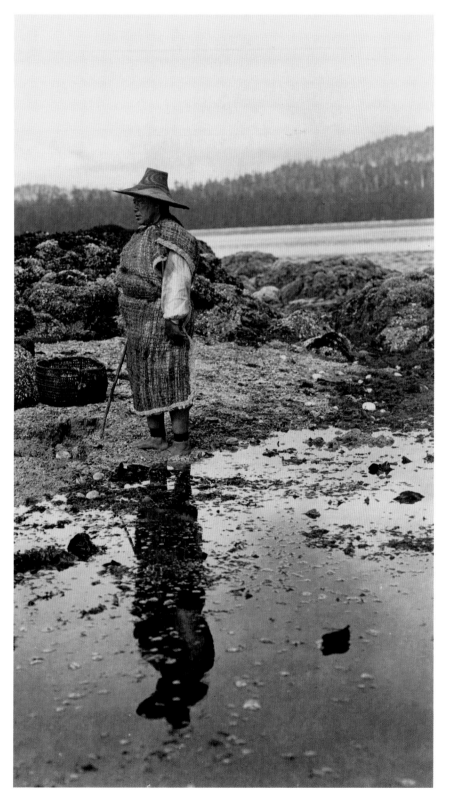

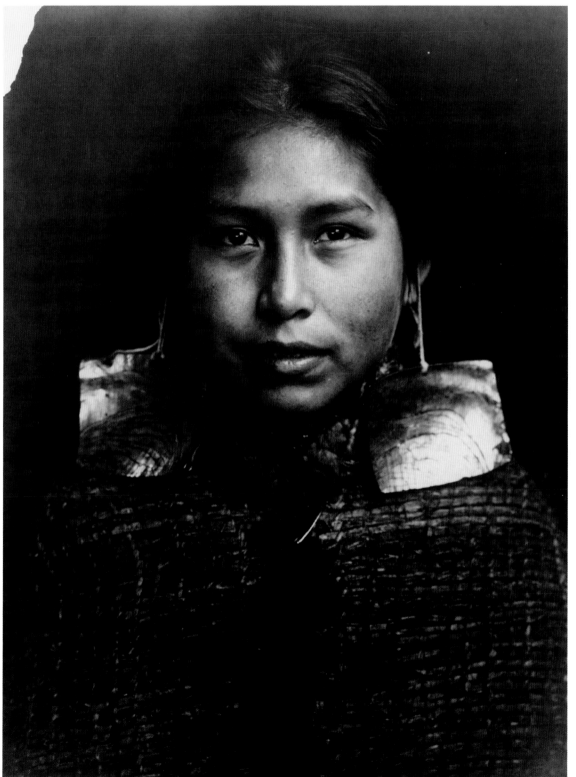

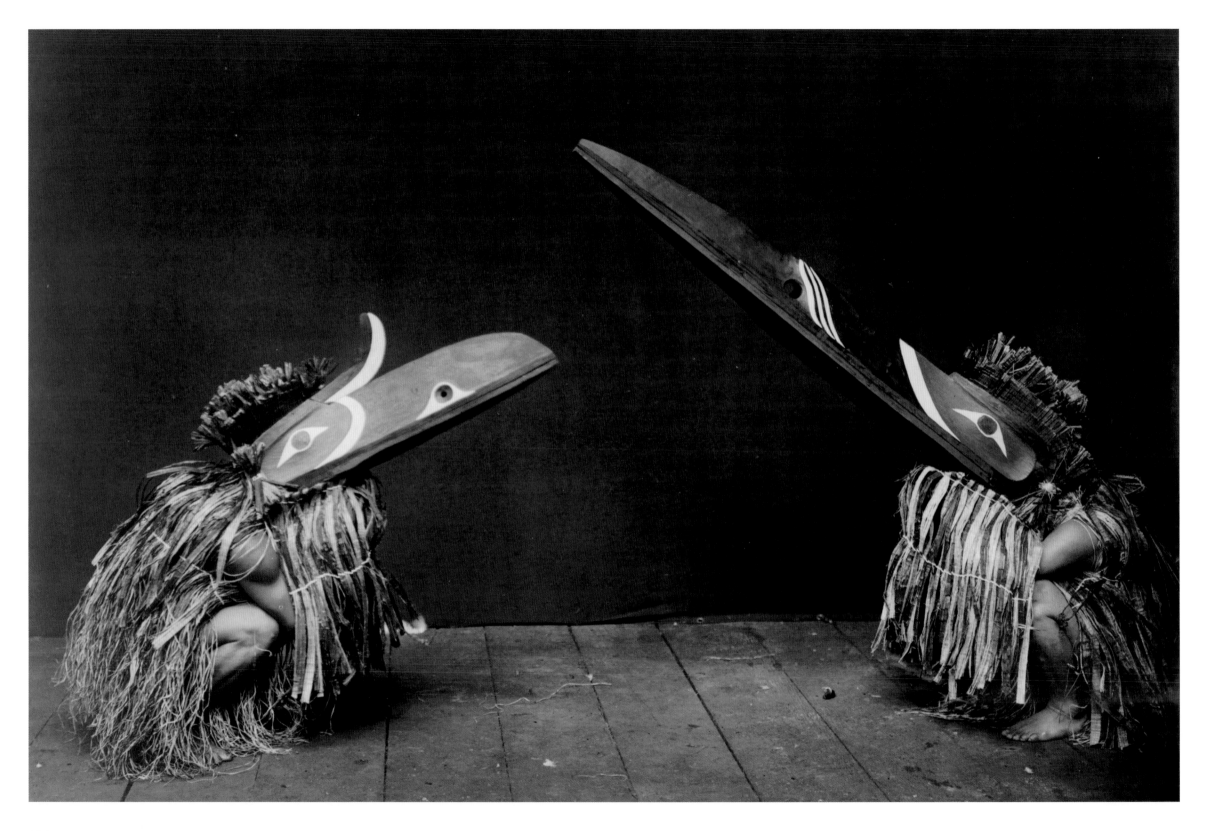

LEFT: Kotsuis and Hohhug, two Nakoaktok, wear ceremonial dress, including beak masks while dancing; c. 1914. The various Kwakiutl bands were not known for giving easy access to outsiders. Curtis succeeded in part because of his patient persistence, but more importantly, he relied on the help of George Hunt, a prominent half-Scottish member of the tribe and something of an amateur ethnographer. Hunt's efforts opened many doors for Curtis and allowed him to deeply explore Kwakiutl culture.
Library of Congress, Prints & Photographs Division, Edward S. Curtis Collection, LC-USZ62-108464

RIGHT: Hamatsa shaman, possessed by supernatural power after having spent several days in the woods as part of an initiation ritual; November 13, 1914. Curtis claimed to have become a Hamatsa during his time with the Kwakiutl, though he was secretive about his activities. This isn't surprising: Hamatsa rituals reportedly included cannibalism. Curtis— whether or not he partook—clearly enjoyed a little mythmaking with regard to his adventures in the field.
Library of Congress, Prints & Photographs Division, Edward S. Curtis Collection, LC-USZ62-52196

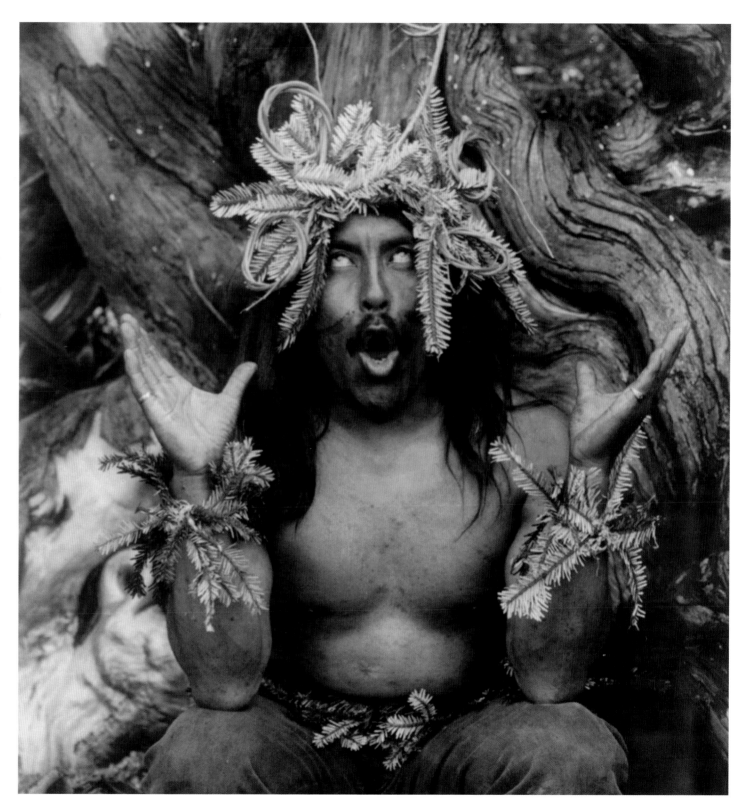

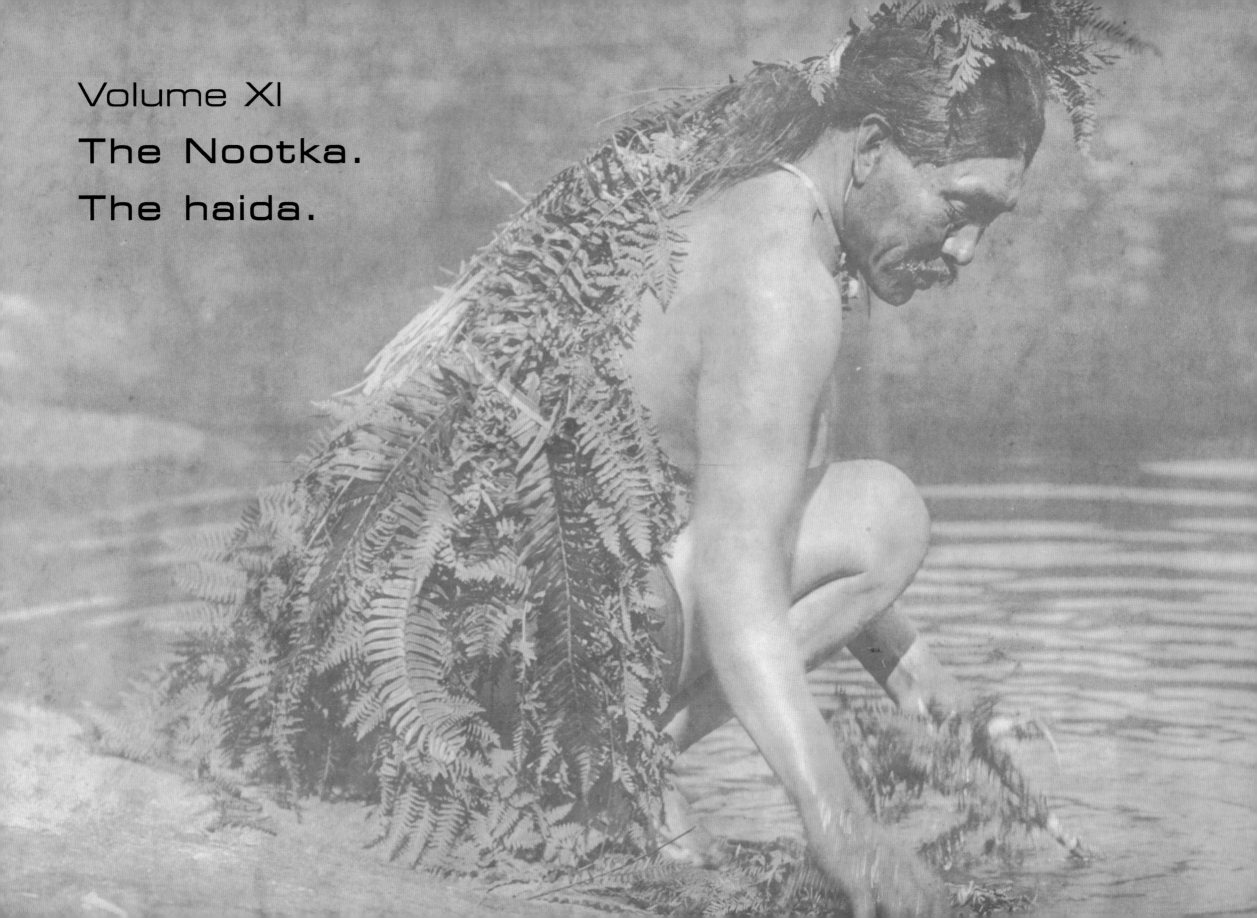

Volume XI

The Nootka.

The haida.

The Nootka and Haida were northwest coast tribes that Edward Curtis and William Myers were able to study in conjunction with their many trips to the Kwakiutl villages. Though Curtis recorded many fine photographs that were used in this volume, it is apparent that Myers did the bulk of the ethnographic work and writing.

The Nootka lived on the western shore of Vancouver Island, and made a living from the ocean, rivers, and forests of the region. They hunted sea otters, seals, and whales, fished for cod and halibut, and were noted for their exceptional skills in basketmaking. The Haida lived farther to the north on the Queen Charlotte Islands. Their large, lavishly adorned community houses and spectacular totem poles made them exceptional, even in a region populated by many fascinating native cultures.

This volume came to print in 1916, the same year that Curtis's wife initiated divorce proceedings, which soon became bitter and very public. Because of this it would be another six years before the next book was published.

A Nootka takes a ceremonial bath, before a whale hunt; c. 1910. Curtis was impressed by these people of Vancouver's west coast who ventured into the Pacific in their canoes and captured the giant sea mammals with only a harpoon. This twice-daily bathing ceremony was part of an elaborate purification ritual that the whalers endured in seeking divine intervention to assist their efforts.
Library of Congress, Prints & Photographs Division, Edward S. Curtis Collection, LC-USZ62-111296

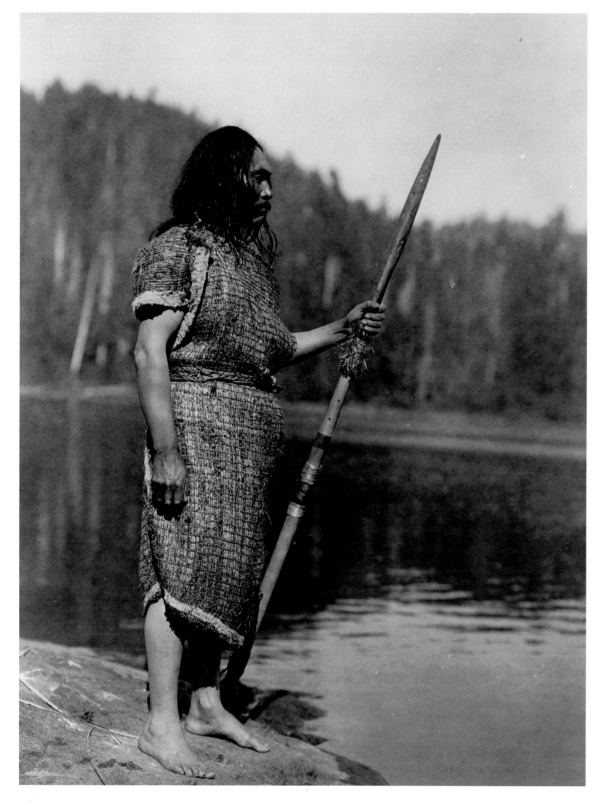

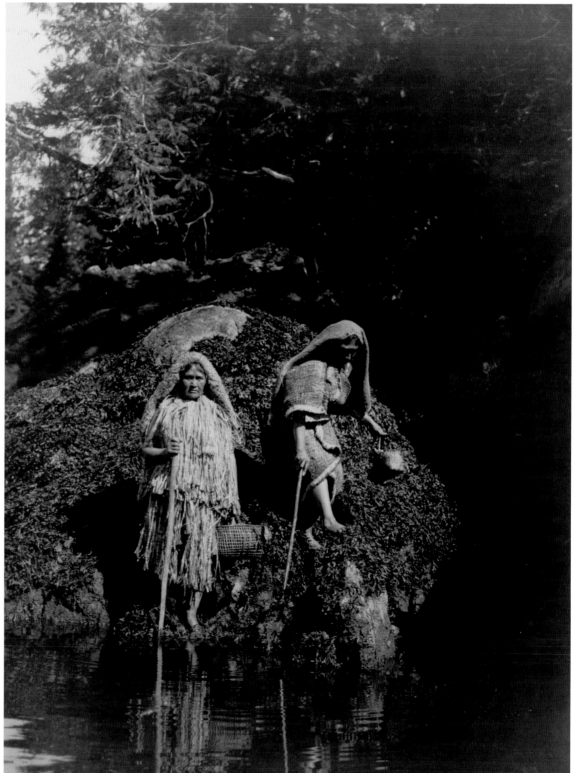

FAR LEFT: The Nootka or Nutka are an important native people of the western shore of Vancouver Island, from Cape Cook on the north to beyond Barkley Sound. They have continued to occupy 18 small village reserves on Vancouver Island, the main ones at Kyoquot, Ahousaht, Clayoquot, Hesquiaht, Nootka, Chiet, Port Alberni (Sheshaht) and Ucluelet. This is a whaler from Clayoquot standing on shore with spear; c. 1910.
Library of Congress, Prints & Photographs Division, Edward S. Curtis Collection, LC-USZ62-106742

LEFT: Two Clayoquot indians with baskets gathering seaweed; c. 1910. The Nootka were both a sea and river people; they fished for halibut and cod, gathered kelp, and hunted whales, seals and sea otters. They also gathered berries, fruits and roots.
Library of Congress, Prints & Photographs Division, Edward S. Curtis Collection, LC-USZ62-115812

RIGHT: A Hesquiat woman; c. 1910. The Nootka were an integral part of Northwest Coast culture; while their carving and painting were generally not as elaborate as those of the northern tribes, they excelled in basketry.
Library of Congress, Prints & Photographs Division, Edward S. Curtis Collection, LC-USZ62-118577

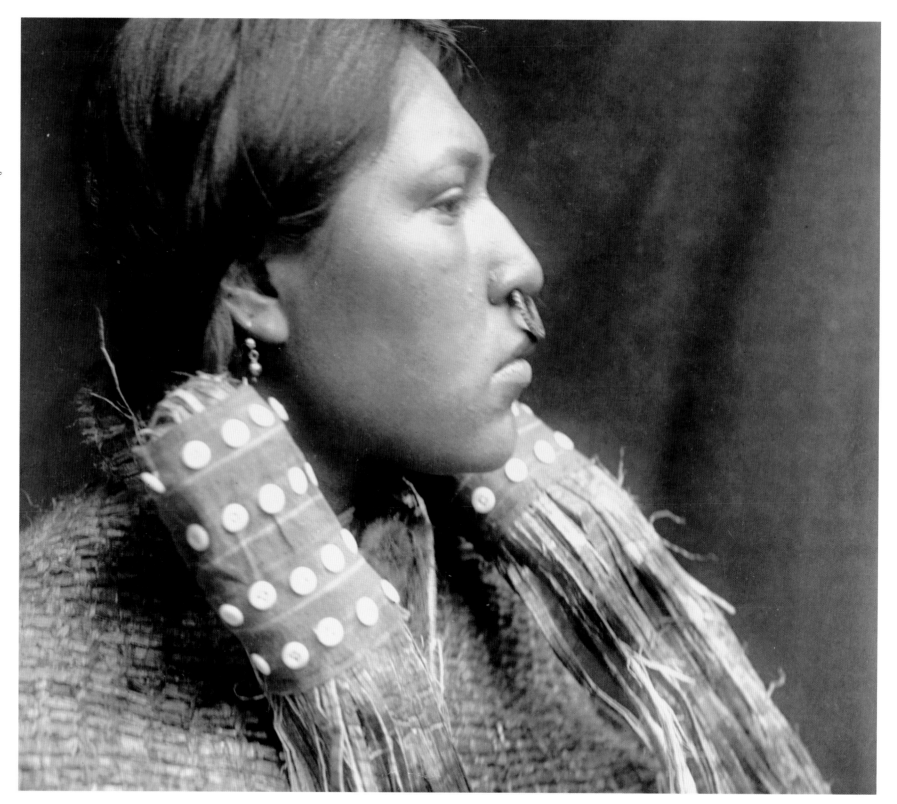

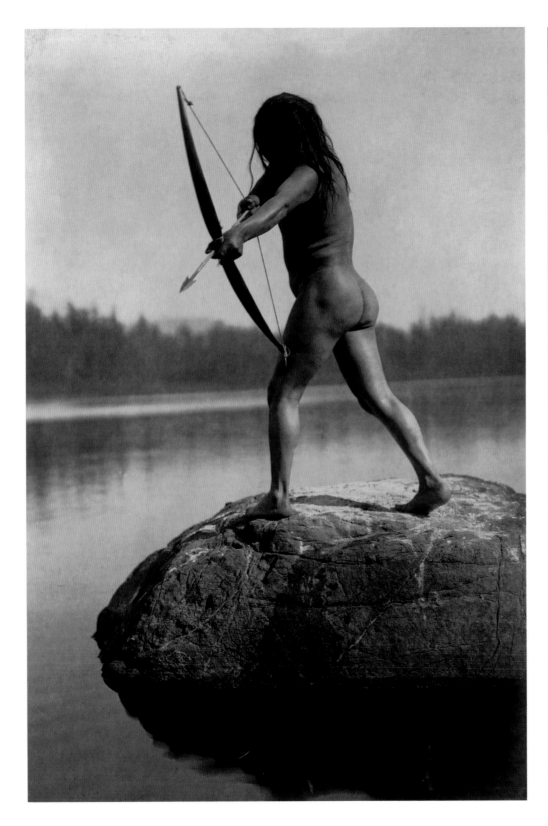

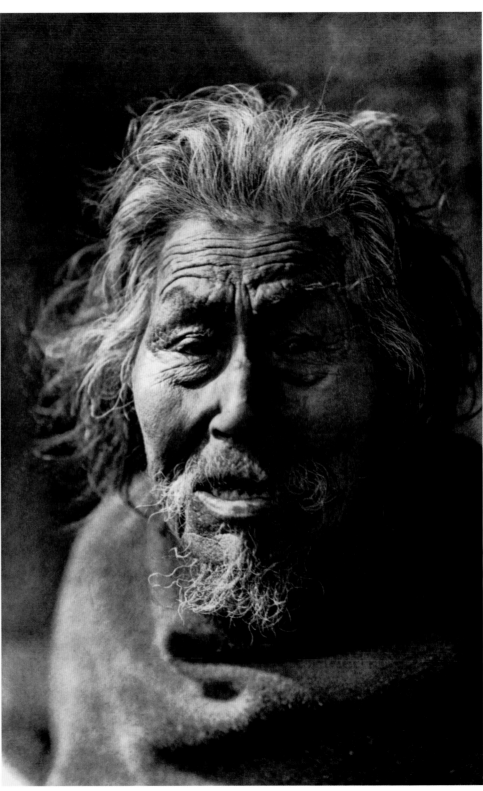

FAR LEFT: "Bowman." A Nuu-chah-nulth hunter. *Corbis*

LEFT: "Oldest Man of Nootka." An elderly Nuu-chah-nulth man. Edward noted, "This individual is the most primitive relic in the modernized village of Nootka. Stark naked, he may be seen hobbling about the beach or squatting in the sun, living in thought in the golden age when the social and ceremonial customs of his people were what they had always been." *Corbis*

RIGHT: "Clayoquot Girl." *Corbis*

FAR RIGHT: "The Whaler." *Corbis*

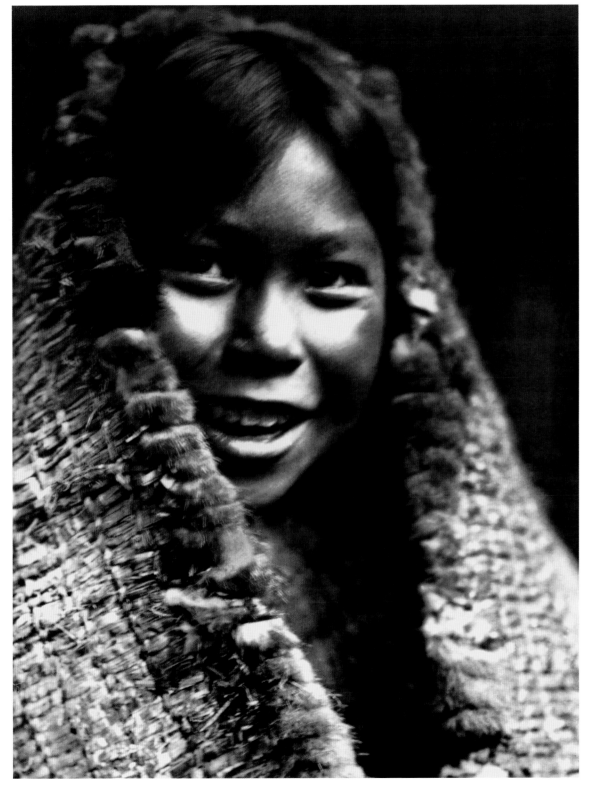

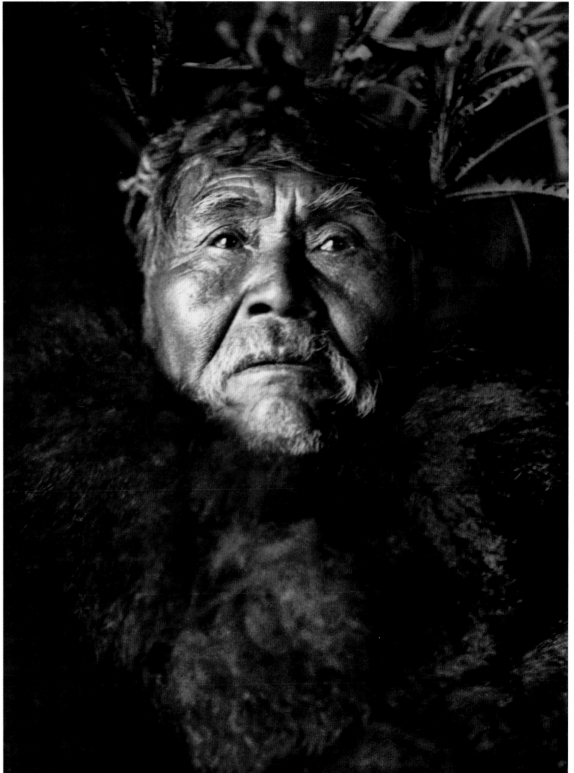

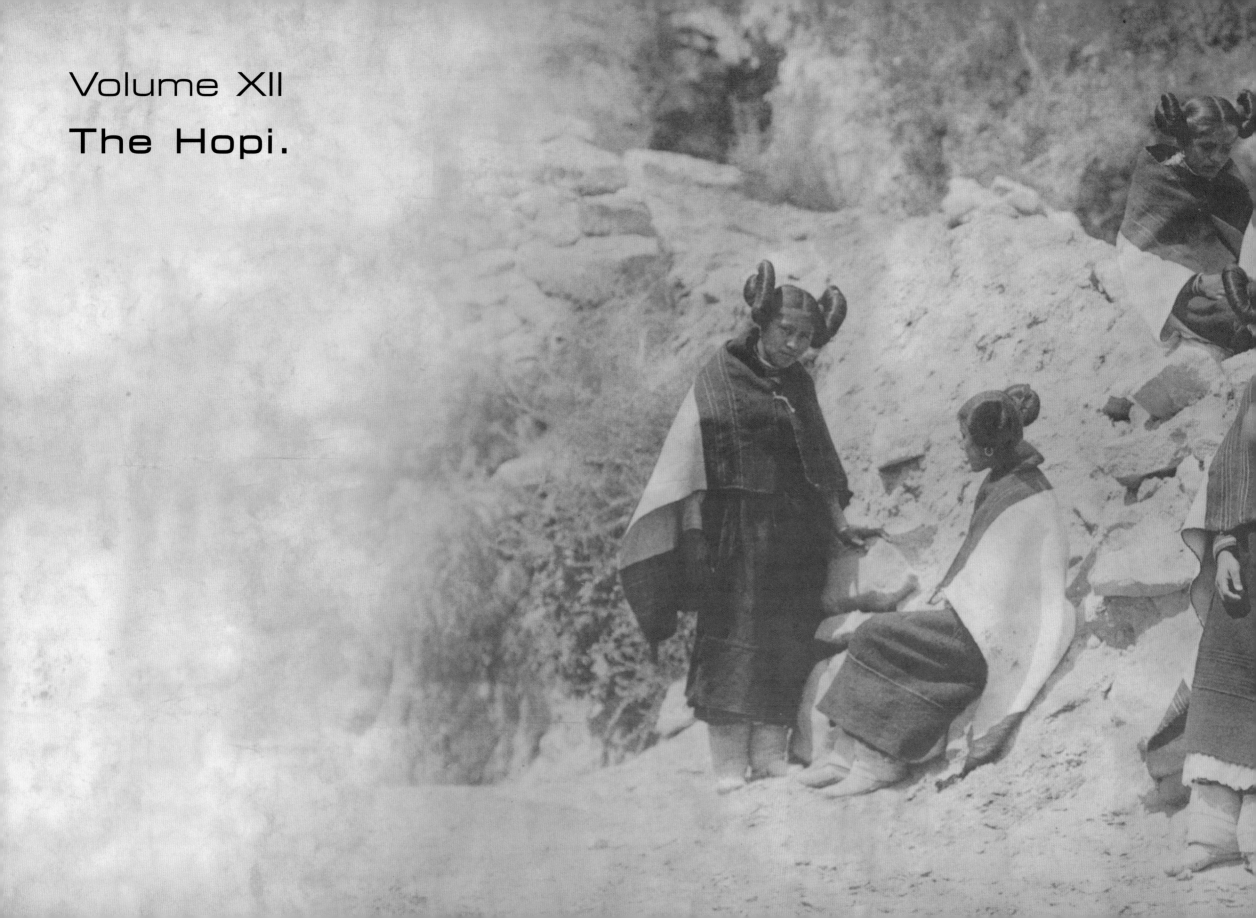

Volume XII

The Hopi.

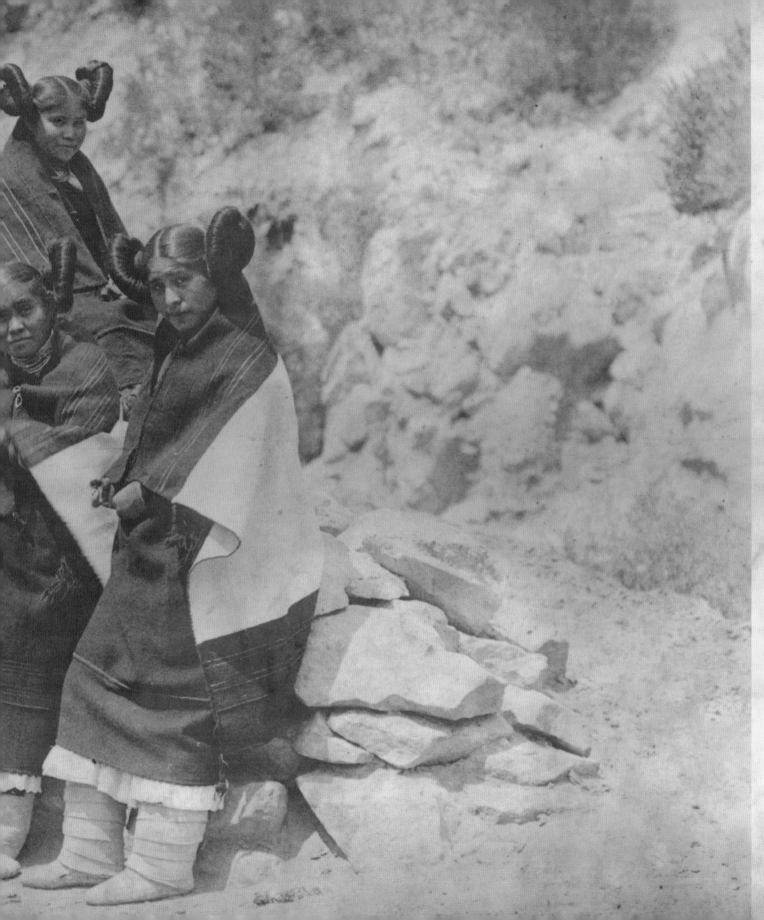

From 1916 onward, William Myers continued gathering information from tribes in Oregon, California, Nevada, Arizona, and New Mexico while Edward Curtis dealt with problems in his personal life. Curtis finally joined Myers in the field in 1919, on the Hopi Reservation in Arizona. The results of that summer's work eventually led to the publication of this volume in 1922.

Curtis had visited the Hopi, a sedentary, pueblo-dwelling people, several times between 1900 and 1912 and had grown very close to the tribe. At one point he was adopted into the tribe and allowed to participate in their legendary Snake Dance ceremony. His early experiences with the Hopi fueled his fascination of native religions and were a strong motivation for developing *The North American Indian* project.

Curtis was dismayed at the changes he found on his 1919 visit to the Hopi pueblos. The influence of missionaries and the government had stripped the tribe of much of its traditional culture and Curtis had difficulty finding subjects to photograph who had not adopted white clothing and hair styles. As a result, he relied heavily on photographs taken during his early visits, a fact that he explained in his introduction to this volume.

"The Morning chat"—an image very similar to "East Mesa girls" published in Volume XII. *Library of Congress, Prints & Photographs Division, Edward S. Curtis Collection, LC-USZ62-112111*

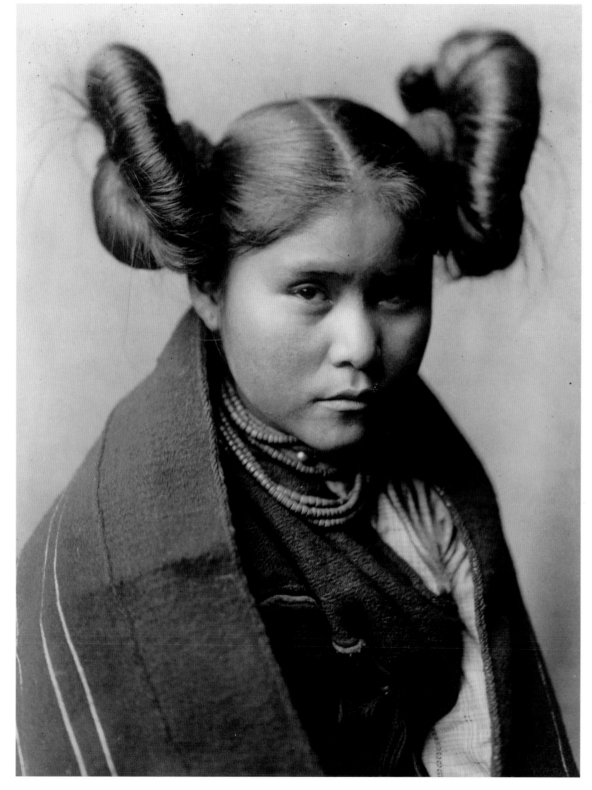

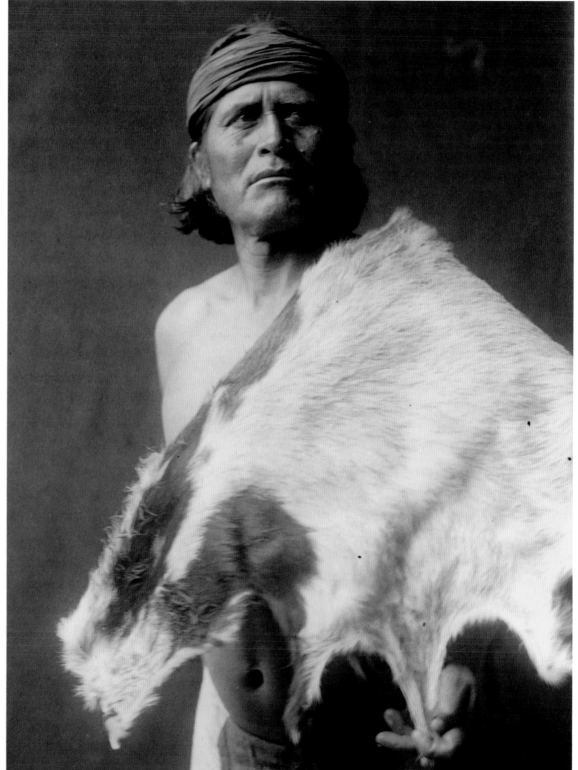

FAR LEFT: Head-and-shoulders portrait of Chaiwa, Tewa girl, facing front; c. 1906. The Hopis have lived in the same area of northeastern Arizona for over 1,600 years. Their present Pueblos are located on three mesas west of Kearns Canyon, the main administrative center for the Hopis. On the First Mesa are the Tewa towns of Hano and Polacca, who joined the Hopi in the 18th century, Shitchumovi (Sichomovi), and Walpi; on the Second Mesa are Shipaulovi, Mishongnovi and Shongopavy (Shungopovi); and on the Third are Bakabi, Hotevilla, Oraibi (the oldest inhabited village in the U.S.A.), Upper and Lower Moenkopi, and Kyakotsmovi (Kiakochomovi) or New Oraibi. *Library of Congress, Prints & Photographs Division, Edward S. Curtis Collection, LC-USZ62-119411*

LEFT: Nato, the goat man: half-length portrait of Hopi man with animal skin; c. 1906. *Library of Congress, Prints & Photographs Division, Edward S. Curtis Collection, LC-USZ62-112227*

RIGHT: Buffalo dancers—costumed dancers wearing dance bustles of Tewa sun god made of turkey feathers; c. 1905. *Library of Congress, Prints & Photographs Division, Edward S. Curtis Collection, LC-USZ62-123302*

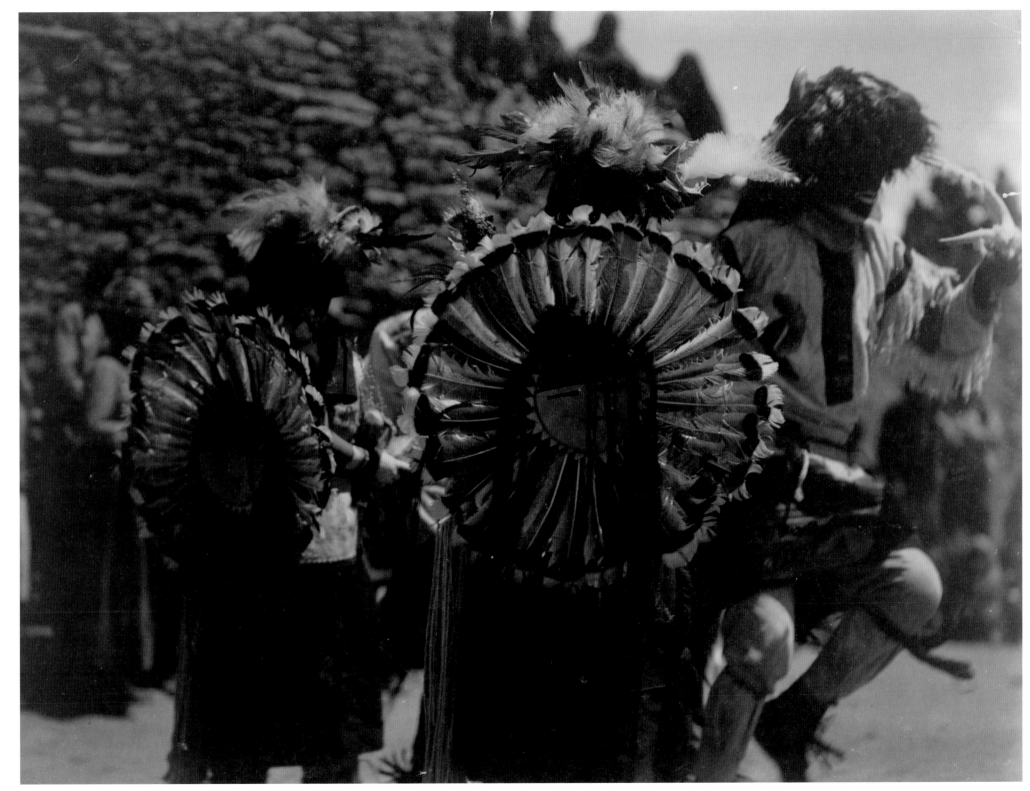

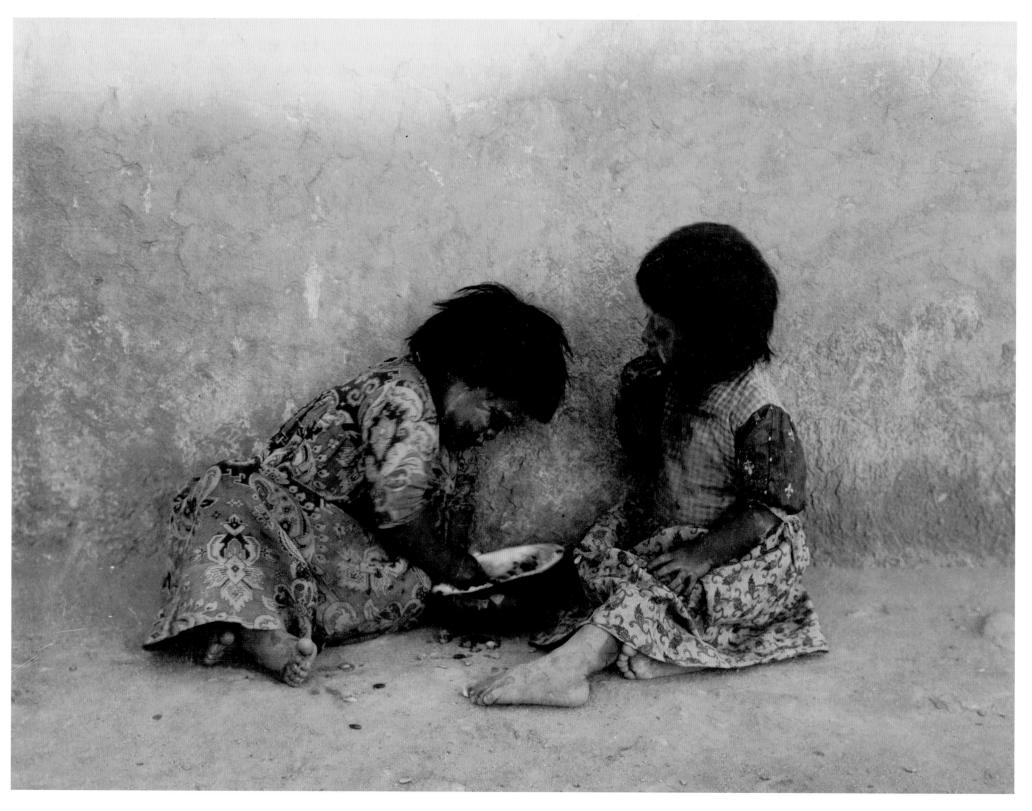

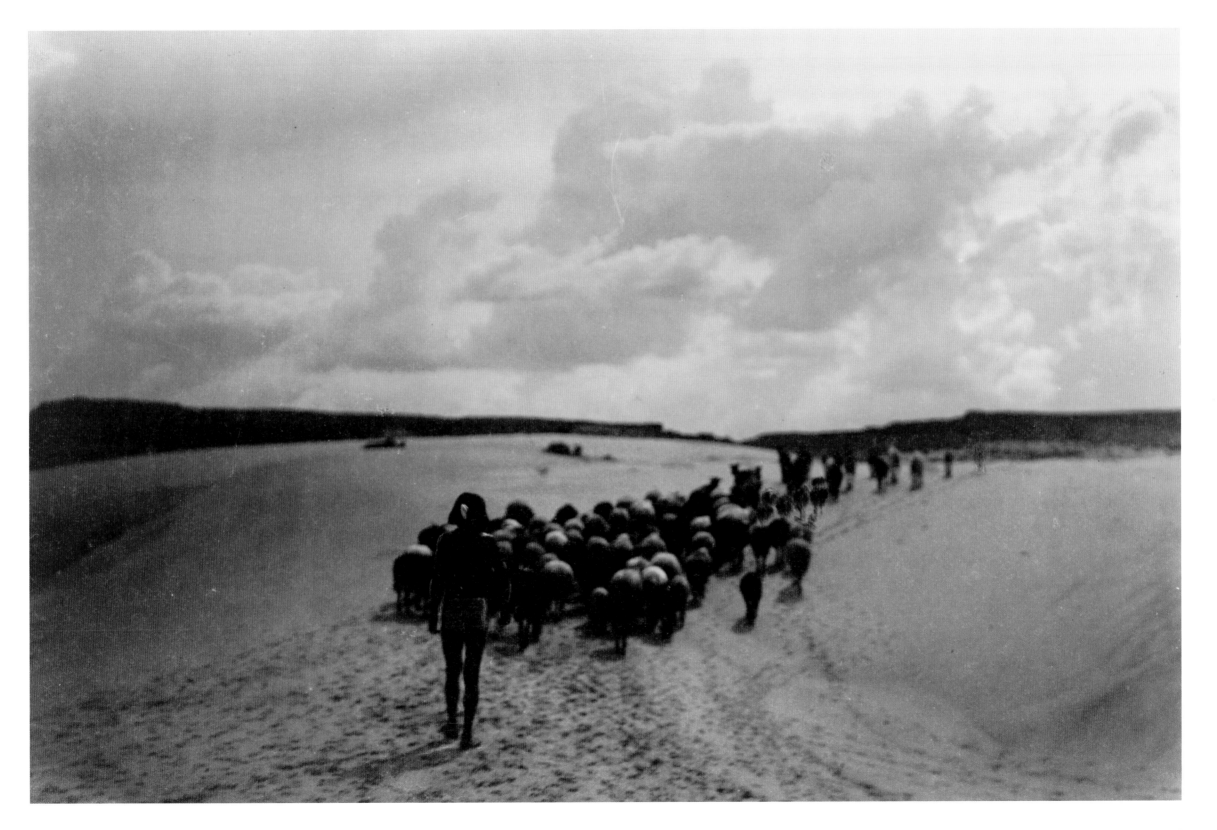

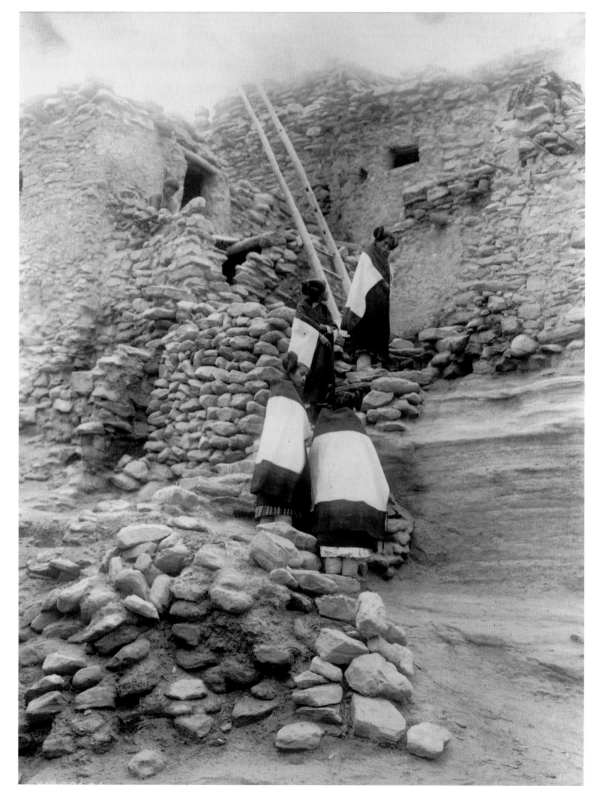

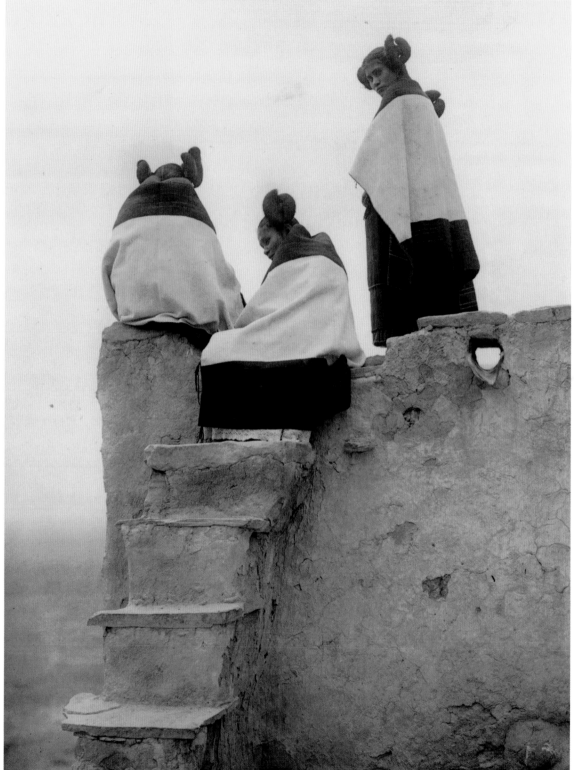

FAR LEFT: Cliff perched homes: Four Hopi women in front of pueblo buildings; c. 1906. Spanish activity in the area was never extensive, although they were known from 1540 to the invaders, who made various attempts to establish missions; but all churches were destroyed in 1680 and further attempts abandoned after 1780, the Hopis being left in isolation to follow the indigenous culture lost to so many tribes.
Library of Congress, Prints & Photographs Division, Edward S. Curtis Collection, LC-USZ62-112228

LEFT: Three Hopi women at top of adobe steps, New Mexico; c. 1906. They wear the traditional "butterfly" or "squash blossom" hairstyle symbolizing virginity; the hair is wrapped around two curved sticks into large whorls. Married women wore their hair tied with a cloth hanging down at the side of the head and over the shoulders. This post-pubescent style is still occasionally seen.
Library of Congress, Prints & Photographs Division, Edward S. Curtis Collection, LC-USZ62-101182

RIGHT: Flute dancers at Tureva Spring: Dancers preparing for ceremony on upper terrace; c. 1905. Hopi social structure contains a number of interlocking social and religious organizations, the latter exhibited in an annual cycle of masked Kachina or unmasked ceremonials in Kivas, or on plazas.
Library of Congress, Prints & Photographs Division, Edward S. Curtis Collection, LC-USZ62-106262

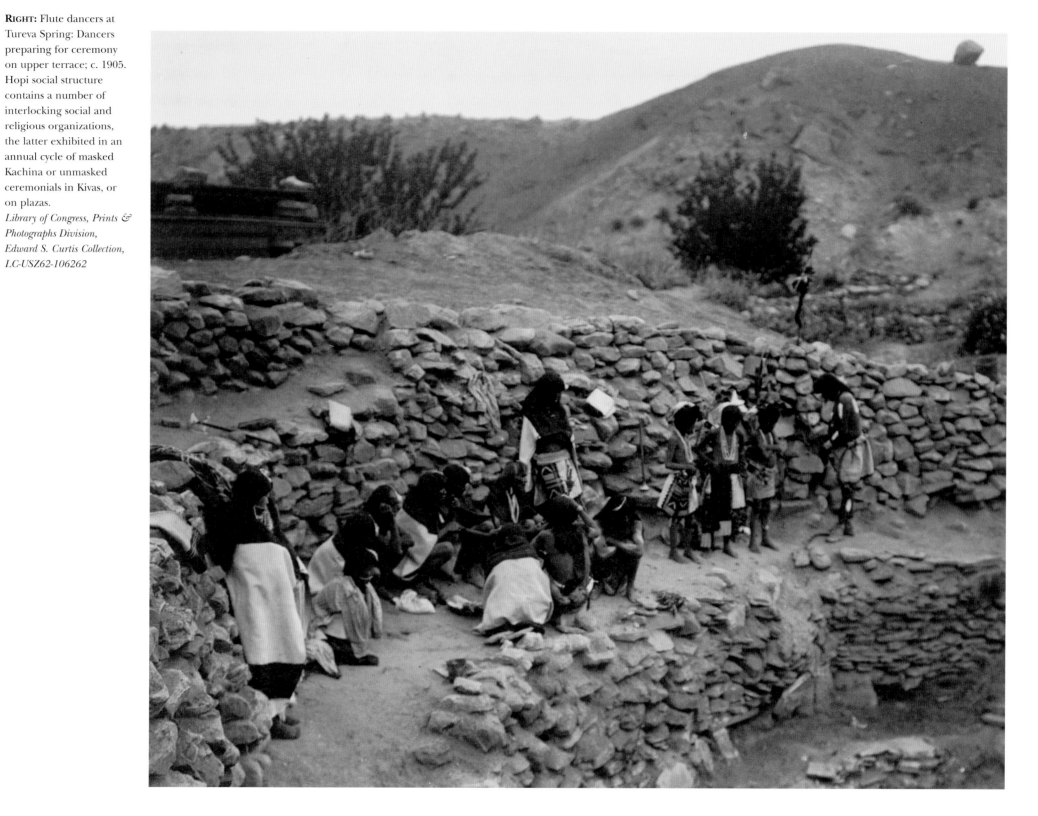

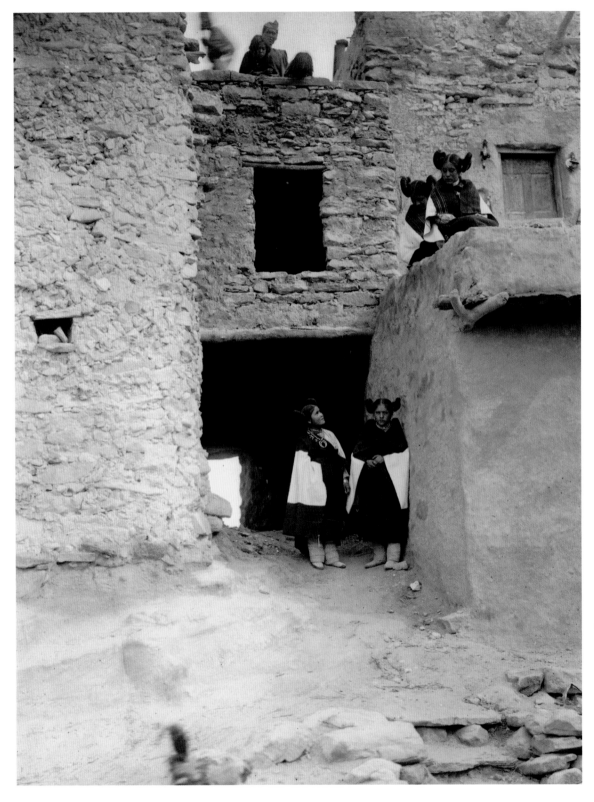

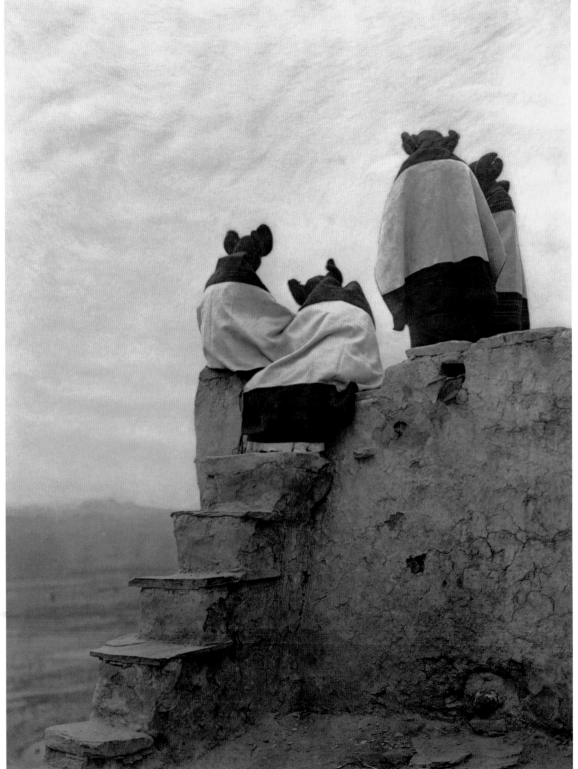

FAR LEFT: "Good morning—Hopi": Pueblo building with people; c. 1906. Hopi country is the southern escarpment of Black Mesa, a highland area about 60 miles wide; and their present reservation, a square within the Navajo Reservation, is a continuing source of disagreement between the tribes concerning ownership.
Library of Congress, Prints & Photographs Division, Edward S. Curtis Collection, LC-USZ62-113081

LEFT: "Watching the Dancers." A photograph of girls at Walpi pueblo. *Corbis*

RIGHT: Hopi children; c. 1905. Curtis said of the Hopi: "Numerically weak, poor in worldly goods, physically small, he possesses true moral courage." He was impressed by the fact that they had stood up to the U.S. government and were still living a traditional lifestyle, but their culture was quickly being overwhelmed by pressure from the white world.
Library of Congress, Prints & Photographs Division, Edward S. Curtis Collection, LC-USZ62-112223

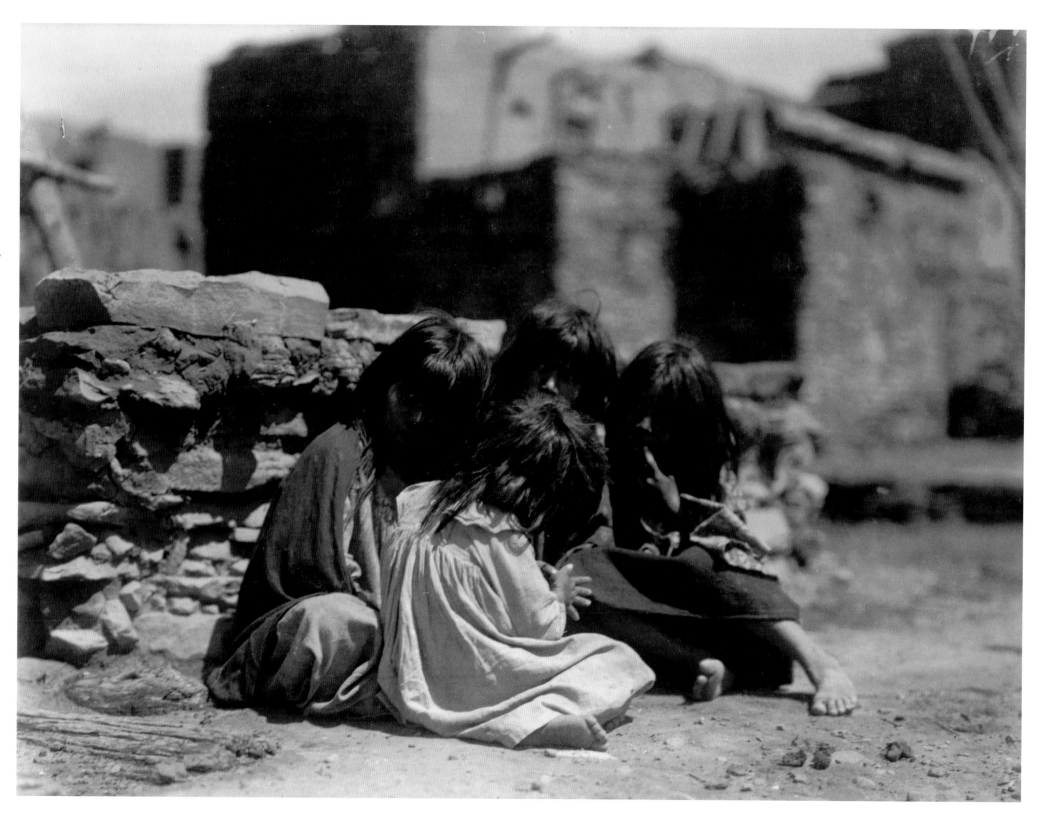

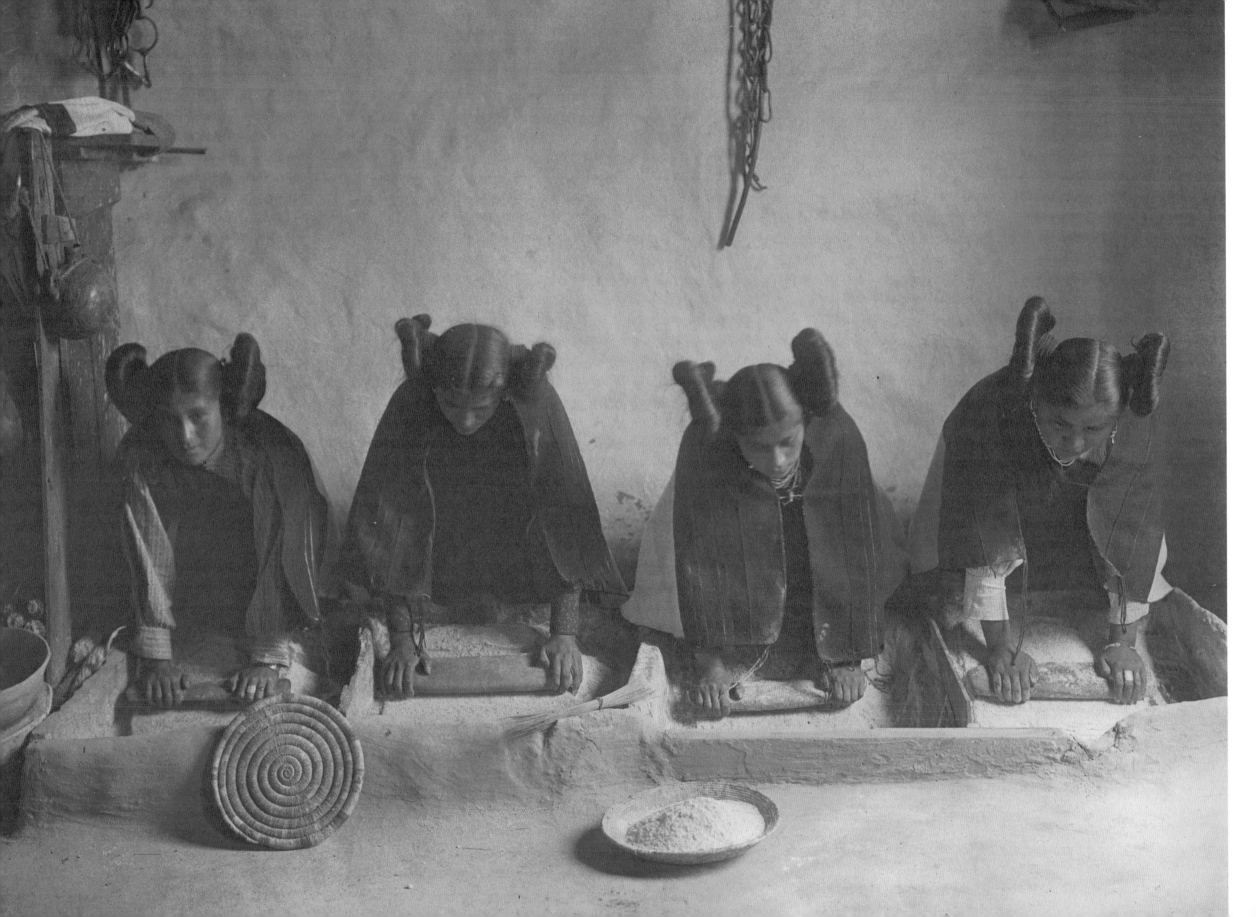

LEFT: Four young Hopi Indian women grinding grain; c. 1906. The Hopis' pottery is characteristically mottled yellow-orange with asymmetric curvilinear black designs. They are the only major basketmaking Pueblo tribe in recent times, mainly using flat coiled technique with abstract birds, whirlwinds and Kachina designs.
Library of Congress, Prints & Photographs Division, Edward S. Curtis Collection, LC-USZ62-94089

RIGHT: The snake priest; c. 1906. Rain brings rattlesnakes to the surface; they are thus associated with this rain dance for the benefit of crops. The ceremony is still performed in Hopi villages by the Snake-Antelope societies in alternate years with the Flute societies. Continual brushing of the snakes' backs with an eagle feather wand prevents them from coiling and striking; during the dance, a gatherer or guard, controls them in conjunction with the carrier. Note the dyed feather headdress, black and white face and body paint, the kilt embellished with the sign of the serpent, and the silver and turquoise necklaces.
Library of Congress, Prints & Photographs Division, Edward S. Curtis Collection, LC-USZ62-113080

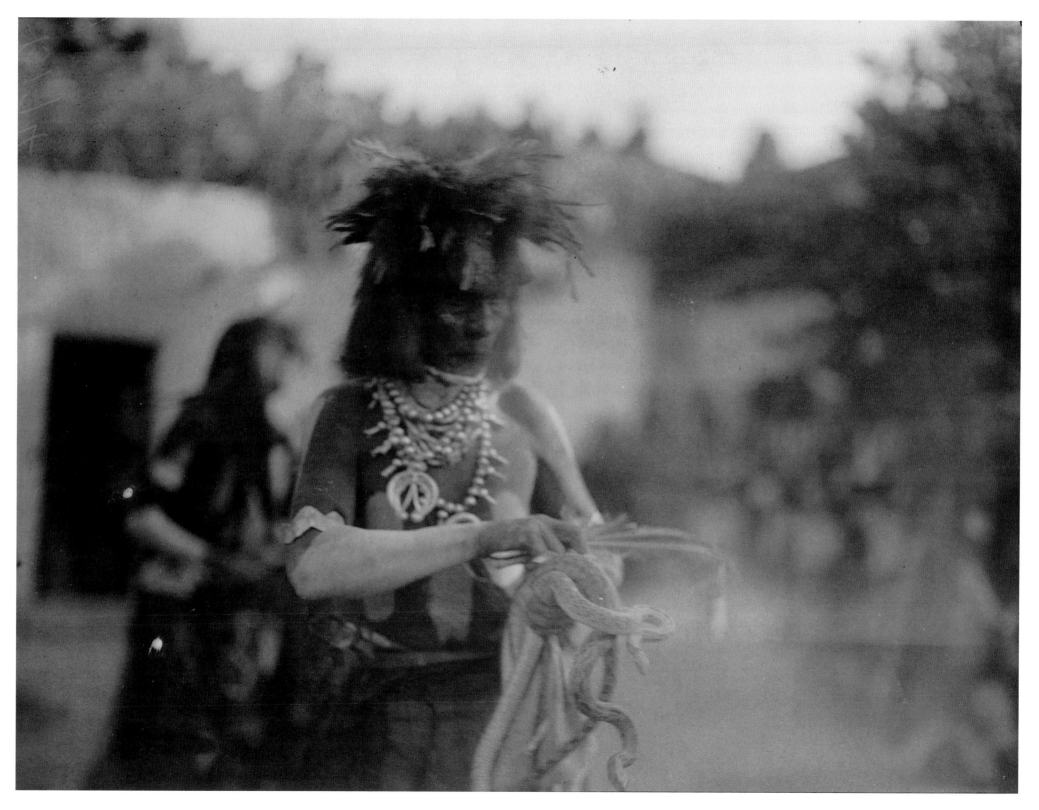

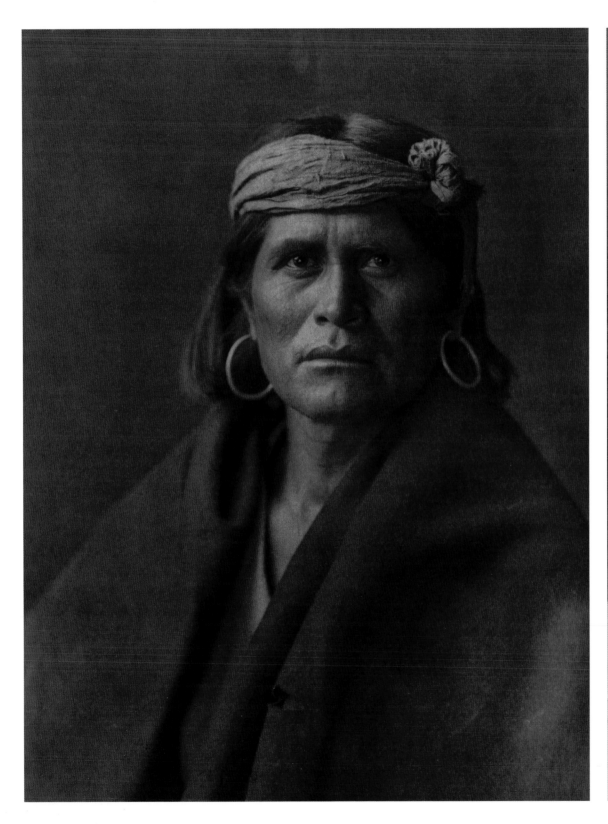

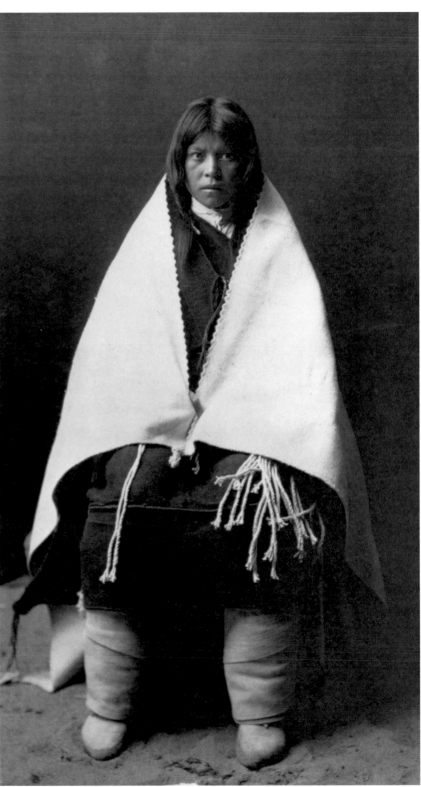

FAR LEFT: Thisw photoghraph shows a man from Walpi, a Hopi pueblo founded in 1700 northeast of Flagstaff, Arizona. Beauitifully situated, and popular today for touists, it was set up after the Pueblo revolt of 1680. *Christie's Images/Corbis*

LEFT: Hopi Bridal Costume. She is wearing buckskin moccasins with a wide strip of buckskin wound around the leg up to the knee (1922). *Corbis*

RIGHT: Tewa Girls. The Tanoan language stock is divided into Tiwa, Tewa, and Towa as follows: Northern Tiwa (Taos and Picuris); Southern Tiwa (Sandia, Isleta, Tigua and Piro); Northern Tewa (Nambe, San Ildefonso, San Juan, Santa Clara. Tesuque, Pojoaque); Southern Tewa (Tano, now Hopi-Tewa); and Towa (Jemez and Pecos). *Corbis*

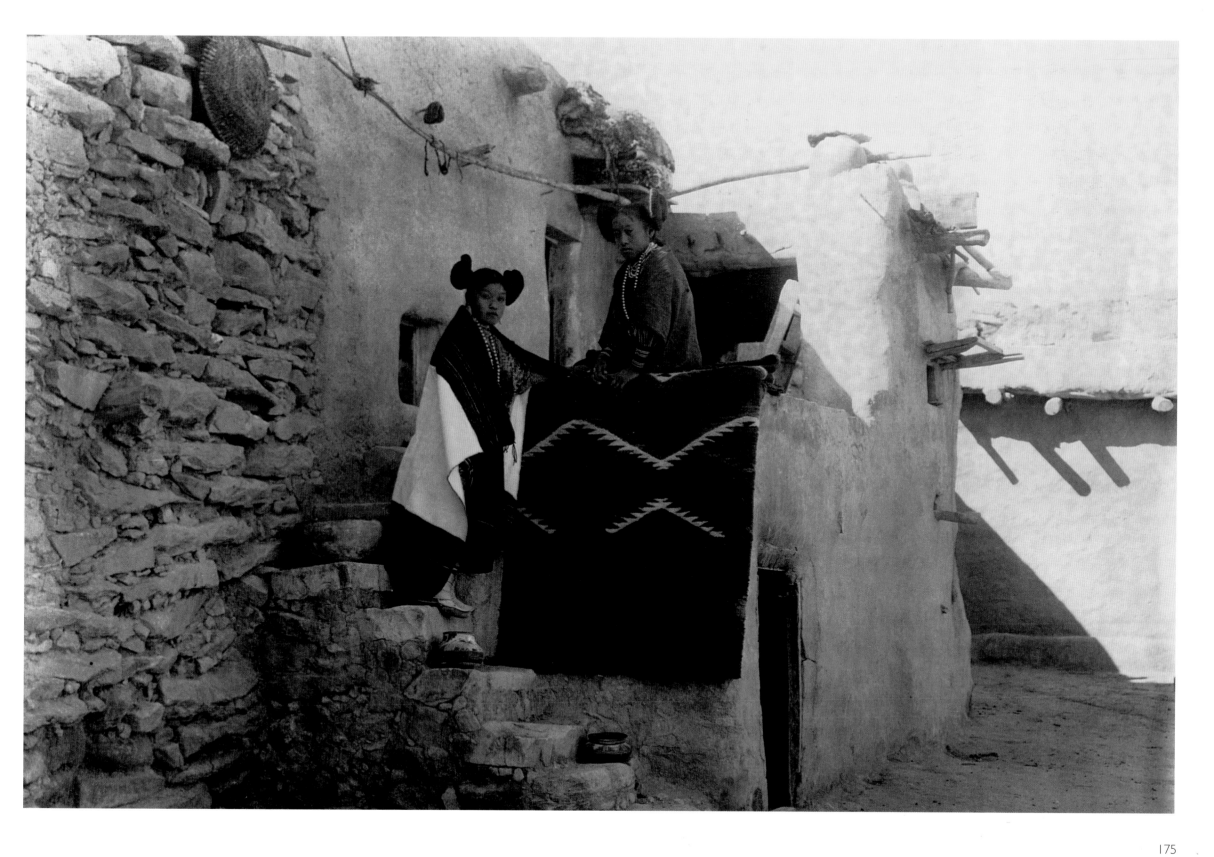

Volume XIII

The Hupa. The Yurok. The Karok. The Wiyot.
Tolowa and Tututni. The Shasta. The Achomawi.
The Klamath.

It was not until 1922 that Curtis was able to join Myers in the field again and continue his photographic work. Curtis's daughter, Florence, joined that summer's expedition and the team had an especially productive season that led to the 1924 publication of the next two volumes in the series.

The many small tribes of this region shared certain characteristics, but being isolated by the mountainous topography they also showed a remarkable diversity in religious beliefs, language, and other cultural traits. Many of the tribes lived along the major rivers of the region—for example, the Yurok along the Klamath and the Hupa along the Trinity—and fished for a living. The inland tribes, though, were hunters and gatherers who struggled to survive in a relatively harsh landscape.

When Curtis encountered these tribes, most were living in extreme poverty. In the nineteenth century, whites looking to exploit the region's natural resources had overrun them. Not being particularly warlike, the tribes signed away their territories in a series of questionable treaties, something for which Curtis took them to task in the introduction of this volume.

A Klamath man looks out over Crater Lake in Oregon, which was created some 7,000 years ago when Mt. Mazama erupted. Set in a caldera six miles wide, brilliant blue, it is hardly surprising that it held a significant place in Klamath life. See page 187 for more information. *Corbis*

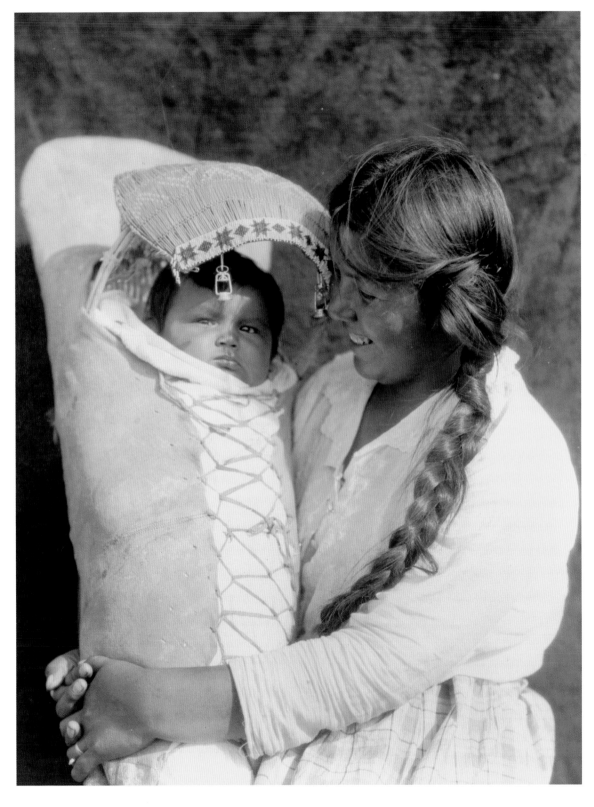

LEFT: Achomawi mother and child; c. 1923. These people were popularly known as Pit River Indians and they suffered somewhat less than most California tribes as a result of white invasion. Curtis was stunned at the poverty he found among native groups in California, whom he called "the greatest sufferers of all," but he was also critical of them for not fighting harder for survival.
Library of Congress, Prints & Photographs Division, Edward S. Curtis Collection, LC-USZ62-110225

RIGHT: A Hupa woman wearing fur and beads around her neck and shoulders; c. 1923. Probably the largest and most important Athabascan tribe in California, the Hupa or Hoopa lived principally on the Trinity River above its junction with the Klamath.
Library of Congress, Prints & Photographs Division, Edward S. Curtis Collection, LC-USZ62-105385

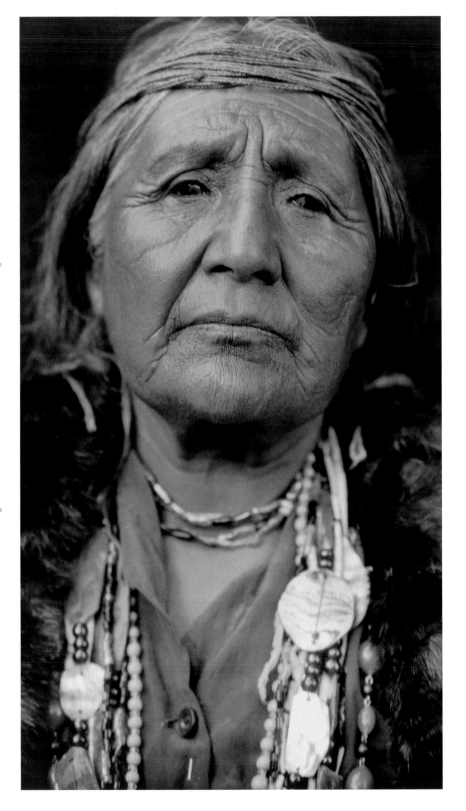

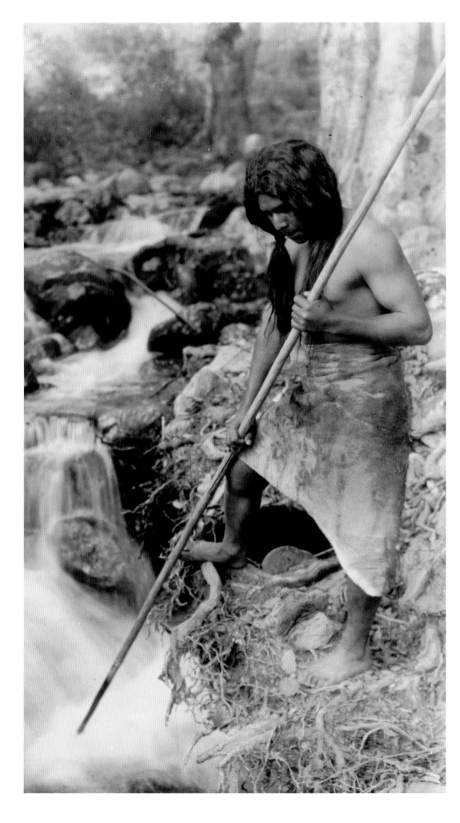

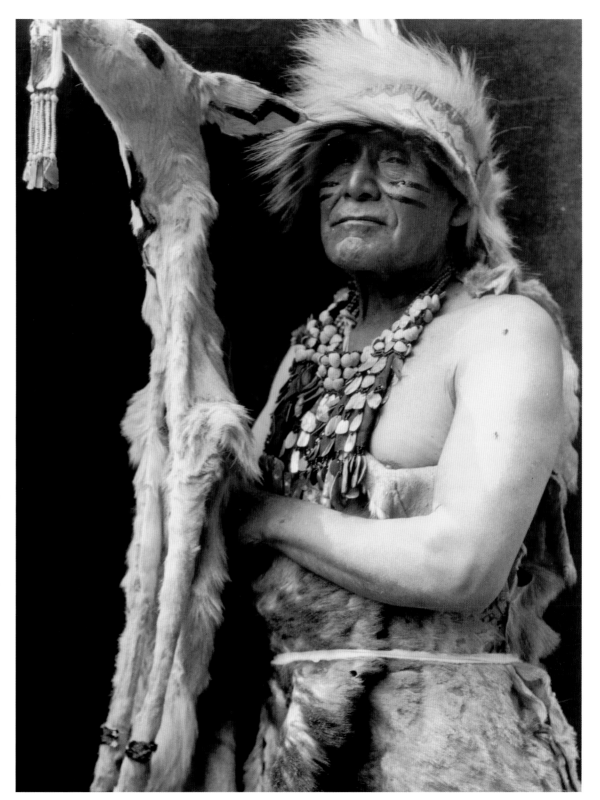

LEFT: Watching for salmon; c. 1923. Salmon and acorns provided the bulk of the Hupa diet. *Library of Congress, Prints & Photographs Division, Edward S. Curtis Collection, LC-USZ62-113079*

RIGHT: Hupa in ceremonial White Deerskin Dance costume; c. 1923. The Hupa, Yurok, and Karok had two major world renewal rituals, correlating with seasonal availability of major food resources: the Jumping Dance for the spring salmon run, and the Deerskin Dance for the fall acorn harvest and second salmon run. Performers held albino or other oddly colored deerskins aloft on poles, or carried obsidian blades covered with buckskin. Some, as here, wore wolfskin headbands and kilts of civet pelts. *Library of Congress, Prints & Photographs Division, Edward S. Curtis Collection, LC-USZ62-101260*

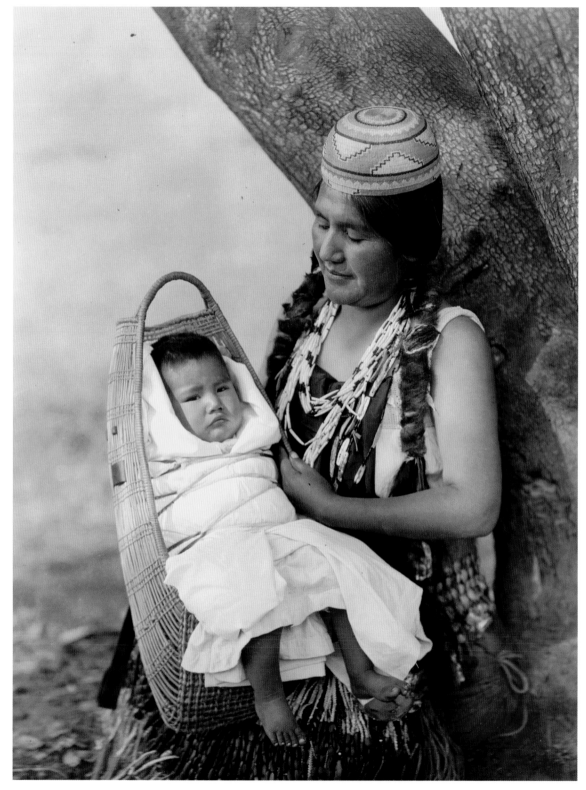

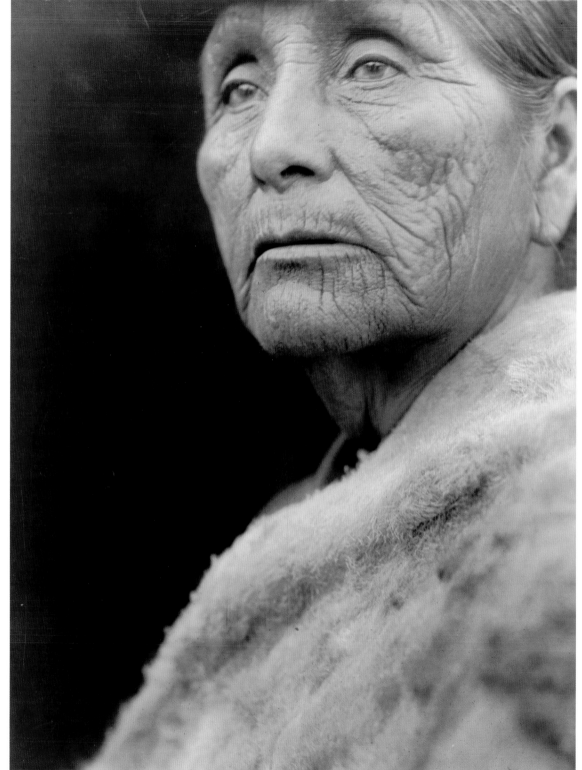

FAR LEFT: Hupa mother holding baby; c. 1923. The Hupa lived in small villages of rectangular plank houses, wore buckskin aprons and skirts, and excelled in basketry.
Library of Congress, Prints & Photographs Division, Edward S. Curtis Collection, LC-USZ62-110505

LEFT: Hupa woman; c. 1923. Over the years the Hupa have settled into a rural American lifestyle, self-supporting and economically perhaps the most advanced among the surviving Indians of California.
Library of Congress, Prints & Photographs Division, Edward S. Curtis Collection, LC-USZ62-115817

RIGHT: Klamath woman seated in front of house thatched with rush mats; c. 1923. The Klamath lived in the area of rivers and marshes around upper Klamath Lake, Oregon. They ceded their lands to the United States in 1864 and were provided with a reservation, which they shared with the Modocs and some Paiutes.
Library of Congress, Prints & Photographs Division, Edward S. Curtis Collection, LC-USZ62-118931

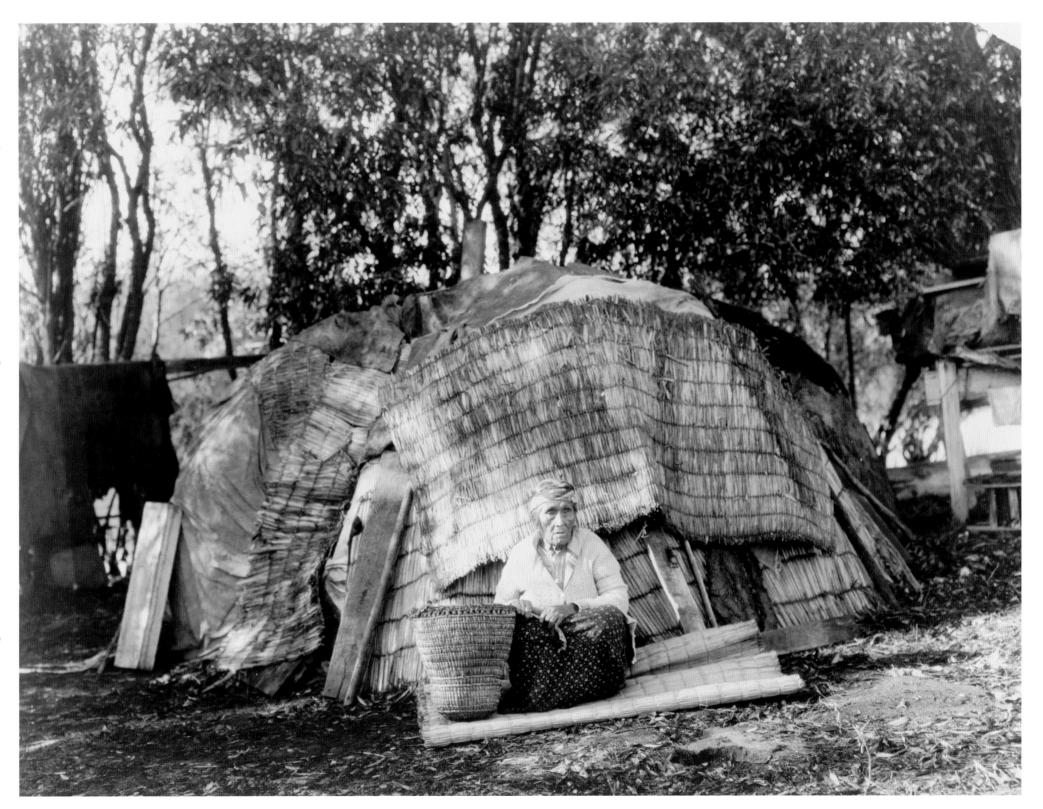

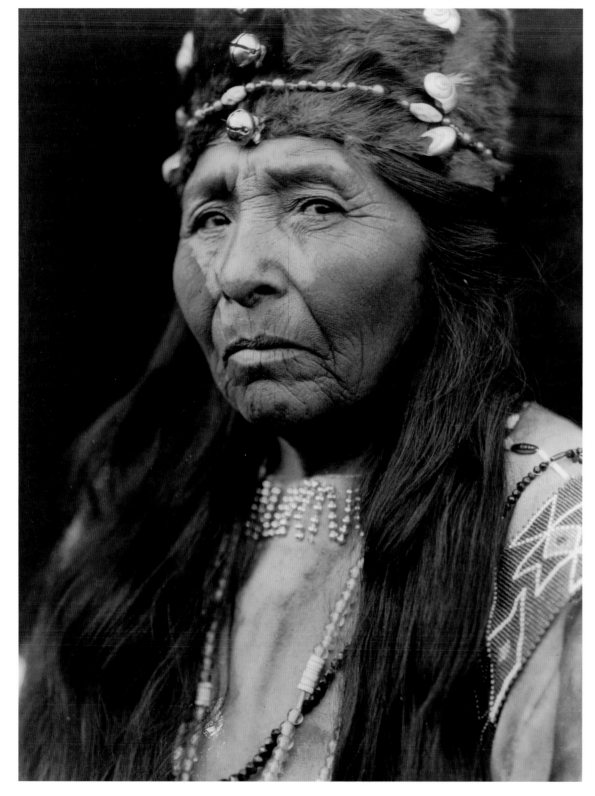

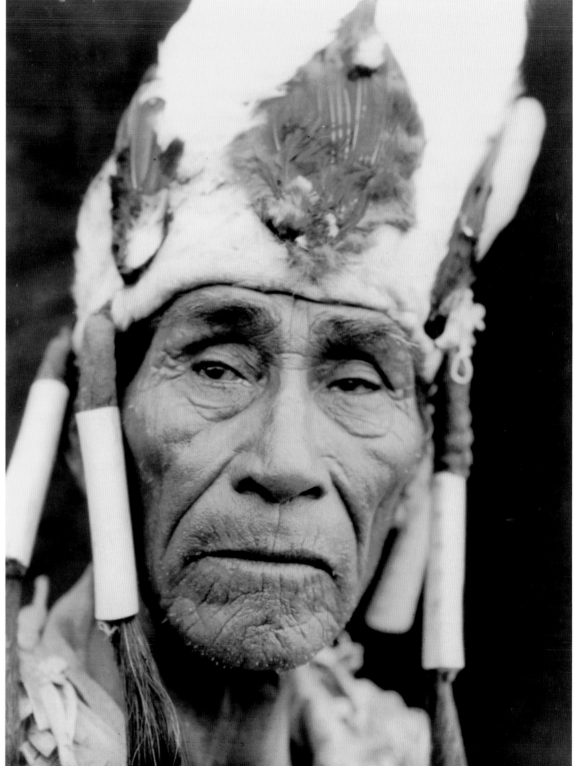

FAR LEFT: Klamath woman; c. 1923. Over the years the Klamath became very mixed with Euro-Americans and lost much of their Indian culture, which led to the termination by the Bureau of Indian Affairs of the reservation's status and of all government programs and assistance. However, the tribe's descendants are pressing for renewed government recognition.
Library of Congress, Prints & Photographs Division, Edward S. Curtis Collection, LC-USZ62-110506

LEFT: Klamath man wearing headdress; c. 1923.
Library of Congress, Prints & Photographs Division, Edward S. Curtis Collection, LC-USZ62-118598

RIGHT: "A smoky day at the Sugar Bowl." Fog partially obscures trees on mountainsides; June 30, 1923.
Library of Congress, Prints & Photographs Division, Edward S. Curtis Collection, LC-USZ62-47020

FAR RIGHT: Tolowa Dorothy Lopez Williams looking out over the Pacific ; c. 1923. She is wearing the classic two-piece skirt of the Klamath River area: a narrow buckskin apron panel with clam and abalone shells covers a fiber and beaded skirt fringed with abalone "tinklers." Note the strings of shell beads, and the basket hat.
Library of Congress, Prints & Photographs Division, Edward S. Curtis Collection, LC-USZ62-120022

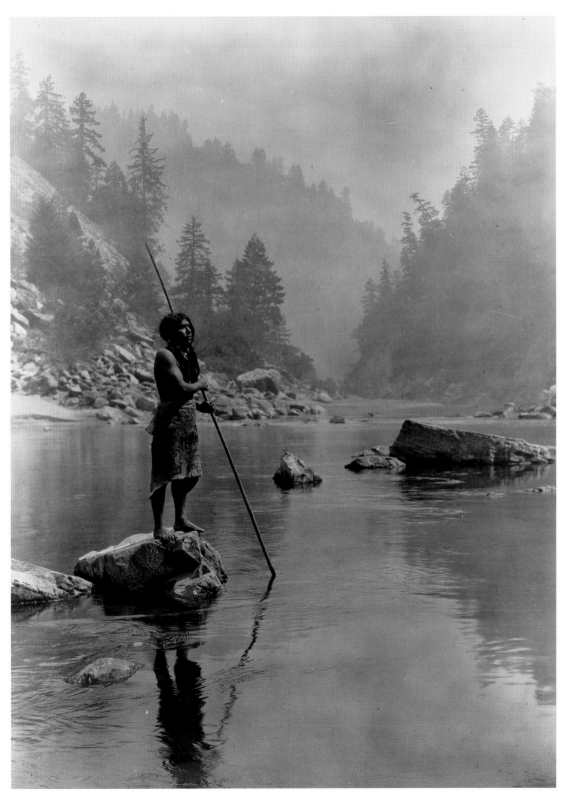

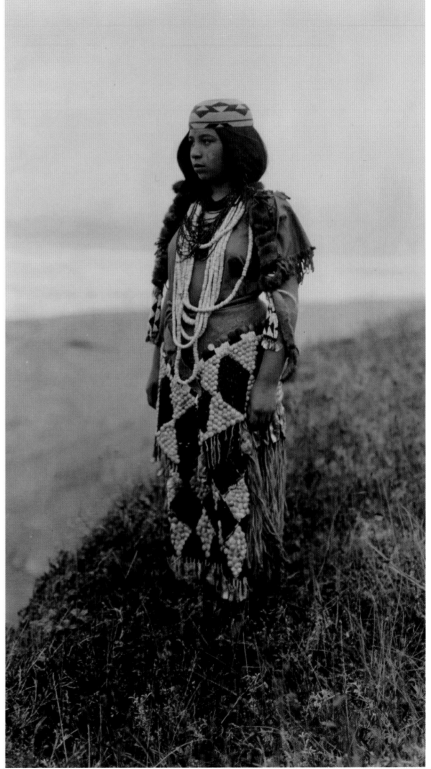

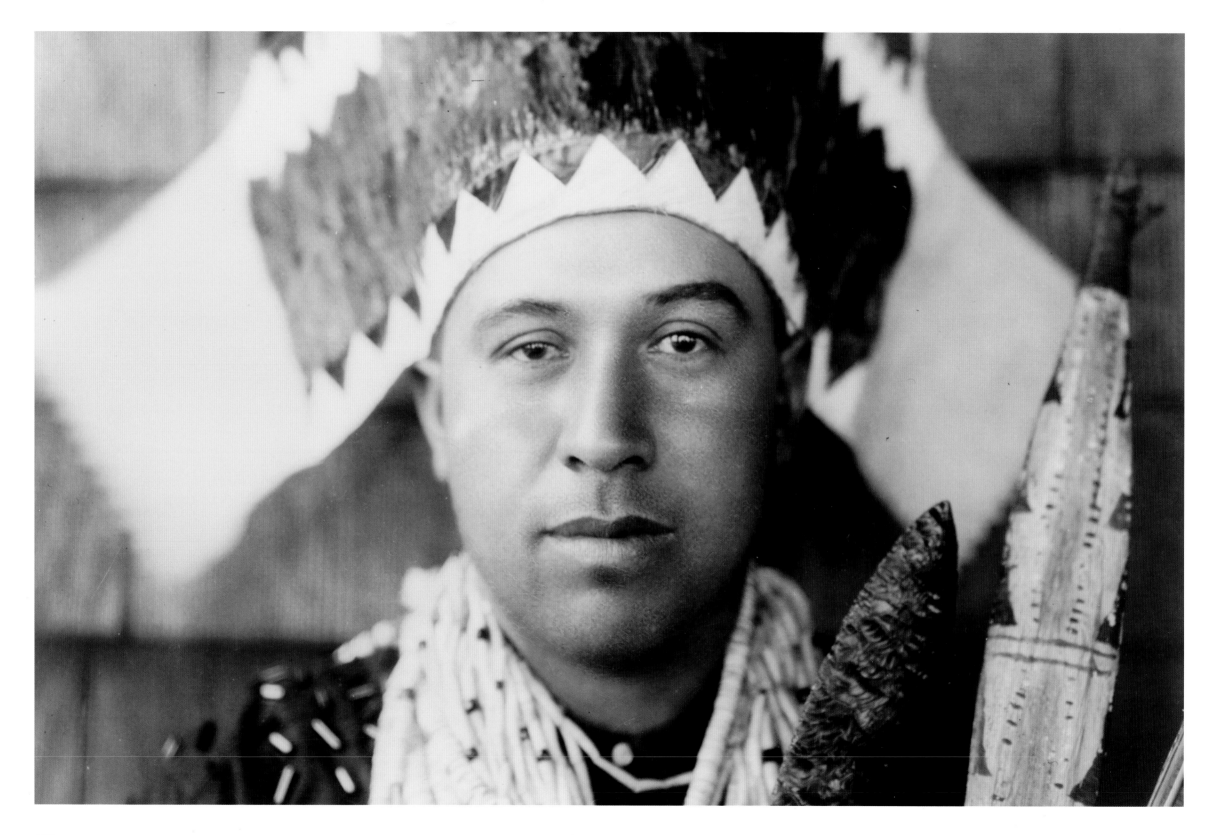

LEFT: Sam Lopez, head-and-shoulders portrait, wearing Tolowa costume including a redheaded woodpecker scalp headress and strings of dentalium shell beads, holding a traditional painted bow and an obsidian blade, a sign of wealth; c. 1923. The Tolowa are an Athabascan tribe who occupied the Smith River drainage and some of the nearby coast in the extreme northeastern corner of California. Linguistically they were closer to the Rogue River tribes to the north than to their relatives to the south. *Library of Congress, Prints & Photographs Division, Edward S. Curtis Collection, LC-USZ62-118596*

RIGHT: A Yurok widow; c. 1923. Edward Curtis's daughter, Florence, joined him on his travels among the northern California tribes. She later recounted her father's professionalism, describing him as a fast, confident worker who displayed "none of the usual fussing" she had seen from less-experienced photographers. And what about his relationship with his subjects? "He was friendly with the Indians, but never personal. They seemed to sense his sincerity." *Library of Congress, Prints & Photographs Division, Edward S. Curtis Collection, LC-USZ62-115818*

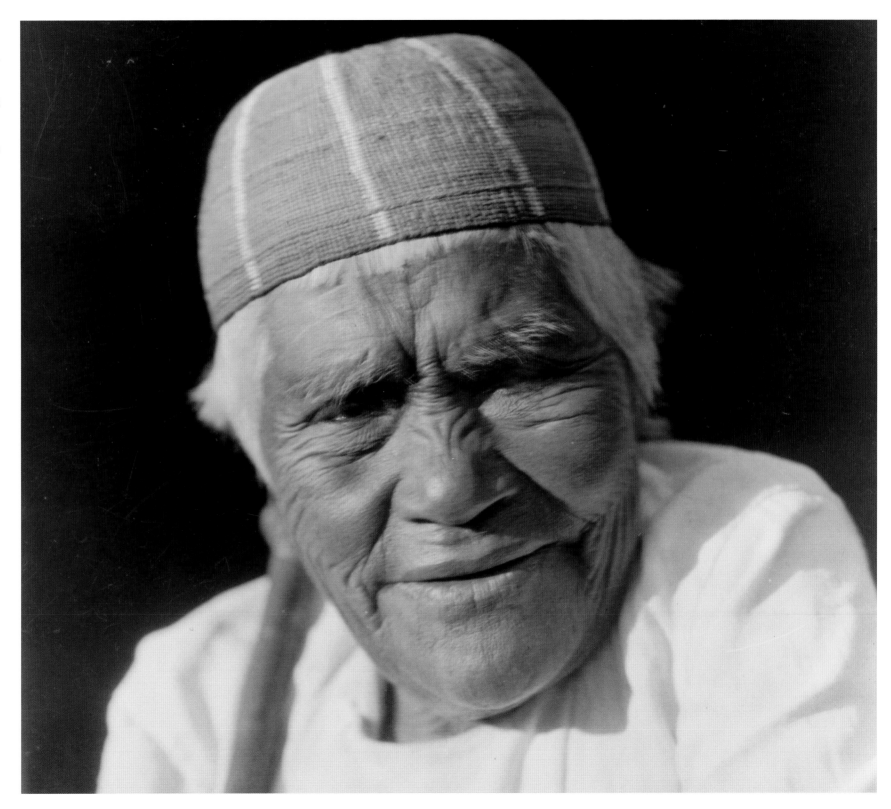

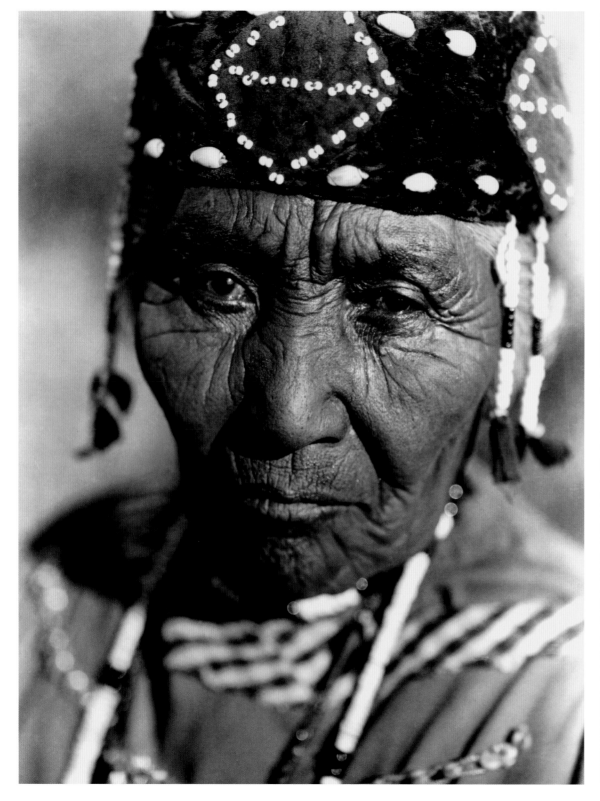

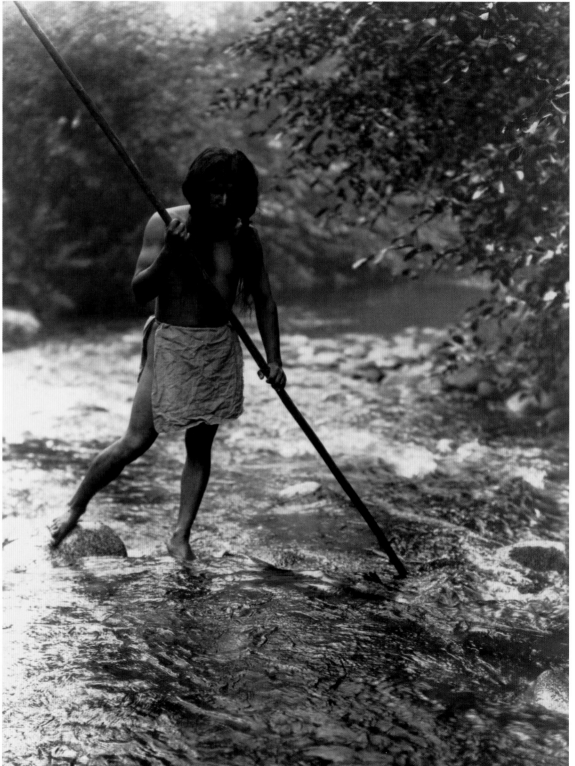

FAR LEFT: "Wife of Modoc Henry—Klamath." A portrait of a Modoc woman. *Corbis*

LEFT: "The Forest Stream." A Hupa man spearing salmon. *Corbis*

RIGHT: The Klamath ceded their lands to the United States in 1864. They were provided with a reservation that they shared with the Modoc and some Paiutes, but their reservation status was revoked by Congress in 1954—and a tribe that had once enjoyed a range of over 23 million acres suddenly had nothing. They were determined to achieve restoration of Federal recognition and did so in 1986—although without the return of their lands. Crater Lake has been part of Klamath mythology for thousands of years—indeed, the volcanic eruption that created the caldera is remembered in the legend of the battle between Skell of the Above World and Llao of the Below World that ended when Llao's home was destroyed and Crater Lake appeared. For aspiring shamans the lake was where they held vigil and fasted. *Library of Congress, Prints & Photographs Division, Edward S. Curtis Collection, LC-USZ62-103070*

FAR RIGHT: Karok woman preparing food. *Corbis*

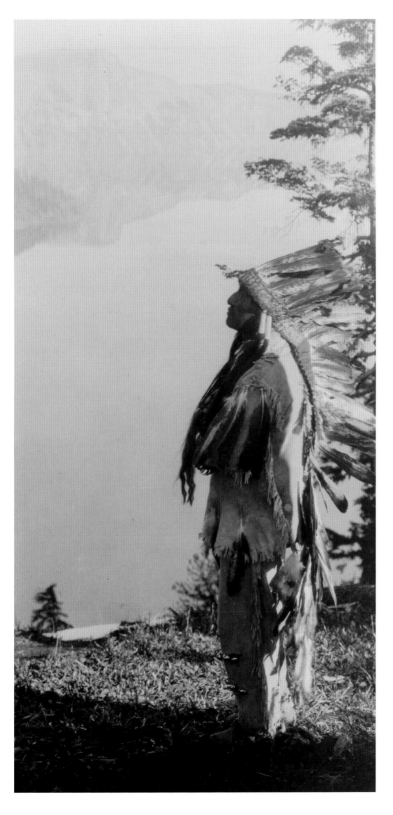

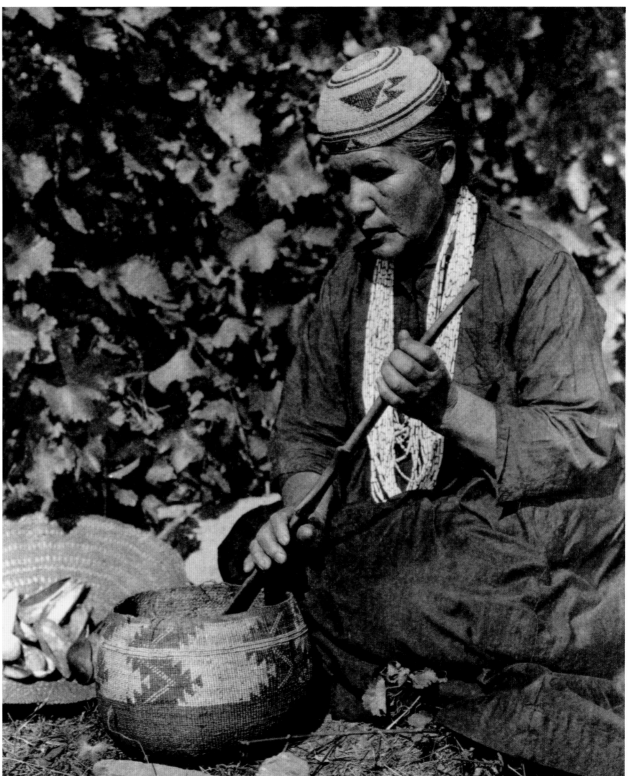

Volume XIV

The Kato. The Wailaki. The Yuki.

The Pomo. The Wintun. The Maidu.

The Miwak. The Yokuts.

All the tribes in this volume—visited by Myers and/or Curtis in 1915, 1916, 1922, and 1924—lived within a broad swath of central California, from the Yokuts who lived in the southern San Joaquin Valley to the Wailaki of the Eel River country to the north. In general, these tribes all had fairly simple cultures and were loosely organized groups of hunters and gatherers. Cut off from neighbors by the mountainous topography, most of these people lived quiet, isolated lives.

The quiet was broken with the arrival of white settlers, and they were easy prey for the newcomers. Prospectors, ranchers, and other fortune seekers quickly pushed them off their land. Tribes featured in this volume were subjected to some of the worst treatment ever experienced by any native people. Curtis was clearly distressed by the recent history of these Native Americans and the terrible conditions in which he found many of them living. His photos from this period are less romantic than his earlier work, reflecting the harsh reality of their lives.

In the tule swamp: A Pomo man paddles a traditional canoe made of rushes; c. 1924. Curtis was disturbed at the condition of the California natives, whom he described "gypsy-like field hands" whose lands had been stolen. While angry at the government for allowing this to happen, he said that the disconnected, disorganized nature of the tribes made them "easy prey" for "the greed of civilization."
Library of Congress, Prints & Photographs Division, Edward S. Curtis Collection,
LC-USZ62-98670

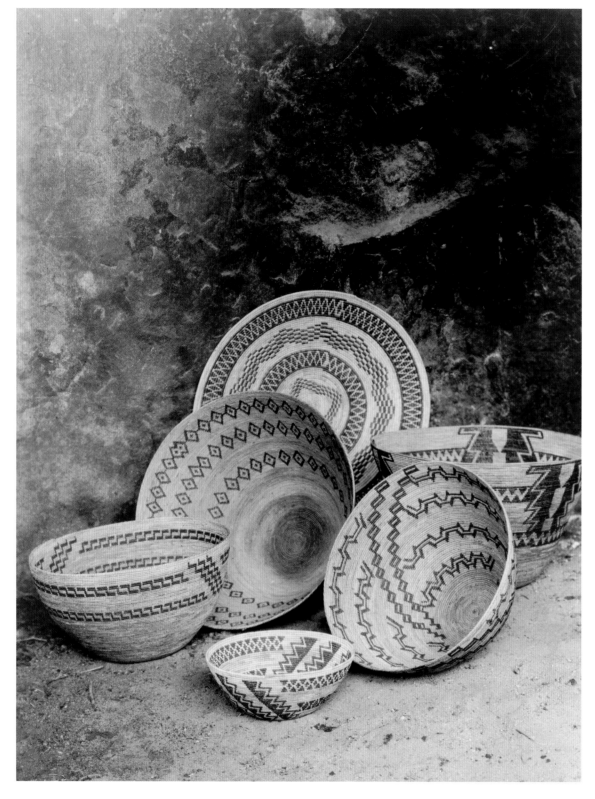 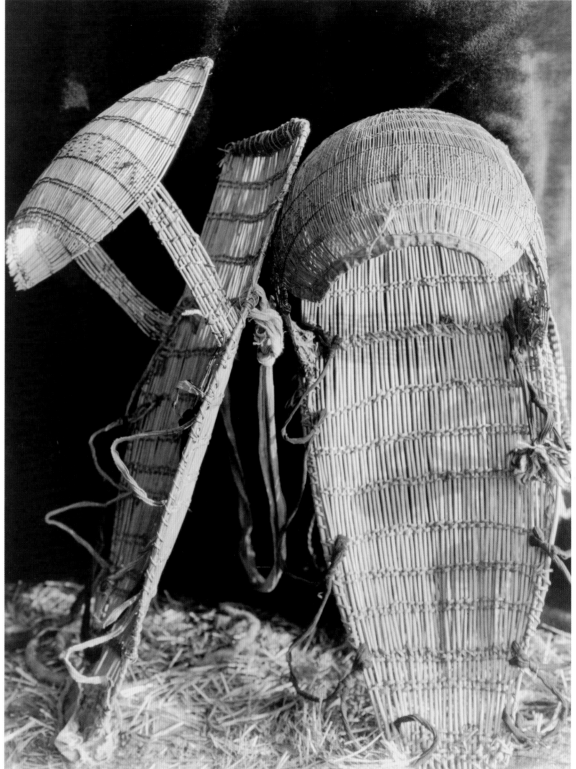

FAR LEFT: "Baskets in the Painted Cave." The Yokuts were not a political group, their relationship being linguistic; but all their groups made excellent basketry; c. 1924. An extensive and large group of 40 or 50 minor tribulets who spoke varying dialects forming a family within the Californian Penutian stock, the Yokuts were the main people of the San Joaquin valley south to Buena Vista Lake, east to the Sierra Nevada foothills and north to the Stockton area. They are divided geographically and culturally into three groups: the Northern Valley, Southern Valley, and Foothills Yokuts.
Library of Congress, Prints & Photographs Division, Edward S. Curtis Collection, LC-USZ62-118769

LEFT: Chukchansi, cradle-baskets; c. 1924.
Library of Congress, Prints & Photographs Division, Edward S. Curtis Collection, LC-USZ62-118770

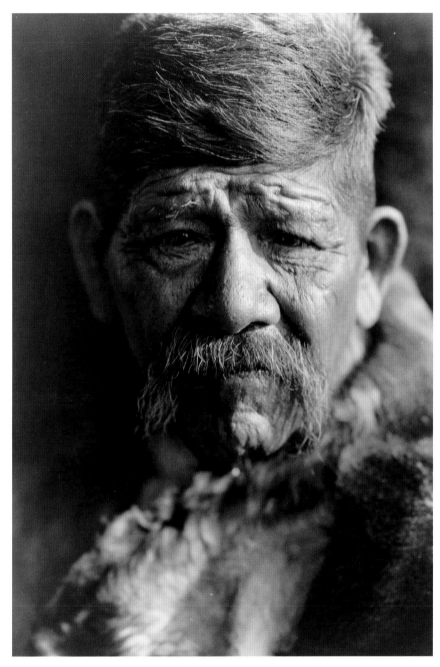

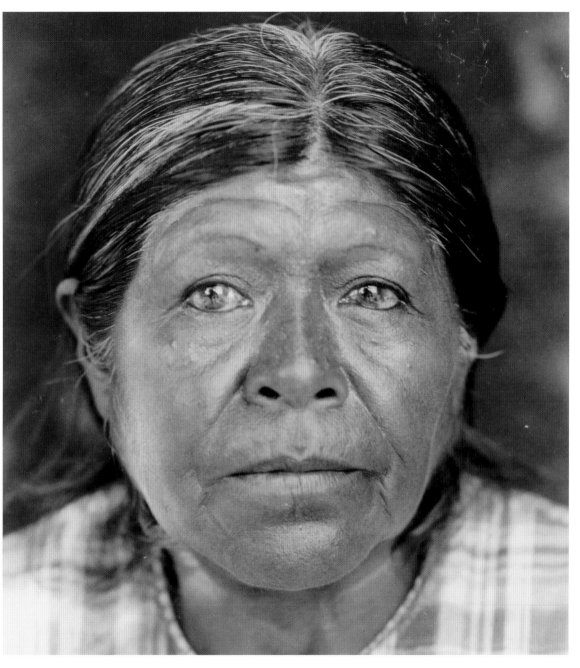

ABOVE: A Chukchansi chief; c. 1924. The Foothills Yokuts are about 15 minor groups; starting in the north from Oakhurst are the Northern Hill group in Fresno County (Chukchansi); the Kings River group (Choynimni) in eastern Fresno County; Tule-Kaweah group (Mikchamni & Yawdanchi) in Tulare County; Poso Creek group (Palewyami) in Kern County; and the Buena Vista group in Kings and Kern counties.
Library of Congress, Prints & Photographs Division, Edward S. Curtis Collection, LC-USZ62-130202

ABOVE: A Chukchansi (Yokut) woman; c. 1924. By this time, Curtis portraits had undergone a noticeable change—his romantic Indian images had been replaced by emotional photographs of suffering people. This change may have been an honest reflection of his subjects' poverty, but it may have been a product of his own personal problems.
Library of Congress, Prints & Photographs Division, Edward S. Curtis Collection, LC-USZ62-115813

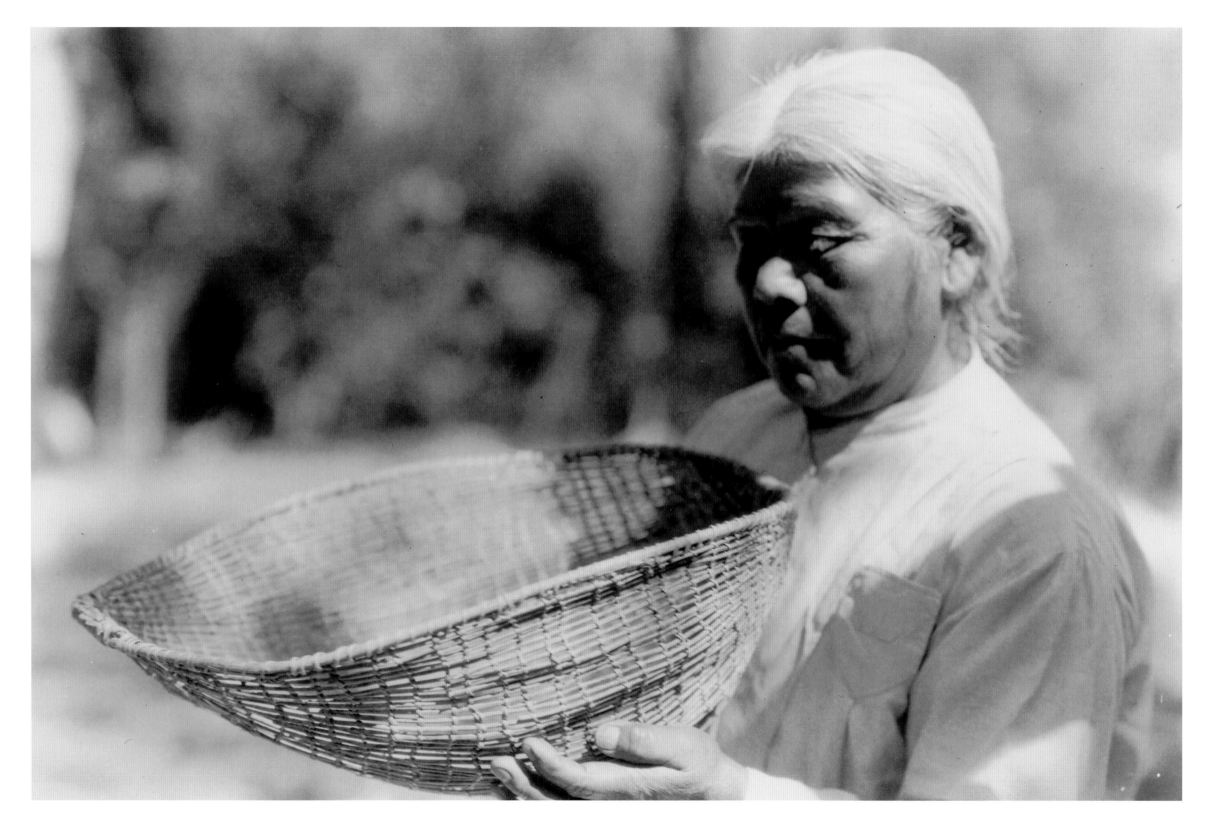

Left: Miwok woman holding sifting basket, California; c. 1924. A large group of Indians forming a linguistic family in central California, they comprise the main body of the family, the Eastern Miwok, in five subdivisions, and two small detached groups, the Coast Miwok and Lake Miwok. The Bay and Plains Miwok disappeared through the combined effects of the Spanish missions and epidemic diseases.
Library of Congress, Prints & Photographs Division, Edward S. Curtis Collection, LC-USZ62-114583

Right: "On the Merced." Southern Miwok man holding spear, sitting on boulder in a creek; c. 1924. Following California's annexation by the United States and the Cold Rush, the remnants of the Miwok eked out a meager existence on the edges of Sierran towns. In 1770 the whole group numbered in excess of 15,000: there were but 670 in 1910.
Library of Congress, Prints & Photographs Division, Edward S. Curtis Collection, LC-USZ62-120024

Far right: A Maidu man; c. 1924. A tribe of north central California, the Maidu were participants in the important Kuksu religious cult of the Sacramento Valley, with its wide variety of rituals, impersonations of spirits, distinctive costumes and use of large semi-subterranean dance houses. They used bark or brush lean-to house structures; and had an elaborate system of shell money exchange between mourners and their friends. They also burned property at funeral rites, including some fine baskets made especially to be consumed in this way, all in honor of the dead. Clothing was scant; they often went naked, or wore aprons or breechcloths of buckskin.
Library of Congress, Prints & Photographs Division, Edward S. Curtis Collection, LC-USZ62-118595

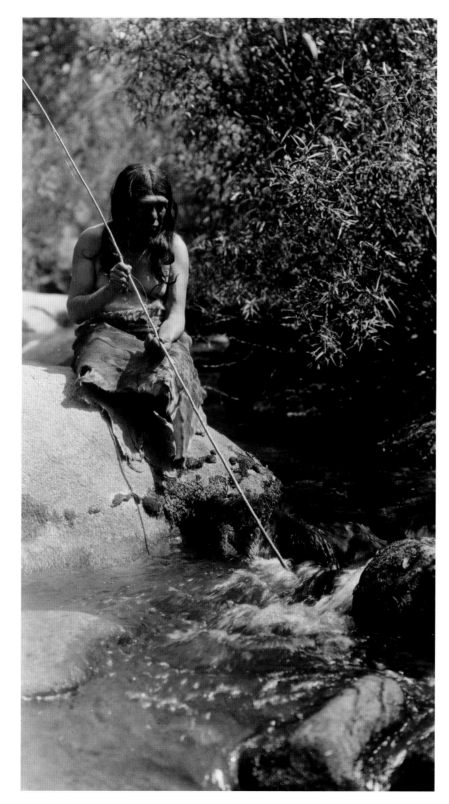

FAR LEFT: Coast Pomo with feather head-dress; c. 1924. An important group of seven related tribes speaking differing dialects forming a family of the Hokan stock centered around Clear Lake and along the coast from Fort Bragg in the north to beyond Stewarts Point in the south in present Mendocino, Lake and Sonoma counties, California. They were a populous people, numbering over 14,000 in the eighteenth century. *Library of Congress, Prints & Photographs Division, Edward S. Curtis Collection, LC-USZ62-102994*

LEFT: Man in Pomo dance costume with headbands of flicker feathers; c. 1924. The social core of Pomo life was the family and the small village; and their beliefs were part of a religious complex called the Kuksu, which stressed curing rituals and elaborate forms of dancing and fire-eating to ensure the absence of danger from ghosts. *Library of Congress, Prints & Photographs Division, Edward S. Curtis Collection, LC-USZ62-110859*

RIGHT: Cecilia Joaquin, Pomo woman, using seed beater to gather seeds into a burden basket; c. 1924. In the mild climate the Pomos used little clothing; in cool weather mantles, capes, robes and skirts of vegetable fiber or skins were worn. They are also known for their excellent quality baskets which survive in abundance in museums.
Library of Congress, Prints & Photographs Division, Edward S. Curtis Collection, LC-USZ62-116525

FAR RIGHT: Cooking acorns—upper Lake Pomo Indian woman cooking in front of a cane tepee, California; c. 1924. They hunted rabbits, deer, sea mammals and bears with bows and arrows, heavy spears, nets and snares. They had ample supplies of fish.
Library of Congress, Prints & Photographs Division, Edward S. Curtis Collection, LC-USZ62-103072

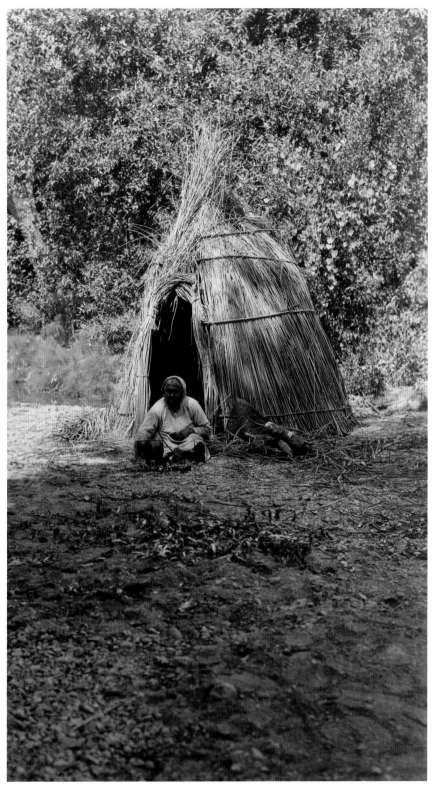

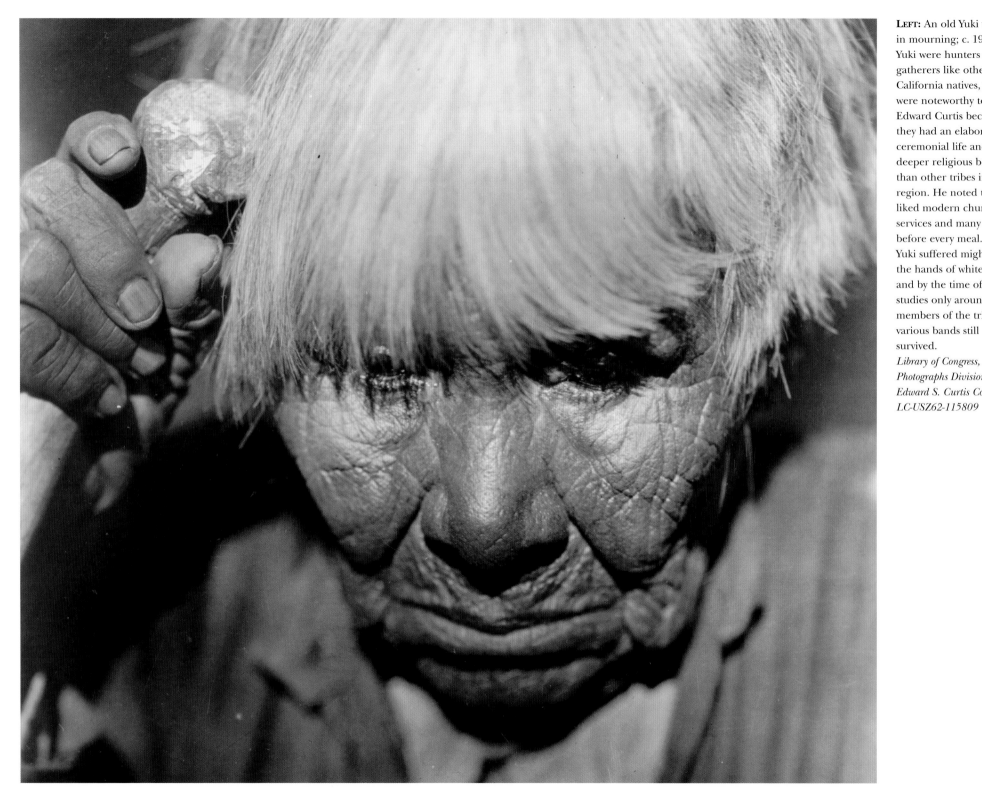

LEFT: An old Yuki woman in mourning; c. 1924. The Yuki were hunters and gatherers like other California natives, but they were noteworthy to Edward Curtis because they had an elaborate ceremonial life and deeper religious beliefs than other tribes in the region. He noted that they liked modern church services and many prayed before every meal. The Yuki suffered mightily at the hands of white settlers and by the time of Curtis's studies only around 200 members of the tribe's various bands still survived.
Library of Congress, Prints & Photographs Division, Edward S. Curtis Collection, LC-USZ62-115809

RIGHT: A Wappo woman; c. 1924. The Wappo were related to the Yuki, Huchnom, and Coast Yuki, with whom they formed the Yukian linguistic family. They lived in the valleys of the Napa and Russian rivers in Napa and adjacent Sonoma counties, California, with a detached branch on the south shore of Clear Lake sometimes known as the Lile'ek. The culture was a simple central Californian type with subsistence use of plant foods, river life and small game. They excelled in basket making in common with their northern neighbors the Pomo.
Library of Congress, Prints & Photographs Division, Edward S. Curtis Collection, LC-USZ62-118772

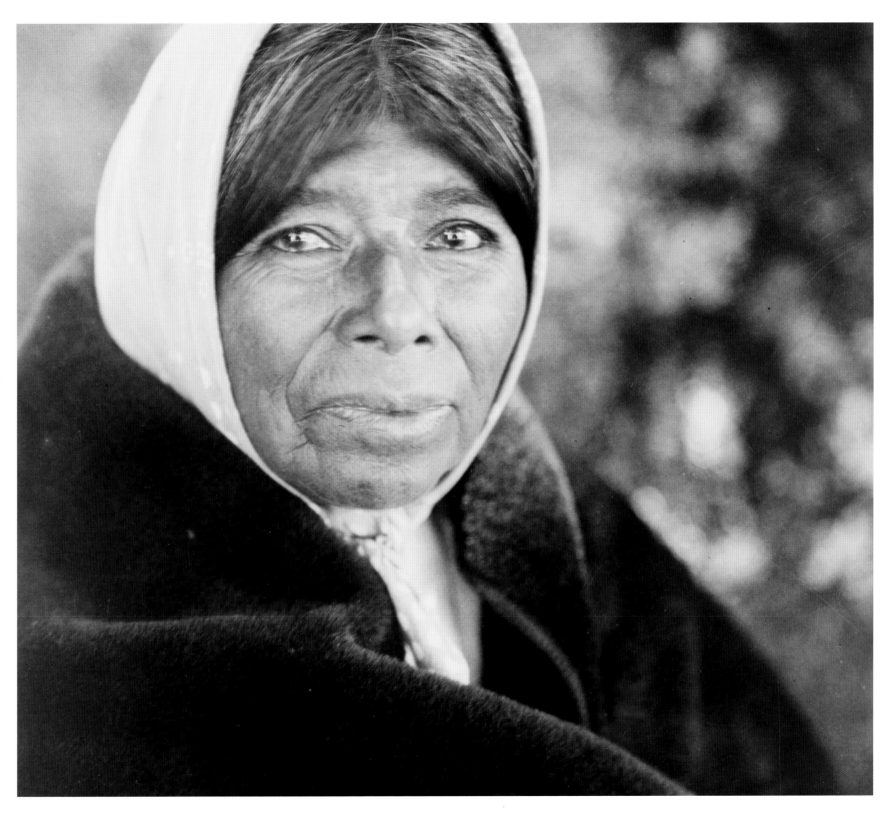

Volume XV

Southern California Shoshoneans. The Diegunenos. Plateau Shoshoneans. The Washo.

This volume was the first of three books published in 1926. The several small tribes featured occupied a vast area of the West. Curtis admitted "…the material has required a much longer time in the gathering than was found to be necessary in the case of some of the more populous tribes.…"—probably the first excuse in print for his much-delayed project.

All of these tribes shared simple lifestyles that revolved around hunting and gathering. The Diegueños and their Shoshonean neighbors, the Luiseños and Cahuilla, all lived in extreme southern California near the Mexican border. All were influenced by Spanish missions built in the region starting in the middle of the eighteenth century. By the time Curtis and Myers visited them, these tribes were an interesting mix of native and Spanish/Catholic culture.

The Mono and Paviotso lived in small bands along the California-Nevada border. Curtis described these people probably the least culturally developed of any tribe he encountered, but he remarked on their exceptional basketry skills. The Washo were also skilled basketmakers and primarily fished for a living in the Yuba, Feather, and other rivers.

Mono summer kitchen; August 5, 1924. As the fairly crude instruments attest, the Mono, along with the Paviotso to the north, were one of the most primitive tribes studied by Curtis. The were simple, peaceful hunters and gatherers, described by the photographer as "contented to gain a livelihood by the least possible exertion."
Library of Congress, Prints & Photographs Division, Edward S. Curtis Collection, LC-USZ62-131363

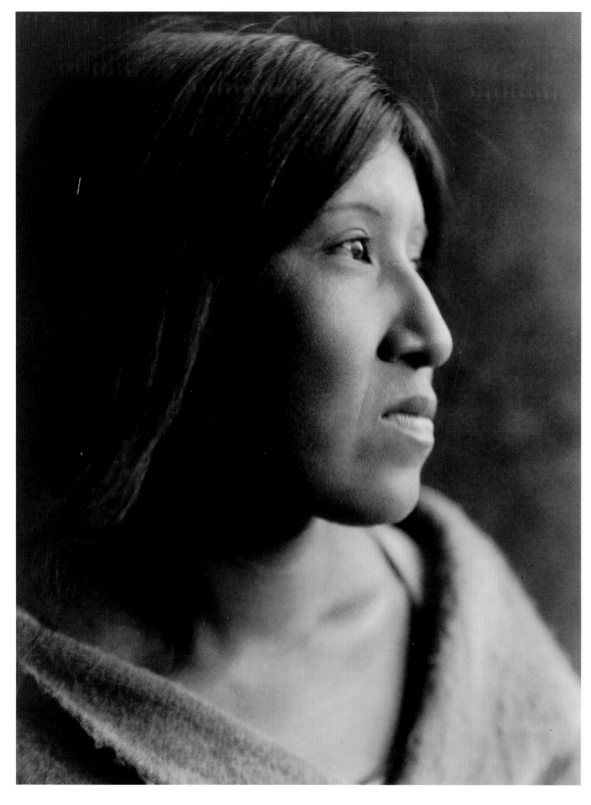

LEFT: A Cahuilla woman, c. 1924. This Takic-speaking tribe lived in the rugged desert north of Salton Sea in southern California. In describing how they dressed, Curtis noted "the subject of clothing could be ignored with little injustice to the Cahuilla"—traditionally they wore little or nothing. *Library of Congress, Prints & Photographs Division, Edward S. Curtis Collection, LC-USZ62-107207*

RIGHT: A Cahuilla woman carries a large basket on her head—the traditional way; c. 1924. The Cahuilla lived in rectangular and dome-shaped brush-covered shelters in small villages. Their food included small game, acorns, piñon nuts, and wild fruits, plus they grew some corn and squash. They had a rich ceremonial life, their rituals reaffirming a relationship to all things, the sacred past, present and nature. *Library of Congress, Prints & Photographs Division, Edward S. Curtis Collection, LC-USZ62-96454*

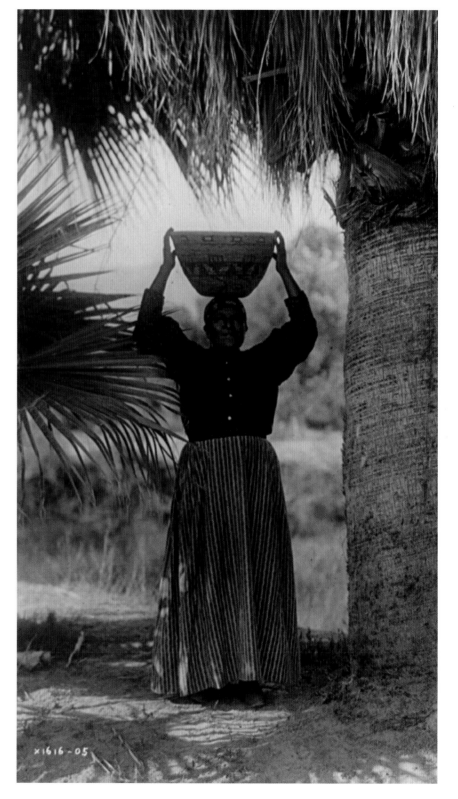

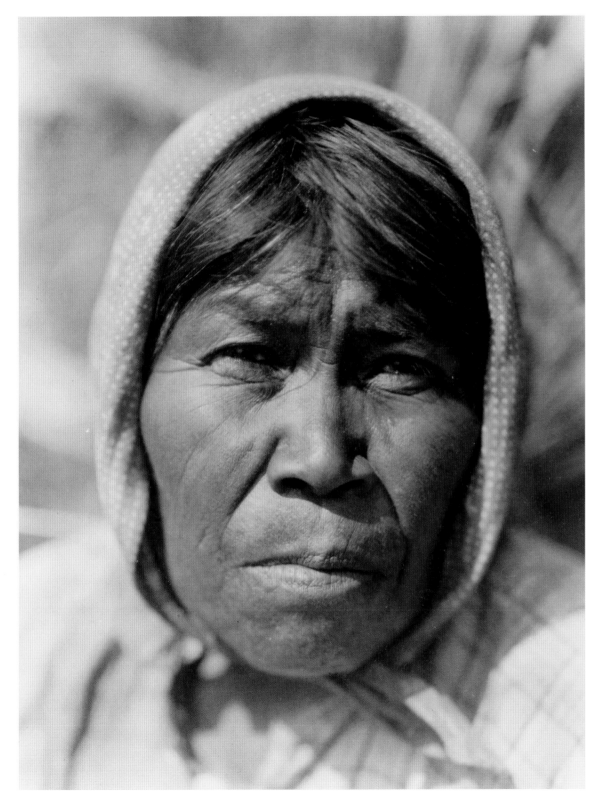

LEFT: A Cupeño woman; c. 1924. A small Takic-speaking tribe, the Cupeño lived east of Lake Henshaw and west of the Santa Rosa Mountains, California, closely related to the Cahuilla. They were missionized and reduced to the social status of near serfs during the Mexican and American periods. *Library of Congress, Prints & Photographs Division, Edward S. Curtis Collection, LC-USZ62-118585*

ABOVE: A Santa Ysabel woman; c. 1924. The Diegueño or Ipai are a people occupying the border country of southern California in present San Diego County south of the San Luis Rey River—an area of coast, mountain and desert. They became part of the so-called "Mission Indians" of southern California, of both Yuman and Takic origin, who were to a large extent under the influence and control of the Spanish missions from 1769 until secularization during the Mexican period. *Library of Congress, Prints & Photographs Division, Edward S. Curtis Collection, LC-USZ62-115820*

FAR LEFT: Serrano woman of Tejon; c. 1924. The Serrano were gatherers, hunters, and fishers; family dwellings were usually circular willow structures covered with tule thatching; in addition they had large ceremonial houses where chiefs or religious leaders lived.
Library of Congress, Prints & Photographs Division, Edward S. Curtis Collection, LC-USZ62-115825

LEFT: Curtis said of this Washo basket-maker, "The coiled baskets produced by this woman have not been equalled by any Indian now living. About ninety years old, Datsolali appears to be in the early sixties. She has the pride of a master in his craft, and a goodly endowment of artistic temperament.
Library of Congress, Prints & Photographs Division, Edward S. Curtis Collection, LC-USZ62-114784

RIGHT: A Lake Mono basket-maker; c. 1924. There are two distinct strands of Mono—the Eastern or Owens Valley Paiute and the Western or Monache. The former occupied the valley of the Owens River parallel with the southern Sierra Nevada Mountains. The latter lived beyond the Sierra Nevadas sharing a general culture with the neighboring Yokuts.
Library of Congress, Prints & Photographs Division, Edward S. Curtis Collection, LC-USZ62-118771

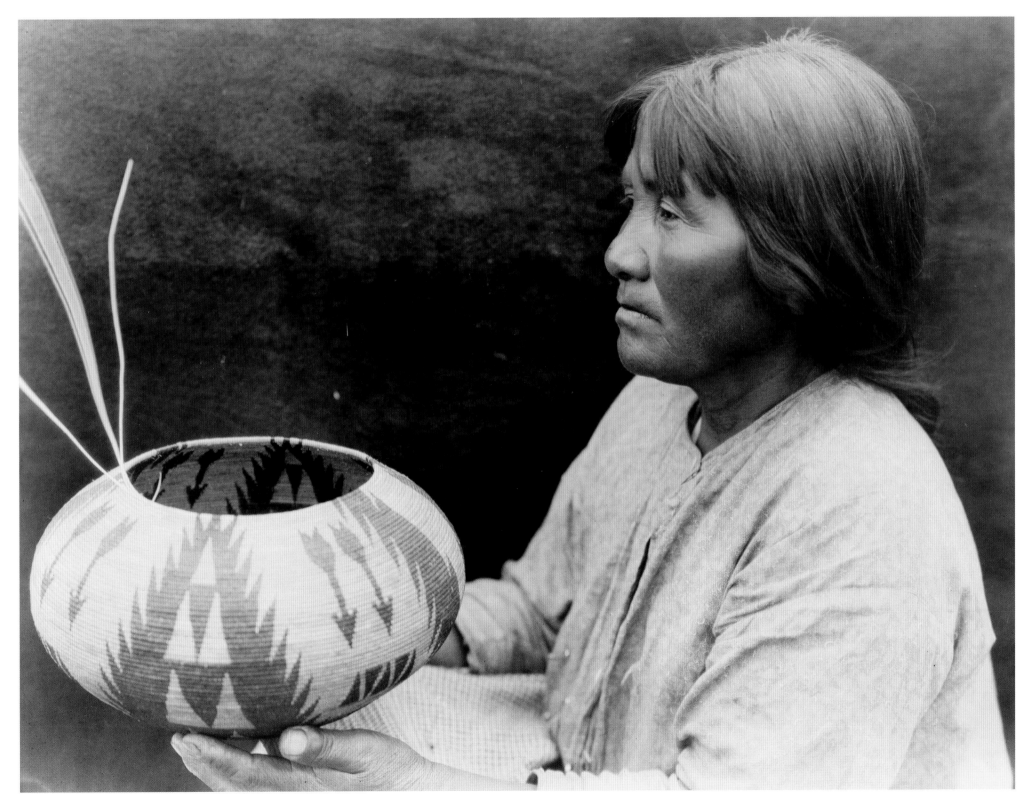

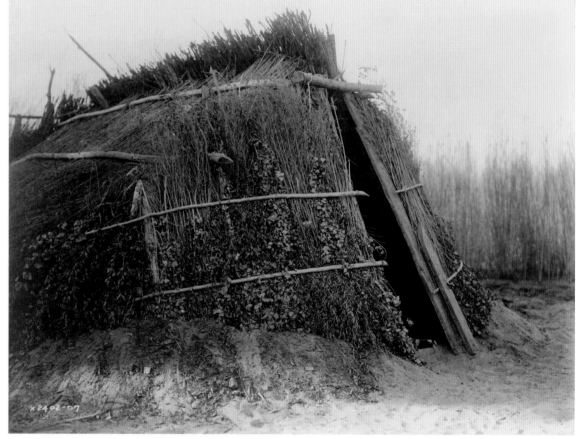

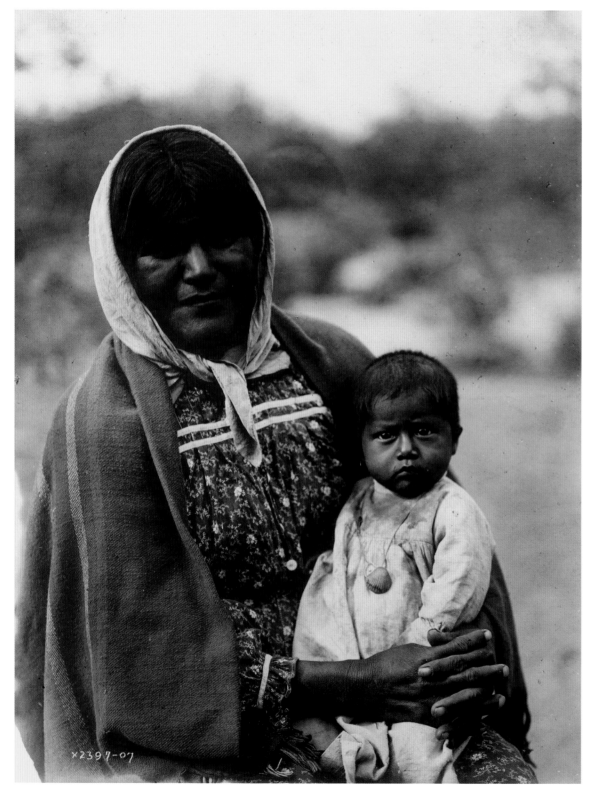

LEFT: Chemehuevi mother and child; c. 1907. The Chemehuevi of San Bernardino County, California, are related to the loose collection of Southern Paiute bands of southern Utah and Nevada, including parts of Arizona above the Colorado River.
Library of Congress, Prints & Photographs Division, Edward S. Curtis Collection, LC-USZ62-112235

ABOVE: Chemehuevi house—thatched shelter built on mounded dirt; c. 1924. They were the typical Great Basin people; the quest for food kept them on the move in search of small game, grasshoppers, gophers, fish, nuts, seeds and wild vegetables. Their shelters were simple brush constructions, but they made fine basketry.
Library of Congress, Prints & Photographs Division, Edward S. Curtis Collection, LC-USZ62-118589

RIGHT: A Paviotso woman at Walker Lake; c. 1924. Curtis discovered that the tribe identified four groups of its people based on their home and primary food: "trout eaters" at Walker Lake; "black-sucker eaters" at Pyramid Lake; "cattail eaters" at Carson Lake; and "tarweed-seed eaters" at Honey Lake. c. 1924.
Library of Congress, Prints & Photographs Division, Edward S. Curtis Collection, LC-USZ62-113075

FAR RIGHT: The primitive artists—Paviotso man standing, marking side of glacial boulder that already has petroglyphs on it; August 5, 1924.
Library of Congress, Prints & Photographs Division, Edward S. Curtis Collection, LC-USZ62-49234

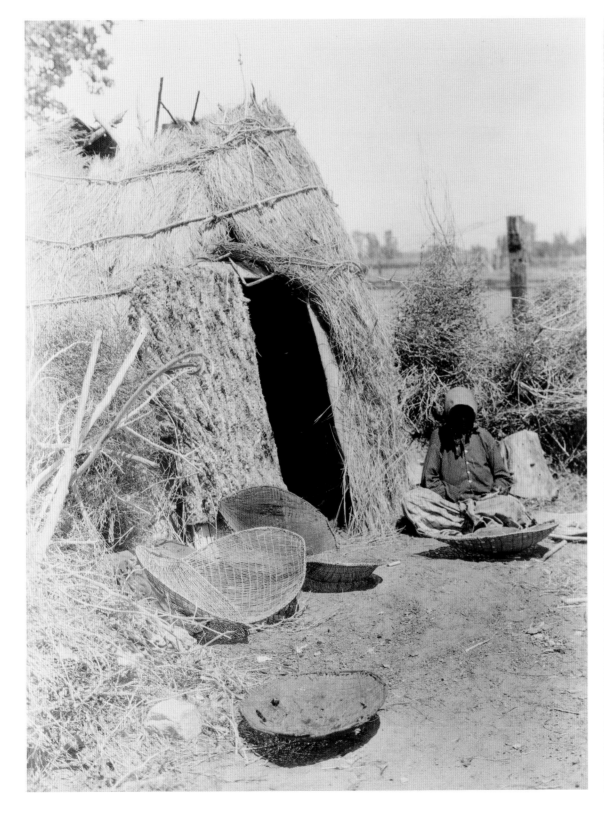

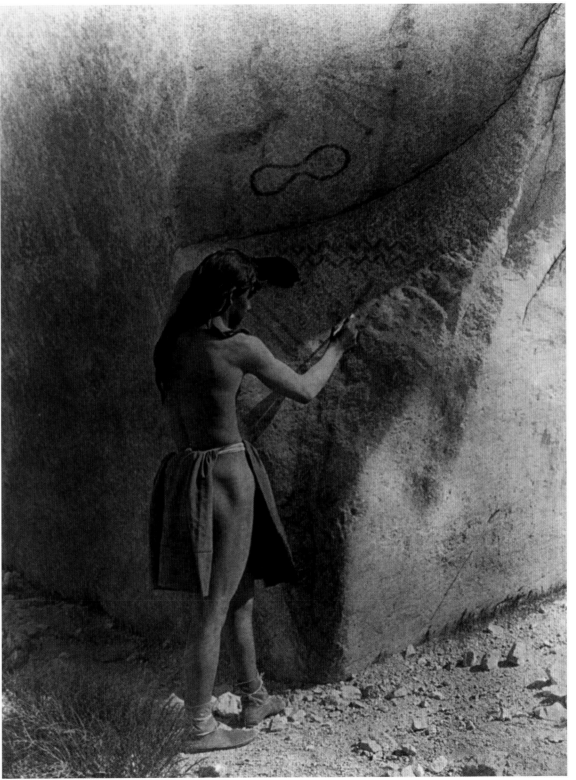

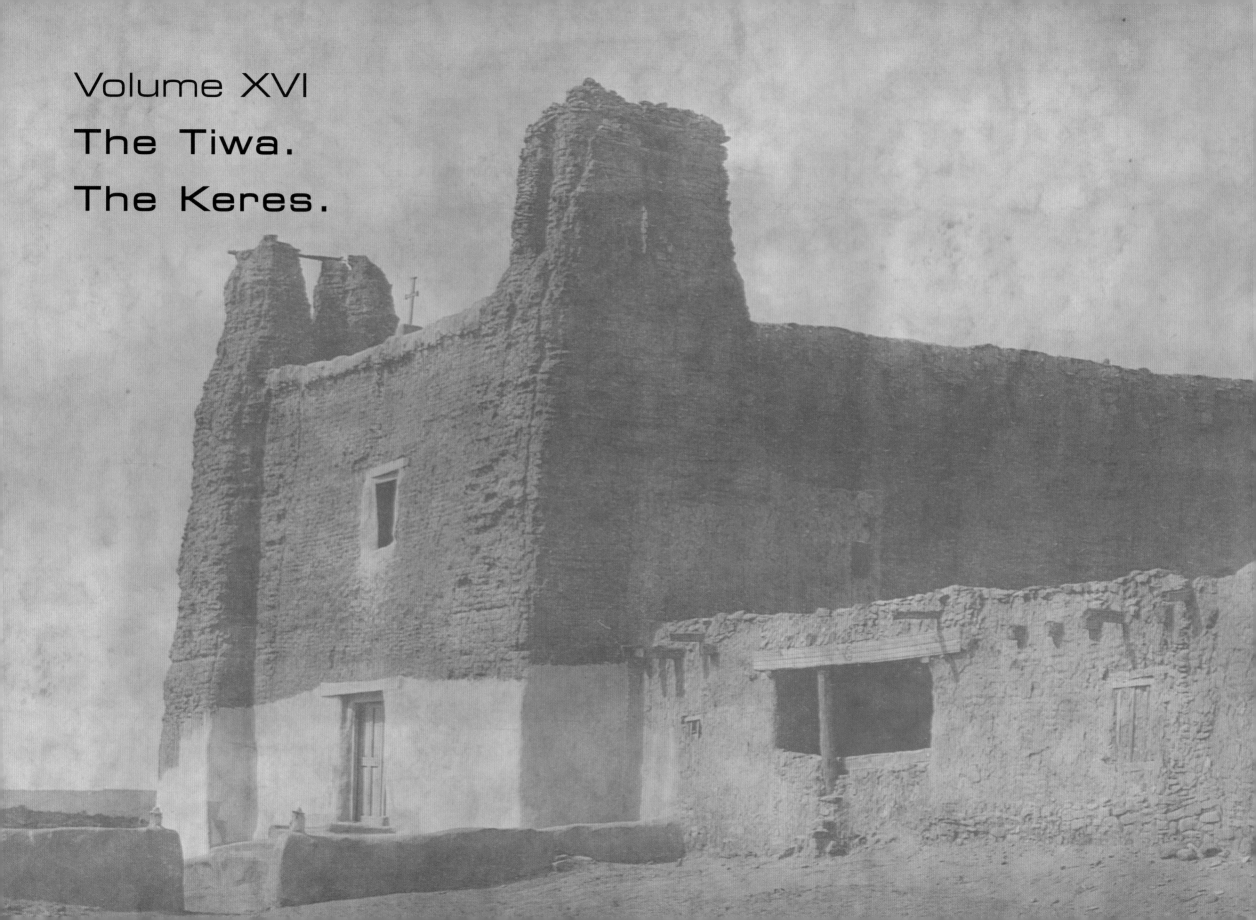

Volume XVI

The Tiwa.

The Keres.

This volume was the first of two that profiled several of New Mexico's famous pueblos. Taos and Isleta were located in the northern part of the state in the Rio Grande Valley and were part of the Tiwa dialect group of the Tanoan language. Cochiti, Santo Domingo, Acoma, and Laguna, located farther to the south also along the Rio Grande, shared the Keresan language.

The name "pueblo" came from the Spanish term for "village" and was a general term applied to all the people of the Southwest that lived in permanent adobe settlements. The people were farmers who grew primarily corn, beans, and squash. They also hunted—including bison on the plains to the east—but eventually adopted domesticated animals from after the Spanish arrived in the region in the sixteenth century.

The Pueblo people had a richly developed religious life, much of which they tended to keep secret from outsiders. They vigorously resisted Spanish attempts to convert them to Catholicism, but eventually embraced a loose version of Christianity while also maintaining their traditional beliefs.

Mission and church of Acoma. Curtis created a controversy with the publication of this volume that simmered for a decade. He described Pueblo religious ceremonies that appeared to offer young girls to shamans for sexual purposes. Curtis later said that he thought this was a violation of the girls' rights. He soon found himself in conflict with proponents of religious freedom for Native Americans. *Corbis*

LEFT: Acoma belfry; c. 1905. The westernmost Keresan Pueblo and one of the most impressive is situated on a mesa almost 400 feet high some 50 miles west of Albuquerque, New Mexico. The Acoma Pueblo vies with Hopi for the title of the oldest continuously inhabited village in the U.S.A.
Library of Congress, Prints & Photographs Division, Edward S. Curtis Collection, LC-USZ62-117710

RIGHT: Head-and-shoulders portrait of an Acoma woman, facing front, with head covered and wearing jewelry; c. 1905. Acoma pottery has hard, thin walls with white to yellow-brown slip and is decorated with geometric motifs and parrot-like birds in overall designs.
Library of Congress, Prints & Photographs Division, Edward S. Curtis Collection, LC-USZC4-8853

FAR RIGHT: Head-and-shoulders portrait of an Acoma man; c. 1904.
Library of Congress, Prints & Photographs Division, Edward S. Curtis Collection, LC-USZC4-8928

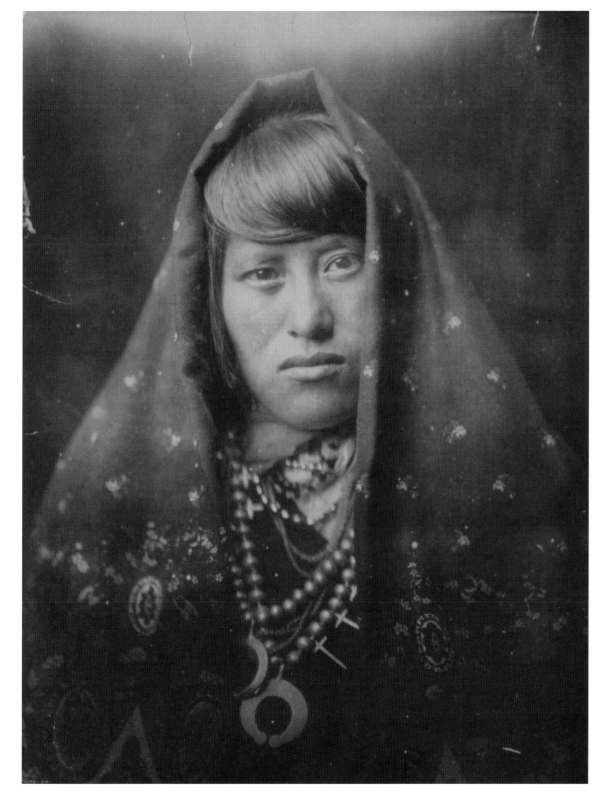

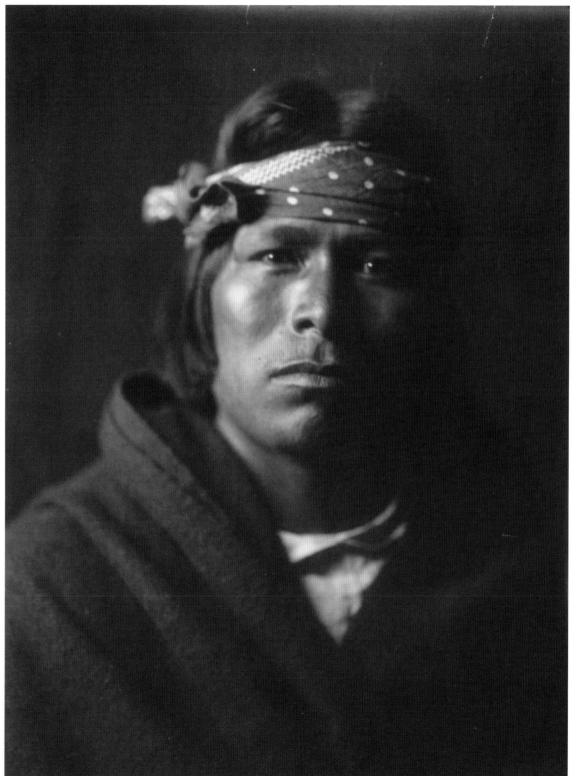

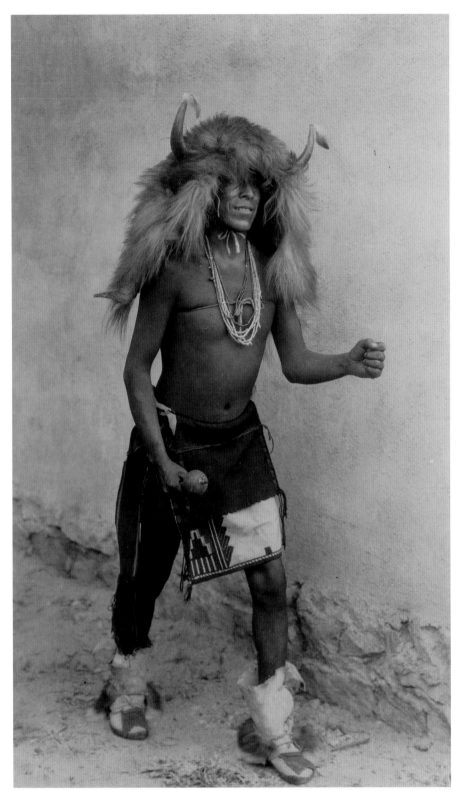

LEFT: Sia buffalo dancer; c. 1926. A Keresan-speaking Pueblo on the Jemez River about 30 miles north of Albuquerque, New Mexico, Zia (or Sia) have gained a livelihood in the recent past from grazing sheep and goats on surrounding lands. *Library of Congress, Prints & Photographs Division, Edward S. Curtis Collection, LC-USZ62-106264*

RIGHT: Shuati, a Sia woman standing, with pot on head; c. 1926. They are noted for making fine pottery with white or yellow-buff backgrounds and varied naturalistic designs of deer, birds and leaves. *Library of Congress, Prints & Photographs Division, Edward S. Curtis Collection, LC-USZ62-106263*

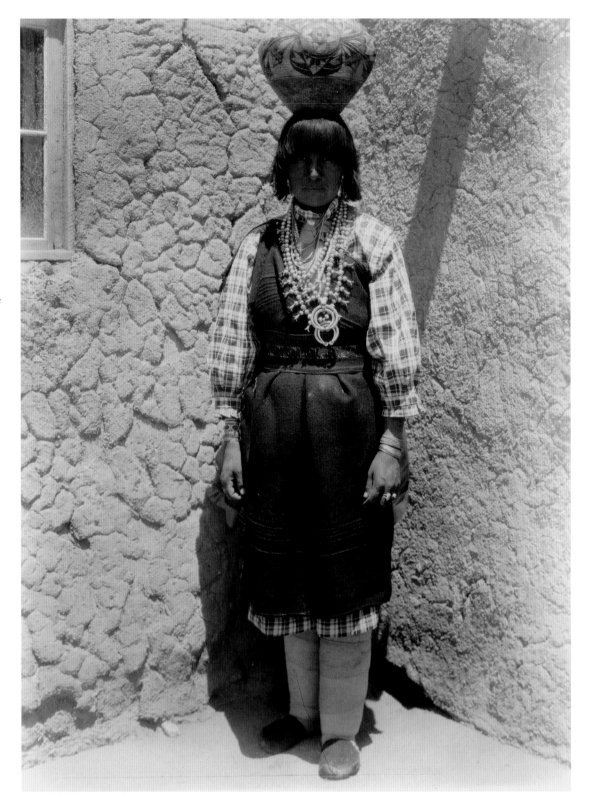

RIGHT: Jemez Indian; c. 1926. The people of this Pueblo speak Towa, a dialect of Tanoan. The Pueblo is located on the Jemez River 30 miles northwest of Bernalillo, and they were participants in the Pueblo Revolt of 1680 and suffered the traumas and punitive expeditions that followed. *Library of Congress, Prints & Photographs Division, Edward S. Curtis Collection, LC-USZ62-108424*

FAR RIGHT: An Isleta woman posed standing in a doorway; c. 1926. The second of the three Southern Tiwa dialects of the Tanoan family is spoken by the inhabitants of this Pueblo situated on the west bank of the Rio Grande 13 miles south of Albuquerque, with an outlying settlement, Chiskal. The Spanish destruction of religious chambers, masks, and para-phernalia led to the Revolt of 1680. Refugees from Isleta moved to the El Paso area after the revolt. *Library of Congress, Prints & Photographs Division, Edward S. Curtis Collection, LC-USZ62-107615*

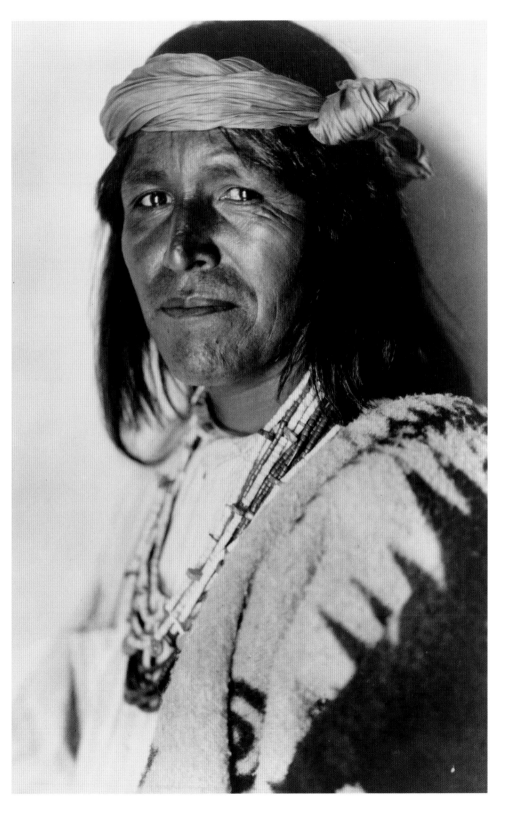

LEFT: A Taos girl; c. 1905. Traditionally one of the more prosperous communities, surrounded by fertile agricultural land, this impressive multi-story Pueblo is about 600 years old. It is geographically close to the Plains Indians, from whom the tribe adopted elements of material culture. Curtis noted that the Taos men, in particular, could have been easily mistaken for Cheyenne in the way they dressed and carried themselves. *Library of Congress, Prints & Photographs Division, Edward S. Curtis Collection, LC-USZ62-106253*

RIGHT AND FAR RIGHT: Walvia ("Medicine Root"), a Taos women. Curtis commented that it was very challenging to interview Taos people and learn their customs. The young seemed especially afraid of talking to Curtis and earning the wrath of their elders for sharing tribal secrets. *Library of Congress, Prints & Photographs Division, Edward S. Curtis Collection, LC-USZ62-106990 and LC-USZ62-106985*

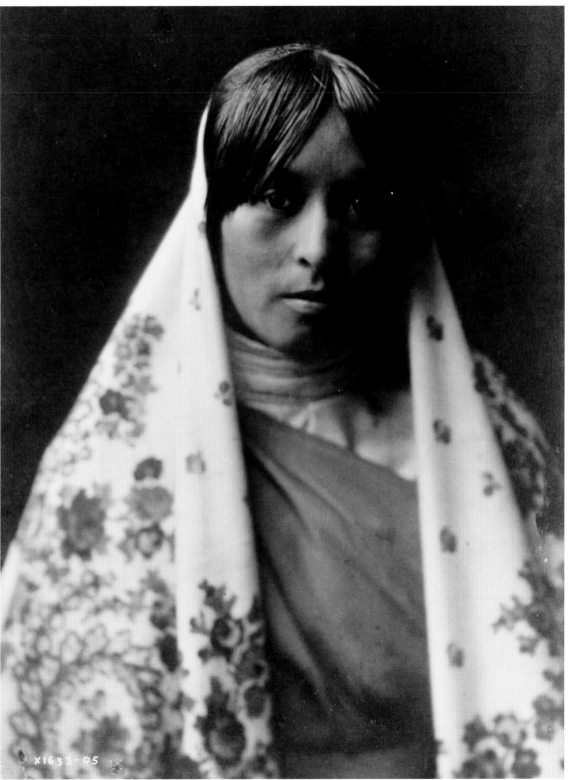

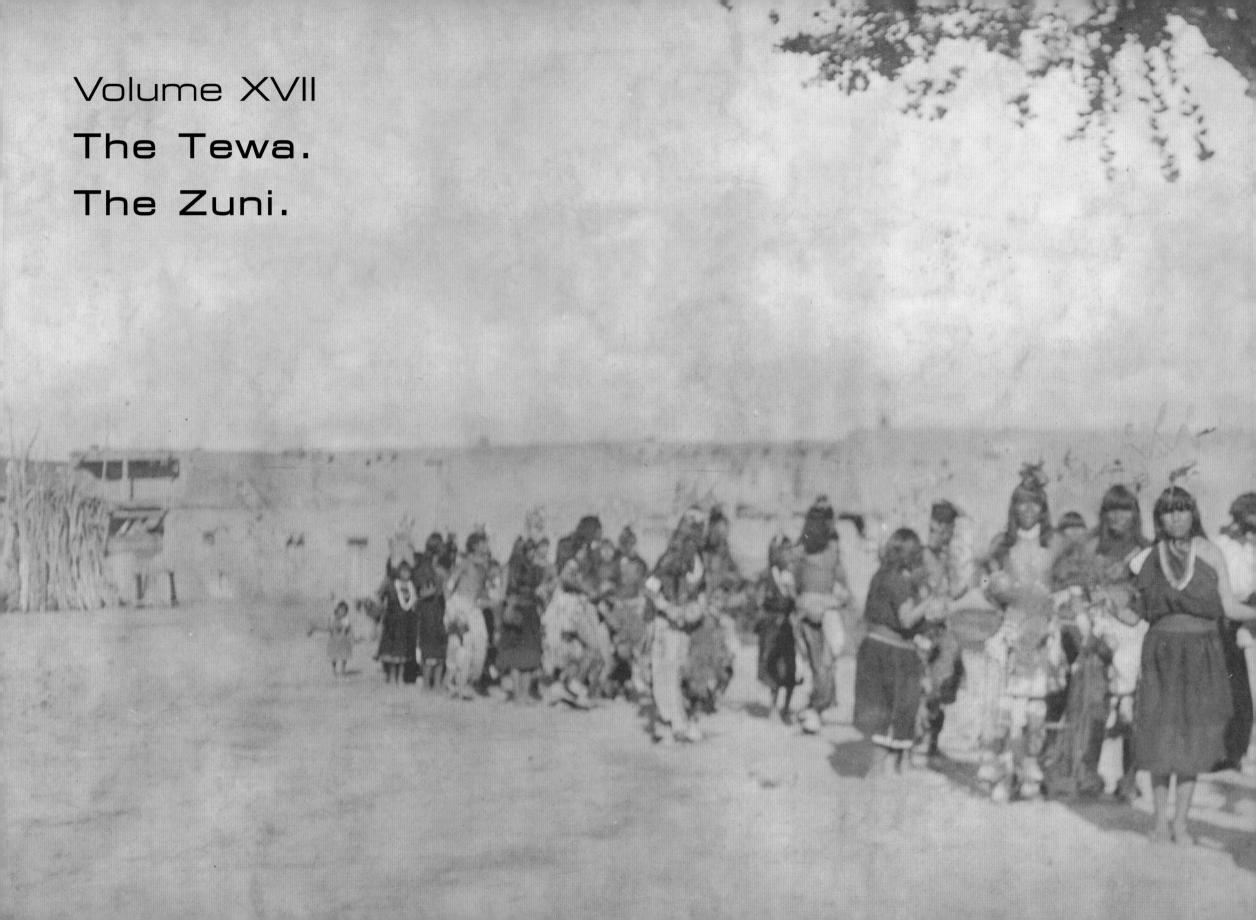

Volume XVII

The Tewa.

The Zuni.

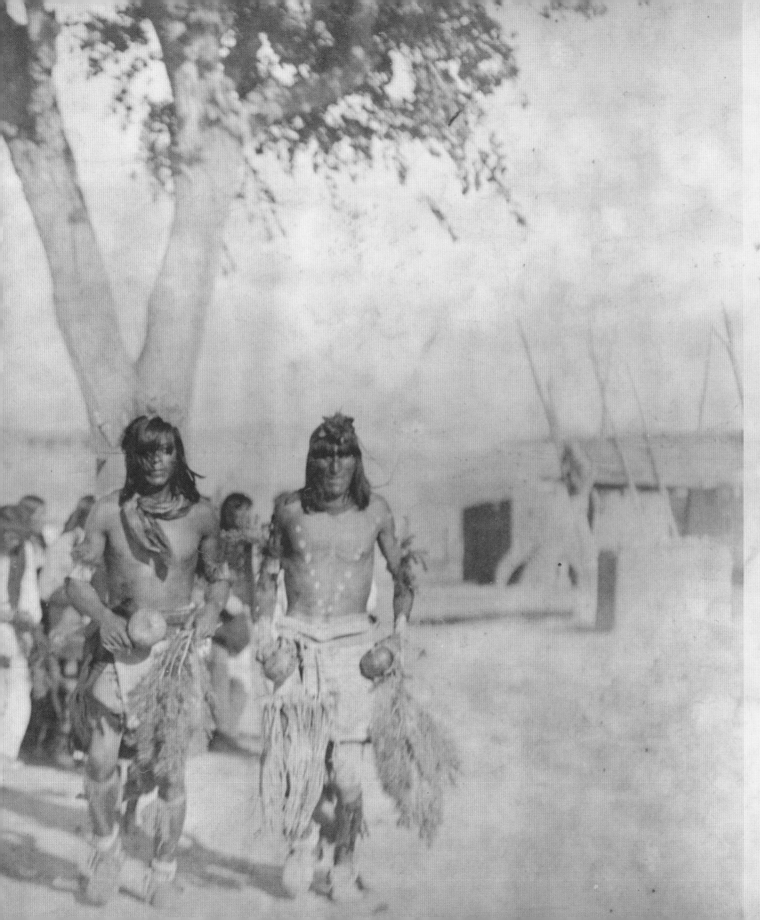

This installment, like the previous, was devoted to New Mexico pueblos: The Tewa villages of San Juan, San Ildefonso, and Nambe in the Rio Grande Valley, and the Zuni—a language, a tribe, and a pueblo—in the western part of the state. All these people were primarily farmers, but today are best known for the beautiful pottery they produced.

The project's ethnographic work with the Pueblos dated back to 1905, when William Phillips—Clara Curtis's nephew and a key employee in the early days of the project—collected information in New Mexico. William Myers visited the Pueblos in 1909, 1917, and 1924. It was during the last fieldwork season that Edward Curtis also did much of the photography for this and the preceding volume.

Both the Zuni and especially the Tewa had been subjected to many years of oppression at the hands of the Spanish, who labored hard to crush traditional native beliefs in favor of Catholicism. Considering this history, Curtis was amazed at how much of the traditional religion was still evident in the early twentieth century. He found the Zuni to be fairly open about their beliefs, but the Tewa were much more guarded, especially about their secretive snake cult, which at one point in history included human sacrifices.

Tablita Dance: Tewa Indians dancing in line formation; c. 1905. Curtis and his team visited the Tewa and Zuni several times over a twenty-year period. Curtis noted that these Pueblo tribes had as long a history of European contact as any he studied. As a result, their cultures did not change as much during the course of the project as other tribes who only recently had started to feel the pressure of white civilization.
Library of Congress, Prints & Photographs Division, Edward S. Curtis Collection,
LC-USZ62-130197

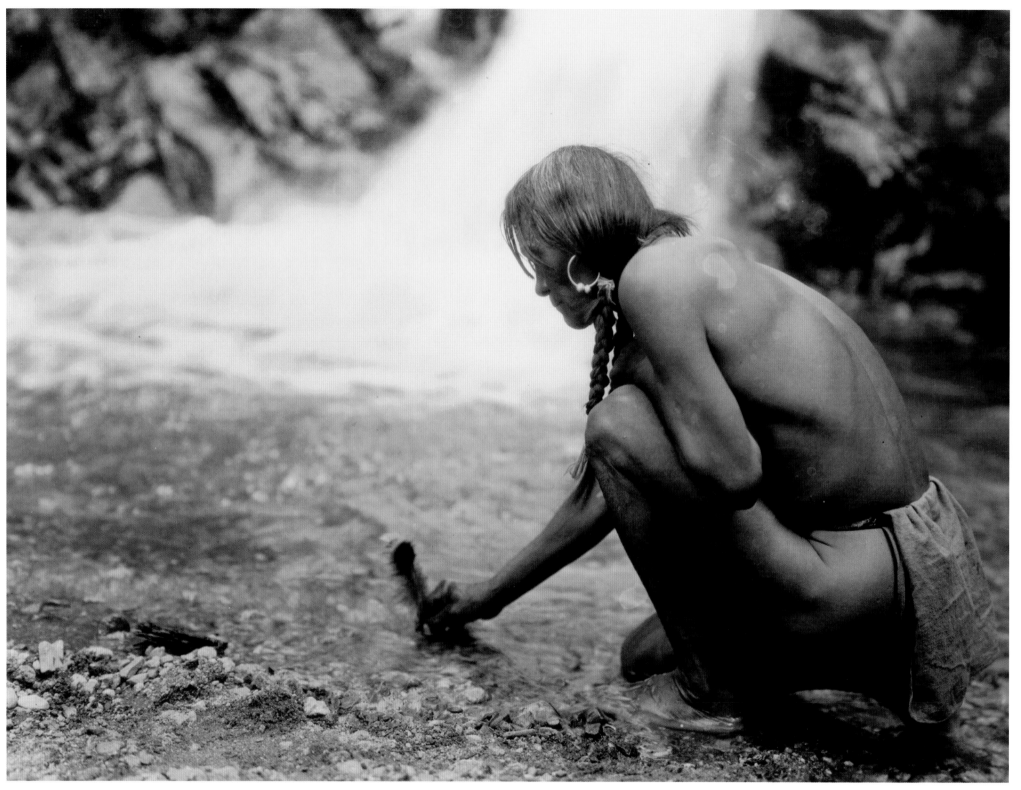

LEFT: A Nambe Indian placing prayer plume at waterfall; c. 1927. A small Pueblo, Nambe lies 15 miles north of Santa Fé, New Mexico, formerly speaking a Northern Tewa dialect of the Tanoan family.
Library of Congress, Prints & Photographs Division, Edward S. Curtis Collection, LC-USZ62-101264

RIGHT: "The Potter"— a Santa Clara woman, seated with pottery; c. 1905. The Santa Clara Indians make polished black and red pottery with modern variations, and are often regarded as one of the wealthiest Pueblos, with a resource-rich land base.
Library of Congress, Prints & Photographs Division, Edward S. Curtis Collection, LC-USZ62-115803

FAR RIGHT: San Ildefonso girl with large jar balanced on her head; c. 1927. This Pueblo is situated on the Rio Grande 20 miles northeast of Santa Fé. They speak a Northern Tewa language of the Tanoan family, and claim descent from people who moved out of the valleys and cliff homes on the Pajarito plateau.
Library of Congress, Prints & Photographs Division, Edward S. Curtis Collection, LC-USZ62-117709

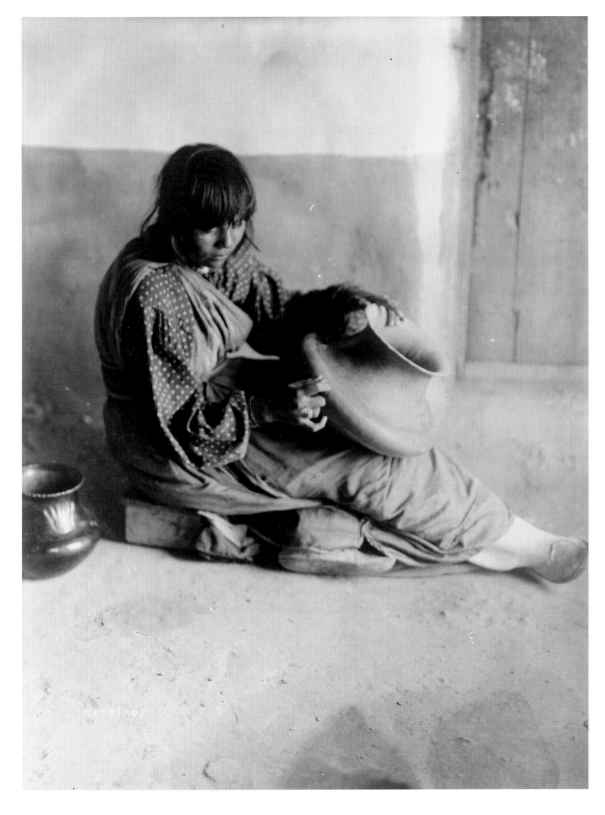

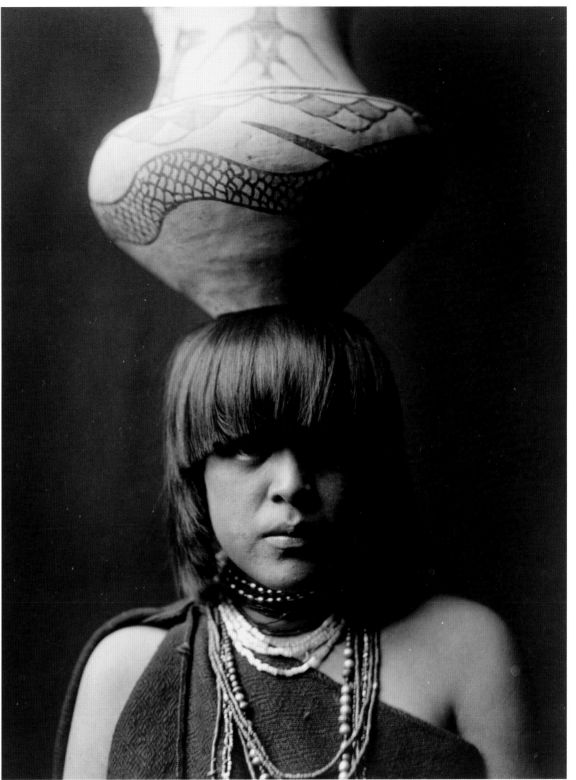

217

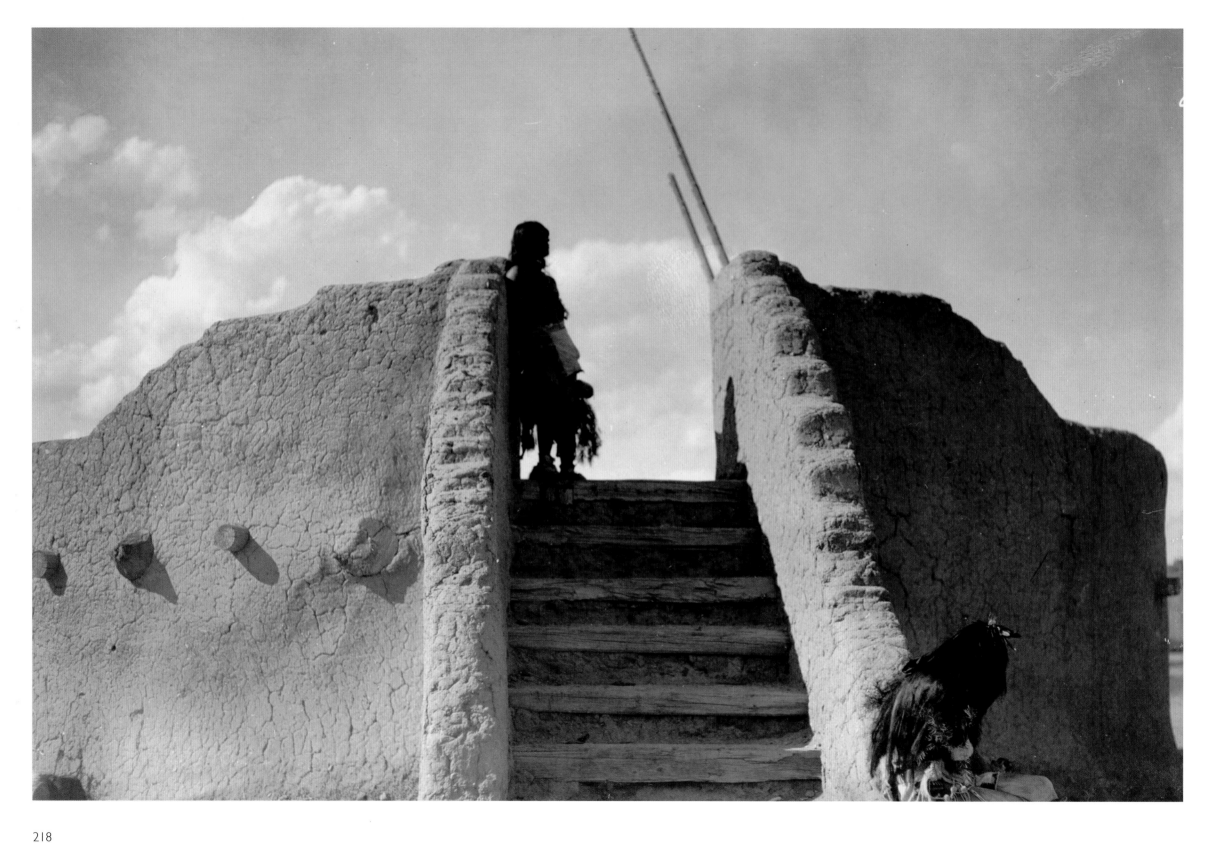

Left: Tewa guard at top of the kiva stairs, San Ildefonso, New Mexico; c. 1905. The man has been positioned to protect the religious ceremonies going on inside the structure from prying eyes. Curtis observed that the Tewa had preserved their religion in the presence of Spanish missionaries by becoming very secretive about their traditional beliefs and practices. *Library of Congress, Prints & Photographs Division, Edward S. Curtis Collection, LC-USZ62-111284*

Right: Two Tewa people processing wheat outside a pueblo structure, San Juan Pueblo, New Mexico; c. 1905. The largest and northernmost of the six Tewa-speaking Tanoan Pueblos, located five miles north of Española on the east bank of the Rio Grande, San Juan people suffered considerable persecution by the Spanish civil and ecclesiastical authorities until they arose in revolt in 1680. *Library of Congress, Prints & Photographs Division, Edward S. Curtis Collection, LC-USZ62-118774*

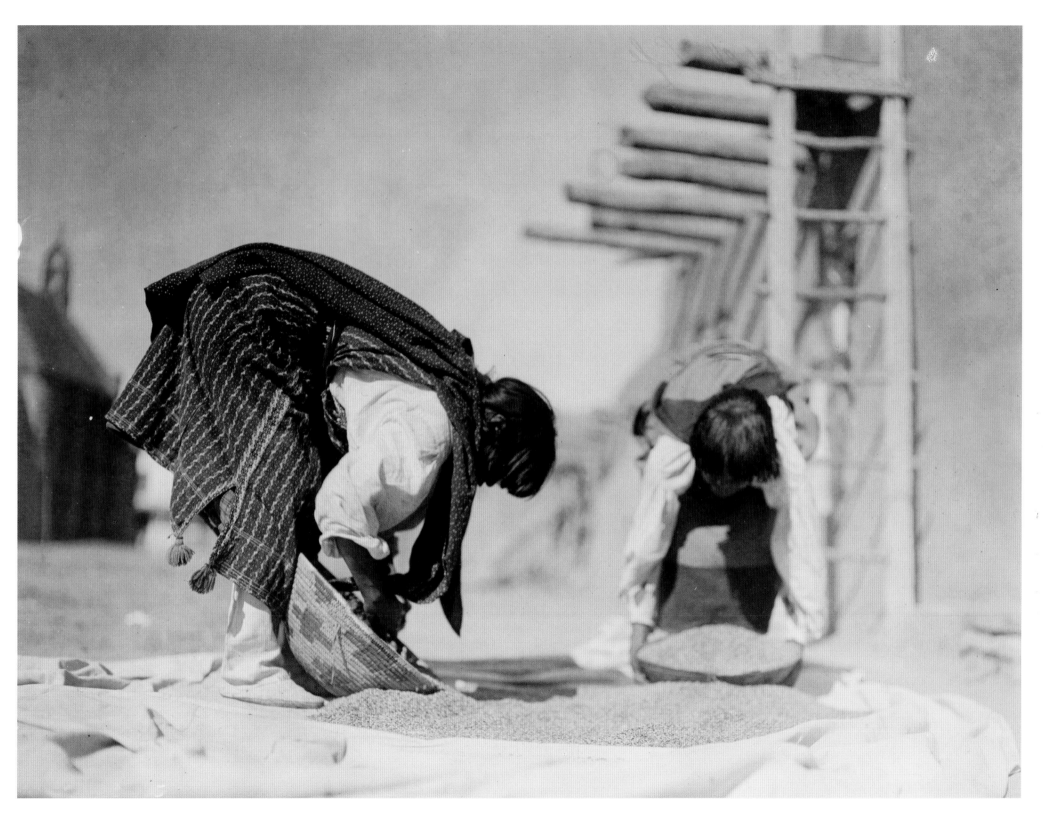

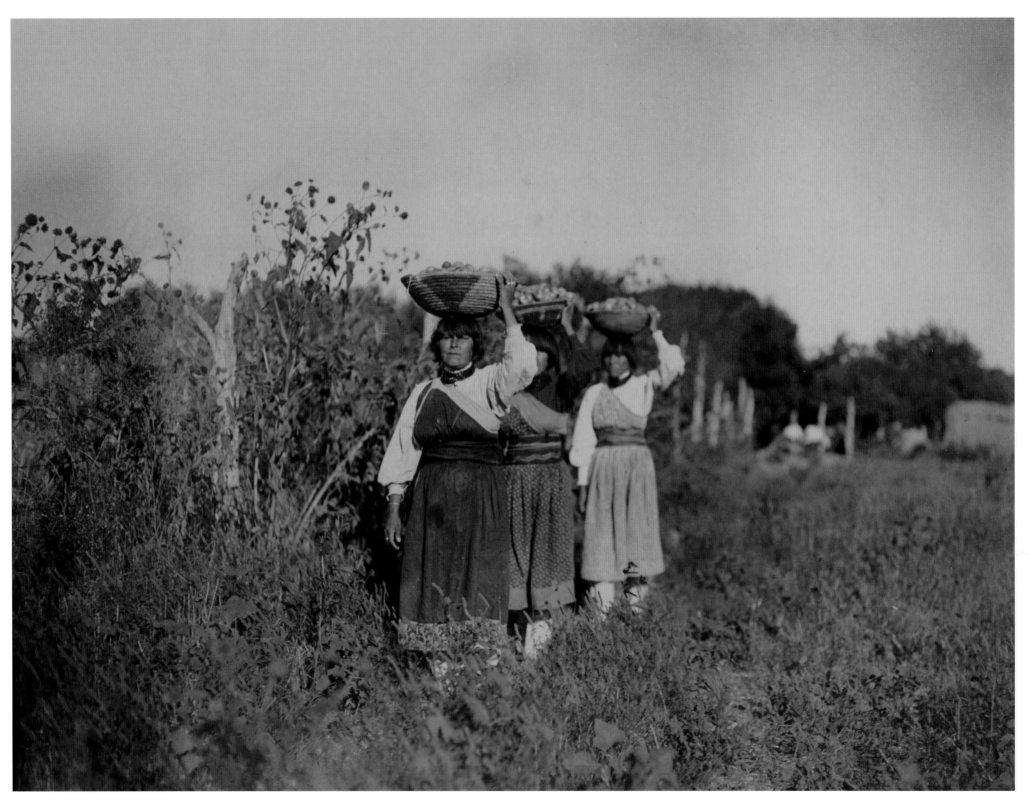

LEFT: Three women carrying baskets on their heads; c. 1905. San Juan pottery is polished red and black ware with some incised and carved types. *Library of Congress, Prints & Photographs Division, Edward S. Curtis Collection, LC-USZ62-115815*

RIGHT: Two Santa Clara women carrying jugs on their heads, examples of the northern Pueblo's distinctive pottery; c. 1905. Curtis discovered that the potters used dinosaur-stomach grinding stones— found in fossil deposits— to polish the pots. The stones were highly prized and closely guarded: the Tewa women believe it was bad luck to lose one. *Library of Congress, Prints & Photographs Division, Edward S. Curtis Collection, LC-USZ62-112218*

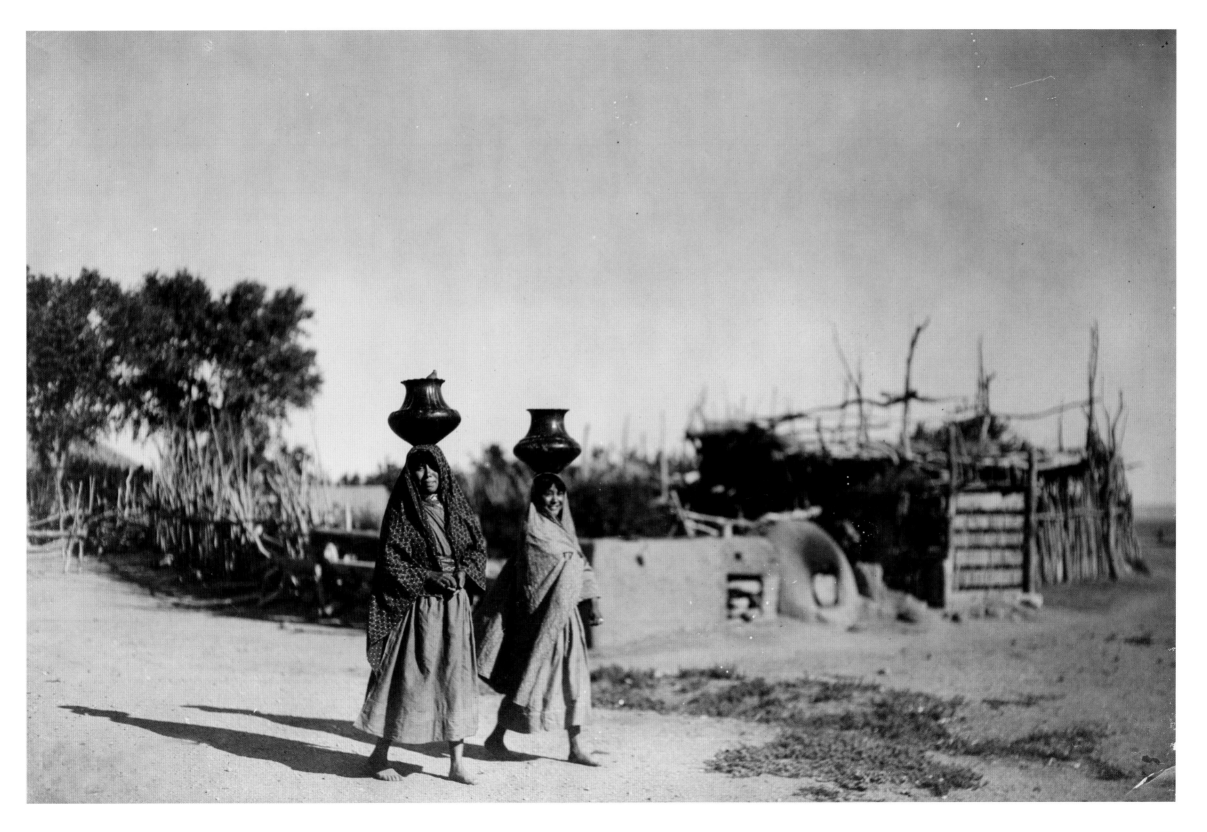

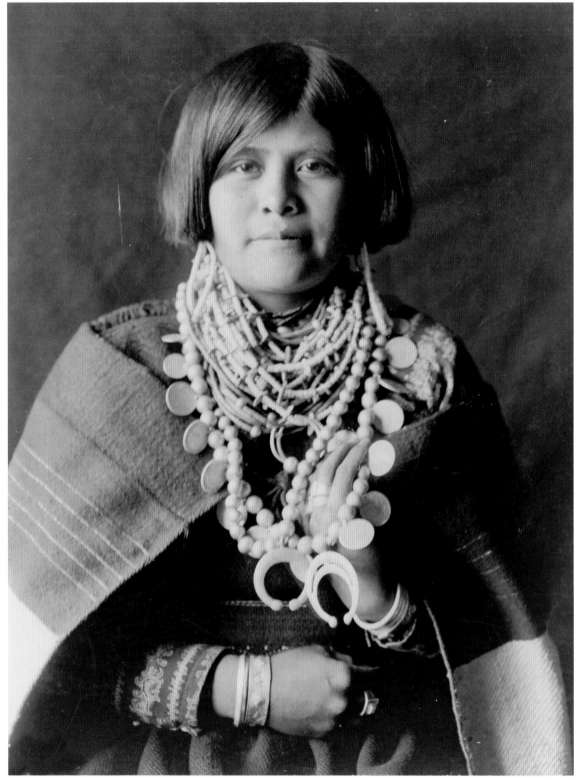

LEFT: Zuni girl wearing several necklaces; c. 1903. The Zunis have been noted for their pottery, chalky-white slip with large brown-black designs, often large rosettes, deer, frogs and dragonflies, but the art has diminished in recent times. The Zunis also produce a great deal of turquoise and silver jewelry.
Library of Congress, Prints & Photographs Division, Edward S. Curtis Collection, LC-USZ62-117706

ABOVE: A Zuni doorway; c. 1903. A tribe, a Pueblo, and a linguistic family whose villages and present reservation are in McKinley County in the western part of New Mexico. Hawikah, one of their towns, was first seen by the Spanish in 1539; and the following year Francisco Vásquez de Coronado captured the town during his expedition to find the "Seven Cities of Cibola," perhaps the seven villages of the Zuni.
Library of Congress, Prints & Photographs Division, Edward S. Curtis Collection, LC-USZ62-102184

RIGHT: The terraced houses of Zuni adobe buildings; c. 1903. Curtis revealed that the Zuni had a strong matriarchal society—men built these houses, but women owned them. Men joined their wife's clan upon marriage—membership that was nullified when the marriage ended. He noted, perhaps seeing the parallels in his own life, that "separations are of frequent occurrence."
Library of Congress, Prints & Photographs Division, Edward S. Curtis Collection, LC-USZ62-102038

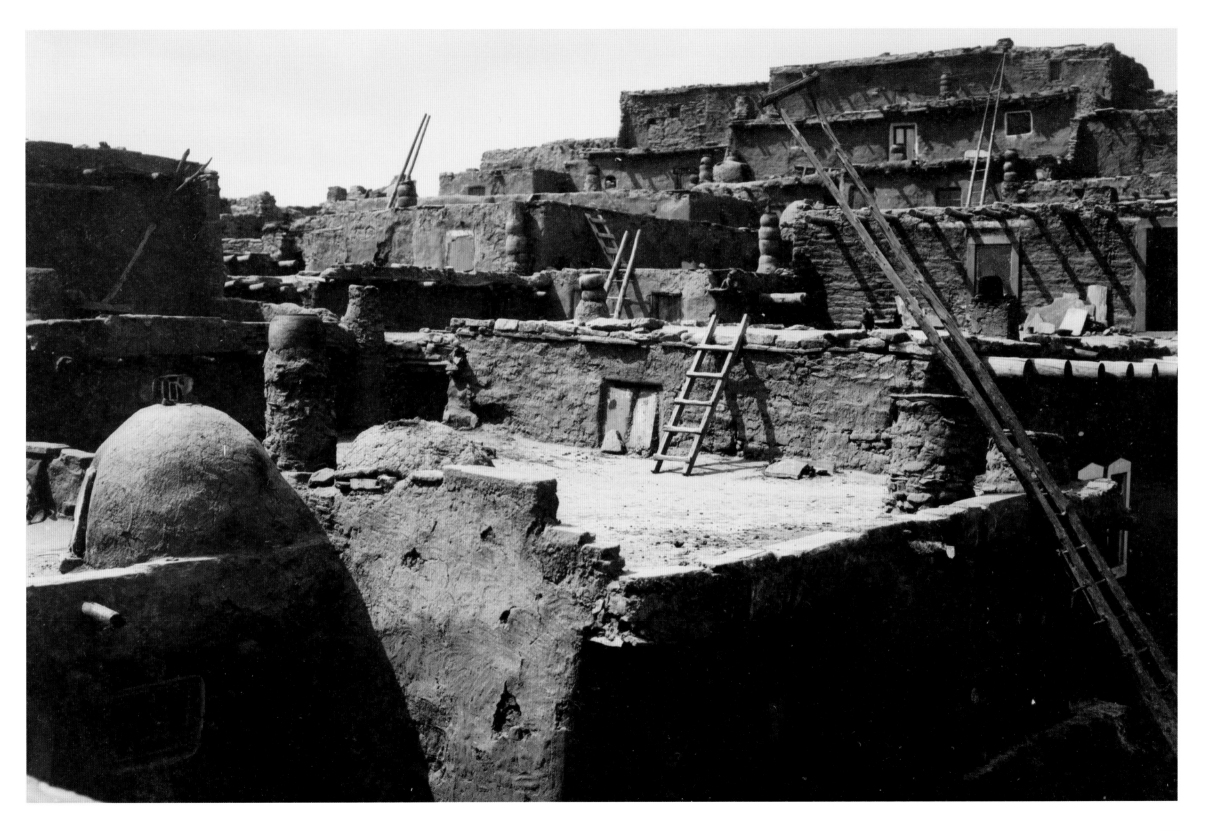

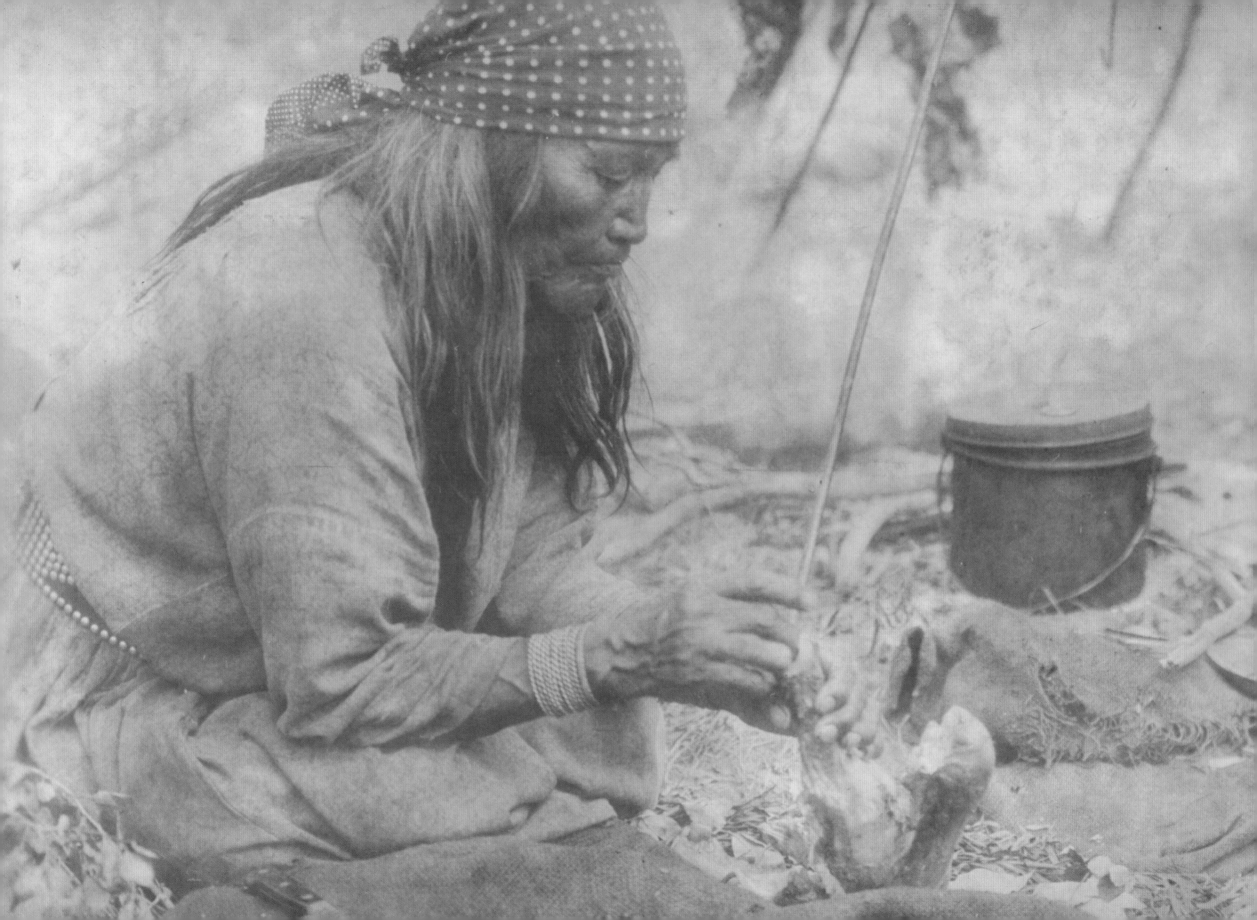

Volume XVIII
The Chipewyan. The Western woods Cree. The Sarsi.

In 1925 Curtis and Myers traveled to Canada to visit several tribes that lived primarily in Alberta. First they studied the northern bands of two tribes, the Assiniboin and Piegan, whose southern populations were covered in volumes III and V. They were disappointed to find that more than two decades of harsh government policies had stripped these people of their traditions and prosperity.

Traveling farther north, they found people still clinging to the old ways of living. The Chipewyan lived in a land of long winters, originally thriving by hunting the region's vast herds of caribou. Eventually they became middlemen working with the white trading posts that popped up across Canada. The Cree also played an essential role in supplying the fur trade and became one of the largest and most important tribes in North America. The Sarsi were a small tribe that had became closely associated with the Blackfoot as a defense against their common enemy, the Cree.

William Myers quit following this season in the field. Curtis used the book's introduction to acknowledge, at least in a small way, the huge contribution he had made to the project.

A Sarsi kitchen—a Sarsi woman cooking over campfire, Alberta, Canada. A small Athabascan-speaking tribe who once lived along the upper waters of the Saskatchewan River in present Alberta, Canada, the Sarsi were probably at one time part of the Beaver Indians, but joined the Blackfoot for protection against their enemies, the Cree and Assiniboin, perhaps some time in the late eighteenth century.
Library of Congress, Prints & Photographs Division, Edward S. Curtis Collection, LC-USZ62-101189

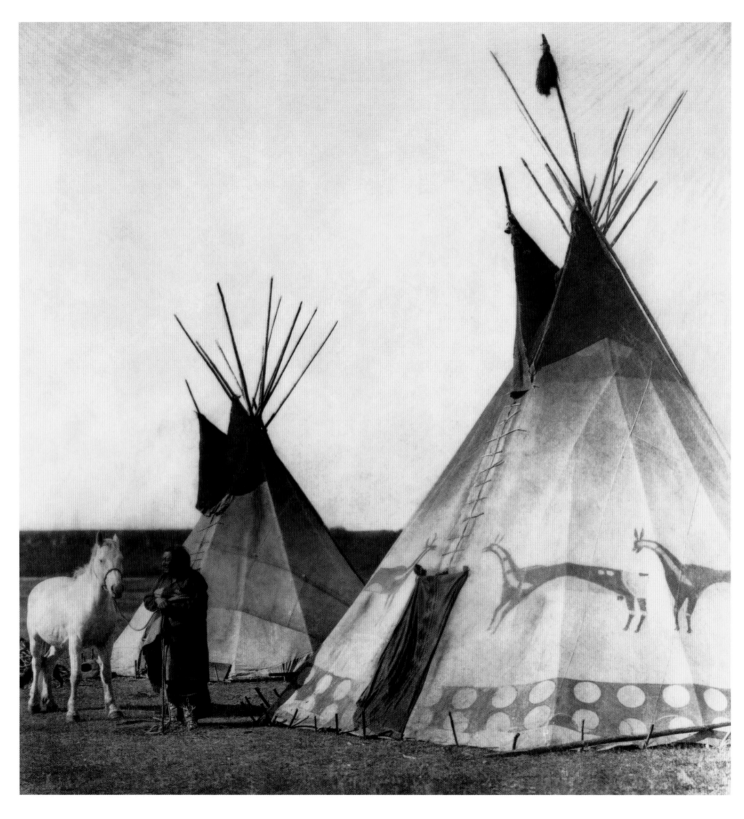

Blackfoot tipis. The conical lodge of the true High Plains nomads, constructed of bison (buffalo) hide erected on a framework of "lodge" poles. Since the destruction of the bison herds the covers have been made of canvas; they are usually erected during powwows or for Peyote meetings. The conical tipi probably evolved from Subarctic prototypes; early forms were relatively small, before the coming of the horse allowed transportation of larger covers and longer poles.

Basic construction was fairly constant throughout the Plains: a tilted cone of straight, slim, peeled poles (usually lodge pole pine, cedar or spruce) slotted into a foundation frame of three or four poles. Three-pole foundations were used by the Cheyenne, Arapaho, Sioux, Assiniboin, Kiowa, Gros Ventre, Plains Cree, Mandan, Arikara, Pawnee, Ponca, Oto, and Wichita; four, by the Crow, Blackfoot, Sarsi, Shoshone, Omaha, Comanche, Hidatsa, Kutenai, Flathead, and Nez Perce.

Foundation poles were usually tied together over the spread ground cover, then hoisted, the remaining poles being slotted into the crotches which they formed. In three-pole foundations, one pole faced east and formed a door pole on the south side; four-pole foundations formed a rectangle, the rear two remaining low at the back and appearing as a "swallow-tail" in the completed lodge. The tipi usually faced east towards the rising sun; being an imperfect cone it had a back steeper than the front, which tended to brace it against the prevailing winds.

Covers were usually of dressed buffalo cow hides before the destruction of the herds in the 1880s, and thereafter of traded canvas duck, usually white. Most nineteenth century tipis were about 12 to 18 feet high, requiring some 12 skins sewn together and cut to a half-circle plan. The cover was hoisted onto the frame with a single lifting pole and spread around the sides; the edges pinned together at the front; and the bottom edge staked down. The cover included two "ear" extensions at the top of the sides, forming smoke flaps held out by external poles; adjusted to the prevailing wind, these helped drag smoke through the gap left at the top. A liner five or six feet in height ran around the inside of the poles, fastened to them and to the floor. A fireplace of stones was made centrally somewhat towards the rear; family beds were usually on the south side, those of guests on the north; at the rear were placed back-rests of slender rods, weapons and medicine bundles. Some covers and liners were painted with naturalistic or geometrical symbolic patterns, usually peculiar to the owner and associated with the intense esoteric spiritual nature of the lodge.

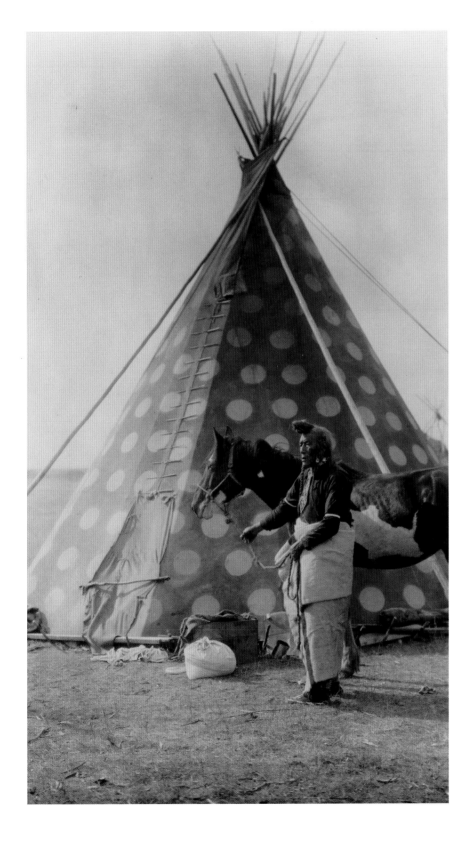

LEFT: A Blackfoot Indian holding a horse outside a tipi; c. 1927.
Library of Congress, Prints & Photographs Division, Edward S. Curtis Collection, LC-USZ62-120103

RIGHT: In camp a Blackfoot man holds decorated sheaths; ceremonial bags suspended from tripod behind him; c. 1927. The historic Blackfoot, an Algonkian people, were a loose confederacy of three closely related tribes: the Blackfoot or North Blackfoot (Siksika), the Blood (Kainah), and Piegan—also spelled Peigan in Canada—(Pikuni), with a close alliance with the Atsina and Sarsi. They once held an immense territory stretching from the North Saskatchewan River, Canada, to the headwater of the Missouri River in Montana, including the foothills of the Rocky Mountains. Religion included the wide use of "bundles" containing symbols (usually remnants of birds, animals and objects) of the power of dreamed or vision experience.
Library of Congress, Prints & Photographs Division, Edward S. Curtis Collection, LC-USZ62-121905

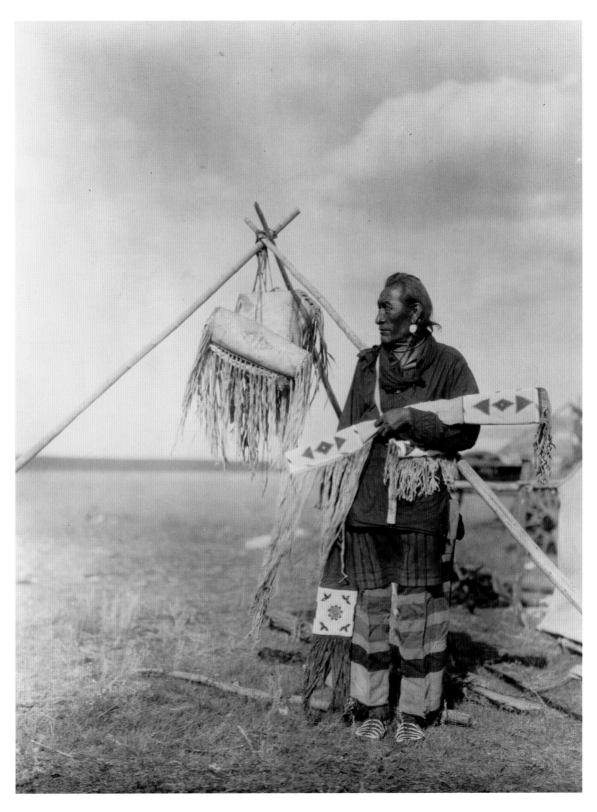

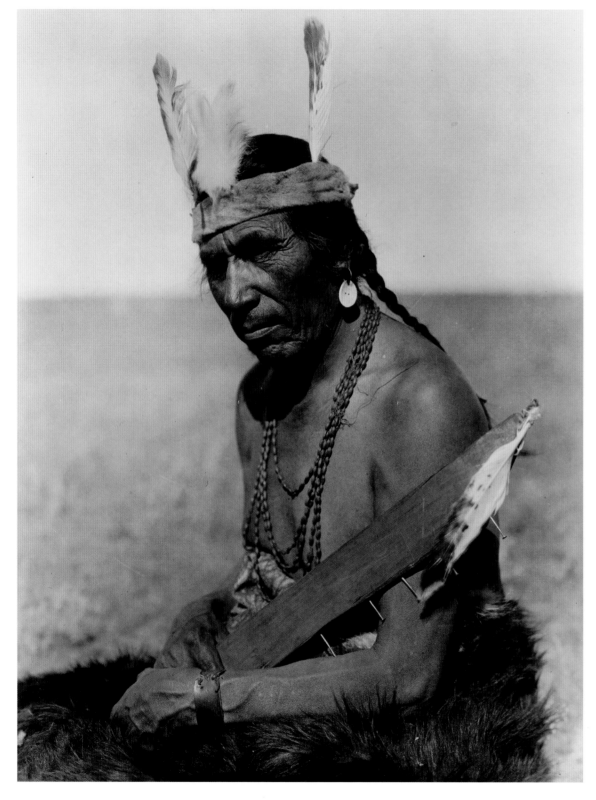

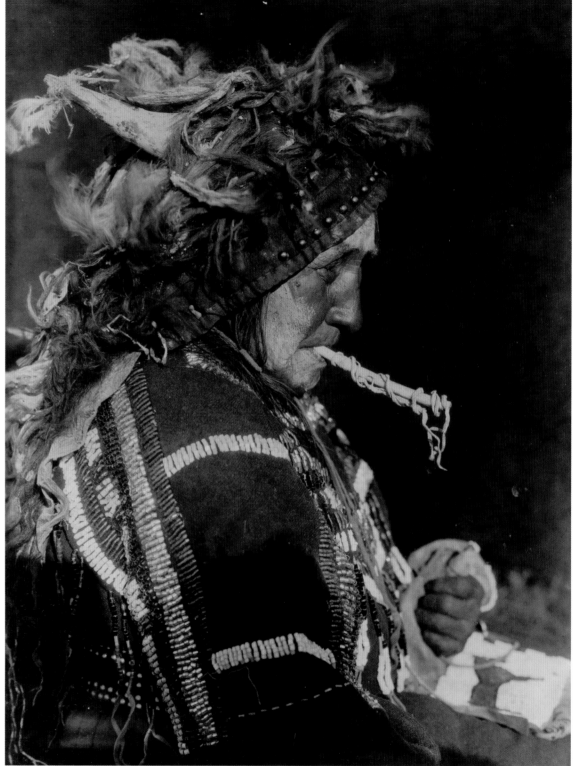

FAR LEFT: Fat Horse with insignia of a Blackfoot soldier, c. 1927, and probably dressed specially for this photo session. Curtis was dismayed at how heavily the Blackfoot confederation had assimilated into white culture by this date—a far cry from the traditional people he had photographed during his first Sun Dance gathering in 1900.
Library of Congress, Prints & Photographs Division, Edward S. Curtis Collection, LC-USZ62-106268

LEFT: Head-dress of Matóki Society. The Blood was one of the three Blackfeet tribes. Alberta, Canada; c. 1927.
Library of Congress, Prints & Photographs Division, Edward S. Curtis Collection, LC-USZ62-101191

RIGHT: Blackfoot Indian fleshing a hide; c. 1927. The Blackfeet were a typical Plains tribe, as exemplified by a dependence on the buffalo for food, for tipis, bedding, shields, clothing, and containers.
Library of Congress, Prints & Photographs Division, Edward S. Curtis Collection, LC-USZ62-111134

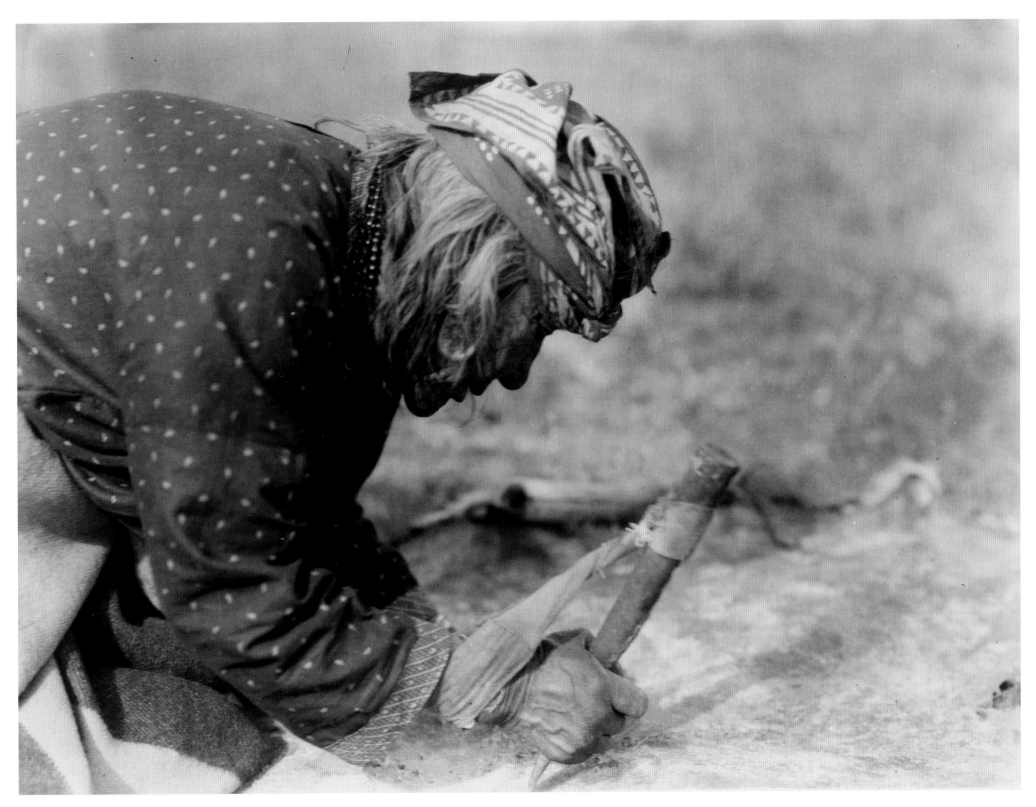

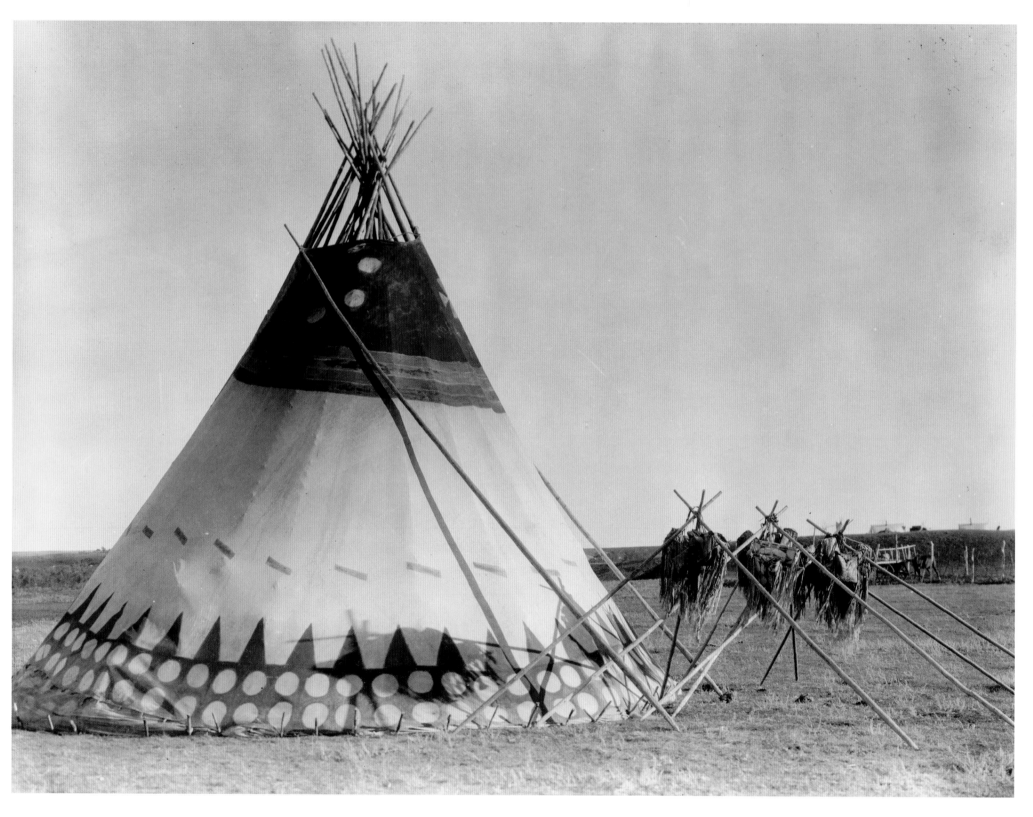

LEFT: Lodge of the Horn Society (Blood), Alberta, Canada, c. 1927. Curtis described this group as something of a religious cult; even at this late date they were active, with about fifty members. Traditionally they wore buffalo headdresses, but with the near extinction of the bison had switched to weasel tails to imitate horns. Among their beliefs: "Love all and speak evil of none," "do not break an animal's spine, for that would cause lameness in your own back," and "cooking food must not be stirred with a knife, lest your teeth loosen and fall out." *Library of Congress, Prints & Photographs Division, Edward S. Curtis Collection, LC-USZ62-101190*

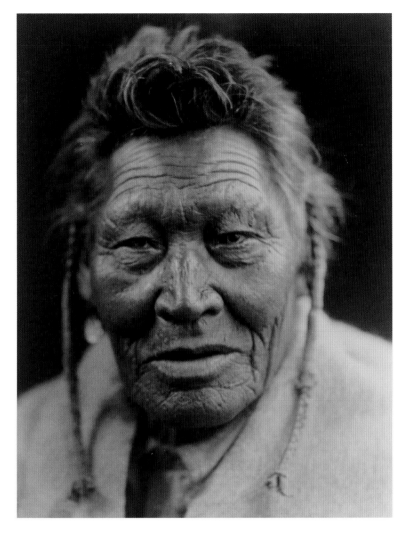

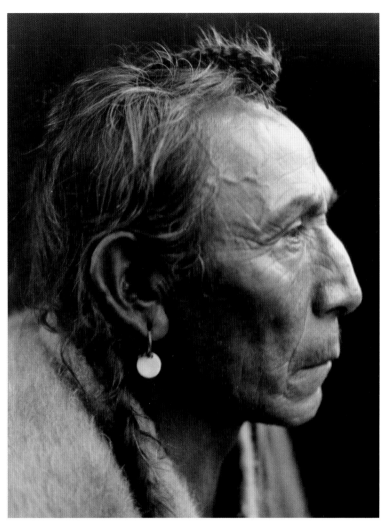

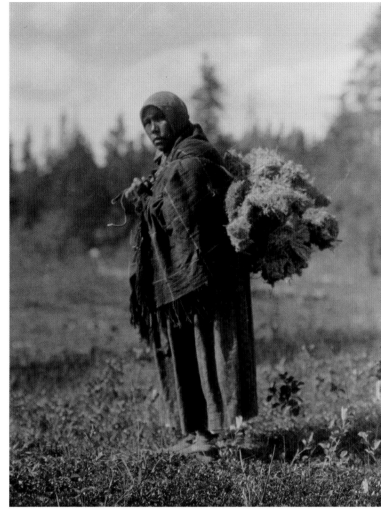

Tsaassi-Mis-salla ("Crow with Necklace"), a Sarsi man; c. 1927. Curtis commented in his text that the Sarsi had been both particularly brave fighters and very friendly with the white traders that crisscrossed the region.
Both these traits had been essential in helping this relatively small tribe survive on the volatile northern plains.
Library of Congress, Prints & Photographs Division, Edward S. Curtis Collection, LC-USZ62-119408

Aki-tanni ("Two Guns") another Sarsi; c. 1927. Curtis reported only about 160 Sarsi living in the village at the time of his visit. Though members of the tribe insisted that not long ago there been many
more, white visitors from the previous century noted a very similar population.
Library of Congress, Prints & Photographs Division, Edward S. Curtis Collection, LC-USZ62-127308

Moss for the baby-bags—Cree woman carrying moss on her back; c. 1927. The Plains Cree—a general term given to cover the Cree bands living partly or wholly on the prairies of Saskatchewan and Alberta from the mid-eighteenth century onward—were distinct from their Woodland Cree cousins. This was because of their adoption of Assiniboine traits which are essentially
"Plains" in format, notably, ceremonials, and the development of a dependence on the buffalo (bison), in common with the Blackfeet, Assiniboin, and Gros Ventre, whom the Plains Cree displaced from the Saskatchewan River.
Library of Congress, Prints & Photographs Division, Edward S. Curtis Collection, LC-USZ62-106995

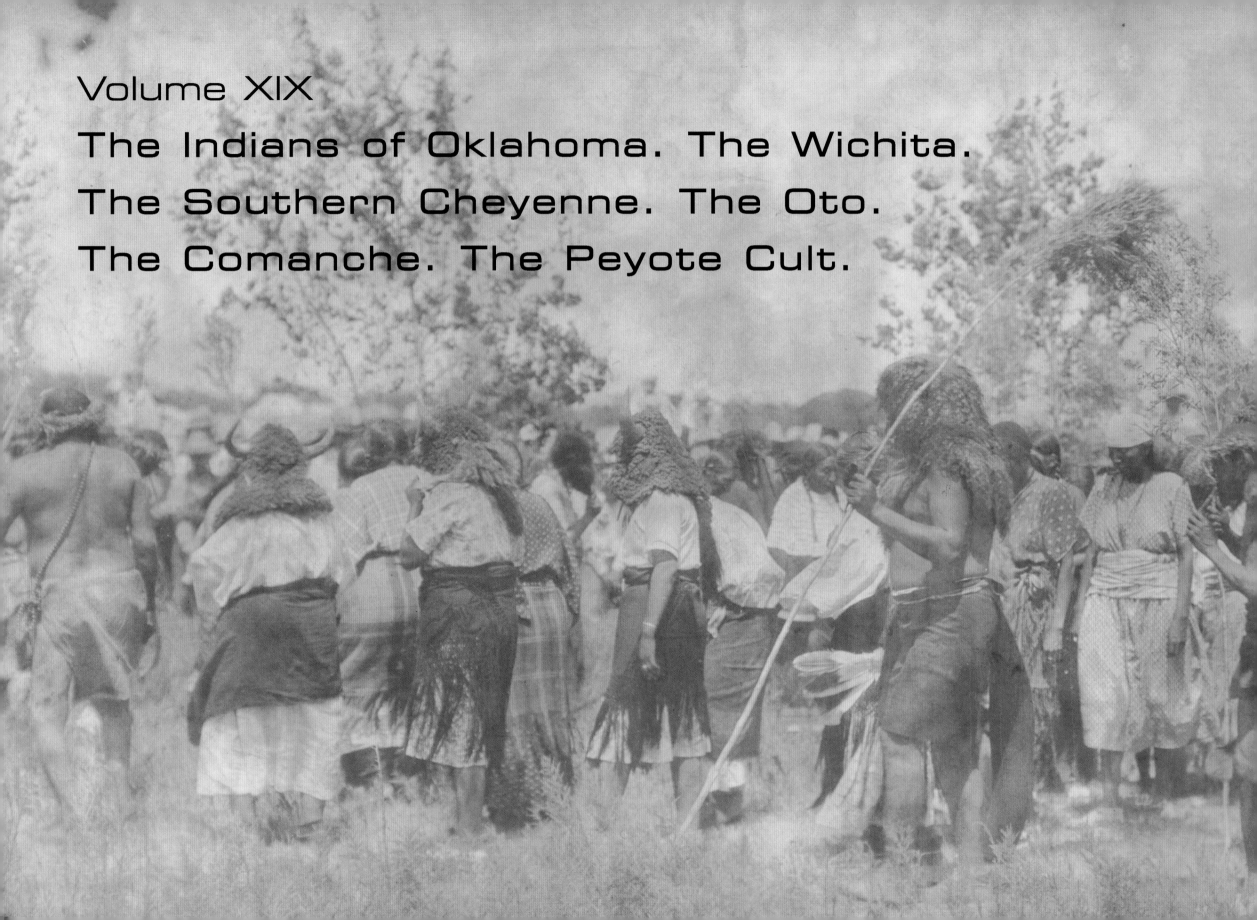

Volume XIX

The Indians of Oklahoma. The Wichita.
The Southern Cheyenne. The Oto.
The Comanche. The Peyote Cult.

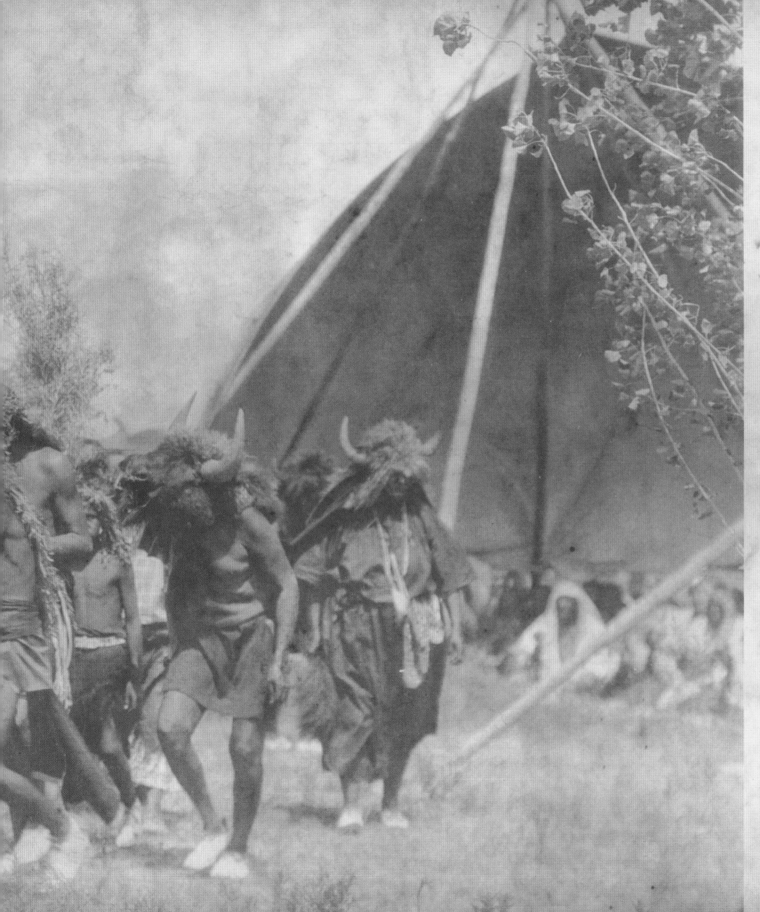

Edward Curtis embarked on his epic quest to record North American Indian culture because he realized that is was on the verge of disappearing. Unfortunately, by the time he reached the end of his journey, many years behind schedule, his prophecy had largely become self-fulfilling.

The tribes of the southern plains covered in this volume were far removed from traditional ways. Most had been on the reservations for decades, and some had been relocated far from their ancestral homelands. In many cases they had been living side-by-side with whites for years and significant numbers had already started to assimilate into mainstream America. By 1926 Curtis was searching for cultures that not only had disappeared, but were little remembered even by older members of the tribes.

Adding to this volume's challenges was new assistant Stewart Eastwood. He was capable but young and inexperienced, and editor Frederick Webb Hodge demanded a complete rewrite of the first draft of the text. This and other problems delayed publication until 1930.

Buffalo Society, animal dance; c. 1927. The Cheyenne became one of the focal points of the Plains culture, characterized by tipi dwelling, development of age-graded male societies, geometrical art, and the development of a ceremonial world renewal complex, the Sun Dance. They were constantly pressed further into the Plains by the Sioux, who later became their firm allies, finally establishing themselves on the upper branches of the Platte River. In consequence of the building of Bent's Fort on the upper Arkansas River in Colorado in 1832, a large part of the tribe moved south to the Arkansas while the rest remained on the North Platte, Powder and Yellowstone rivers. Thus came into being the geographical division of the tribe into the Northern and Southern Cheyenne. Their population before the cholera epidemic of 1849 was about 3,000.
Library of Congress, Prints & Photographs Division, Edward S. Curtis Collection, LC-USZ62-106277

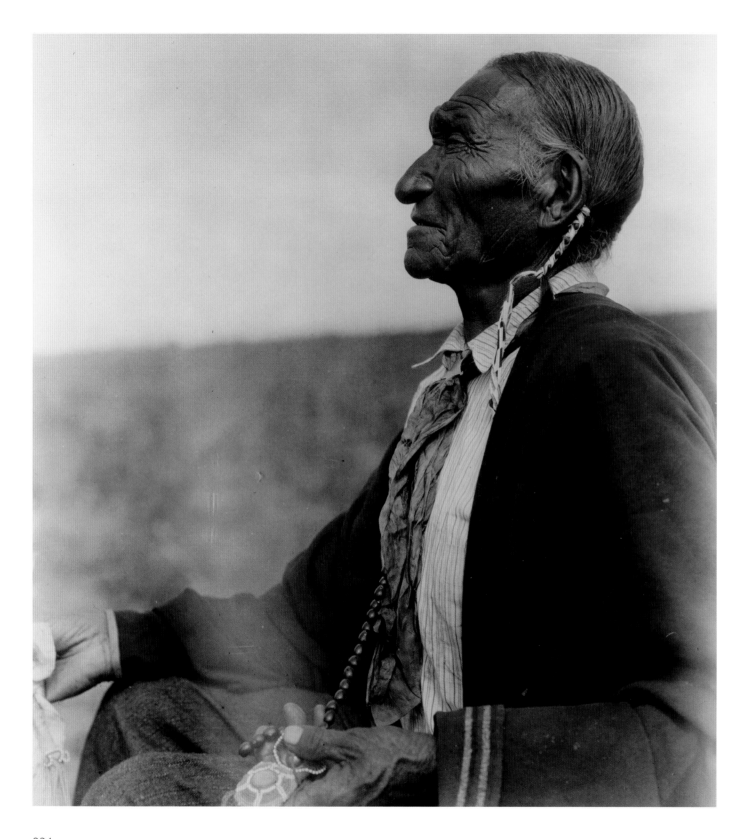

LEFT: A Cheyenne Peyote leader; c. 1927. In a time of despair following the loss of much of their culture in the nineteenth century, there appeared several nativistic movements, such as the Ghost Dance of the 1880s-1890s and the Peyote cult—a mixture of Mexican Indian, Christian, and Plains Indian symbolism. Peyotism has a strong following in the southern Cheyenne.
Library of Congress, Prints & Photographs Division, Edward S. Curtis Collection, LC-USZ62-106276

RIGHT: The Wolf, Cheyenne animal dance; c. 1927. An important Algonkian tribe of the High Plains, whose earliest known home was present Minnesota between the Mississippi and Minnesota rivers. At this time, they lived in fixed villages, practiced agriculture, and made pottery, but lost these arts after being driven out onto the Plains to become nomadic bison hunters.
Library of Congress, Prints & Photographs Division, Edward S. Curtis Collection, LC-USZ62-120094

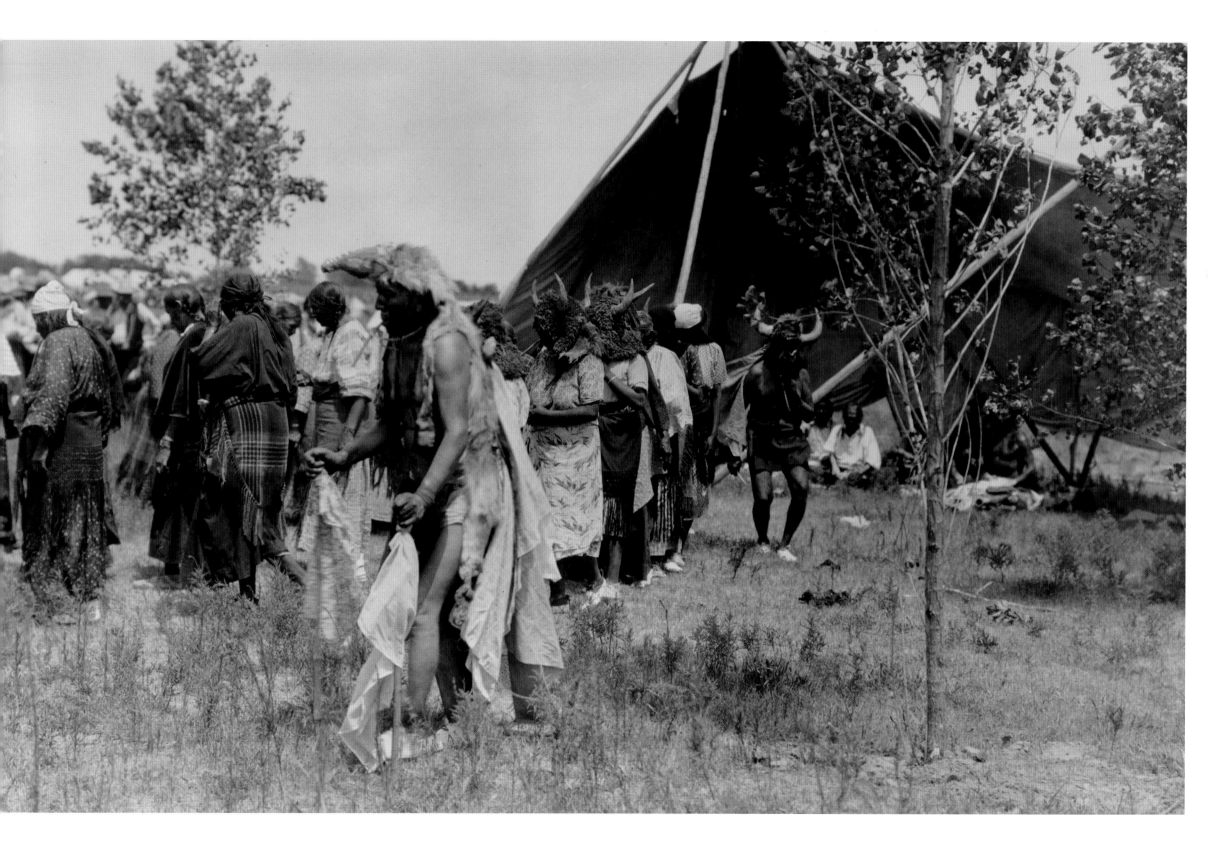

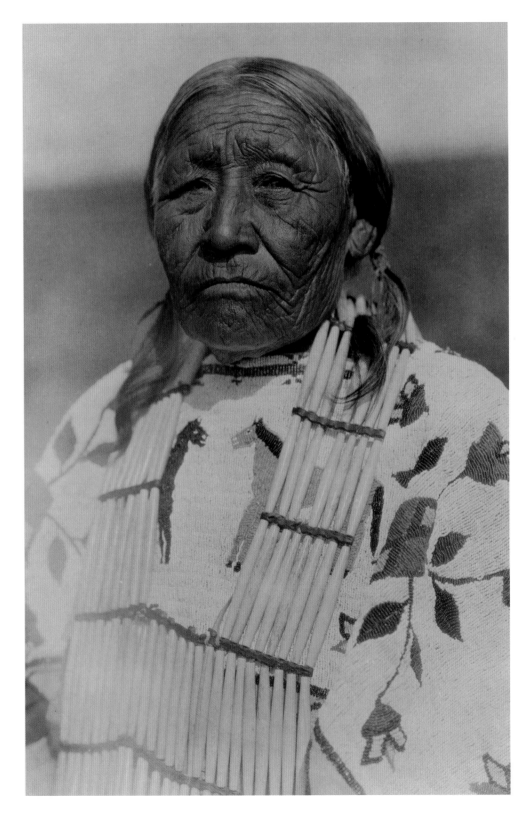

LEFT: Wife of Old Crow, Cheyenne woman; c. 1927. The Southern Cheyenne agreed to move to a reservation located in western Indian Territory by the terms of the Medicine Lodge Treaty of 1867. Reservation conditions were harsh and became intolerable, and parts of the allotted Cheyenne and Arapaho Reservation opened to white settlement in 1892. *Library of Congress, Prints & Photographs Division, Edward S. Curtis Collection, LC-USZ62-115823*

RIGHT: Rueben Taylor (Isotofhuts), Cheyenne man; c. 1927. The Southern Cheyenne have retained traditional symbols of ethnic unity, the Sacred Medicine Arrows; they can be found in Custer, Roger Mills, Canadian, Kingfisher, Blaine and Dewey counties, Oklahoma. *Library of Congress, Prints & Photographs Division, Edward S. Curtis Collection, LC-USZ62-121687*

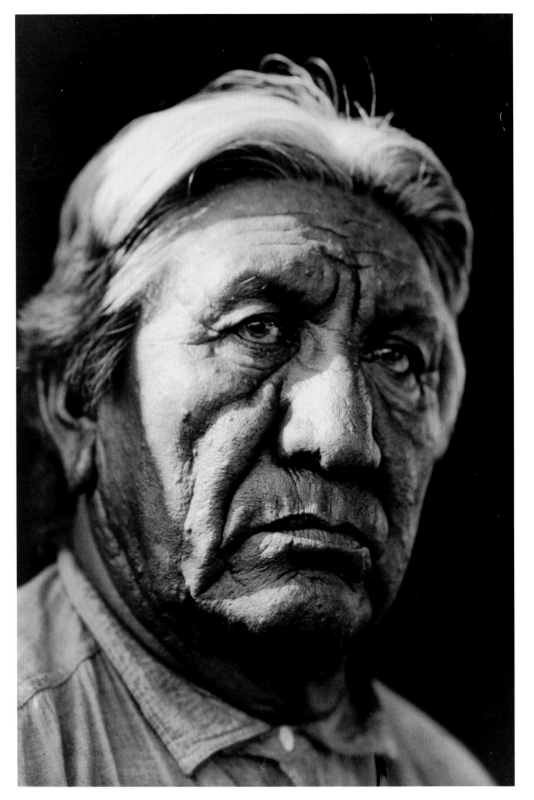

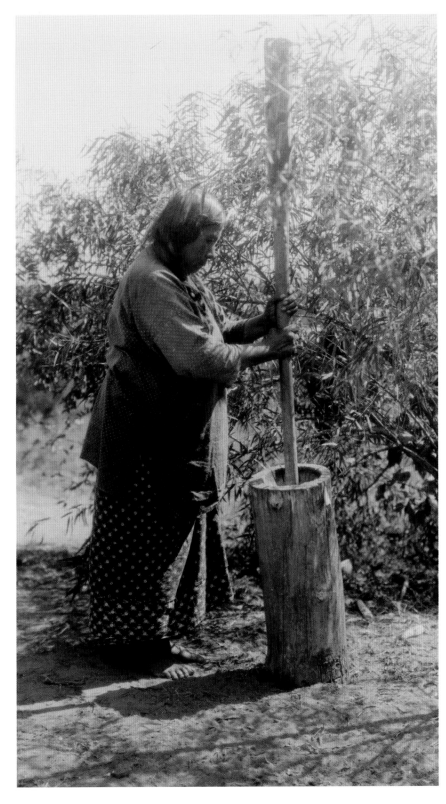

LEFT: Wichita woman using mortar and pestle; c. 1927. The largest known historic tribe of the southern Caddoan-speaking group, who lived along the Canadian River in present Oklahoma, Most Wichitas now live around Gracemont north of the Washita River in Caddo County, Oklahoma. *Library of Congress, Prints & Photographs Division, Edward S. Curtis Collection, LC-USZ62-115824*

RIGHT: A Wichita woman, c. 1927. The Wichita were unique among the Oklahoma tribes studied by Curtis in that they were native to the state. Most of the tribes had been relocated from elsewhere, for example the Cherokee from the southeast U.S. and the Cheyenne from the plains. Curtis said that the Wichita could be physically distinguished from the many Plains natives around them because they were shorter, stockier, and darker skinned. *Library of Congress, Prints & Photographs Division, Edward S. Curtis Collection, LC-USZ62-115822*

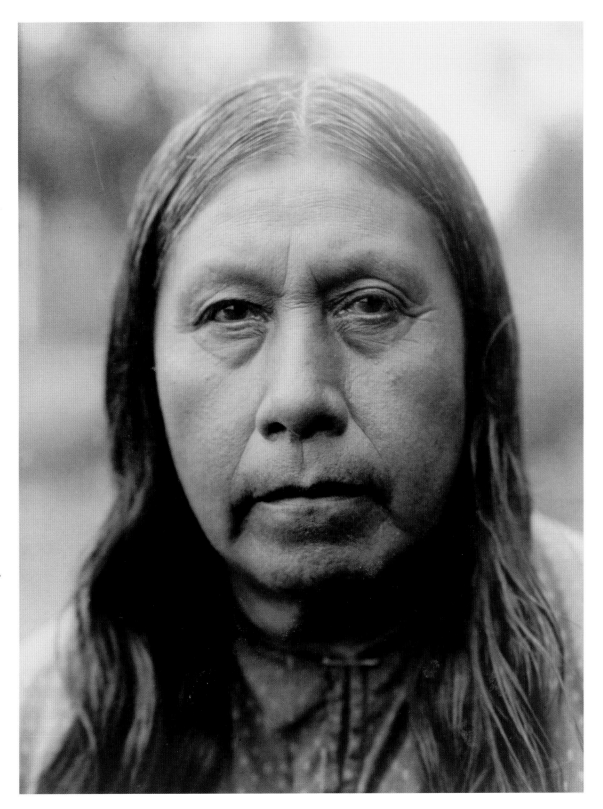

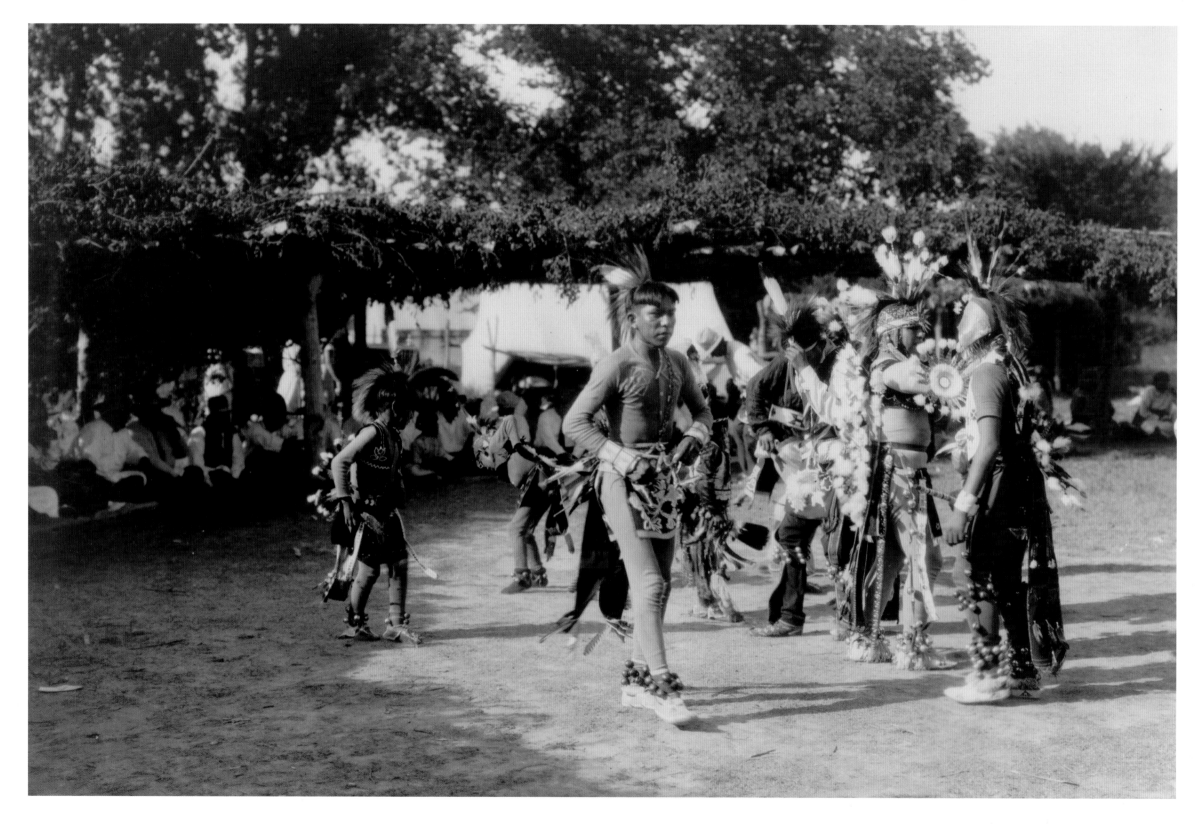

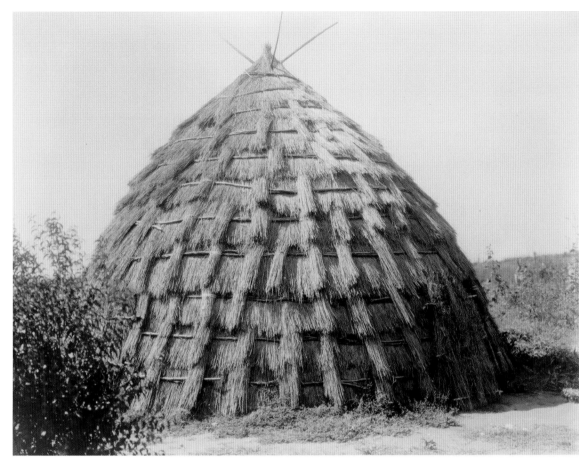

LEFT: Skidi and Wichita dancers in ceremonial dress; c. 1927.
Library of Congress, Prints & Photographs Division, Edward S. Curtis Collection, LC-USZ62-106281

ABOVE: A traditional thatched Wichita grass-house, c. 1927. Curtis was pleased to find a few of these houses still standing, but they were clearly on the way out. He remarked that while the structures weren't complicated for the Wichita to assemble, "the art of building them is as decadent as most of their native culture."
Library of Congress, Prints & Photographs Division, Edward S. Curtis Collection, LC-USZ62-118773

RIGHT: Interior of Wichita grass-house; c. 1927.
Library of Congress, Prints & Photographs Division, Edward S. Curtis Collection, LC-USZ62-118599

Volume XX

The Alaskan Eskimo. The Nunivak.
The Eskimo of Hooper Bay. The Eskimo of
King Island. The Eskimo of Little Diomede
Island. The Eskimo of Cape Prince Wales.
The Kotzebue Eskimo. The Noatak.
The Kobuk. The Selawik.

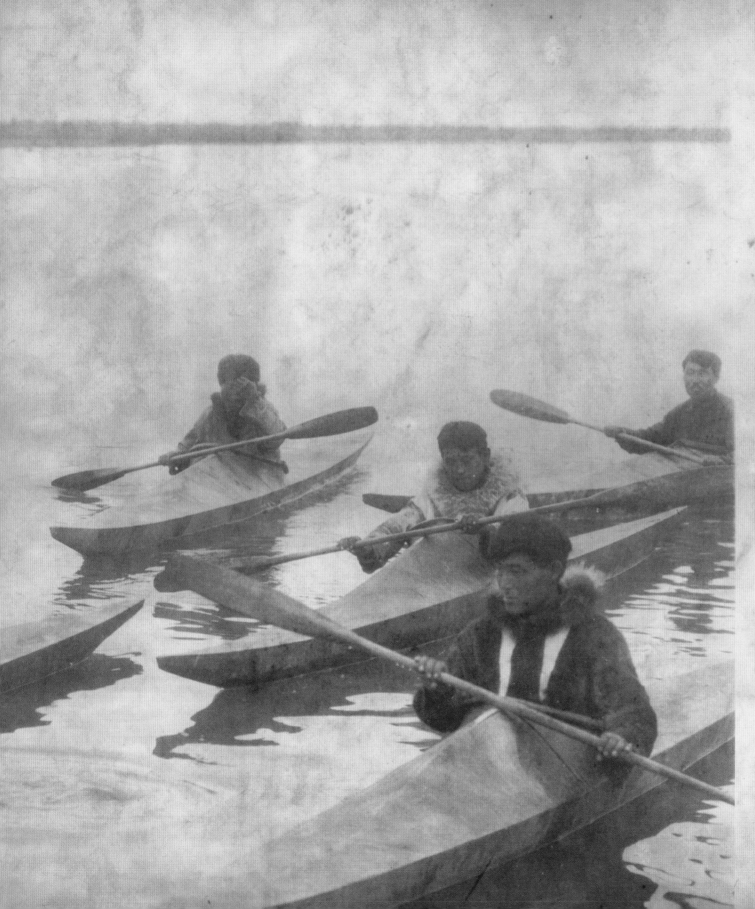

The summer of 1927 was going to be the last season of fieldwork for the last volume in *The North American Indian* project. Curtis was reeling from two summers of working with reservation-bound tribes that had drifted far from their traditional ways of life. As a remedy for this situation, he looked north to Alaska in hopes of finding native people still relatively untouched by the modern world.

Curtis wasn't disappointed. For nearly four months, Curtis, Eastwood, and—for a time—Curtis's daughter, Beth, experienced high adventure along the coastal islands that were home to many small bands of Eskimo. The hardy but friendly people were still living much as they had for generations, paddling their kayaks, hunting seals, and practicing religious ceremonies involving distinctive masks. In the process, Curtis rediscovered why he had embarked on the project in the first place.

In this final book, which was published with little fanfare, Curtis acknowledged a debt to all who had supported him. He then closed the series—which had consumed thirty years of his life—in a very simple fashion: "…Great is the satisfaction the writer enjoys when he can at last say to all whose faith has been unbounded, 'It is finished.'"

Eskimos in kayaks, Alaska; c. 1929. The modern era was fast catching up with North American natives as Curtis's epic project was drawing to a close. In traveling to Alaska, he was rewarded with the chance to study and photograph many people whose culture had yet to be greatly influenced by whites. He arrived in the north just in time. Within a decade after his visit, many Eskimo villages found their lifestyles under attack by Christian missionaries and other outside influences.
Library of Congress, Prints & Photographs Division, Edward S. Curtis Collection, LC-USZ62-111135

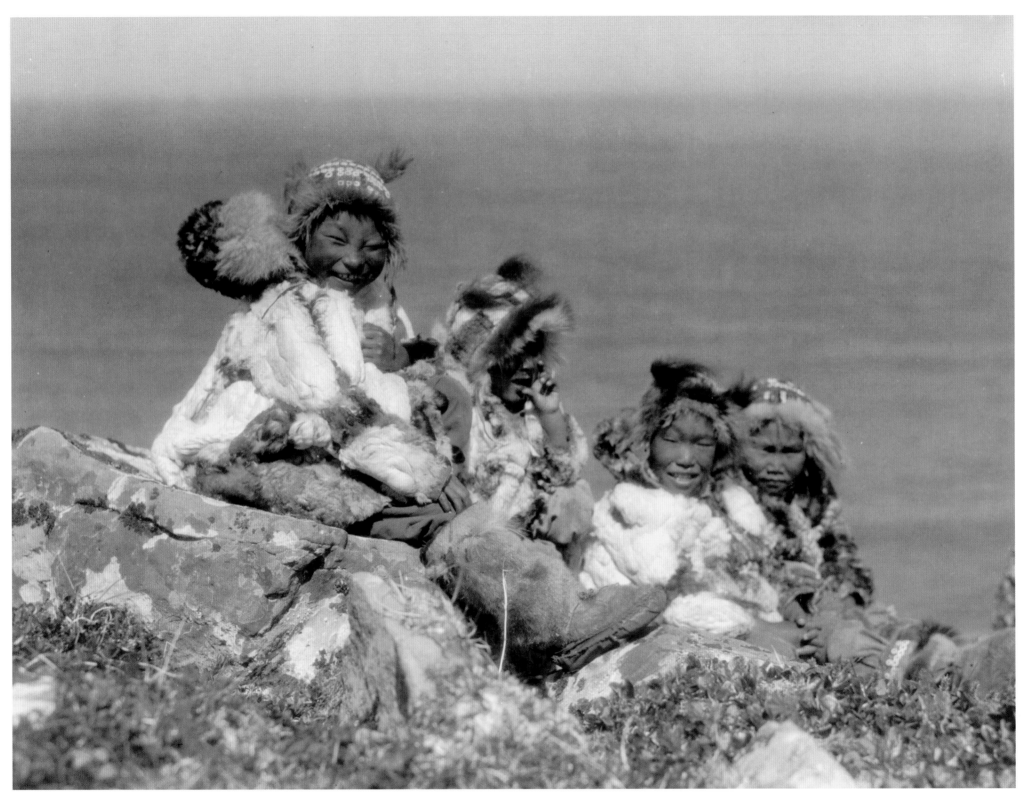

LEFT: Four Eskimo children, at edge of cliff, in holiday costume, Nunivak, Alaska; c. 1929. The Eskimo—now usually called Inuit—and the Aleut live an area that extends in a 5,000-mile sweep from Siberia to Greenland, including most of the islands and coastal areas of Alaska, Canada including Labrador, and Greenland. Their ancestors seem to have been the last major influx of people from Siberia across the Bering Straits, perhaps between 5000 and 6000 B.C., with the Aleuts probably splitting from the main body fairly early on. *Library of Congress, Prints & Photographs Division, Edward S. Curtis Collection, LC-USZ62-107325*

RIGHT: Eskimo with whale meat on poles, Hooper Bay, Alaska; c. 1929. The Eskimo for the most part relied for their subsistence on the sea, where the food chain ensured a large population of seals, whales, and walruses. In summer, when the usually featureless landscape briefly became warm and sustained exuberant flora and fauna, they turned inland to hunt caribou. They survived mostly on fat and meat, much of which was eaten raw, which gave them all the vitamin C required for health. Their tools, spears, harpoons, sleds, kayak frames and even bows often had to be pieced together in composite constructions from driftwood and antler since they had only limited access to trees.
Library of Congress, Prints & Photographs Division, Edward S. Curtis Collection, LC-USZ62-101258

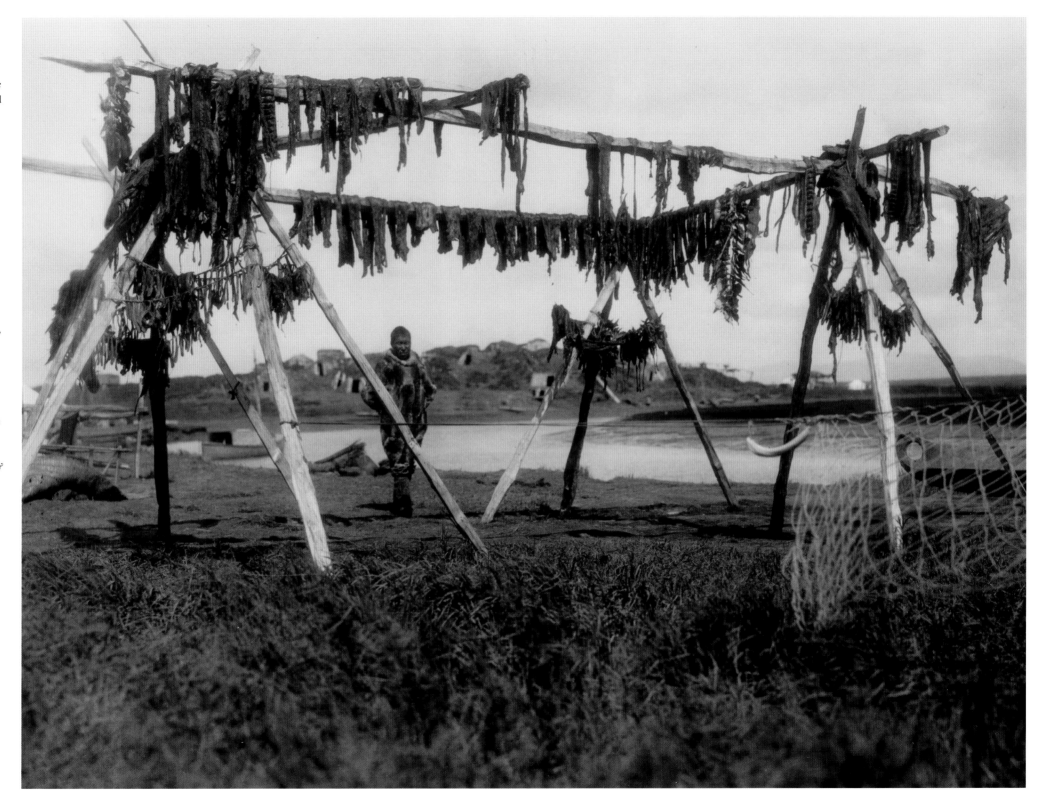

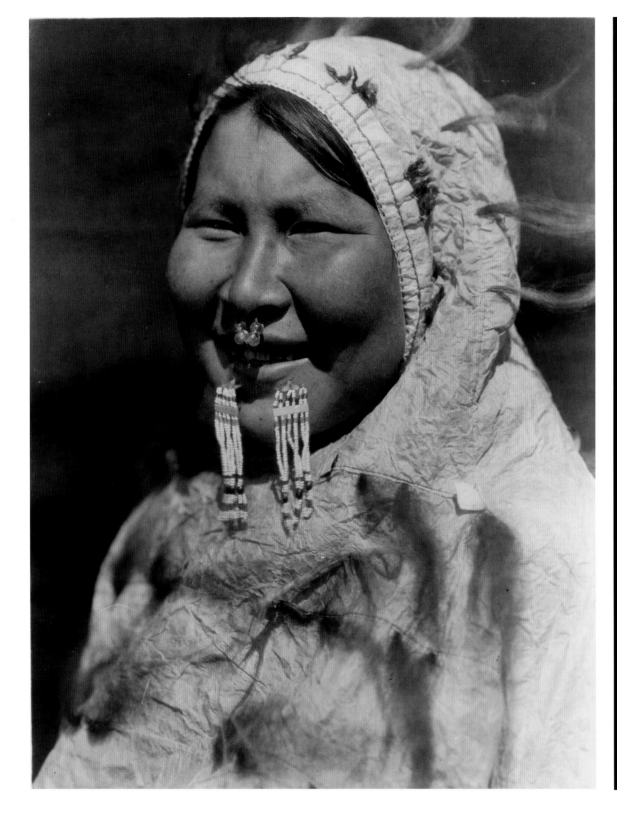

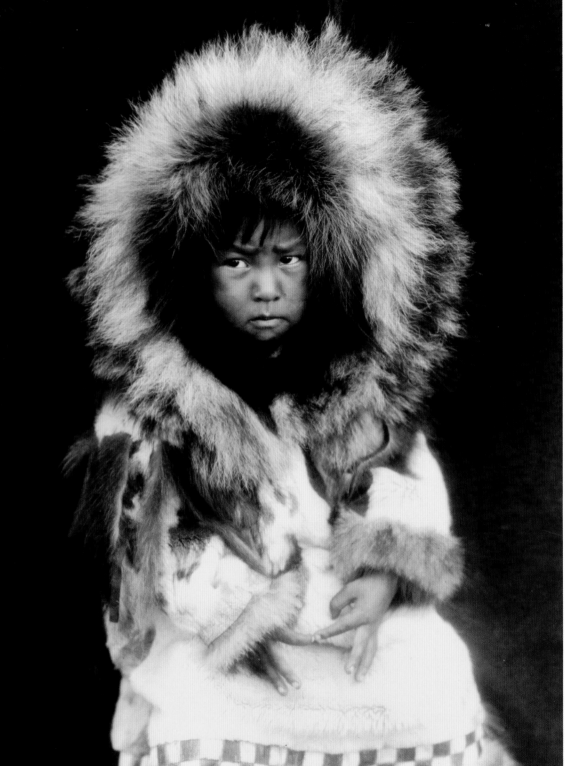

FAR LEFT: Head-and-shoulders portrait of Eskimo woman of the Arctic region, wearing a nose ring and labret. Her hooded parka is made of intestinal parchment; c. 1929. Female tattooing earned the subject rewards in the afterlife for her endurance of pain for the sake of beauty. Female parkas had extended hoods to allow the carrying of babies; and the tailoring and manufacture of the parka established a metaphysical identification with the animals on which these peoples relied for their existence. *Library of Congress, Prints & Photographs Division, Edward S. Curtis Collection, LC-USZ62-101193*

LEFT: Noatak child; c. 1929. *Library of Congress, Prints & Photographs Division, Edward S. Curtis Collection, LC-USZ62-107281*

RIGHT: Ceremonial mask, Nunivak; c. 1929 February 28. Two major rituals were celebrated annually: one to release the sea animals, and the other to welcome the return of the sun, the herald of winter's end. In both celebrations costumed figures, often masked and simultaneously male and female, suggest the renewal of creation. Shamans used symbolically decorated costume. *Library of Congress, Prints & Photographs Division, Edward S. Curtis Collection, LC-USZ62-66041*

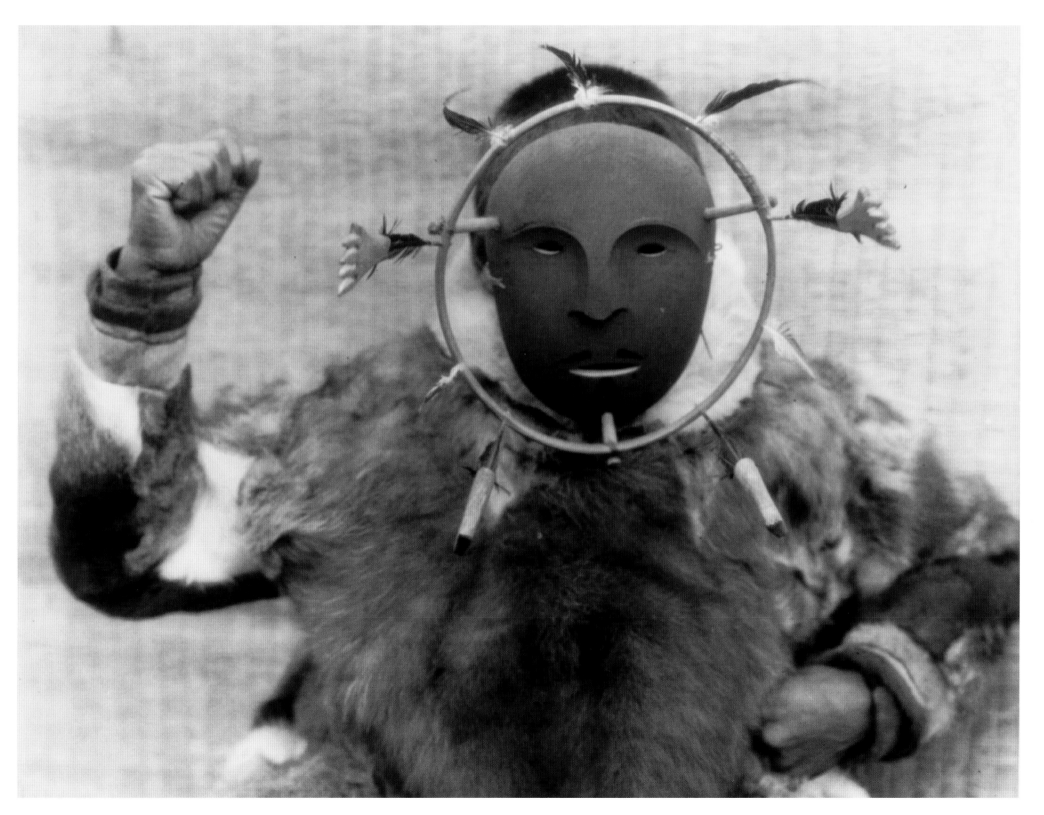

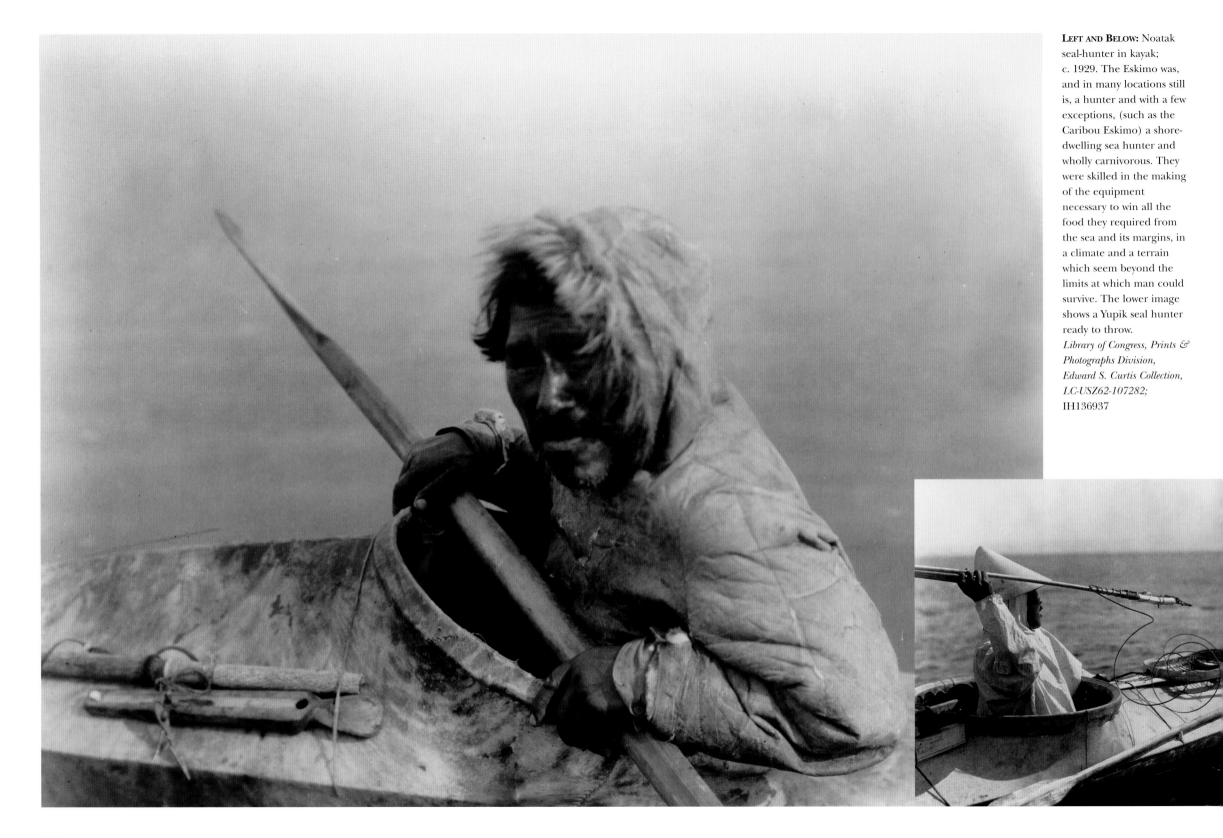

LEFT AND BELOW: Noatak seal-hunter in kayak; c. 1929. The Eskimo was, and in many locations still is, a hunter and with a few exceptions, (such as the Caribou Eskimo) a shore-dwelling sea hunter and wholly carnivorous. They were skilled in the making of the equipment necessary to win all the food they required from the sea and its margins, in a climate and a terrain which seem beyond the limits at which man could survive. The lower image shows a Yupik seal hunter ready to throw.
Library of Congress, Prints & Photographs Division, Edward S. Curtis Collection, LC-USZ62-107282; IH136937

RIGHT: A Noatak family group; c. 1929. Curtis and his daughter, Beth, spent sixteen pleasant days on Nunivak Island among the Noatak Eskimos, people he described as happy and content. He was pleased to have finally "found a place where no missionary has worked" and wasn't shy about saying he hoped things stayed that way: "Should any misguided missionary start for this island, I trust the sea will do its duty."
Library of Congress, Prints & Photographs Division, Edward S. Curtis Collection, LC-USZ62-89847

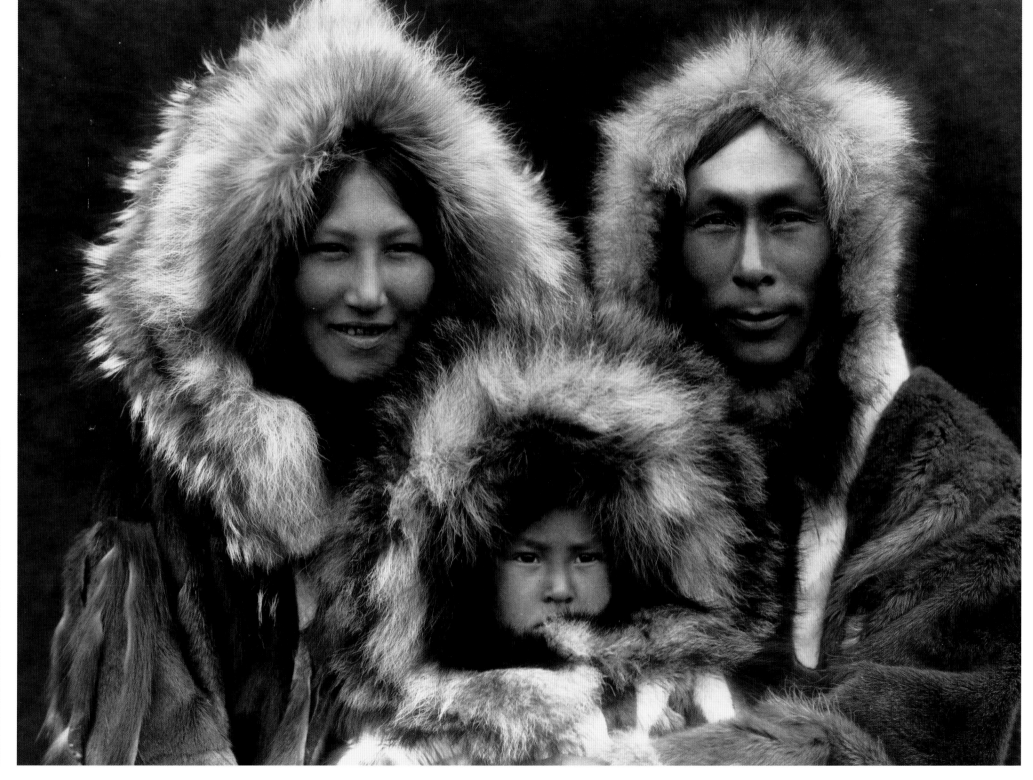

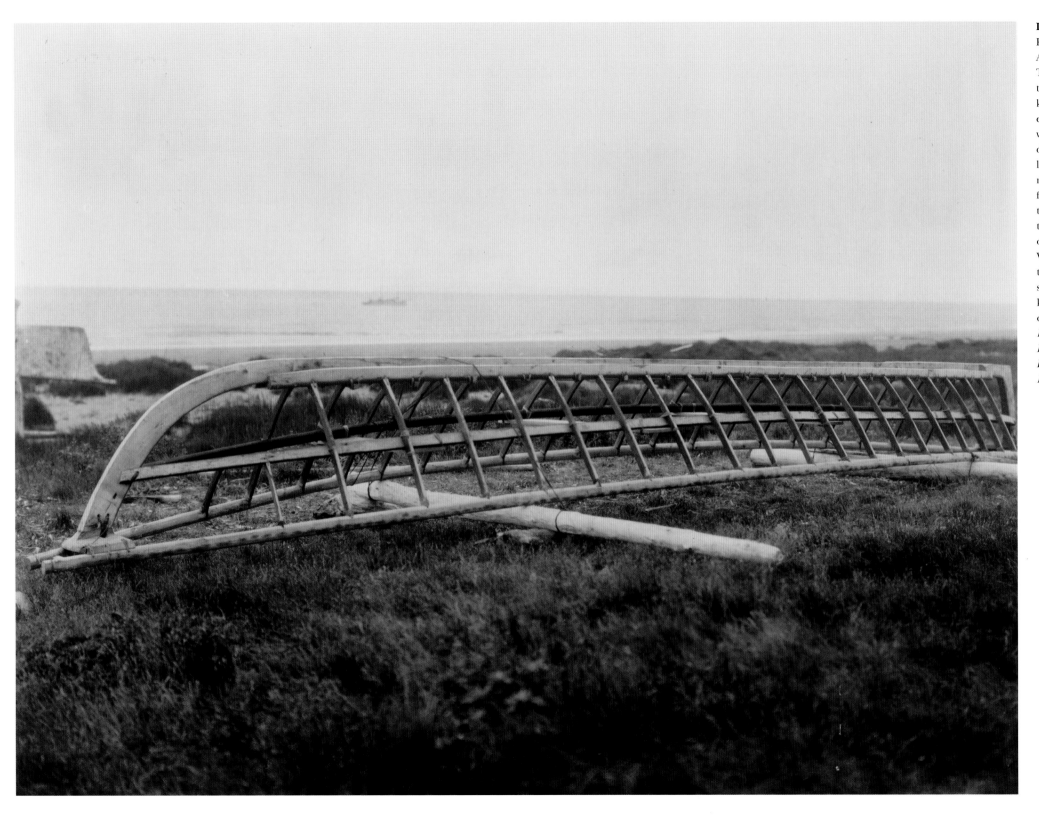

LEFT: Umiak frame, Kotzebue, Northern Alaskan Eskimo; c. 1929. Two forms of water transport were known, the kayak was common in the east, and umiak in the west. The umiak is described by Curtis as a large skinned boat used mainly for transporting a family or two families together with dogs and the household goods from one village to another. Very seaworthy in spite of their lightness, although slower than the smaller kayak the umiak uses a sail or is propelled with oars. *Library of Congress, Prints & Photographs Division, Edward S. Curtis Collection, LC-USZ62-107287*

RIGHT: The muskrat-hunter—a Kotzebue man paddles his kayak through marsh; c. 1929. Muskrats are small rodents trapped when the rivers are free of ice and supply food and furs for garments.
Library of Congress, Prints & Photographs Division, Edward S. Curtis Collection, LC-USZ62-116540

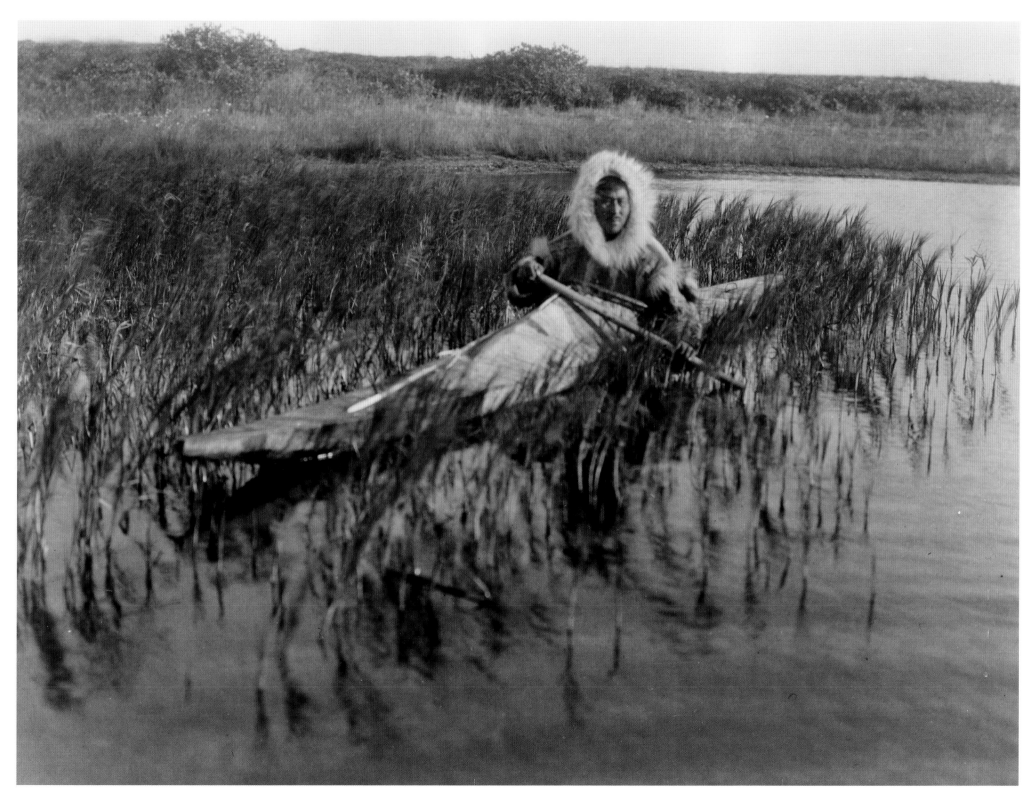

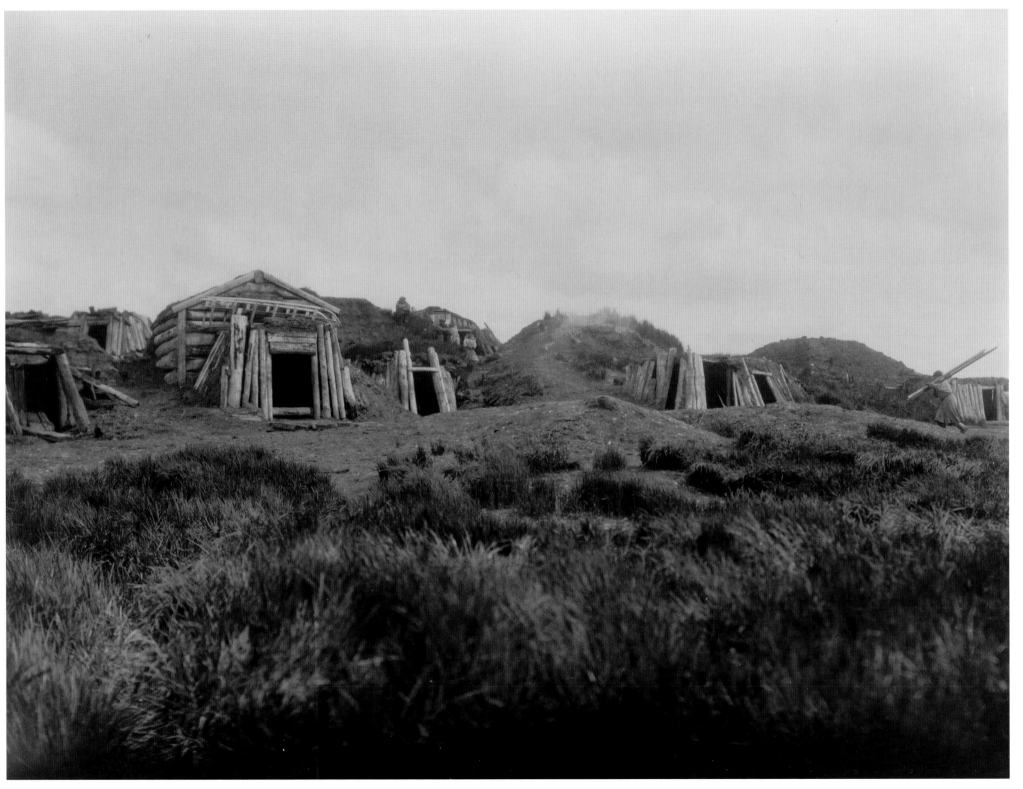

LEFT: Hooper Bay homes, Alaska; c. 1929. Hoping to fulfill his dream of participating in a traditional whale hunt, Curtis convinced the Hooper Bay people to take him out in search of the white beluga. Sadly, modern technology was his undoing: A gas-engined boat towing the small fleet of native kayaks broke down and the hunt was abandoned. *Library of Congress, Prints & Photographs Division, Edward S. Curtis Collection, LC-USZ62-107324*

RIGHT: Nunivak Island is home to Yupik-speaking (in Siberia and the western edges of Alaska) eskimos. Traditional art included ivory carvering, as here, has been affected in recent times by world reassessment of whaling. The people of the Arctic and Subarctic lived almost exclusively on whaling in the past. *Corbis*

FAR RIGHT: Jukuk, on Nunivak Island. *Corbis*

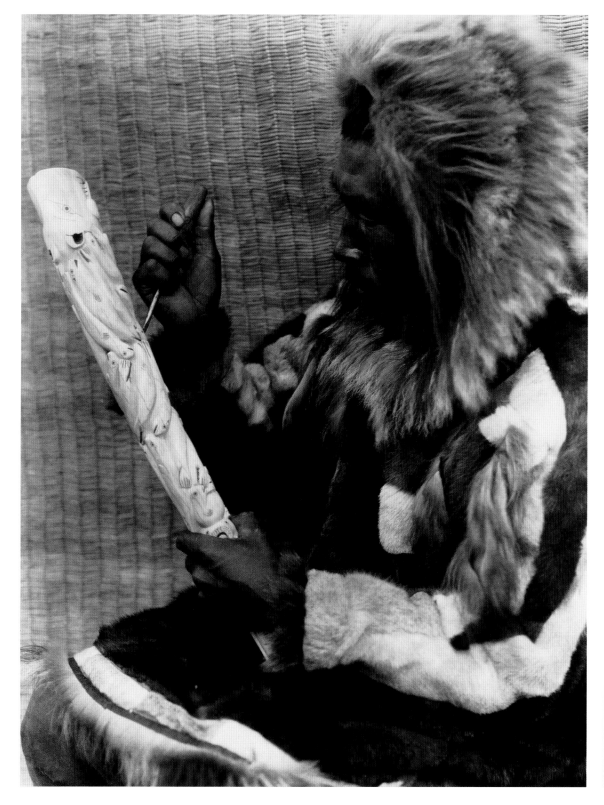

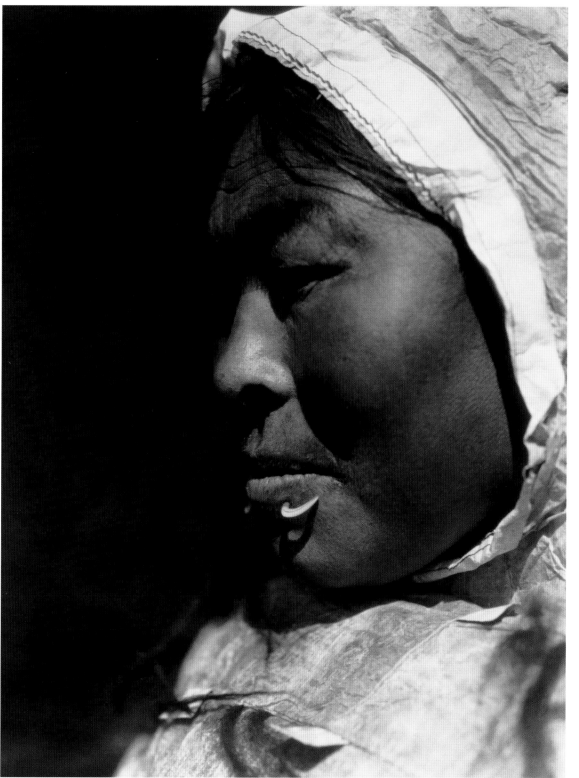

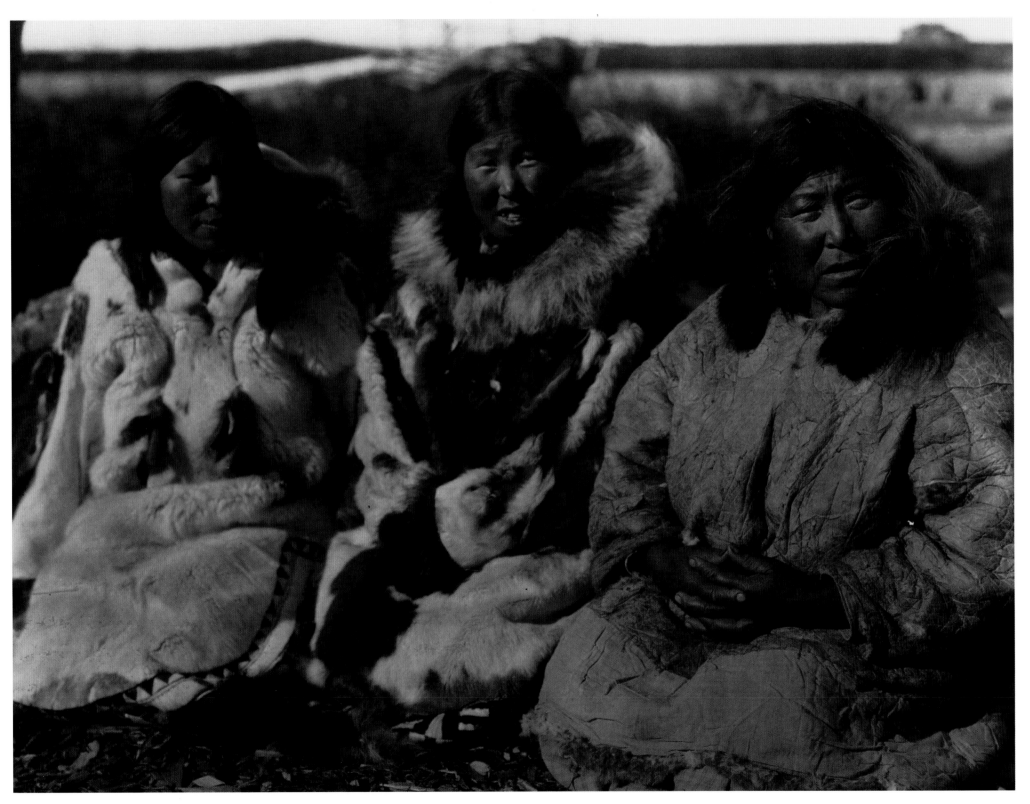

LEFT: The Inupiat are the Inuit (eskimo) of Alaska proper and speak Inupiaq. These women are from Selawik, southeast of Kotzebue. Today whaling quotas and global warming threaten their traditional way of life.
Corbis

RIGHT: "Noatak Home." A photograph of an Inupiat home. *Corbis*

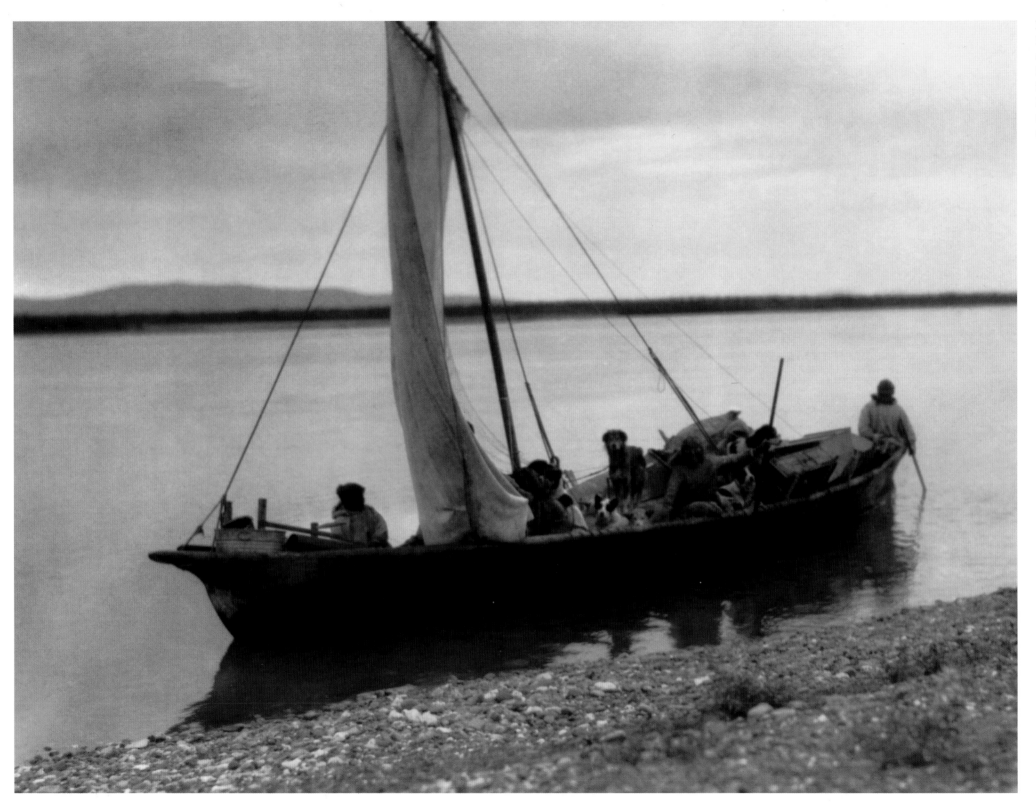

Left: "Starting up the Noatak River." A umiak in sail. Sails were an invention of great importance to the Alaskan Eskimo, whose material culture reached a highly advanced stage. *Corbis*

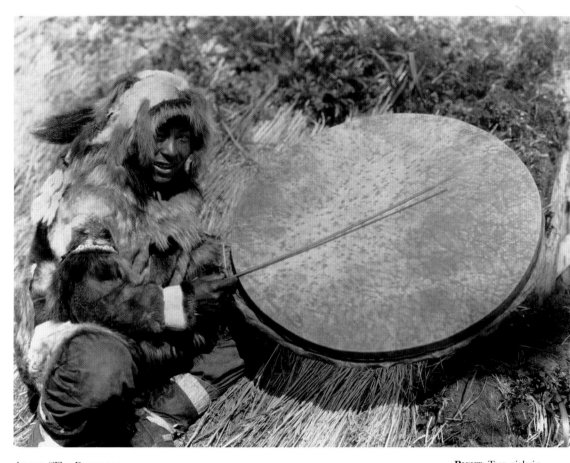

ABOVE: "The Drummer—Nunivak." This tambourine-like instrument, its head made of walrus stomach or bladder, is used chiefly in the winter ceremonies. Such drums vary in diameter from a foot to five feet; the one illustrated measured three feet six inches. When beaten, the drum is held in position varying from horizontal to vertical. The drum-stick is a slender wand. *Corbis*

RIGHT: Two girls in waterproof parkas on Nunivak Island. The parkas are made from the gut of sea mammals. *Corbis*

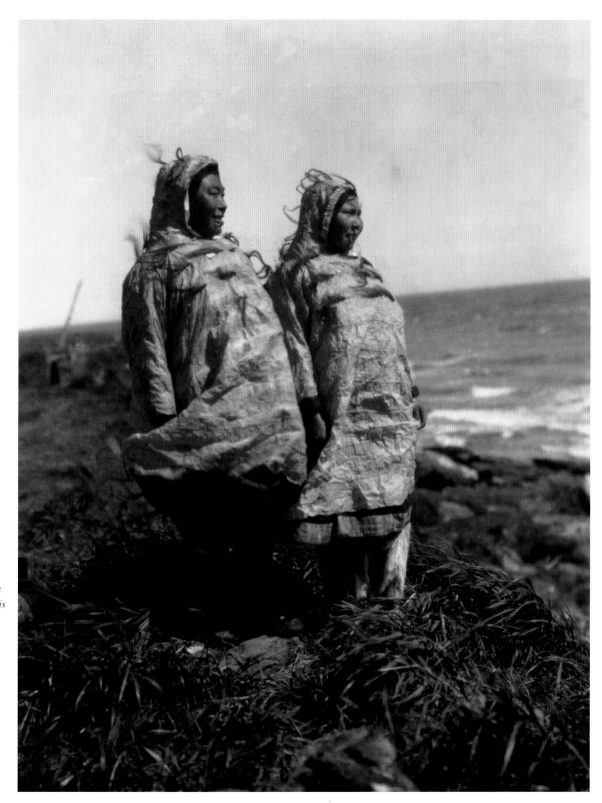

INDEX